The Complete Raw Workflow Guide:

How to get the most from your raw images in
Adobe Camera Raw, Lightroom, Photoshop and Elements

Philip Andrews

ELSEVIER

AMSTERDAM • BOSTON • HEIDELBERG • LONDON • NEW YORK • OXFORD
PARIS • SAN DIEGO • SAN FRANCISCO • SINGAPORE • SYDNEY • TOKYO
Focal Press is an imprint of Elsevier

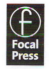
Focal
Press

Focal Press is an imprint of Elsevier
Linacre House, Jordan Hill, Oxford OX2 8DP, UK
30 Corporate Drive, Suite 400, Burlington, MA 01803, USA

First edition 2008

British Library Cataloguing in Publication Data
A catalogue record for this book is available from the British Library

Library of Congress Cataloging-in-Publication Data
A catalog record for this book is available from the Library of Congress

ISBN: 978-0-240-81027-0

For information on all Focal Press publications visit our website at www.focalpress.com

Printed and bound in Canada

Layout and design by Karen and Philip Andrews in Adobe InDesign CS3

07 08 09 10 11 10 9 8 7 6 5 4 3 2 1

Working together to grow
libraries in developing countries

www.elsevier.com | www.bookaid.org | www.sabre.org

ELSEVIER BOOK AID International Sabre Foundation

Contents

Section Two: Core Processing

5: Camera-based Converters 123

6: Processing with Photoshop Elements 131

Section Three: Advanced Editing/Enhancement

Section Four: Raw File Management

Preface

These days it seems that trying to stay ahead of the game as a digital photographer is like trying to catch the wind. You gradually build your skills and knowledge and no sooner do you get a handle on the best workflow for your style of image making that the industry changes not only the goal posts, but the very game you are playing.

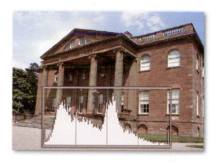

Shooting raw is such a change for the quality conscious photographer. The way we photograph and process our images has, again, changed for ever. Choosing to shoot raw over other capture formats is not just a matter of changing the file type on your camera, it requires a change in the way that you think about your photography. No longer are we condemned to allowing our camera the lion's share of decision making when it comes to converting the basic picture data that is recorded by the sensor. Choosing to shoot raw is an act that rightly repositions the photographer and his or her skills at the very center of the picture-making process.

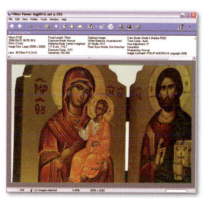

This book is a celebration of the return of the photographer as the master of the whole process – from capture to archive. So join me as I show you the skills, techniques and knowledge that you need to reassert your rightful place in this ever changing world of photography.

Philip Andrews

Dedication

As always, I dedicate this book to the loves of my life – Karen, Adrian and Ellie. Oh, and good coffee, crusty bread and French cheese, but don't tell my wife and kids. OK?

Philip Andrews

Author's acknowledgements

Thanks also to the dedicated staff at Focal Press whose aim, thankfully, is always to produce great books.

Cheers also to Richard Earney of ***www.inside-lightroom.com*** fame, whose time and effort in providing technical feedback on the book has certainly helped create a more accurate, balanced and even text. For those of you who don't know Richard, he is a beta tester for Photoshop and Lightroom and is also an expert on digital workflow. He has been a photographer for over 30 years and is a Licentiate of the Royal Photographic Society and of course, runs the Inside Lightroom website.

Picture credits

My thanks goes to the following generous photographers who kindly let me feature some of their great raw-based images though out the text.

Darran Leal of ***www.wildvisions.com.au*** has led over 300 photo events to a range of countries all over the world. His wildlife and landscape images have graced the pages of hundreds of magazines and also feature in calendars and books. His photo explorer safaris are designed to build your photo skills in the field while shooting some of the most amazing scenery around.

Peter Eastway is editor and publisher of *Better Photography* magazine in Australia and is a Grand Master of Photography, one of only two in the world. His award winning landscape photography has led to much recognition around the world and is one of the reasons that Lonely Planet choose him to write their international guide book on landscape photography. See more of Peter's work at ***www.betterphotography.com***.

Cover photo courtesy of Jade Summer (***www.jadesummer.com***).

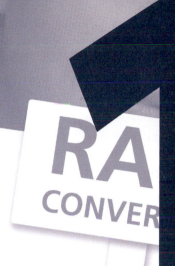

1

Raw
School 101

It's a new day in photography. The earth-shattering change brought on by the availability of instant feedback on the digital camera's LCD, or directly on computer monitor through tethered or wireless camera-to-computer capture, with histogram and capture information displayed, has changed the way we work and play in the realm of photography. Many, if not most, of us have ditched the chemicals and transformed our film darkrooms into digital darkrooms. We're showing our clients or family and friends our work on various devices or as a quick print right after it's produced, and we're printing our own masterpieces or transmitting the image files directly to our imaging bureau. What is the next step in this ongoing digital development? Well, now many of us are embracing the advantages of 'raw' capture and building the new skills necessary to process and enhance our raw files in order to bring them closer to perfection or, at the very least, our liking.

Unless you have been sleeping, or is that hibernating, under a rock for the last few months you will already know that 'shooting raw' is the latest hot topic for digital photographers the world over. More and more mid- to high-level SLR and compact cameras provide the option for switching from the traditional capture formats of JPEG and TIFF to raw. This capture format change gives photographers even more control over the digital photos they create by taking back a bunch of processing steps that until now have been handled by the camera, and placing them firmly in the hands of the shooter. By providing access to the image data early on in the processing workflow, photographers have more creativity options and better quality control with their pictures but, as with

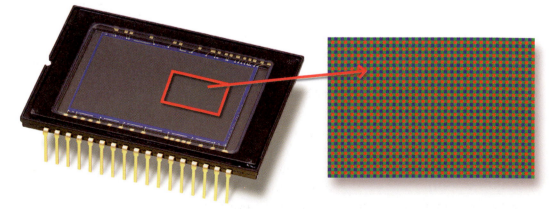

The standard camera sensor is made up of a grid of filtered sensor sites colored red, green and blue (RGB). The grid pattern used by most cameras contains twice as many green sensor sites as either red or blue, and in a special Bayer pattern. The RGB color design records both the color and brightness of the various parts of the scene.

most things, along with this new found flexibility comes increased responsibility. Over the next few chapters we will take a close look at what it means to shoot, process and output raw files, and also examine the new wave of 'complete raw workflow' enhancement tools and techniques that are now entering the market. But before we get ahead of ourselves let's start at the beginning with some details on the format itself.

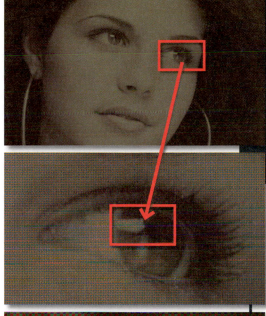

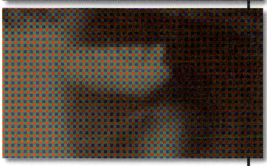

What is raw?

To get a handle on what this file format is, and how it can help you make better pictures, we need to start by looking at the capture part of the digital photography process. All single-shot digital cameras (except those using the Foveon chip) contain a sensor that is made up of a grid, or matrix, of light-sensitive sites. Each site responds proportionately to the amount of light that hits its surface. By recording and analyzing each of these responses a tone is attributed to each sensor position in the grid. In this way a digital picture can be created from the range of scene brightnesses that are focused through the lens onto the sensor's surface. Fantastic though this is, this process only results in a monochrome (black, white and gray) picture as the Charge Coupled Device (CCD) or Complementary Metal Oxide Semiconductor (CMOS) sensors by themselves cannot record the color of the light, only the amount of light hitting the sensor site.

A raw file is the photo converted from its analog beginnings into a digital format but the photo is still separated into the Bayer pattern, where each sensor site represents one color only.

So how do our cameras create a color photo using mono sensors? Well, to produce a digital color photograph a small filter is added to each of the sensor sites. In most cameras these filters are a mixture of the three primary colors red, green and blue, and are laid out in a special design called a Bayer pattern. It contains 25% red filters, 25% blue and 50% green, with the high percentage of green present in order to simulate the human eye's sensitivity to this part of the visible spectrum. Adding a color filter to each sensor site means that they respond to both the color and brightness of portions of the scene. Using this system the various elements of a color scene are recorded as a matrix or pattern of red, green and blue pixels of varying brightnesses. If you greatly magnify one of these images you will see the three-color matrix that was created at the time of capture.

The unprocessed sensor data saved at this point is referred to as a raw file. It contains information about the brightness and color of the scene, but in a form that can't be readily edited or enhanced with standard photo software. Until the current influx of raw-enabled digital cameras and software, photographers were blissfully unaware of the existence of such files, as the images that they received from their cameras were already converted from the raw state to the much more familiar (and usable) JPEG or TIFF form. This conversion occurs as an integral part of the capture process, where the raw data coming from the sensor is used to create a full color image. Special algorithms are employed to change the Bayer-patterned data to a standard RGB form; in the process the extra details for non-red sites, for instance, are created using the information from the surrounding red, green and blue sites. This process is called interpolation, and though it seems like a lot of 'smoke and mirrors' it works extremely well on most cameras.

So you opt to save your images in JPEG or TIFF formats, the capture and interpolation process happens internally in the camera each time you pushed the shutter button. Selecting raw as your preferred capture format stops the camera from processing the color-separated (primary) sensor data from the sensor, and simply saves this data to your memory card. This means that the full description of what the camera 'saw' is saved in the image file and is available to you for use in the production of quality images.

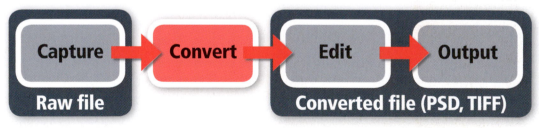

Photographers switching from JPEG or TIFF capture to raw take on a conversion step in the photographic process that is not needed when working with the other formats.

When selecting raw for image quality, the digital camera stores only the raw image and EXIF or metadata (camera type, lens and focal length used, aperture, shutter, and more). Any camera presets and parameter settings you make, such as contrast, saturation, sharpness and color tone (found in the Parameters menu on the Canon EOS 20D, for example), do not affect the data recorded for the image. They do, however, become the defaulted values during raw conversion, until you elect to change all or some of them. Only ISO speed, shutter speed and aperture setting are processed by the camera at the time of capture.

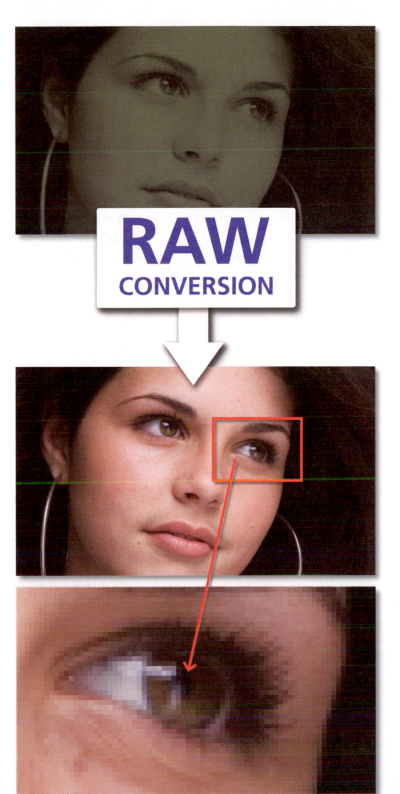

Generally speaking, before a raw file can be enhanced with a standard editing program, the picture has to be converted into a standard RGB picture format. This conversion process is usually handled by a dedicated conversion utility such as Adobe Camera Raw. This situation is changing somewhat as programs like Lightroom provide more and more enhancement options and editing software such as Photoshop becomes more 'raw aware'.

Also the non-destructive enhancement tools in Adobe Camera Raw and Lightroom are so desirable that in the latest releases of these programs their editing abilities can also be used with JPEG and TIFF files.

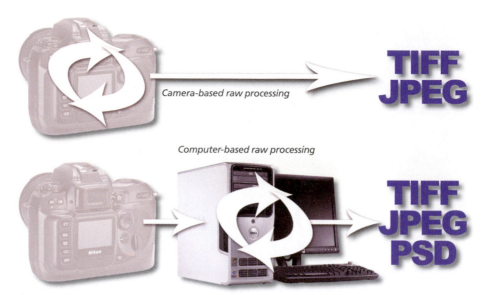

Camera-based raw processing

Computer-based raw processing

Switching your camera to raw format capture removes the conversion step from being handled in-camera and allows more considered and creative conversions on the desktop.

An extra processing step

Sounds great, doesn't it? All the quality of an information-rich image file to play with, but what is the catch? Well, for the most part raw files have to be processed before they can be used in a standard image editing application like Photoshop. It is true that brand new applications, like Adobe's Lightroom, can enhance raw files without first converting them, but for the most part serious editing can only take place on a converted raw file. So to access the full power of these digital negatives you will need to employ a special raw converter. These programs come as either stand-alone pieces of software, or as a dedicated feature in your favorite editing package. Some can process files from capture devices of several manufacturers, others are restricted for use with single camera models only. They range from very expensive, fully featured, professional workhorses to free bundled utilities supplied with raw-enabled cameras. In this text we will concentrate on the raw processing abilities of Adobe Camera Raw, which ships with Photoshop and Photoshop Elements, and Photoshop Lightroom, the complete raw workflow product from Adobe.

Designed specifically to allow you to take the unprocessed raw data directly from your camera's sensor and convert it into a usable image file, these editors also provide access to other image characteristics that would otherwise be locked into the file format. Variables such as color space, white balance mode, image sharpness and tonal compensation (contrast and brightness) can all be accessed, edited and enhanced as part of the conversion process.

Camera Data
(f-stop, shutter speed, ISO, camera exposure mode, focusing distance etc)

Image Data
(white balance, sharpening, color mode, tonal compensation)

Image
(full 16 or 12-bit color and tone)

RAW File

Differences between raw and other formats

Raw files differ from other file types in that some of the options that are fixed during the processing of formats such as TIFF or JPEG can be adjusted and changed losslessly with a raw format. In this way you can think of raw files as having three distinct sections:

Camera Data, usually called the EXIF or metadata, including things such as camera model, shutter speed and aperture details, most of which cannot be changed.

Image Data which, though recorded by the camera, can be changed in a raw editor and the settings chosen here directly affect how the picture will be processed. Changeable options include color space, white balance, saturation, distribution of image tones (contrast) and application of sharpness.

The **Image** itself. This is the data drawn directly from the sensor sites in your camera in a non-interpolated form (Bayer pattern form). For most raw cameras, this image data is supplied with a 16-bit color depth, providing substantially more colors and tones to play with when editing and enhancing than found in a standard 8-bit JPEG or TIFF camera file.

Behold the new negative

So to put it simply, a raw file is a digital photo file format that contains the unprocessed image data from a digital camera's sensor. Cameras with raw file support save the white balance, saturation, contrast, color, tone and sharpness settings for the file as tags (or place markers) but do not process them at the time of recording. The same settings for JPEG (and TIFF) files are processed in-camera and cannot be undone, if you will, in the digital darkroom. With raw capture you have full control over your raw file's destiny. Capturing what you see in raw mode is the closest you can get to producing pure, unadulterated image data that will be ready for your creative control and interpretation.

A raw file is often called a digital negative for two or more reasons. First, raw files may be processed and converted multiple times without ever damaging the original image data. Second, the photographer is required to process and convert the digital negative in the digital darkroom post-capture, in a way similar to working with a negative in a traditional film darkroom. You always have the negative, whether digital or film, to reinterpret at a later date.

SHOOTING MENU
Image Quality

NEF (Raw) ▶ OK
TIFF-RGB
JPEG Fine
JPEG Normal
JPEG Basic

Choosing raw over other capture file formats is not just a matter of preference it is also a choice to take full control of the processing of your digital photos.

Why bother with raw? Why not just stick to JPEG?

OK, I know what you are thinking. Shooting in raw means more processing work for the photographer. So why bother? Why not just stick to JPEG? Well the answer is twofold – better image quality and more creative control.

Not too long ago when asked why I would ever choose raw over JPEG, I often said, 'I shoot raw for the creative control I have over the images'. I've given this broad answer much thought and now think that it does not say quite enough about the power of raw. It's not just about creative control. It's also about quality control and assurance, if you will – not to sound too much like a Ford or General Motors executive or anything. When we tell our camera not to go ahead and process our files in-camera and make the decision to become the processing lab ourselves, we decide we want full creative control over working with our images to make them color correct, void of artifacts and defects (which are inherent in JPEG files) and great images overall, and we expect to assure our clients and/or ourselves what we have produced is of top quality. That's creative control, quality control and quality assurance all rolled into one!

When we shoot raw instead of JPEG (or TIFF) we have as much control over image quality as we want and we can make creative changes to our raw file within the raw converter (or conversion process) well before we even get to the enhancement stage using imaging software. The camera sets markers for the selections we make at capture and we can move (adjust) the markers for exposure, white balance and more during conversion. This is not the case for JPEG files as they are processed in-camera and after download we take what we get (a fully processed file) and go from there. We have to try our best to recover detail or fix a problem in Photoshop or other imaging software, often using up precious time and creating more frustration than the image is worth to us. With raw capture, if your exposure and white balance are off just a little or, heaven forbid, even way off, you have the advantage of being able to correct and adjust your initial capture settings with a fair amount of success. With JPEG capture, if the exposure and white balance, for example, are a little askew you're stuck, baby! Throw it away!!

When only the best will do!

Just as many photographers pride themselves in only shooting in manual mode, or boast about using the Levels or Curves features in Photoshop, rather than the Auto options, quality conscious shooters eagerly jump at the opportunity that raw capture affords by allowing them to get their hands on their photos early on in the processing chain. The conversion options provided by the camera at the time of capture, good though they may be, still provide an automatic-only approach to this important step. In contrast, armed with the top quality raw editing software that is now available and a raw-enabled camera, the desktop photographer can make careful and considered judgments about the many variables that impact on the picture conversion, providing customized picture-by-picture solutions never possible in the camera.

One advantage of working with raw files is the ability to use the full color depth that the image was captured in when processing and editing the file.
For instance, in the Workflow Options of Adobe Camera Raw the user has the opportunity to select 16 bits per channel depth for all converted and saved files.

One of the real advantages of enhancing your photos during raw conversion is the changes are being applied to the full 12- or 14 -bit image rather than the limited color space of the 8-bit JPEG image. The changes are made to the file at the same time as the primary image data is being interpolated to form the full color picture. Editing after the file is processed (saved by the camera in 8-bit versions of the JPEG and TIFF

format) means that you will be applying the changes to a picture with fewer tones and colors. And we all know the benefits, or should do, that such high bit editing provides.

Shooting tethered no longer requires you to connect you camera to the computer via cables; the big camera companies have wireless options for their mid- to high-range DSLR cameras.
Here the Nikon D2XS can be seen with the WT-2/2A wireless transmitter attached to the bottom of the camera. Good for up to 100 feet range approximately (30 meters), the transmitter can control the camera remotely (when used with Nikon Capture) and is also able to upload photographs directly to an FTP or file server over a wireless network.

Making the switch

The progression from JPEG to raw capture is probably much easier (and more addictive) than you ever imagined, providing you do your homework and learn the fundamentals. What may be difficult at first is finding your way around the raw converter menus and knowing what to do with a range of options. After all you are literally crawling through the attributes of a raw file and you're in control of each attribute's destiny. But once the terminology, control types and settings become familiar you will not want to relinquish your new found creativity and power over the quality of the images that you produce.

For the production photographer there are extra bonuses as most raw conversion programs also contain batch processing options. These allow the user to set up general parameters for a group of images and then instruct the program to process and save each file in turn automatically. This is a real time saver when you have to edit a bunch of pictures taken under the same shooting circumstances. In the same vein, some software also includes the ability to shoot and adjust pictures whilst your camera is attached to the computer. This feature, usually referred to as shooting 'tethered', works particularly well for studio photography and has the advantage of saving files directly to your computer, bypassing the camera's memory card system.

Being tethered doesn't necessarily mean having wires connecting you camera and computer though. Both Canon and Nikon have wireless options for their leading DSLR cameras that provide the same connectivity as a cable but with loads more freedom.

Advantages of shooting raw

There are plenty of times when the features and benefits of raw capture make it the file format of choice. If we select an improper white balance at the time of capture or we have exposure or color saturation issues, for example, we can merely click on a drop-down menu tab in our raw converter and make adjustments. If creating the largest possible file size is paramount, raw is an excellent choice. If low light conditions prevail, we can use raw to make small adjustment requirements. These reasons are all fairly obvious to many of us who have heard about or tried raw capture with even a modicum of success. Professionals and amateurs alike: listen up! There are other big reasons.

- You get to use the full tonal and color range that was captured by the camera.

- You can remove many of the file processing decisions from the camera to the desktop, where more time and care can be taken in their execution (and more importantly, you are in control!). This includes:

 - White balance changes
 - Highlight, shadow and midtone adjustments
 - Applying sharpness
 - Manipulating saturation
 - Color mode (sRGB, Adobe RGB etc.) switches.

- You create and save the most comprehensive digital picture file – 'digital negative' – currently available.

- You can make image data changes, such as switching white balance settings, without image loss. This is not possible with non-raw formats as the white balance settings were applied when the image was processed in the camera.

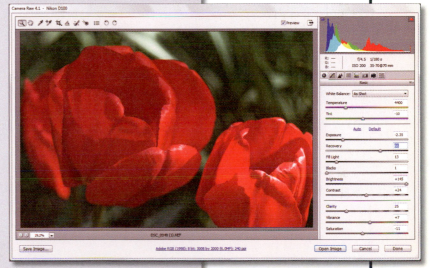

Working your way through the various settings used to process a raw file is a great way to gain more understanding about the digital photography process.

- You can 'upscale' using primary image data (straight from the sensor) rather than preprocessed information, which arguably leads to better results.

- The original raw file is maintained. You can do a ton of work to your raw image prior to converting it without damaging the original negative, such as cropping (yes even cropping), color correction and more.

- A digital negative for archiving. With a raw original, you can always go back to an unprocessed file and revisit your approach to converting and processing it. Completely reinterpret the image if you like – warm it up, cool it down. Whatever. And you can do this over and over and over to perpetuity.

- Work with a wider dynamic range. Dynamic range in a digital camera is the range of black to white the image sensor can detect, from the highest measurable values of white to lowest black. (Don't confuse this with gamut, the range of different colors the camera or other device, like a printer, can generate.) Our objective is to get the widest possible range of tones between black (shadows) and white (highlights) without clipping the shadows or blowing out the highlights. Our in-camera histogram will give us an approximation of this spread or range of tones within a particular image but we will really find out the truth when we open the file with a raw converter.

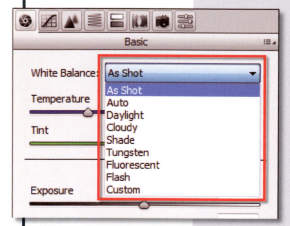

Parameters set in the camera at the time of capture, such as white balance, can be altered at the time of raw processing with no loss to the original file.

- Embrace high bit editing with 16-bit raw image files. A higher bit depth means more tones to play with, which eventually means smoother gradients and transitions in the final photograph. You have ever so much more data to work with in 16-bit mode.

- Correct poor exposures (somewhat!). Think about this. Not only can you bracket your raw exposures, you can then adjust exposures up or down by one or more stops on your computer. Obviously you should try to nail your exposures in-camera and hope for just a minor tweak to exposure in the raw converter, but shooting raw does allow for a larger margin of correctable exposure error than other file types. Now I'm not saying that you can fix major problems; completely blown out highlights and shadows with lost data are not recoverable even in raw mode, but photos with

minor errors are savable. In fact both Adobe Camera Raw and Lightroom have special controls for just this purpose. The Recovery slider in both programs reconstructs missing details in one channel with the data from the other two. Cool!

- Background batch processing: save time by batch processing raw images in the background, for example when using Adobe Bridge as an image adjuster and batch processing command center, or within other programs.

- Edit and correct lens-based problems such as vignetting and chromatic aberration.

	Auto	Default	
Exposure			-2.35
Recovery			56
Fill Light			13
Blacks			1
Brightness			+145
Contrast			+24

The high bit, high dynamic range nature of raw capture means that it is possible to fine-tune or correct minor exposure problems at the time of processing.

Raw disadvantages

There's not many, but it wouldn't be fair to overlook the issues that some photographers rate as raw's main disadvantages.

- Bigger file sizes to store on your camera's memory card. That means fewer photos per card.

- Having to process the images before being able to use them in your standard image editing program. Yep, that's more time in front of the screen and less time shooting.

- Big file sizes plus on-the-fly processing can be a drain on meagre computing resources. Faster previews of raw conversion changes require up-to-date hardware which can be expensive.

- In some cases, needing specialist raw processing software to convert files, in addition to your favorite image editing package.

High-resolution cameras capturing raw files do require bigger, faster memory cards than when JPEG is selected as the capture format. Thankfully companies such as Lexar continue to release cards with higher capacities and faster read/write speeds.

The DNG or Digital Negative file format is an open source format proposed by Adobe as a means of creating a common standard among digital cameras.

Proprietary and open raw file formats

By now it should be plain to see that the raw format has many advantages for photographers, offering them greater control over the tone and color in their files, but unfortunately there is no one standard available for the specification of how these raw files are saved. Each camera manufacturer has their own flavor of raw file format. This can make the long-term management of such files a little tricky. What happens, for instance, if over time the specific format used by your camera falls out of favor and is no longer supported by the major editing packages? Will you be able to access your picture content in the future?

In February 2005 Adobe released a specification for a new non-proprietary file format for storing Camera Raw files. The Digital Negative format, or DNG, is being put forward by the company as a candidate for a common raw standard that both camera and software manufacturers can adopt. Most photographers believe that the new format is a step in the right direction, as it brings compatibility and stability to the area along with the assurance that your raw files will be able to be opened long after you camera has gone by the wayside.

The Digital Negative format comprises actual image data and the metadata that describes the image file. The major feature of DNG

is its handling of metadata, the information that stays with a file about camera and lens used to capture the file, camera settings, and more. DNG is designed to work with a wide range of camera designs and features and will evolve with introductions of new cameras and technology within them. The Digital Negative specification helps ensure your images are accessible and readable in the future.

In addition to providing a common raw file format, the DNG specification also includes a lossless compression option which, when considering the size of some raw files, will help reduce the space taken up with the thousands of images that photographers accumulate. Also included is the ability to embed the original raw file (in its native format) inside the DNG file. This step does increase the size of the final file but it also provides peace of mind for those users who want to always maintain the original file. The original RAW Files can be extracted later using Adobe's DNG Converter

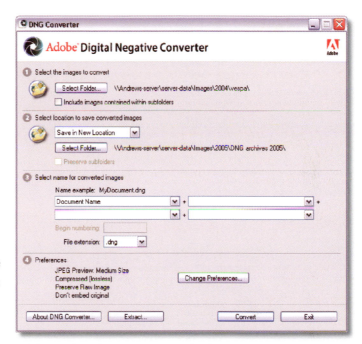

Adobe supplies a free DNG converter that lets you change your proprietary format raw files into the DNG format. Get your free DNG converter here: www.adobe.com/products/dng/. Though not strictly an open source format, Adobe freely publishes the specifications for the format and it can be used by hardware and software developers without charge.

Common raw file format extensions

Canon	.CRW	Nikon	.NEF
Sigma	.X3F	Fuji	.RAF
Kodak	.DCR	Sony	.SRF
Canon	.CR2	Minolta	.MRW
Olympus	.ORF	Adobe	.DNG
Pentax	.PEF	Sigma	.X3F

The DNG or Digital Negative file format is an open source format proposed by Adobe as a means of creating a common standard among digital cameras. More information about the format plus the free DNG Converter software for both Macintosh and Windows machines is available from the www.adobe.com website.

The company hopes that the specification will be adopted by the major manufacturers and provide a degree of compatibility and stability to the raw format area. At the moment Hasselblad, Leica, Ricoh and Samsung have all produced cameras that capture in the DNG format, with more predicted to follow.

Adobe has included DNG output options in Photoshop CS2/CS3, Photoshop Elements 4.0/5.0 and Lightroom, and also provides a DNG converter that can change many proprietary Camera Raw formats directly to DNG. The converter is free and can be downloaded from www.adobe.com.

Capture → Convert

RAW file

The **Convert then Edit**...
The raw file is downl...
more readily sup...

2

Establishing a Raw Workflow

By now you will have realized that making the decision to switch to raw capture has implications that reverberate throughout the rest of the photographic production process. The biggest change, of course, is that you will need to alter the way that you treat the editing and enhancement of your photos, as they are now captured in a specialized format.

A specialized format that requires specialized processing, specialized tools for that processing, and a specialized workflow to structure the processing steps.

Establishing a workflow that works for you

As with many things digital, there are a range of different ways to process, edit and enhance your raw files. Here I present a variety of workflow approaches, all designed for specific photographic environments. It will be your task to pick the approach that best fits with how you work. Like an old glove, the workflow that you choose should fit comfortably.

Most workflows fit within two different methods of working. To get us started, let's look at each of these approaches as well as the software components that form the base of these workflows.

The 'Convert then Edit' approach

Until recently, the only way to deal with raw files was to convert them from their unprocessed format to a file type that could be manipulated by photo editing software. The conversion process was handled by specialist software such as Adobe Camera Raw, or the raw utilities

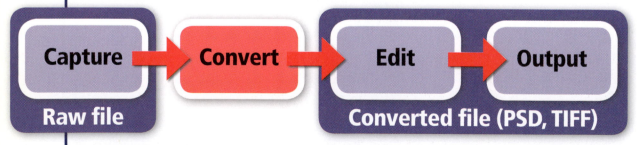

*The **Convert then Edit** approach is the most popular workflow currently used by raw shooting photographers. The raw file is downloaded from the camera and the first task in the process is to convert the file to a type that is more readily supported by photo editing programs such as TIFF or PSD.*

supplied with the camera. There are a variety of global enhancements (contrast, brightness, color, white balance, etc.) that can be applied to the photo during the conversion process handled by such utilities, but for many photographers the real work only commences after this process is finished. For this reason, this workflow is often referred to as a *Convert then Edit* approach.

Very nice thank you!

The workflow structure sits well with new raw users as it allows them to carry on with their standard editing approach after the conversion is complete. It also mimics the traditional photographic process where a single negative (raw file) could be processed in many ways, providing a variety of different outcomes. The process takes full advantage of the quality gains available from careful processing of the raw file and it is still the primary way that many photographers unleash the visual power of their raw files.

Example photographer 'A' – the portrait photographer

How does this workflow look and feel in practice? Well let's take example photographer 'A'. He is a portrait photographer who regularly shoots 20 or 30 photos per session. Previously he would have captured these photos in high quality JPEG or TIFF format but now he selects the raw format. After shooting, the files are downloaded to the computer via a card reader.

The transfer process is handled by the utility supplied by his camera manufacturer. This small program automatically starts when a card is inserted into the reader. After inserting details about where the images are to be stored, and how the files are to be named, the utility transfers the files to the computer and opens the photos in a dedicated file browser (again supplied by his camera manufacturer). Here the files are examined and the best images selected. The batch conversion option in the camera-based raw software is used to convert (using general or auto settings) and export most of the selected photos in a TIFF format.

Specific images that would benefit from individual attention are selected and opened into the raw conversion software. Here color, tone, sharpness and noise settings are customized for each photo before these

images too are exported in the TIFF format. The converted files are then opened into Photoshop where they are enhanced and edited in preparation for presentation to the client.

In this example, the raw files are converted with the camera-based software and then further edited in Photoshop. To ensure the best image quality it is important for photographer 'A' to make good conversion decisions early on in the process, as once converted, key parameters of the files are set.

Captured Raw Files

Transfer Files

File Preview/Select

Photographer 'A' workflow

The portrait photographer in this example uses a traditional Convert then Edit workflow for processing and editing his raw files. Once converted, the photos are edited and enhanced in just the same way as pictures captured in JPEG or TIFF formats.

The downside of the 'Convert then Edit' approach

The disadvantage of this approach is that once the conversion has taken place the ability to adjust the conversion settings is lost. Yes, it is possible to reconvert the original file with different settings to facilitate a different outcome, but essentially the core of the workflow is that at a specific stage in the process the raw file will no longer be the base reference for the image. In essence the processing that used to occur in the camera is delayed and handled, albeit more consciously and carefully, on the desktop, but the result is the same – the raw file is converted to another file type, and factors such as white balance become fixed and irreversible in the conversion.

Batch Auto Convert

Converted TIFF Files

Individual Conversion

Photoshop Editing

Capture → Edit → Output

Raw file maintained throughout

*In contrast to the previous approach, programs that provide a **full workflow** approach maintain the raw file throughout the whole digital imaging process. This completely non-destructive workflow is the way of the future for raw shooters and it is growing in support, with both Apple and Adobe releasing dedicated raw workflow products for the professional photography market. Not to be left out, new editing and enhancement techniques and 'workarounds' for Photoshop and Bridge users that adopt this workflow approach are being promoted all the time.*

Full raw workflow options

Until the release of Aperture, Lightroom and, to a lesser extent, the Smart Object technology in Bridge and Photoshop, *Convert then Edit* was the only option open to dedicated raw shooters. But that was then, and this is definitely now! Raw shooting and processing is no longer in its infancy, and along with the area's growing maturity has come new ways of working and new products to facilitate new workflows.

With these new approaches it is possible to maintain the raw state of the picture file throughout the whole digital imaging process. With this workflow the multitude of raw conversion, or development, settings normally applied to a photo can be edited, reversed or even cleared at any time in the process. The primary image data is never destructively altered, only the way that this data is interpolated and previewed on

Captured Raw Files

Transfer Files

Preview & Select

screen is changed. This is the future of raw processing and I predict that more and more image editing products will adopt a full workflow attitude as raw shooting becomes the norm, rather than the exception, for quality hungry shooters.

Example 'B' – the wildlife photographer

How does a professional photographer apply a full raw workflow? Well, let's use the example of a wildlife photographer who also shoots more than his fair share of the landscapes. After returning back to the office with a bag full of packed memory cards, or a full portable hard drive, the first task is to transfer the files to his production machine. As Photoshop Lightroom is his software of choice, this means employing one of the Import options listed in the File menu. In the download dialog he can name, add metadata and even apply saved develop settings to the raw files as they are transferred to his machine. Next, the features inside the Library module are used for sorting, tagging and selecting suitable images to enhance. Individual photos are edited and enhanced via the tools in the Develop module. Core changes that are common to all photos, or groups of similar images, are saved as a Preset and then applied to the selected photos. Finally, the images are presented with either the Slideshow or Web modules and/or output to media with the options in the Print module.

Photographer 'B' workflow

In this example a wildlife landscape photographer makes use of the full raw workflow afforded by Photoshop Lightroom to handle his files from download, through enhancement to output.

Apply Develop settings

Present and/or Print

Hybrid approaches

In reality most photographers will still resort to a mixture of both these systems for their daily work. They will use more of a hybrid approach that performs as many image management, editing, enhancing and presentation functions with the photo remaining in the raw format for as long as possible. Many images will not need to be taken beyond this raw-only workflow for them to reach their full potential, but there will be some photos, or imaging projects, that will require editing functions or techniques that are not present in the workflow. It is at this point that the raw file is exported to another program and/or format.

As an example, think of the photographer who handles all his raw work in Photoshop Lightroom and wants to make a montage of several of his best images in a single document that can be used as a poster. For this to occur the raw files will need to be exported to Photoshop, where the separate images will be combined. During the export process, the raw files will be duplicated and converted to PSD (Photoshop), TIFF or JPEG files, thus losing the ability to edit the raw parameters of these copies later.

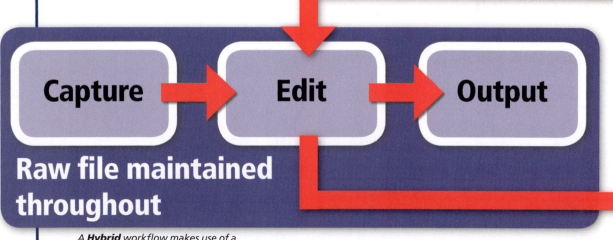

A **Hybrid** workflow makes use of a full raw workflow product for most enhancement tasks and then employs either a convert or embedded raw file approach for editing outside of the main workflow program.

In the greater scheme of things, this is no big deal as we always have the original raw files, our original digital negative, from which to commence any further iterations of the photo. In this way, the hybrid approach truly does resemble a traditional film capture and print process, as the original storage device (the raw file) is the basis of a variety of processing outcomes. In the old days this meant different prints, some with more or less exposure, others with areas dodged and burned in, and still more with changes in color or contrast all originated from a single negative. For raw shooters the results are similar, with the raw file sitting at the start of a variety of output options – print, web galleries and slideshows.

Currently the area of hybrid processing is in a state of flux. With the ever increasing power of the Smart Object technology in Photoshop, and the ability for raw files to be processed in Adobe Camera Raw in Bridge, it is now possible to perform quite complex editing in Photoshop without the need to convert the raw file first. This is one of the most exciting areas of raw editing as the most innovative techniques are both non-destructive and are also based around a non-converted raw file sitting in a Smart Object.

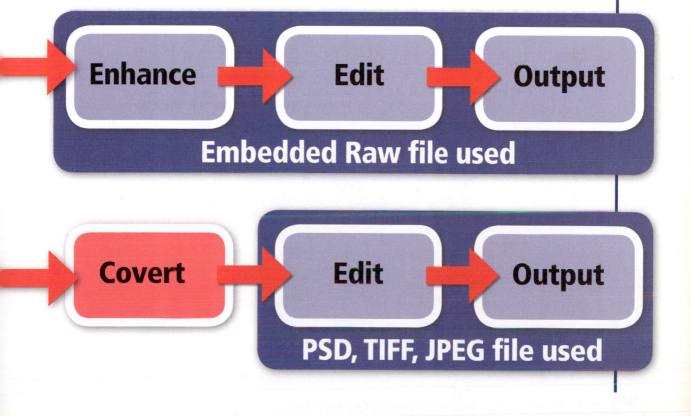

Example 'C' – the editorial photographer

The example photographer for the hybrid approach to raw file handling is an editorial photographer. Put simply this means that he can be called upon to produce a range of image types according to what is required by the magazine editor.

In one issue he might be commissioned for a series of photos in a documentary style. By definition, these images require little editing beyond that which is possible with the tools available from a Full Raw Workflow product such as Photoshop Lightroom. Consequently he uses the program to make all global color, tone and sharpness enhancements. Using the Remove Spots tool, he can eliminate marks in the photos caused by sensor dust and the Remove Red Eye tool can be employed for problem flash photos.

In another edition of the publication, he is asked to produce a series of highly manipulated images that are more illustrations than they are photos. For this series he makes basic adjustments to his raw images in Adobe Camera Raw or utilizes the changes he has already made before opening the files as Objects in Photoshop. This step embeds the raw file in a Smart Object layer inside a Photoshop document. Adjustment layers together with masks are used for changes to specific areas and the new Smart Filtering technology in CS3 is employed for all filtering tasks. In this way he is able to maintain the integrity of the raw file throughout while still editing the image beyond the capabilities of Lightroom.

The Smart Object technology inside Photoshop CS2 and CS3 enables you to embed a raw file inside a Photoshop document and continue to edit the file non-destructively.

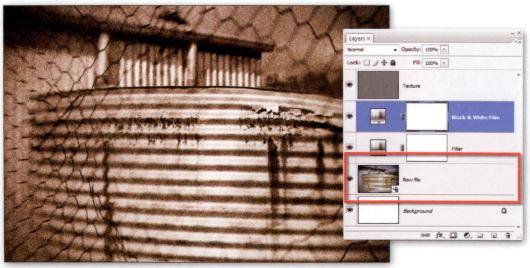

Building workflows upon a firm foundation

Now that you have a good idea of the various workflow options available to you, I thought it best to spend a few pages looking at some general foundations that should underpin all workflows. In particular, we will concentrate on the importance of good color management and making sure that your hardware is also up to the task. Though not specifically related to raw workflow, these areas are critical for the efficiency and accuracy of your raw processing.

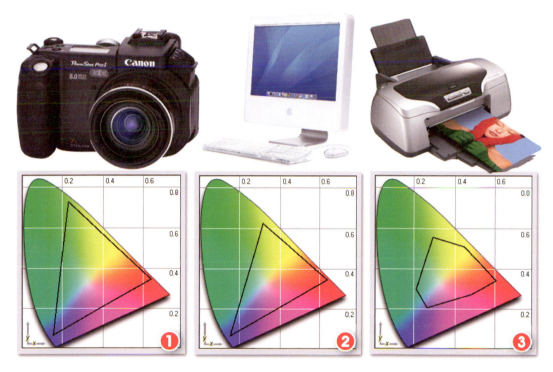

Ensuring color consistency between devices

One of the biggest problems faced by the digital photographer is matching the color and tone in the scene with what they see on screen and then with what is output as a print. Despite the sophistication of raw processing techniques, such basic color consistency is still a core issue that will affect image quality if not handled correctly. This problem comes about because, when working digitally, we use several different devices to capture, manipulate and output color photographs – the camera, or scanner, the monitor or screen, and the printer.

The devices used to capture, process and output color pictures all respond to color in a different way. Each piece of hardware is only capable of working with a subset of all possible hues. This range of colors is called the device's color gamut.
1. Camera gamut.
2. Screen gamut.
3. Printer gamut.
Graph images generated in ICCToolbox, courtesy of www.icctools.com.

Each of these pieces of hardware sees and represents or depicts color in a different way. The camera converts a continuous scene to discrete digital tones/colors, the monitor displays a full color image on screen using phosphors or filtered LCDs and the printer creates a hard copy of the picture using inks on paper.

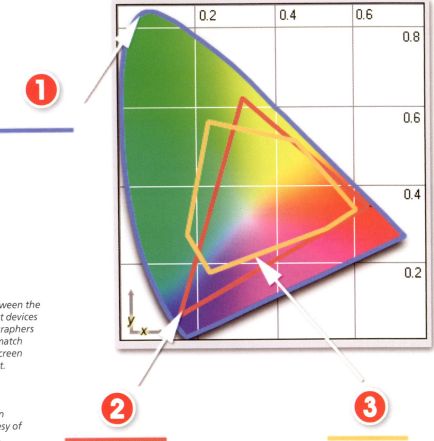

The difference between the gamuts of different devices can lead to photographers not being able to match what they see on screen with printer output.
1. All visible colors.
2. Screen colors.
3. Printable colors.
Graph generated in ICCToolbox, courtesy of www.icctools.com.

One of the earliest and most complex problems facing manufacturers was finding a way to produce consistent colors across all these devices. As many readers will attest to, often what we see through the camera is not the same as what appears on screen, which in turn is distinctly different to the picture that prints. These problems occur because each device can only work with a small subset of all the possible colors. This set is called the color gamut of the machine. As the gamut changes from device to device so too does the range of colors in the picture. For example, the range of tones and colors the camera recorded may not be visible on screen and the detail that can be plainly seen on the monitor may be outside the capabilities of the printer.

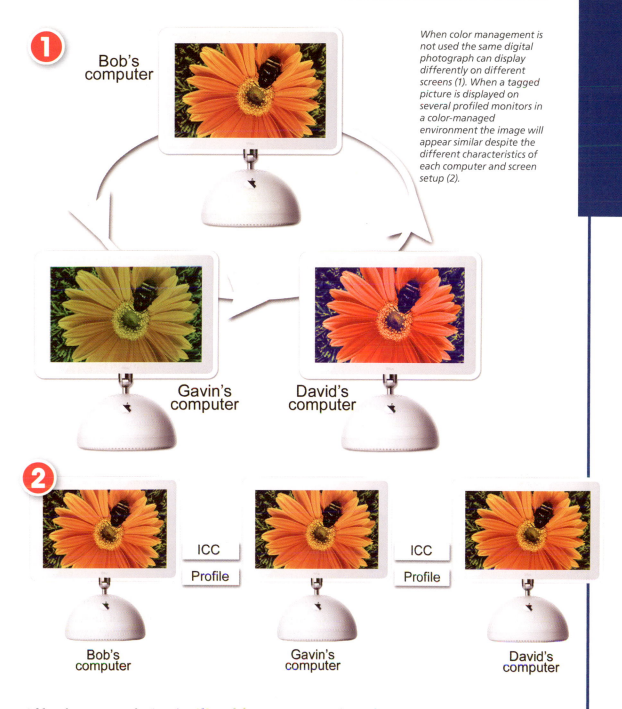

When color management is not used the same digital photograph can display differently on different screens (1). When a tagged picture is displayed on several profiled monitors in a color-managed environment the image will appear similar despite the different characteristics of each computer and screen setup (2).

Add to this scenario the fact that if I send the same image to three of my friends it will probably appear differently on each of their screens. On one it may be a little contrasty, on another too blue and on the last screen it could appear overexposed. Each of the monitors is interacting with the digital file in a slightly different way.

So with all these complexities are raw shooters condemned to poor color consistency? The answer is a resounding NO! Through the use of a color-managed system we can maintain predictable color throughout the editing/enhancing process and from machine to machine.

Essentially color management is concerned with describing the characteristics of each device in the editing chain. This description, often called an ICC profile, is then used to translate image detail and color from one device to another. Pictures are tagged, when they are first created, with a profile and when downloaded to a computer, which has a profiled screen attached, the image is translated to suit the characteristics of the monitor. With the corrections complete the tagged file is then sent to the printer, where the picture is translated, again to suit the printer's profile.

A similar scenario occurs when viewing files on different machines. As the picture is passed around, the profile for each monitor translates and accounts for individual hardware and color changes. The result is a picture that appears very similar on all devices.

Pro's tip: To ensure that you get the benefits of color management at home, be sure to turn on color management features for your camera, scanner, monitor, software and printer. Always tag your files as you capture them and then use this profile to help keep color consistency as you edit, output and share your work.

Color management, image quality and workflows

So how does color management impact on our raw processing workflows? Well, as we have already seen, much of the quality of the final outcomes of the editing and enhancement process is determined by decisions as early as the capture format used for the photograph. Color management is no different in this respect. It is a fact that the digital photographer who considers color management at the point of shooting, and then again when editing, will output better quality (and more predictable) printed and presentation images than one who doesn't. So at each stage of the digital process – capture, manipulation (editing/enhancing) and output – your pictures should be color managed.

Color-managed capture – For non-raw shooters it is critical to make sure that any color management, or ICC profile, settings in the camera are always turned on. This will ensure that the pictures captured will be tagged with a profile. The circumstance for photographers capturing in raw is slightly different. The decision about the color space used for the captured photo is delayed until the raw file is processed and exported. Both Lightroom and Camera Raw have a variety of output color spaces (ProPhoto RGB, AdobeRGB, sRGB) which can be selected at conversion or export time.

Capture

Color-managed manipulation – When editing and enhancing files in Lightroom or Adobe Camera Raw, both products place the images in a default, working, color space. For Adobe Camera Raw, this is ProPhoto RGB, and for Lightroom, it is a variation of ProPhoto RGB, code named 'MelissaRGB'. These programs always use a color-managed workflow. Photoshop too uses a fully color-managed workflow but with the option to alter the default working profiles of RGB, CMYK and Grayscale images via the Color Settings preferences. In Photoshop Elements, we should make sure that one of the color management options is selected in the Color Settings dialog of the program. These measures will ensure that tagged pictures coming into the workspace are correctly interpreted, and displayed ready for editing and enhancement. It also guarantees that when it comes time to print, or output to screen, the software can correctly translate your raw masterpieces into a format that your printer, or monitor, can understand.

Manipulation

Color-managed output – The final step in the process is output to screen or printer and it is critical, if all your hard work to this point is going to pay off, that you load and use the printer's profile, or select a suitable screen profile (such as sRGB) for output that will be viewed on the web. This step means that the tagged file exiting the program will be accurately translated into the colors and tones that the printer or screen is capable of creating.

Output

Think of the whole system as a chain. The strength of your color management, and therefore the predictability of the process, is based on both the integrity of the individual links and their relationship to each other. ICC profiles are the basis of all these relationships. They ensure that each device knows exactly how to represent the color and tones in an image, as well as how to best translate the colors from one device to another.

Setting up a color-managed workflow

Now that I have convinced you that a color-managed system has distinct quality advantages over a 'hit and miss' non-managed approach, you will, no doubt, be eagerly wanting to make sure that all the components in your workflow are color managed. So here are the steps that you will need to follow to put in place a full ICC profile color-managed system for capture, manipulation and output.

Unlike other capture formats, the color space or ICC profile associated with a raw photo is determined not at time of capture but when the file is processed and saved to another format. For instance, Adobe Camera Raw users can choose the output profile from several options in the Workflow Options dialog.

Camera profiles for raw shooters

All cameras that are capable of raw file capture should be sufficiently color aware straight out of the box. As the selection of a color space for the image is delayed until processing when shooting raw, there is no need to select a color space or ICC profile option in the camera's setup dialog.

Some models will still allow you to select an output space when the camera is locked into raw capture. In these cases the selected profile, generally either sRGB or AdobeRGB, becomes the color space default in the Output section of Adobe Camera Raw but is not locked in and can be changed at any time. In fact it is possible to output the same raw file in four different color spaces by selecting a Space entry in the Workflow Options and saving off the resulting file.

Companies like X-RITE do provide sophisticated capture targets and analysis software designed for creating custom camera profiles for specific lighting circumstances. For JPEG or TIFF shooters, this provides a very accurate way to ensure good capture color, but given that both Lightroom and Adobe Camera Raw do not have the option to use these profiles, creating a custom profile helps little in a full raw workflow. This is not to say that including a GretagMacbeth (X-RITE) color checker in a reference shot for a series of images captured under the same lighting conditions is not a good idea. In fact, doing so will mean that it is

Windows XP users can check the profile that is being used for the monitor via the Settings > Color Management section of the Display control panel.
Vista users will find similar controls in the Devices section of the Color Management option in the Control Panel.
Mac OSX users will locate the default monitor profile in the Color section of the Display control panel.

possible to ensure good white balance adjustment in your conversion software. If you are using Adobe Camera Raw, it will also mean that you can customize the default profile used for your camera with the controls in the Camera Calibration tab of the software. Chapter 9 contains full details of the process used.

Monitor and screen profiles

Now let's turn our attention to our screen or monitor. Most manufacturers these days supply a general ICC profile for their monitors that installs with the driver software when you first set up your screen. The default profile is generally the sRGB color space. If you want to check what profile is set for your monitor then Windows XP users will need to view the options in the Advanced settings of the Display control panel. If you are running Vista then the same details can be found in the Devices section of the new Color Management entry in the Control Panel. If you are working on a Mac computer using OSX then you will find a similar group of settings in the Color section of the Display control panel which is located in the System Preferences.

At this stage, simply ensure that there is a profile allocated for your screen. If one isn't to be found then use the step-by-step guides on the next page to add a monitor profile to your system.

In the following techniques, I will show you how to create specific profiles for your screen using either a hardware tool such as ColorVision's Spyder, or if you are using an older version of Photoshop, or Photoshop Elements, I also include instructions for the Adobe Gamma monitor calibration utility. This utility no longer ships with the latest versions of either product and Adobe now recommends using one of the hardware options that are available. Mac OSX users, however, can still take advantage of the Calibrate utility, a software-based utility included with the Mac operating system. It is located in the System Preferences under the Displays option and the Color tab.

Windows XP

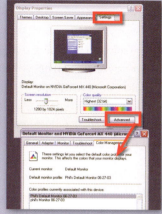

1. Windows XP users should select the Control Panel option from the Start menu.

2. Click on the Display icon from those listed.

3. Select the Settings tab and then the Advanced settings. Click Add to install a new profile.

Windows Vista

1. In Windows Vista select the Control Panel option from the Start Orb menu.

2. Click on the Color Management icon in the Control Panel.

3. Choose your monitor from the Device menu and then click the Add button to locate the ICC profile from the driver disk.

Mac OSX

1. To add a new monitor profile to a Macintosh computer copy the profile to either one of these directories /Library/Colorsync/Profiles (System wide) or ~/Library/Colorsync/Profiles (User folder).

2. To check what profile is currently being used navigate to the ColorSync panel (OSX) and then selecting the Devices or Profiles tabs from the list at the top. Now click on the Displays entry and you will see the profile currently being used by the system.

Hardware-based monitor calibration

For more accuracy than wizard-based screen calibration software alone, professional photographers often use a combined hardware/software solution like the well-known Spyder2 from ColorVision (www.colorvision.com) or the i1 from Xrite (www.xrite.com). Like the Adobe Gamma utility of old, the system will calibrate your screen so you can be sure that the images you are viewing on your monitor have accurate color, but unlike the Adobe utility, this solution does not rely on your eyes for calibration accuracy.

Instead, the ColorVision option uses a seven-filter calorimeter attached to the screen during the calibration process. This piece of hardware samples a range of known color and tone values that the software displays on screen. The sampled results are then compared to the known color values, the difference calculated and this information is then used to generate an accurate ICC profile for the screen. Unlike the Adobe Gamma approach, this method does require the purchase of extra software and hardware, but it does provide an objective way for the digital photographer to calibrate his or her screen.

The ColorVision Spyder2 system works with both CRT (standard) and LCD (flat) screens. A similar system is also available from X-RITE.

Spyder2 target settings for general digital photography:

Color temp. – 6500
Gamma – 2.2 (Win)
Gamma – 2.2 (Mac)

Step 1: *Start by selecting the display type that needs calibrating. Here I have chosen an LCD screen.*

Step 2: *Now select the target color temperature and gamma from those listed in the drop-down menu.*

Step 3: *Choose the Luminance mode between Visual (single screen) and Measured (multiple screens).*

Step 4: *Review the target display settings to check that they are correct.*

Step 5: *Indicate which controls are present on the monitor.*

Step 6: *Return all settings to their factory default. Check with the monitor manual for instructions.*

Step 7: *Check that four separate white blocks can be seen in the scale. Adjust with the contrast control.*

Step 8: *Check that four separate black blocks can be seen in the scale. Adjust with the brightness control.*

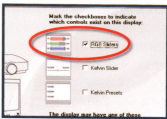

Step 9: *Choose the way that the monitor adjusts color from the three options listed.*

Step 10: *Attach the Spyder and check to see that it is set up correctly for your screen type.*

Step 11: *Attach the Spyder to the monitor ensuring no other light sources are reflecting on screen.*

Step 12: *The sensor will initialize and then several colors will be displayed and tested.*

Step 13: *Adjust the individual Red, Green and Blue controls to balance the screen color.*

Step 14: *Press the Continue button and let the Spyder read the color and tone swatches displayed.*

Step 15: *When the program is finished, save the new profile.*

Software-based monitor calibration

The profile that is included with your screen drivers is based on the average characteristics of all the screens produced by the manufacturer. Individual screens will display slightly different characteristics even if they are from the same manufacturer and are the same model number. Add to this the fact that screens' display characteristics change as they age and you will start to understand why Adobe packaged a monitor calibration utility with older versions of Photoshop and Photoshop Elements. Designed to account for these age and screen-to-screen differences, the Adobe Gamma utility provides a way for users to calibrate their monitor and in the process write their own personal ICC screen profile. The program provides a step-by-step wizard that sets the black

and white points of the screen, adjusts the overall color and controls the contrast of the midtones. When completed these settings are saved as an ICC profile that Adobe Gamma loads each time the computer is switched on. In Windows, Adobe Gamma is located in control panels or the Program Files/Common Files/Adobe/Calibration folder on your hard drive. For Macintosh users with OS9 and Elements 1.0 and 2.0, select the option from the Control Panels section of the Apple menu. OSX users should use Apple's own Display Calibrator Assistant as Adobe Gamma is not used in the new system software.

NOTE: Adobe Gamma is not included in the latest versions of Photoshop or Photoshop Elements. Instead, Adobe recommends a hardware calibration solution such as the ones provided by X-RITE or ColorVision.

Step 1: Check that your computer is displaying thousands (16-bit) or millions (24-bit) of colors.

Step 2: Remove colorful or patterned backgrounds from your screen.

Step 3: Ensure that light from the lamps in the room, or from a nearby window, is not falling on the screen surface.

Step 4: Use the monitor's built-in controls to select the color temperature/white point (e.g. 6500 K). Locate and open the Control Panel menu. Double-click the Adobe Gamma icon to start.

Step 5: Select the Step-by-Step Wizard (Win) or the Assistant (Mac) option and click Next.

Step 6: Input a description for the ICC profile. Include the date in the title. Click Next.

Step 7: *Set the screen's contrast to the highest setting and then adjust brightness. Click Next.*

Step 8: *Select the Phosphors that suit your screen. Check with manufacturer for details. Click Next.*

Step 9: *With Windows default set, adjust the Gamma slider until the square inside matches the outside in tone. Uncheck single Gamma and do the same for each R, G and B slider. Then recheck single Gamma and check it again. Click Next.*

Step 10: *Click the Measure button and calibrate the screen's white point using the '3 squares' feature. Click Next.*

Step 11: *Choose the Same as Hardware option as per Step 4 above. Click Next and then Finish.*

Step 12: *Save the completed profile with a file name the same as the profile description.*

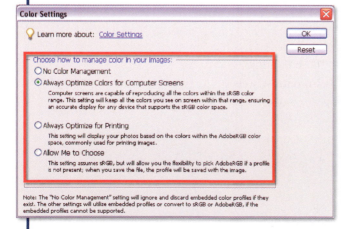

In Photoshop Elements 4.0/5.0 the color management system includes four different options in the Color Settings dialog.

Software color management – Photoshop Elements

From version 4.0 of Photoshop Elements Adobe revamped the color management system to make it easier to understand and more logical to use. There are now four options to choose from in the Edit > Color Settings dialog. To ensure that Elements is operating with a color-managed workflow think about how you would normally view your work and then choose between Screen Optimized and Print Optimized options. If you need image-by-image control over what profile is used then select the Allow Me to Choose setting.

No Color Management – *This option leaves your image untagged, deletes attached profiles when opening images and doesn't add a profile when saving.*

Always Optimize Colors for Computer Screens – *Attaches sRGB to photos without a profile and uses sRGB as the working space but maintains any attached profiles when opening images.*

Always Optimize for Printing – *Attaches AdobeRGB to photos without a profile and uses AdobeRGB as the working space but maintains any attached profiles when opening images.*

Allow Me to Choose – *Maintains all attached profiles but allows the user to choose between sRGB and AdobeRGB when opening untagged files (Editor workspace only).*

Elements:

Software color management – Photoshop

The options that govern color management in Photoshop are grouped in a single dialog titled Color Settings. Here you select the working profiles that will be used for each picture type (RGB, CMYK and Grayscale) and determine when, and how, any color space conversions will occur.

The Color Settings dialog includes the following sections and options:

Working Spaces – Unlike print, monitor, camera or scanner profiles, a working profile or space is not linked to specific input or output characteristics. Instead a working space acts as an intermediate profile that provides a base for editing and enhancing picture colors and tones, and also establishes a known reference point for these tones and colors when converting to other output-specific spaces.

The ICC profile that you choose to use as your working space should reflect the requirements of the area that you work in the most. For instance, many photographers whose work is destined for the printed page choose to use the AdobeRGB profile as their working space, feeling that this space best suits their work environment. Those wanting the largest of the work spaces select ProPhoto RGB. In contrast, web designers often prefer to use sRGB as their working space as it reflects the characteristics of screen-based display more easily than other choices. The options in the Edit > Color Settings dialog allow you to set the working spaces that will be used in Photoshop for RGB, CMYK, Gray and Spot (color) pictures.

Color Management Policies – Also in this dialog are controls (Color Management Policies) that govern how Photoshop handles opening pictures that are not tagged or tagged with a profile that is different

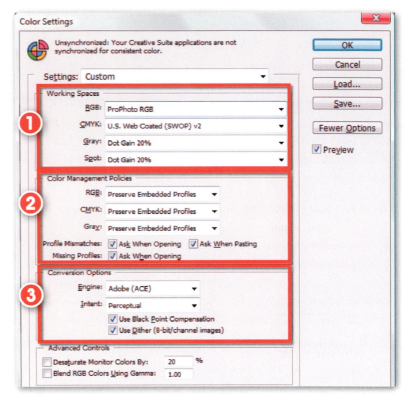

All Photoshop color management options are contained in a single Color Settings dialog (Edit > Color Settings). The dialog is split into three main sections.
1. Working Spaces.
2. Color Management Policies.
3. Conversion Options.

to the one nominated for the working space. Here you can choose to preserve the profile already embedded with the photo or convert the colors to a new profile. If a file needs converting then the conversion is based upon two main factors, the Conversion Engine and the Rendering Intent.

Conversion Engine – Here you can select the Adobe (ACE), Microsoft ICM, or Apple CMM in the Mac version method for conversion. Most photographers favor the Adobe route.

Rendering Intents – At various points in the digital photography process it is necessary to change or alter the spread of colors in a picture so that they fit the characteristics of an output device, such as a screen or printer, more fully. Perceptual is one of the four different approaches that Photoshop can use in this conversion process. The other choices are Saturation, Relative Colorimetric and Absolute Colorimetric.

Each approach produces different results and is based on a specific conversion or 'rendering intent'. The **Perceptual** setting puts conversion emphasis on ensuring that the adjusted picture, when viewed on the new output device, appears to the human eye to be

very similar to the original photo. So this is a good choice for photo conversions.

The **Saturation** option tries to maintain the strength of colors during the conversion process (even if color accuracy is the cost). The **Relative Colorimetric** setting squashes or stretches the range of colors in the original so that they fit the range of possible colors that the new device can display. The **Absolute Colorimetric** option translates colors exactly from the original photo to the range of colors for the new device. Those colors that can't be displayed are clipped.

Specific Rendering Intents are also selected as part of the printing process via the color management controls in the Show More Options section of the Photoshop Print Preview dialog or the Lightroom Print Job settings.

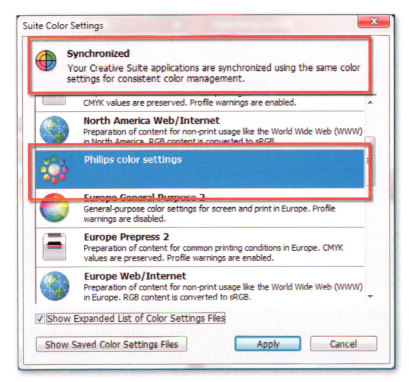

Creative Suite users can quickly synchronize the color settings across the full range of CS2/CS3 programs using the Color Settings inside Bridge.

Bridge-based color synchronization

For Creative Suite owners the Bridge application not only provides a single place to access and manage your media assets, it also contains the ability to synchronize the color settings used in all Adobe CS2/CS3 applications.

To synchronize your color settings in CS2 start with Bridge open and the Bridge Center option selected from the Favorites list (1). Next press the Synchronize color management button (2) at the bottom of the window and choose the color setting from those listed in the dialog that is displayed.

CS3 users can synchronize their settings by selecting Edit > Creative Suite Color Settings from inside Bridge. Next, choose the Settings type that best suits your workflow from the list displayed and click the Apply button. Automatically these settings are applied across all CS3 Suite components. To see custom color settings saved previously in Photoshop (via Edit > Color Settings) click the Show Saved Color Settings Files button at the bottom of the dialog.

The Synchronized Color options in Bridge are only available to Creative Suite 2/3 owners. The version of Bridge shipped with Photoshop alone does not contain these options.

Software color management – Adobe Camera Raw and Photoshop Lightroom

As both Lightroom and ACR are at the front end of the process, these programs take the raw file which doesn't yet have a profile attached and preview the file using an internal color space. At the point of output (to screen or print) or editing in another program, the file is converted from its raw base and a profile is attached.

ACR manipulates images within a ProPhoto RGB working space. Lightroom, on the other hand, carries out the adjustments using ProPhoto RGB, but with a twist in that it uses a gamma of 1.0 instead of 1.8. This custom version of ProPhoto RGB is referred to as Melissa RGB. The gamma of 1.0 matches more closely the gamma of the captured raw file, resulting in less processing of the file as you make changes.

Neither program has color settings options that are accessible to users, nor is their a requirement for the software to be 'set up' in order to be color management aware. These are the new breed of imaging programs where color management is second nature, built-in and therefore less visible to the end user......thank goodness.

Checking the profiles of images

To check to see if your pictures are tagged, open the file in the Photoshop or the Photoshop Elements' Editor and click the sideways arrow at the left of the status bar (at the bottom of the picture window) to reveal a

Check the profile associated with an image quickly and easily by selecting the Show > Document Profile option from the bottom border of the document window. The profile will then be displayed in the border.

fly-out menu. Choose the Document Profile option from the list. Now to the left of the arrow you will see the profile name attached to your file. If the picture is not tagged then it will be labelled 'Untagged RGB'. Alternatively, you can also display the profile as part of the Info palette (Window > Info) by selecting the setting from the More Options button.

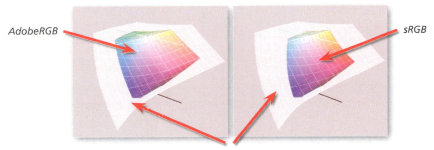

sRGB versus AdobeRGB versus ProPhoto RGB

When talking about working spaces, a lot of discussion centers around two widely used industry standards – sRGB and AdobeRGB. AdobeRGB encompasses a range of colors (color gamut) that more closely matches the characteristics of both desktop and commercial printers, whereas sRGB is a profile that is very closely aligned with the gamut of the average computer screen.

Each of the main working spaces encapsulate a different range of colors. This range is usually referred to as the gamut of the profile. Here we can see how the gamut of both AdobeRGB and sRGB profiles (shown in color) are smaller than that of the ProPhotoRGB profile (show in light gray).

More recently, and with the growing acceptance of raw workflows as daily modus operandi, more and more photographers are working with a third space, ProPhoto RGB. One reason for this change is the fact that this is the basic working space for both Adobe Camera Raw and Lightroom (with a slight change in gamma). The other reason is because ProPhoto RGB is an extremely wide gamut working space and encompasses more colors than either sRGB or AdobeRGB. In practice, this means that you have more space to make color corrections and adjustments in ProPhoto RGB without the fear of clipping details.

Printer calibration

The photo quality of desktop printers is truly amazing. The fine detail and smooth graduation of vibrant colors produced is way beyond my dreams of even just a few short years ago. As the technology has developed, so too has the public's expectations. It is not enough to have colorful prints; now the digital photographer wants these hues to be closely matched with what is seen on screen. This is one of the reasons why a lot of printer manufacturers are now supplying generic, or 'canned', printer profiles. Using such profiles at the time of printing greatly increases the predictability of your output.

To check that you have a printer profile installed on your system, open the Color Management section of the printer driver and search the list of installed profiles for one that matches your machine. If one is not listed then check the manufacturer's website for the latest drivers or profile updates. The general nature of these profiles means that for most pictures, on most surfaces, you will get a good result, but for the best prints you will need a different setup for each paper stock that you use. Some manufacturers provide matched profiles for all the media they supply, which makes the job of choosing a suitable profile much easier.

Elements:

Step 1: To check to see if you have a printer profile installed, open a picture in Photoshop Elements and then select Print from the File menu.

Step 2: Tick the Show More Options feature in the Print Preview dialog to display the printer Color Management settings.

Step 3: Click the down arrow in the Profile section of the dialog and locate your printer profile.

Photoshop:

Step 1: To check to see if you have a printer profile installed, open a picture in Photoshop and then select Print from the File menu.

Step 2: Choose the Photoshop Manages Colors from the Color Handling section in the right of the dialog.

Step 3: Click the down arrow in the Printer Profile section of the dialog and locate your printer profile.

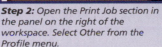

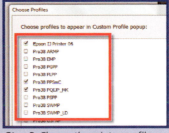

Lightroom:

Step 1: *To check to see if you have a printer profile installed, select a photo from the Lightroom library and then choose the Print module.*

Step 2: *Open the Print Job section in the panel on the right of the workspace. Select Other from the Profile menu.*

Step 3: *Choose the printer profiles from the dialog that is displayed. These will now reside as options in the profile menu.*

Power processing

As image makers we spend much of our time concentrating on how to produce the best pictures possible. And rightly so, after all creating fantastic photos is the reason that most of us got into this game in the first place. Right? But with so much of our time spent playing with editing and enhancement techniques, it leaves precious little head space to consider what actually goes on inside the boxes that drive our favorite imaging software. Couple this with the fact that it is pretty difficult to find and understand how all the different technology (hardware parts and operating system) components impact upon the running of everyday tasks, and you have a situation where the average raw shooter settles for machines that are more suited to net surfing, or word processing, than pixel pushing.

AMD, Intel and Apple: *AMD and Intel both manufacture single, dual and quad core CPUs which can be installed in single or twin processor configurations.*

What's inside the box?

To get us started let's take a simple look at some of the bits and pieces that lurk inside the box that we generally call 'the computer'. For those readers who are already familiar with these systems' parts (or for anyone who is under 15 and seems to know and understand these things inherently) feel free to skip this section. Each component of the box that sits on your computer desk plays an important part in the raw editing and enhancement process.

Example filter	Single Core	Dual Core	Dual vs Single
Shape Blur	170.42	91.63	46.23%
Lens Flare	7.43	3.0	59.62%
Smart Sharpen	8.38	5.30	36.79%
Lens Correction	23.70	28.06	- 18. 37%
Reduce Noise	68.24	65.18	4.48%
Diffuse	95.78	95.29	0.50%

Single vs Dual core processing results: *Results from tests conducted by AMD with a 3.3 Mb JPEG image. All test times are in seconds. Smaller is better.*

Dual core/processors:
Dual core/processor systems split the photo editing workload and process changes more quickly and efficiently. Workload distribution graphs for dual core (1) and single core (2) machines.

Processor (CPU) – It seems that every 6 months or so the major chip manufacturers produce a new version of their front-line processors. These chips are the engine of your computer and as such determine how quickly your machine will complete most tasks.

For many years processors have been categorized in terms of their cycle or clock speed and generally speaking, the higher the number, the faster and more powerful the chip. At present the fastest processors are rated at 3800 MHz (3.8 GHz), and compared to the 12 MHz 'Turbo' chip that drove my computer in 1989, these new processors just fly. But despite the long-held tradition of using clock speed to equate image editing performance, processor speed no longer tells the whole story. Some of the best chips for intensive image editing tasks (filtering in particular) are not those with the highest clock speeds but rather those with the new dual, or quad, core architecture. These chips work like twin or quad processors, churning through pixel changes more efficiently than a single core chip at a higher clock speed.

For the best power overall choose twin processors and if possible twin dual core processors. For a balance of power and economy select a dual core chip and for an entry-level option choose the fastest single core chip you can afford.

Intel, Asus, MSI, Giga-Byte and Abit:
For the latest information on matching CPUs and chipsets check out the websites of the major board manufacturers. Most have web wizards that match CPUs and motherboards.

Motherboard – The motherboard is the component that links all the other computer parts together. Issues such as bus speed and chipsets are often considered, by the 'technology phobic' amongst us, as too complex to even think about, but like it or not, the motherboard provides a substantial amount of the functionality and efficiency that digital photographers demand on a daily basis. This core component moves the information between CPU, RAM, graphics card (and therefore display) and hard drive via bus pathways. The ability of these pathways to move large chunks of data around determines to a large extent how efficiently the whole system works. A board with slow pathways is not capable of delivering information quickly enough to keep the CPU busy, resulting in the processor not being fully utilized and slower overall system performance. In essence the motherboard is the foundation upon which the other components are built. Careful

selection here will ensure that the rest of the system parts run to the best of their ability.

The chipsets resident on the motherboard control the way in which the various components in the system work together. Often manufacturers release new board chipsets to coincide and work with new processor designs. When selecting a motherboard check that the chipset is matched with the processor and that it supports CPU features such as dual core and/or Hyper-Threading. Also pay particular attention to speed of the system bus (connection between component parts) and the total amount of memory that can be installed and addressed. Aim for at least 2 Gb, an option to install 4, 8 or even 16 Gb being preferable.

Motherboard wish list	Good	Better
Memory capacity	2 Gb	4 – 8 Gb
Graphics interface	AGP 8×	PCI Express ×16
Disk controller	SATA	SATA RAID 0
Chipset	General	Matched with CPU

Next, look to the type of interface that is used for plugging in graphics cards and attaching hard drives. For graphics the AGP 8X connection is okay but the newer PCI Express X16 is preferable as it provides 3.5 times the performance of the older system. In terms of hard drive connections try to find a board with both a standard SATA (Serial ATA) link as well as a RAID 0 controller (for better scratch disk performance in Photoshop).

Memory (RAM) – RAM memory is the short-term memory where the imaging program, image data and various Undo Steps and History States are kept during the editing, enhancement and raw conversion process. It is different to the memory of your hard drive or DVD disk, as the information stored in RAM is lost when your computer is switched off. For efficient raw editing the amount of RAM your computer has is just as important as processing power. In general terms you should buy as much memory as you can afford. The amount usually supplied with off-the-shelf systems is sufficient for most word processing and spreadsheet tasks but is usually not enough for good quality digital imaging.

How much memory do I need? Well an image maker with 1 Gb of RAM (2 × 512 Mb) would find that Photoshop would be noticeably more responsive and efficient to work with than a machine with half the memory. Professionals, or dedicated enthusiasts, working with 20–30 Mb files should install at least 1 Gb of RAM as a base figure. Increasing this amount to 2 Gb will provide real gains in terms of workflow speed and more efficient multi-tasking (working on several documents at once) as well. Running Photoshop on a 64-bit operating system such as Apple's OSX or Windows XP 64 or Vista 64 provides the added benefit of enabling the program to access more memory than has previously been possible. Professional users employing these setups can take advantage of RAM levels beyond 2Gb which provide real gains in complex environment where very large documents are altered regularly.

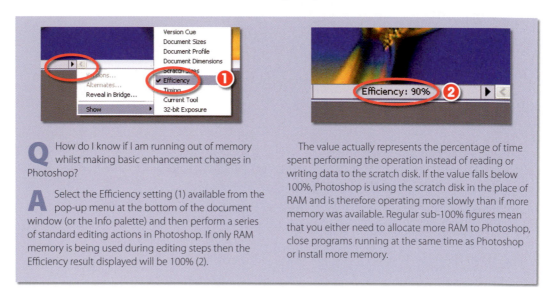

Q How do I know if I am running out of memory whilst making basic enhancement changes in Photoshop?

A Select the Efficiency setting (1) available from the pop-up menu at the bottom of the document window (or the Info palette) and then perform a series of standard editing actions in Photoshop. If only RAM memory is being used during editing steps then the Efficiency result displayed will be 100% (2).

The value actually represents the percentage of time spent performing the operation instead of reading or writing data to the scratch disk. If the value falls below 100%, Photoshop is using the scratch disk in the place of RAM and is therefore operating more slowly than if more memory was available. Regular sub-100% figures mean that you either need to allocate more RAM to Photoshop, close programs running at the same time as Photoshop or install more memory.

Storage (hard disk) – The sad fact is that digital imaging files take up a lot of storage space. Even in these days where standard hard disks are measured in terms of hundreds of gigabytes the dedicated digital darkroom worker will have little trouble filling up the space. But the disk requirements for raw shooters are a little more complex than just ensuring that they have enough photo storage space. As Photoshop in particular is such a memory hungry beast the program cleverly uses part of the hard disk as 'fake memory' when the software runs out of conventional RAM.

This fake memory space is called a scratch disk and one key to efficient photo processing is ensuring that this hard drive space is situated on a separate fast drive from those used for programs and photo storage. This

saves the problem of Photoshop and the OS competing for the same disk space (they both have virtual RAM technologies). The speed of this second drive, the size of the drive's memory cache and its connection type (ATA, SATA or SCSI) all contribute to the efficiency of the scratch disk. If you have a choice select an SATA or SCSI drive with a minimum of 8 Mb cache that spins 7200 rpm.

The next option for more speed is to control two such drives via a RAID controller and dedicate this RAID as your scratch disk. Using a level 0 RAID will split the read/write activities across both units, effectively increasing the overall speed of the scratch disk and Photoshop in turn.

 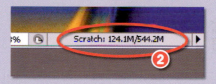

Q How do I know what is the total amount of memory (both RAM and scratch disk space) available to Photoshop during editing operations?

A Photoshop displays RAM and scratch disk usage and allocation in the Scratch Sizes section of the status bar (1). The number on the left represents the amount of memory currently being used by the program to display all open images. The number on the right represents the total amount of RAM available for processing these images (2).

Screen or monitor – The screen is the visual link to your digital file. It follows then that money spent on a good quality screen will help with the whole cycle of production. Screen size is important, as you need to have enough working space to lay out toolbars, dialog boxes and images. Screens are categorized in terms of a diagonal measurement from corner to corner. 17- or 19-inch models are now the standard with 20-inch and larger (widescreen format) being the choice of imaging professionals. Although a few years ago the screen of choice for all professionals was definitely the CRT or Cathode Ray Tube (think old television sets), things have changed. More and more dedicated image makers are now turning to LCD or Liquid Crystal monitors as their displays.

Video card – The video card is the most important part of the pathway between computer and screen. This component determines not only the number of colors and the resolution that your screen will display, but also the speed at which images will be drawn. For best results pick a card with a fast processor and as much memory as you can afford. Don't assume that

ATI, NVIDIA and Matrox:
ATI and NVIDIA are the kings of video card technology so check out their websites for the latest in offerings for the 2D graphics user. Also worth a look is Matrox, who pride themselves in creating cards for graphics professionals.

good 3-D performance will also be reflected in the area of 2-D graphics. Many of the most touted and most expensive cards on the market are optimized for game play, rather than photo editing efficiency.

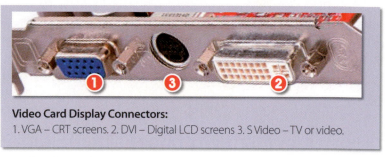

Video Card Display Connectors:
1. VGA – CRT screens. 2. DVI – Digital LCD screens 3. S Video – TV or video.

So rather than look for the fastest and latest units, concentrate primarily on the memory amount and the interface the card uses and then consider processing speed. One board with 256 Mb of card memory is a great place to start, but users with big, high-resolution screens should try to upgrade to 512 Mb for better performance.

The latest graphics interface standard is PCI Express, which provides better performance than the older AGP standard. The card type you can use is determined by the connectors on the motherboard. So make sure that your board supports the connection type first, before shelling out the cash for a new video card. And finally, as the video card links the computer to a display or monitor, ensure that the card you choose has the same connection as the screen.

Mouse or graphics tablet – Much of the time spent working on digital images will be via the mouse or graphics tablet stylus. These devices are electronic extensions of your hand, allowing you to manipulate your images in virtual space. The question of whether to use a mouse or stylus is a personal one. The stylus does provide pressure-sensitive options in programs such as Photoshop not available with a mouse-only system. Wacom, the company foremost in the production of graphics tablets for digital imaging use, produces a cordless mouse and stylus combination that allows the user to select either pointer device at will.

3

Shooting in Raw Mode

Though the basics of camera control, such as focus, composition and exposure adjustment, remain the same regardless of the capture format you choose, the inherent differences in the characteristics of JPEG/TIFF and raw mean that some changes in your shooting workflow are warranted. Here we look at the steps needed to shoot in the raw and the issues that surround the practice.

Getting set to shoot in the raw

Making the commitment to go after the best picture file you can get out of your digital camera, an achievable goal with raw files, dictates paying close attention to detail and following through consistently and persistently on several requirements. A commitment to raw necessitates developing a workflow, or sequence of steps, you will routinely use to 'get it right every time (or almost every time)'. Your mission, should you choose to accept it, fellow photographers, is to develop your own brand of raw workflow that works best for you, hopefully incorporating some of the observations, analyses and recommendations that follow.

Changing your workflow to accommodate

'Once I have switched my camera to raw will there be any change in the way that I shoot?' Well, the short answer is 'maybe'. Most experienced photographers pride themselves on their ability to control all the functions of their cameras. Often their dexterity extends way beyond the traditional controls such as aperture, shutter speed and focus to 'digital-only' features such as white balance, contrast, sharpness and saturation. For the best imaging results they regularly manipulate these features to match the camera settings with the scene's characteristics.

For instance, a landscape photographer may add contrast, boost saturation and manually adjust the white balance setting of his or her camera when confronted with a misty valley shot early in the morning. In contrast, an avid travel photographer may choose to reduce contrast and saturation and switch to a daylight white balance setting when photographing the floating markets in Thailand on a bright summer's day. It has long been known that such customization is essential if you want to make the best images possible and are capturing in a JPEG or TIFF format. But as we have already seen, settings such as these, though fixed in capture formats such as TIFF and JPEG, are fully adjustable when shooting raw.

Most mid- to high-end compact cameras and almost all digital SLR cameras have the ability to capture in the raw format.

Implications for capture variables or camera parameters

What does this mean in our day-to-day photography? Well, if after documenting some interiors you accidentally forget to switch the white balance setting from tungsten back to daylight before commencing to photograph outside, all is not lost. The white balance setting used at the time of capture is recorded with the raw file but is only applied when the picture is processed. This means that when you open the images in a raw converter, the picture is previewed using the capture setting (tungsten) but you can easily select a different option to process the file with. In this example it would mean switching the setting from tungsten back to daylight in the white balance menu of the conversion software. All this happens with no resultant loss in quality. Hooray!

The same situation exists for other digital controls such as contrast, saturation and, with some cameras, sharpness. As before, the settings made at the time of shooting will be used as a basis for initial raw previews but these are not fixed and can be adjusted during processing. This leads some people to believe that there is no longer any need to pay attention to these shooting factors and so consequently they leave their cameras permanently set to 'auto everything' (auto contrast, auto white balance, standard saturation), preferring to fix any problems back at the desktop. Other photographers continue to control their cameras on a shot-by-shot basis, believing that an image captured with the right settings to start with will end up saving processing time later. Both approaches are valid and which suits you will largely get down to a personal preference, and the choice of whether you would prefer to spend your time manipulating your camera or computer.

Switching to raw capture workflow means adjusting the way that you shoot. Factors like white balance, contrast, saturation and sharpness, which were critical when recording to TIFF or JPEG, are less crucial as they can be adjusted losslessly after capture.

Capturing your first raw picture

You will probably realize by now that we still need to emphasize a workflow that strives for excellence during capture and that shooting raw should not be used as a crutch for poor camera technique. Your primary concern should be to check that your exposure settings are carefully chosen as this will help ensure that shadow, highlights and midtone details are all recorded. You will also need to change your standard approach to setting camera parameters as the application of features like contrast enhancement, saturation control and white balance adjustment are pushed into the raw conversion phase. But we are getting a bit ahead of ourselves. Let's spend the next few pages working step by step through the various issues surrounding enabling our cameras for quality raw capture.

1. Enabling the camera

With most raw-enabled cameras, switching from one capture format to another is a simple matter of entering the camera setup menu and selecting the Raw entry from the Image Quality options. This option may also be accessed via a quality toggle or switch elsewhere on the camera. Some models also offer the choice between compressed and non-compressed versions of the file. Compressing will mean that pictures will take up less space on the memory card, but the process

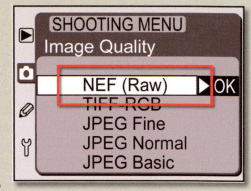

of compression does result in longer saving times. For most shooters this isn't an issue but if you like to photograph sports or action, then the extra time taken to compress the file will reduce the frames per second rate of your camera.

There are several cameras on the market that also have the ability to save both raw and JPEG versions of the same file at the time of capture. This option can be a real time saver if you need to access your pictures quickly, but the feature is less of an advantage if you regularly perform many enhancement steps to your files, as in the end the captured JPEG will not resemble the processed raw file. Shooting both raw and JPEG can also complicate matters when importing as some software sees both photos as the same file. They will have the same name but different file extensions, .JPG for JPEG and .CR2 for raw (in the case of Canon shooters). This was indeed a problem in the 1.0 release of Lightroom but thankfully the issue was addressed with the free 1.1 update.

To ensure that your JPEG and raw file duplicates are imported as separate photos into Lightroom

1.1 go to the Edit > Preferences dialog and select the 'Treat JPEG next to raw files as separate photos' option from under the Import tab.

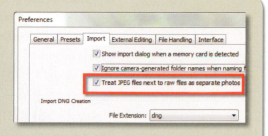

At the big end of town most of the high-resolution camera backs, which are destined for use with medium format camera bodies, only capture in raw formats. Most of these backs store their images in a proprietary format that is converted by the camera-based software. However, the latest models from Hasselblad, Samsung, Richo and Leica use Adobe's DNG format, making the transition to Adobe Camera Raw or Lightroom a simple one.

In practice

For the purposes of this workflow example we have included step-by-step instructions for both Nikon and Canon cameras below.

Canon workflow (example camera EOS 30D)

1. Turn the Quick Control Dial to select the Quality heading and then press Set; this will display the Recording Quality screen.

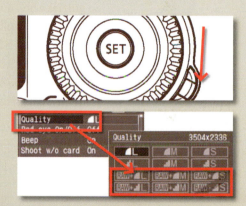

2. Next, use the Quick Control Dial again to choose one of the raw options from those listed. Depending on the camera model your choices may include Raw and Raw + JPEG. Press Set to set the selected capture mode.

Note: Canon cameras divide the controls into two levels, Basic and Creative (advanced). They name these control subsets different Zones. If your camera is currently in the Basic Zone you won't be able to choose any raw caption options. To do this, you will need to switch to the Creative Zone first, and then alter the Recording Quality. Canon's menu system also varies from consumer to pro models so check with the manual if you are unsure.

Nikon workflow (example camera D100)

1. To switch the default capture format to raw, activate the menu on the back of the camera and then use the Multi-selector control to navigate to the Shooting Menu (second option on the left side of the screen). Use the right arrow on the Multi-selector control to pick menu options.

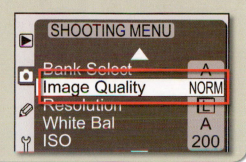

2. From the first page of the menu list, select the Image Quality entry. This will display another screen containing a list of quality options – three JPEG, one TIFF and one NEF (Nikon's version of raw). At this screen choose the NEF (Raw) heading.

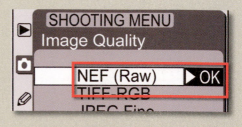

3. Selecting NEF will display a final screen with a choice of two different raw capture modes – 'Comp. NEF (Raw)' or compressed and 'NEF (Raw)' uncompressed. Select one of these options and then exit the menu.

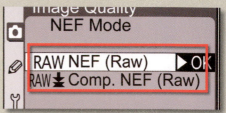

2. Determining pixel dimensions

One step that is normally undertaken when adjusting your camera settings prior to shooting is to select the size or pixel dimensions of the picture that is recorded. Sometimes this setting is incorrectly called the resolution of the photo in camera menus and handbooks. Resolution is a measure of the number of pixels (or dots in the case of printing) per inch or centimeter rather than the total dimensions of the

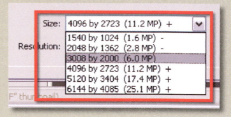

photo. Generally you can choose from the largest capture size possible with your camera, which equates to the one sensor site per image pixel, to a range of progressively smaller dimensions.

Having said this, when working with raw as the capture format, most cameras will not provide the ability to alter the dimensions of your photo. The largest photo possible (one sensor site to one pixel) is recorded in the raw file. If you want to alter these photo dimensions then size changes can be made in a raw conversion utility such as Adobe Camera Raw. This approach has the advantage of enabling upsizing as well as downsizing of the final file.

Note: Cameras with Raw + JPEG capture options often provide choices for altering the JPEG dimensions and image quality. This means that it is possible to automate the production of small dimension, JPEG compressed, web ready thumbnails which can be used for web galleries.

3. Picking bit depth

Most readers would already have a vague feeling that a high bit file is 'better' than a low bit alternative, but understanding why is critical for ensuring the best quality in your own work.

The main advantage is that capturing images in high bit mode or 16 bits per channel provides a larger number of colors for your camera to construct your image with. This in turn leads to better color and tone control in the digital version of the scene and finer adjustments in the editing phase.

This line of thinking leads most photographers who are concerned about image quality to adjust their cameras to the 16 or 12 bits per channel capture mode over the standard 8 bits per channel option whenever possible. The higher bit rate provides substantially more colors (and tones) to play with. For example, the standard 8-bit file has the possibility of 256 levels of tone for each of the red, green and blue, whereas the 16-bit version has over 65,000 levels of tone in each channel. Raw photographers automatically get access to these increased levels of tone because nominating raw as the preferred capture format negates bit depth settings and automatically provides the full depth capable by the sensor.

At time of conversion you can elect the bit depth of the converted file. In Adobe Camera Raw this feature is displayed when the Show Workflow Options is selected (bottom left of screen). Here you can choose from 8 bits per channel or 16 bits per channel entries.

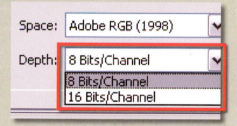

Note: With most camera makes and models the raw file is said to be 16 bits per channel but the sensor only records 12 bits per channel which is then interpolated into a 6 bits per channel file format. Check your camera manual for specific details on the bit depth of raw capture with your model.

4. Adjusting color settings – saturation, white balance and color space

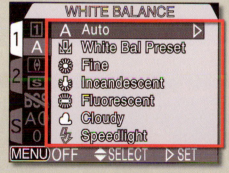

Digital cameras provide much more control over the color that is recorded than was possible when film was king. Even low-end models provide saturation and white balance features. But as we have seen, switching to raw capture means that the settings used with these features, though recorded and used as the default values at the time of conversion, are able to be changed later in the process with no image quality loss. So where does this leave us when it comes to setting color options when shooting raw? Do we need to pay any attention to these settings at all now that they can be altered in the conversion process?

Most photographers find it hard to break the habits of a lifetime and so when they shoot raw and are confronted with a scene that contains multiple light sources they adjust the white balance setting manually and tweak the saturation value before pressing the shutter button. Though there is no strict need to do so (as these characteristics can be altered later), they persist in 'matching the camera setup to the scene'. For many practitioners this approach is at the heart of the craft of their beloved photography and I am not here to tell them to stop.

In fact, working this way has three distinct advantages:

1. Correctly captured pictures need less correction when converting, saving valuable time,

2. The white balance settings determined at time of capture provide a good starting point for further fine-tuning during the conversion process, and

3. If a Raw + JPEG capture mode is being used then the color in the accompanying JPEG photo will better match the processed raw file as it was more accurate at the time of capture.

What of color space?

When it comes to the matter of selecting the color space for capture many authors advocate selecting sRGB for images destined for the screen and AdobeRGB for those photos that will end up as prints. There is merit in this advice as sRGB has a color range (gamut) that is more suited to the capabilities of the average monitor and the wider gamut of AdobeRGB makes the most of the hues available with the standard printer. When shooting

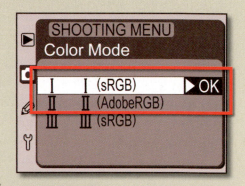

raw the selection of color space again becomes a decision that can be postponed until the time of conversion. It is at this point in the process that the colors captured by the sensor (in Bayer pattern) are being interpolated into the standard RGB format that we are all familiar with. One of the processes involved in this conversion is the mapping of the color to an ICC color space. During this conversion process the user can choose which space will be used for the photo.

As with most settings we have reviewed the color space is not set when the image is captured in raw format. The space you choose in the camera setup is the default option selected in the conversion software, but doesn't limit you from selecting from the others listed. In Adobe Camera Raw you can select from four different profiles (sRGB, AdobeRGB, ColorMatch RGB and ProPhoto RGB), which is two more than most cameras offer.

Pro's tip: For true color aficionados, or those who need to accurately record the color in the scene before them, the white balance tweaking options offered by most of the raw conversion

utilities can be put to good use by including a Macbeth color chart in the first photograph of a series taken in tricky lighting. During the conversion process the way the colors in the chart are recorded can be used as a reference point for sophisticated color correction techniques. See Chapter 9 for more details.

5. Managing the tones – contrast control

Some DSLR cameras have the option to manipulate the contrast with which the scene is recorded at the time of capture. Sometimes called the Tone Compensation or Contrast setting, this control adjusts the scene's tones according to a setting selected by the user. Most cameras have the choice to increase or reduce contrast and some even have an option to build a custom contrast curve that can be uploaded to the camera and applied at will. The feature is invaluable when shooting in difficult

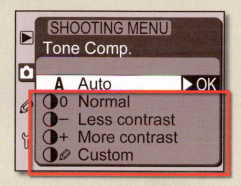

lighting scenarios and saving the results back to TIFF or JPEG files. Raw shooters have the luxury of being able to make these types of contrast adjustments much more accurately and on an image-by-image basis back at the desktop. In fact, most cameras will not allow the user to make tonal compensation choices if raw is selected as the capture format.

6. Applying sharpening and noise reduction

The very process of capturing a digital file introduces an inherent fuzziness to the photo.
This is true irrespective of the quality of the camera (or scanner for that matter) or the size of the files it produces. For this reason the enhancement process of any digital file is not complete until some sharpening has been applied.

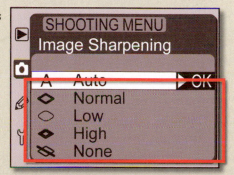

To this end most photographers see sharpening as a 'one-off' activity designed to increase the look of crispness of their photographs and they elect to apply sharpening at time of capture via the options available in their camera sctup, figuring that it'll be one less task to perform later at the desktop. The problem with this action is that it uses a 'one solution fits all' approach that fails to take into account the content of the photo and the intended use for the image. For the best results both these factors have to be considered when sharpening your photos. This is the

reason that informed professionals now employ a sharpening workflow that applies sharpening at three different times during the enhancement process – at time of capture, during enhancement and then when preparing for output.

For raw shooters this means adding a little global sharpening in-camera or at the time of conversion. Both approaches are fine as long as the sharpening is kept to a minimum with the idea that it will be fine-tuned later to account for subject matter and output destination.

The problem of noise

Noise is usually seen as a series of randomly spaced, brightly colored pixels that sometimes appear in your digital images. A large amount of noise in an image will reduce the overall sharpness and clarity of the picture. Particularly noticeable in shadow areas, there are two distinct factors that control the amount of noise present in a picture:

High ISO – Increasing the ISO setting of your camera will increase the level of noise in the image. Images exposed with an 800 setting will contain more of these randomly spaced and brightly lit pixels than the same photograph exposed with a 100 ISO setting.

Long exposure times – Pictures taken with exposure times longer than ½ second will contain more noise than those shot with a fast shutter speed. The longer the exposure the more noticeable the noise becomes.

As both these factors come into play when shooting in low light situations you will find that the images you take at night are more susceptible to noise problems than those photographed on a bright sunny day.

Features for reducing noise

In a perfect world there would never be an occasion when there was a need for photographers to use either a high ISO value or a long exposure and so all the images produced would be beautifully noise free. But alas this is not the case and all too regularly you will find yourself shooting in environments with very little light. Does this mean that we have to put up with noise-filled images for the sake of shooting convenience? The answer is no.

Most mid- to high-range digital cameras now contain specialized noise reduction features that help to minimize the appearance of random pixels in images produced with either high ISO or long exposure settings. These tools attempt to isolate and remove the errant pixels from the photo, creating much cleaner and sharper images in the process. Noise can also be minimized via the Reduce Noise features in Photoshop, when used after the raw conversion, or the Luminance Smoothing and Color Noise Reduction controls located under the Detail tab of Adobe Camera Raw. Cameras, such as those in the Nikon range, have a choice of two noise

reduction systems that function in slightly different ways:

NR (Noise Reduction) – This is the standard noise reduction setting that functions on all of the camera's different resolution settings as well as in conjunction with other features such as Best Shot Selector and Exposure Bracketing. Taking at least twice as long as a standard image to process and record, the camera's in-built software attempts to identify and eliminate noisy pixels in the image.

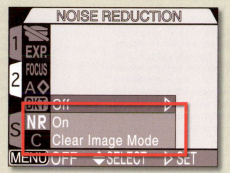

Noise Reduction functions attempt to rectify the random pixels that appear in photos taken with long exposure or high ISO settings.

Clear Image Mode – This setting minimizes noise and increases color graduation by capturing a sequence of three images of the one scene. The first two pictures are exposed with the shutter open, the third with the shutter closed. Using some sophisticated processing the three images are compared and a single 'noise reduced' image is recorded. As several images are recorded it is recommended that a tripod is used when employing this feature.

Pro's tip: Photographers want the best quality images all the time so why not set up your camera so that the noise reduction features are left permanently on? In theory this sounds fine but in practice the extra processing and recording time taken to reduce the level of noise in an image would greatly increase the time period between successive shots. In most normal shooting circumstances, where noise isn't a problem, the extra time lag between shots would hamper the photographer's ability to shoot successive images quickly. Add to this the fact reducing noise on the desktop, either during raw conversion or afterwards inside Photoshop, provides better overall control over the process and therefore better results than the auto approach adopted in-camera. If you plan on reducing noise with either your raw converter or a third-party digital noise removal program, read the recommendations of the software before using it. Most digital noise removal software recommends that camera noise removal should be disabled.

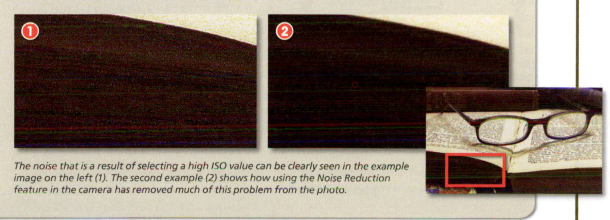

The noise that is a result of selecting a high ISO value can be clearly seen in the example image on the left (1). The second example (2) shows how using the Noise Reduction feature in the camera has removed much of this problem from the photo.

7. Setting the ISO

For those of us growing up with film, the idea of an ISO number (or if I really show my age – ASA number) indicating how sensitive a particular film is to light is not new. These values ranging from slow (50 ISO) through medium (125 ISO) to high speed (3200 ISO) have been one way that photographers have selected which film stock to choose for particular jobs. Each film type had its advantages and disadvantages and selecting which was best was often a compromise between image quality and film speed. If the day's shooting involved a variety of different subjects then the decision was always a difficult one, as once the choice was made you were stuck with the same stock for the whole of the roll.

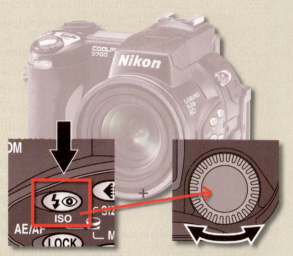

Changing the ISO on your camera is generally a simple operation. On this model you hold down the ISO button and turn the command dial to change the sensitivity setting of the chip.

In the digital era the restrictions of being locked into shooting with a single film with all its particular abilities and flaws have been lifted. The ISO idea still remains though strictly we should refer to it as 'ISO equivalence' as the original ISO scale was designed specifically for film not CCDs. Most cameras have the ability to change the ISO equivalent setting for the sensor, with a growing number offering settings ranging from 50 to 1600. Each frame can be exposed at a different 'ISO' value, releasing the digital shooter from being stuck with a single sensitivity through the whole shooting session. Oh happy days!

The lower the ISO setting you choose the lower the likelihood of introducing noise (digital equivalent of grain) into your images. Often the lowest ISO setting is 100 yet some cameras provide 50 on the regular preset menu or allow you to use a custom preset menu to go lower than 100. On the other hand, some cameras have no noticeable change at an ISO of 200. Determine through a few trials when noise becomes apparent; be sure to zoom in on your image after opening it with the raw converter.

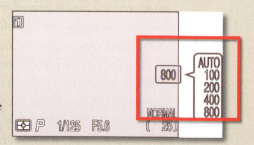

On most cameras the current ISO setting is displayed on the LCD screen and sometimes in the viewfinder as well.

The table below summarizes the benefits and disadvantages of different ISO settings. Use it as a guide when selecting which value to use for your own work.

ISO equivalent	100 – 200	400 – 800	Above 800
Benefits	• Low noise (fine grain) • Good color saturation • Good tonal gradation	• Good noise/sensitivity balance • Good sharpness, color and tone • Can be used with a good range of apertures and shutter speeds	• Very sensitive • Can be used with fast shutter speeds, large aperture numbers or long lenses • Good depth of field
Disadvantages	• Not very sensitive • Needs to be used with fast lens or tripod • Needs bright light	• Not the absolute best quality capable by the camera • May not be fast enough for some low light or action scenarios	• Obvious noise throughout the picture • Poor picture quality
Best uses	• Studio • Still life with tripod • Outdoors on bright day	• General handheld shooting	• Sports • Low light situations with no flash • Indoors

Auto ISO

Some cameras also contain an Auto ISO setting that can be selected instead of specific sensitivity values. This feature keeps the camera at the best quality option, usually 100 or lower, when the photographer is shooting under normal conditions, but will change the setting to a higher value automatically if the light starts to fade. It's a good idea to select and use this option as your camera's default setting. It's good for most situations and you can always change to manual when specific action or low light scenarios arise.

Pro's tip: When using higher ISO settings and the JPEG capture format turn off the camera's sharpening feature as this function can tend to exaggerate the noise that is present in the image.

8. Establishing exposure

Though not normally discussed as part of the process of enabling and setting up your camera for raw shooting, exposure, unlike most of the other factors considered here, is not something that can be adjusted losslessly after capture. In fact, it would not be an overstatement to say that exposure is one of the most important factors to consider when capturing any photos. In later chapters we will talk about how some conversion software allows you to rectify small problems of over- or underexposure but this option should only be considered as a last resort, and only if the picture cannot be rephotographed with the correct exposure settings.

To guarantee the best quality in your raw conversions and, by extension, your final photographs, ensure that you capture as much of the detail in the scene as possible. This means trying to squeeze in both the highlight and shadow areas of the scene into a single capture.

This is not a difficult task if you are photographing on a gray winter's day in London where the difference between highlight and shadow is small, but shooting at midday in the desert is another story. In these sort of conditions the brightness range (difference between shadows and highlights) can be so great that it is beyond the capabilities of the camera. Well-calculated exposure in this situation is critical. As some detail is bound to be lost or clipped it is up to you as the photographer to determine where to position your exposure and, consequently, which details to record and which to abandon.

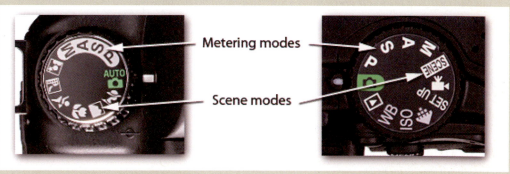

Understanding key camera controls such as aperture and shutter speed along with functions like metering and scene modes will help you establish the best exposure for a range of circumstances.

This should be a conscious decision taken by the photographer and not one that is left up to the automated exposure options of the camera. By manipulating the shutter speed and aperture (f-stop) combination you can selectively choose how highlights, shadows and midtones are recorded. This includes how bright each of these tonal areas is in the final image (yes, you can make the deep folds in black fabric white just by adjusting the f-stop and shutter speed you use to record them) as well as where any clipping occurs.

For more details about controlling how tones are recorded check out the 'Exposure essentials' section on the next few pages.

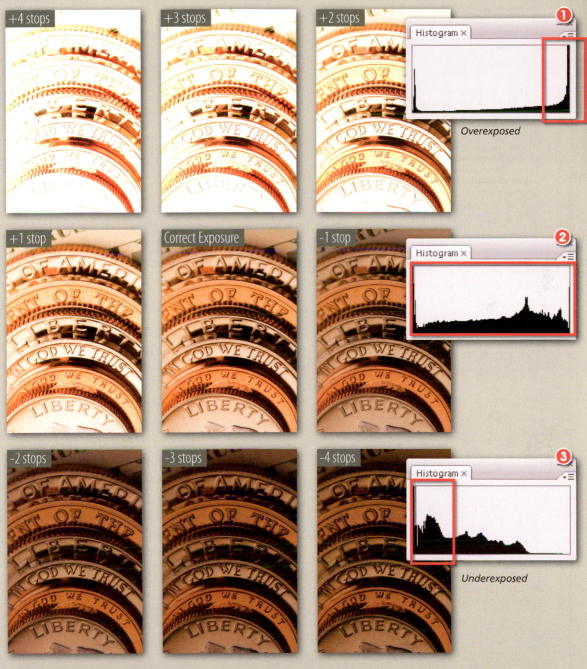

Establishing a good exposure for a picture is one of the most critical steps in creating a great photograph. Overexposure (too much light) produces washed-out photos (1) with little or no details in the highlights. In contrast, underexposed pictures (3) suffer from too little light during exposure and appear dark with shadow areas containing no detail. A well-exposed photo produces an image that is a happy medium (2), showing detail from shadows through midtones to highlights.

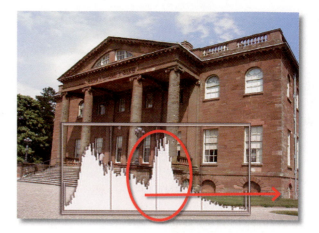

Substantially more detail is present in digital photos where the exposure has been carefully adjusted so that as much of the detail as possible falls to the right-hand end of the histogram. This approach is called 'Exposing Right'.

Exposing to the right

Though most camera techniques that underpin good exposure have remained the same with the transition from film to digital, in some areas your thinking may need to be realigned slightly to take into account how the new technology works. One such area is the capture of highlight details. Because of the way that the camera sensor responds to light the highlight area of the image is captured with more levels of tone than the mid areas. Similarly the midtone areas of the picture are recorded with more tones than the shadows.

'What impact does this have on how we photograph?' Well, I'm glad you asked! Keep in mind that our aim is to capture as much detail in the scene, from shadow to highlights, as possible and that recording comparatively fewer tones in the shadow areas means that there are fewer discrete tones to represent precious shadow detail. Add to this the fact that underexposure pushes all of the scene's details towards the shadow end of the spectrum (where there is less detail) and you will see how critical it is to position the majority of your scene's details in the mid to highlight area. This technique has be termed 'Exposing Right' because you are placing the bulk of the detail to the right end of the histogram.

This isn't a simple matter of overexposing your photos though. It's true adding more light will move all the scene's details towards the highlight end of the tonal range but you must make sure that you don't clip the highlights in the process. The Histogram function or Highlight Warning feature found on most cameras can help in this regard. Use these devices to check that you are balancing shifting the details to the right and at the same time not losing (clipping) any highlights. Your reward for all this effort is more detail to play with, especially in the shadow areas.

How a sensor records tone in detail

The reasons behind the 'Exposing Right' idea are based firmly on how digital sensors record picture detail. Most DSLR cameras are capable of 12 bits per channel capture. This means that the resulting image will contain up to 4096 possible discrete tones for each of the red, green and blue color channels. Most users assume that these tones are spread evenly over the whole of the tonal range recorded by the camera. In other words, we would naturally think that highlights, shadows and midtones would receive an even split of all possible tones. This is, in fact, not how digital capture systems function.

5 f-stop range	F-stop 1	F-stop 2	F-stop 3	F-stop 4	F-stop 5
4096 levels of tone	2048 levels	1024 levels	512 levels	256 levels	128 levels
Typical tonal areas	Highlights	Light tones	Midtones	Darker tones	Shadows

There are 4096 levels of tone possible with the typical 12 bits per channel capture found in many DSLR cameras. Half of all tones are used to depict the brightest parts of the photo in the first f-stop of exposure. The next f-stop uses half of the remaining tones or 1024 levels. This process continues until the final f-stop where the shadow details is described with just 128 levels of tone.

If we assume that a standard digital camera can capture a brightness range, from shadow to highlight, of 5 f-stops (this will vary from camera to camera), then it is true to think that the 4096 tones will be distributed throughout this f-stop range, but, instead of being evenly distributed, the first f-stop (the one that captures all the highlight details) uses half of all available tones. In our example, this means that the highlights use 2048 levels of tone. This is because sensors respond to changes in light in a linear fashion and changes in f-stops equate to a doubling or halving of the amount of light entering the camera. The second f-stop then takes up half of the remaining levels of tone, meaning that these bright middle values use another 1024 of the total available tones. This process continues until we reach the last f-stop which records the shadow areas. In this example, there are only 128 levels of tone left for these important details. With such few tones left in this region of the image, shadow details can easily become posterized. This is a situation where the transition between one tonal level and another occurs abruptly rather than gradually.

Intentionally adjusting your exposure so that more of the middle values of the scene are recorded brighter than they would be if captured on film pushes all the details in the photograph to the detail-rich first few stops worth of exposure. This in turn provides more levels of tone for the shadow detail.

Exposure essentials

The mechanics of creating a photograph are based on controlling the amount of light entering the camera and falling on the sensor. This process is called 'exposing' the sensor. All cameras have mechanisms designed to help ensure that just the 'right' amount of light enters the camera. Too much light and the image will appear washed out and too light – overexposed. Too little and the picture will be dark and muddy – underexposed.

Two different camera parts are used to control the amount of light entering the camera – the aperture and the shutter.

- The **aperture** is basically a hole in the center of the lens. The smaller the hole the less light is able to enter the camera. Conversely if the hole is larger more light can enter. Various size holes are referred to as f-numbers or f-stops. Confusingly, the smaller the f-stop number the bigger the hole. It may be helpful to think of the aperture as being similar to your eyes' iris. In bright light the iris is small, restricting the light entering the eye. In dark situations the iris grows larger to encourage more light into the eye. The aperture in your camera should be used in the same way – increase the size of the hole to lighten the photograph, decrease the hole to darken.

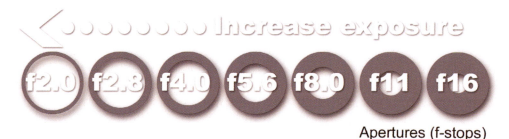

Apertures (f-stops)

- The **shutter** works a bit like a roller blind in an office window. Opening lets light into the room and closing stops the light entering. The length of time that the camera's shutter is open, called the shutter speed, determines the amount of light that enters the camera. Fast shutter speeds are used when photographing bright scenes to restrict the light coming into the camera, whereas long shutter speeds are used for night or indoor photography. Faster shutter speeds are represented by a series of numbers that are fractions of a second. Longer speeds are displayed in whole seconds.

Shutter speeds

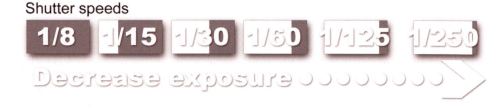

'But how do I know what shutter speed and aperture setting will be suitable for a particular scene?' All cameras have a built-in metering system designed to measure the amount of light entering the camera. The camera uses this measurement as a basis for setting the correct shutter and aperture. Simple cameras use an 'auto exposure' system which performs this function without the photographer even being aware that it is happening. More sophisticated models also include manual override options. These features allow the photographer to take more control of the exposure process, select the shutter speed and aperture that suits and even disregard the camera's recommendations altogether.

For 85% of the time there may be no need to disagree with the camera's meter or the settings it uses but there are occasions when the camera can be fooled. It is on these occasions when you as the photographer need to anticipate the problem and take control.

Use the following Exposure Commandments list as a guide to making better exposures.

Commandments for better exposure

1. Use the camera as a guide

The metering system in your camera is a very sophisticated device and for the most part your camera will choose the right exposure settings for a scene. All but the most basic models will allow you to see the settings for shutter and aperture in the viewfinder or on the LCD screen. Start to take notice of these settings and recognize how your camera reacts to different lighting situations.

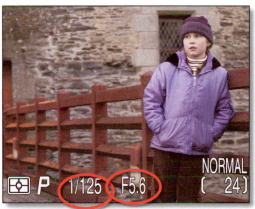

Shutter speed and aperture or f-stop settings are often displayed in the viewfinder.

2. Fill the frame with your subject

Most meters use the subject that is in the center of the frame as a guide for the exposure of the whole image. A good way to ensure that your image is well exposed is to make sure the most important parts of the picture feature in the center of the frame and are therefore used to calculate exposure. Be warned though, filling the center of the frame on all occasions for the sake of good exposure can lead to monotonous symmetrically balanced compositions.

If your meter is center weighted then make sure that this part of the frame is over an important subject area when setting your exposure.

3. Off center can mean bad exposure

In wanting to be more creative in your compositions you may wish to try designing the frame with your subject a little off center. Doing this may help the look of your images but your exposures may suffer. To solve this it is helpful to know that most cameras have the ability to lock exposure (and focus) by pushing down the shutter button halfway. For the situation where you want to create an off-center shot, point your camera at the subject and press the button halfway and then, without removing your finger, recompose the picture before pushing the button down fully to expose the photograph.

Use the lock exposure feature to gauge the exposure of an off-center subject.

4. Watch out for dark subjects

The camera's meter works on averages. When you point your lens at a scene the meter averages the various colors, tones and brightnesses in that scene to a mid-gray. The shutter speed and aperture recommended by the camera are based on reproducing this mid-gray. Now for most multi-colored scenes this is a good approach but in special circumstances it just doesn't work. For example, in a scene containing mostly dark subjects the camera will try to suggest using settings that will result in the picture being too light (overexposed). Knowing this you can adjust your settings to compensate. Simply increase your shutter speed setting by one or two speeds, or close down your aperture by a couple of f-stops. The amount you will need to alter these settings will be determined by your scene, but the beauty of digital is that you can preview your results straightaway and reshoot if necessary.

Keep an eye out for subject matter that will fool the camera's meter. Here the meter's suggested aperture and shutter speed combination resulted in a picture that was too bright (1). Reducing the exposure by 1 f-stop or EV setting produced more accurate results (2).

5. Keep an eye on light color scenes

For the same reason you should always be wary of light colored scenes as well. Prime examples are the type of images that we all take on holidays to the beach or the snow fields. Most pictures in these environments contain large areas of lightly colored subjects. Leave the camera to its own devices and you will end up with muddy, underexposed (too dark) pictures. The solution is to add more exposure than is recommended by the camera. You can do this manually as detailed in Commandment 4 or try using the Exposure Compensation feature on your camera. Usually labelled with a small plus and minus sign, this feature allows you to add or subtract exposure by simply pressing and turning the command dial. The change in exposure is expressed in fractions of f-stops. For the beach and snow scenes add 1.0 or 1.5 stops using this control.

For light toned subjects you may need to increase the exposure beyond the shutter and aperture that the camera suggests to correctly record the tones. In this example the picture taken with the camera reading is too dark (1), whereas opening up (adding extra exposure) the aperture by 1.5 f-stops produced a more realistic result (2).

6. Be careful of backlighting

A nice portrait taken in front of an open window with a beautiful vista in the distance sounds like the scenario for a great photograph, but often the results are not the vision of loveliness that we expected. The person is too dark and in some cases is even a silhouette. Now this is not necessarily a bad thing, unless of course you actually wanted to see their face. Again your meter has been fooled. The light streaming in the window and surrounding the sitter has caused the meter to recommend using a shutter speed and aperture combination that causes the image to be underexposed.

The light from behind subjects can also fool the camera's meter. Be sure to add extra exposure to compensate in these situations.

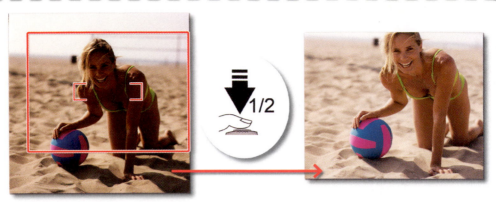

One way to overcome the effects of backlighting is to ensure that the center portion of the viewfinder is positioned over the main subject area, then press the shutter button halfway down to lock exposure (and focus) and then recompose the frame before pressing the button fully to take the photo.

To rectify this, increase the amount of light entering the camera either manually, zoom into the main subject and press the shutter button halfway to set your exposure or use your camera's exposure compensation feature. Shoot the portrait again and preview the results on screen. If need be change the settings and shoot again.

7. Histograms to the rescue

Being able to preview your work immediately on the LCD panel on the back of your camera is a real bonus for digital photographers. This means that a lot of the exposure mistakes made during the days when 'film was king' can be avoided via a simple check of the picture. Any under- or overexposure problems can be compensated for on the spot and the image reshot. But let's not stop there. Many cameras also contain a built-in graphing function that can actually display the spread of tones in your image. This graph, usually called a histogram, can be used to quickly and easily diagnose exposure problems. A bump of pixels to the right-hand end of the graph means an underexposed picture, a bump to the left end means overexposure.

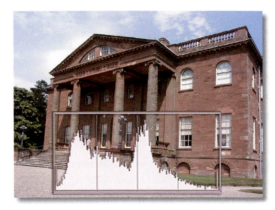

Use the histogram to check the exposure of difficult images rather than rely on how the photo appears in the monitor. This said, it is important to realize that histogram on the back of your camera is based on a JPEG version of the captured file. This is the case, even if you are shooting in Raw. This means that the histogram will be close but not a direct representation of the distribution of tones in your raw file.

Shooting tethered

Many DSLR cameras now offer the option of capturing raw photos whilst the camera is connected to a computer. Some photographers would never need, nor see the benefits of, shooting in this fashion as in their chosen area of speciality the added burden of dragging around a laptop computer as well as all their camera gear is a complication that they can do well without. But for studio, product, architectural and even some landscape photographers the ability to preview, and even process, the photos captured almost immediately on a large screen is too good to miss.

The utility software that comes bundled with most mid- to high-end DSLR cameras and medium format camera backs does an admirable job of providing the required software link between camera and computer. The physical connection is generally provided via a USB or Firewire connection, although some models can now connect wirelessly using a pretty standard setup.

The typical tethered setup works in the following manner:

1. Install camera drivers

Before connecting the camera ensure that you have installed any camera drivers that were supplied with the unit. These small pieces of software ensure clear communication between the camera and computer and are usually installed along with other utility programs such as a dedicated browser (e.g. Nikon View or Canon's ZoomBrowser/ImageBrowser) and camera-based raw conversion software (e.g Nikon Capture or Canon's Digital Photo Professional). Follow any on-screen installation instructions and, if necessary, reboot the computer to initialize the new drivers.

2. Connect the camera

The next step is to connect the camera to the computer via the USB/Firewire cable or wireless network. Make sure that your camera is switched off, and the computer on, when plugging in the cables. For the best connection and the least chance of trouble it is a good idea to connect the camera directly to a computer USB/Firewire port rather than a hub.

3. Check the connection

With the cables securely fastened switch the camera on and, if needed, change to the PC connection mode. Most cameras no longer require this change but check with your camera manual just in case. If the drivers are installed correctly the computer should report that the camera has been found and the connection is now active and a connection symbol (such as PC) will be displayed on the camera. If the computer can't find the camera try resinstalling the drivers and, if all else fails, consult the troubleshooting section in the manual. To ensure a continuous connection use newly recharged batteries or an AC adaptor.

4. Start the remote shooting software

With the connection established you can now start the remote capture software (e.g. Nikon Capture Camera Control or Canon's Digital Photo Professional). With some models the action of connecting the camera will automatically activate the software. Most versions of these utilities provide more than just a means of releasing the shutter from the computer and instantly (well nearly, it does take a couple of seconds to transfer big capture files) viewing captured photos. They contain options to set most camera functions as well. This can include items such as shutter speed, ISO, aperture, capture format, contrast, saturation and white balance controls.

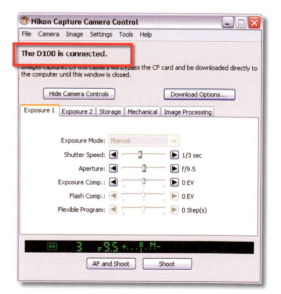

5. Set download options

With all these settings to play with where do you start? Start by adjusting the download options. The four big settings are:
- Where the files are to be transferred to,
- How they are to be labelled,
- What metadata is to be added to the files during this process, and
- What happens to the file once it is transferred.

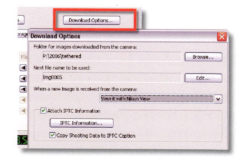

It is a good idea to create a new folder or directory for each shooting session and to nominate this as the place to download the captured files. Now select a naming scheme that provides enough information to allow easy searching later. This may mean a title that includes date and name of shoot or subject as well as a sequence number. In terms of additional metadata at the very least you should always attach a copyright statement as well as any pertinent keywords that describe the subject. Finally you need to nominate what happens to the captured files. Most users will want to transfer the pictures directly to a preview utility such as one of the browser programs or alternatively if you want to process the photo on the spot you could pass the file directly to a raw converter.

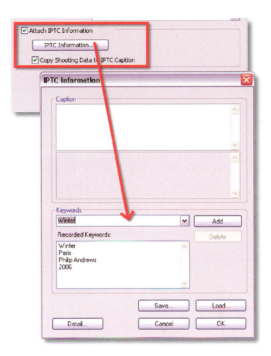

6. Adjust camera settings

As we have already covered which of these camera settings should be used by the raw shooter we won't spend too much time on how to adjust these settings here. It is worth noting, however, that with most systems aperture and shutter speed can both be set remotely and that exposure aids, such as highlight warnings and the histogram, are also available.

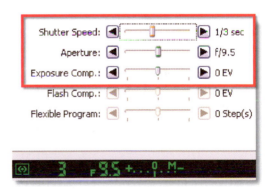

7. Compose, focus and release the shutter

Now the nuts and bolts of the capture. Most remote capture systems don't offer a live preview feature so composing and framing is still a through the viewfinder and lens event. Some photographers adopt a shoot and review policy, preferring to shoot a couple of test images and review these full size on their computer screens to check composition, focus and even exposure. Once you are happy with all your settings you can release the shutter and automatically transfer the file from camera to computer.

8. Disconnecting the camera

Before turning the camera off or disconnecting the cable make sure that any transfer of information or images is complete. Mac users can drag the camera volume from the desktop to the trash. Windows users should click the Safely Remove Hardware icon in the system tray (bottom right of the screen) and select Safely Remove Mass Storage Device from the pop-up menu that appears.

Pro's tip: Some remote capture software, like that offered by Nikon's Capture Camera Control program, contains batch processing features designed to automate the capture and processing phases. Predetermined raw image conversion and enhancement options are applied to photos on the fly as they are captured. The converted file is then saved straight to disk. This streamlined and efficient workflow is designed for processing large numbers of files that have been captured under similar lighting and exposure conditions.

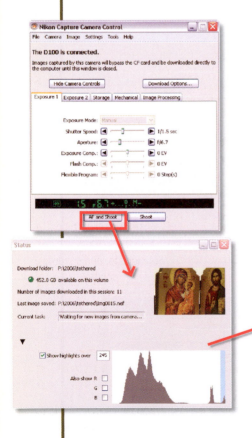

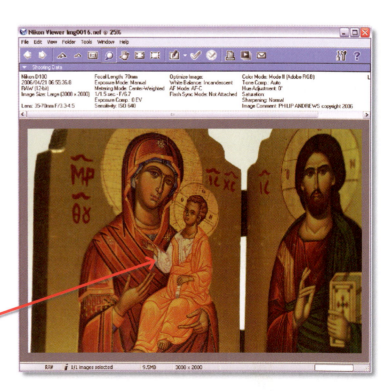

Raw versus non-raw capture workflow

This table summarizes the steps involved in three different approaches to photographing depending on the file format used for capture. Notice that the bulk of the raw image optimization happens in the processing stage back at the desktop. This is in contrast to the situation for JPEG and TIFF capture, where color, contrast, sharpening, color mode and pixel dimension options are set at time of capture.

Shooting workflows compared

		Select capture format — **JPEG**	Select capture format — **TIFF**	Select capture format — **raw**
Before shooting		Choose image quality (level of compression)	–	–
		Pick color depth (8 or 16 bits per channel)		–
		Select pixel dimensions of capture		–
		Set color mode or space (sRGB for web work, AdobeRGB for print work)		–
		Set saturation		–
		Set white balance (for the dominant light source or using the customize option)		–
		Set tonal compensation (more or less contrast)		–
		Set ISO value		
		Select Sharpening setting		–
		Set Noise Reduction options		–
During shooting		Arrange composition		
		Adjust focus (check depth of field)		
		Set exposure (check histogram/highlight warning)		
After capture conversion processing		–		Determine orientation and set cropping
		–		Set highlight and shadow points
		–		Alter brightness and contrast
		–		Adjust white balance and saturation
		–		Select color space
		–		Determine image dimensions and resolution
		–		Apply Sharpening and Noise Reduction

Raw capable cameras

Canon – EOS-1D, EOS-1Ds, EOS-1D Mark III, EOS-1D Mark II, EOS-1Ds Mark II, EOS 1D, Mark II N, EOS 5D, EOS 10D, EOS 20D, EOS 20Da, EOS 30D, EOS D30, EOS D60, EOS 300D (Digital Rebel/Kiss Digital), EOS 400D, EOS Rebel XT (EOS 350D/EOS Kiss Digital N), PowerShot 600, PowerShot A5, PowerShot A50, PowerShot Pro 1, PowerShot S30, PowerShot S40, PowerShot S45, PowerShot S50, PowerShot S60, PowerShot S70, PowerShot G1, PowerShot G2, PowerShot G3, PowerShot G5, PowerShot G6, PowerShot Pro70, PowerShot Pro90 IS

Contax – N Digital

Epson – R-D1, RD1s

Fujifilm – FinePix E900, FinePix F700, FinePix S5000 Z, FinePix S5200/5600, FinePix S9000/9500, FinePix S7000 Z, FinePix S2 Pro, FinePix S3 Pro, FinePix S5 Pro FinePix S20 Pro

Hasselblad – H2D

Kodak – DCS 14n, DCS Pro 14nx, DCS720x, DCS760, DCS Pro SLR/n, EasyShare P850, EasyShare P880

Konica Minolta – DiMAGE A1, DiMAGE A2, DiMAGE A200, DiMAGE 5, DiMAGE 7, DiMAGE 7i, DiMAGE 7Hi, Maxxum Dynax 5D (Europe), Maxxum 5D (USA), Maxxum 7D/Dynax 7D

Leaf – Aptus 22, Aptus 65, Aptus 75, Valeo 6, Valeo 11, Valeo 17, Valeo 22

Leica – Digital-Modul-R, D-Lux 2, D-Lux 3, Digilux 2, Digilux 3, V-Lux1

Mamiya – ZD

Nikon – D1, D1H, D1X, D100, D200, D2H, D2Hs, D2X, D40x, D50, D70, D70s, Coolpix 5000, Coolpix 5400, Coolpix 5700, Coolpix 8400, Coolpix 8700, Coolpix 8800

Olympus – E-10, E-1, E-20, SP-310, SP-550UZ, SP-350, SP-500UZ, E-300, E-330, E-400, E-410, E-500, C-5050 Zoom, C-5060 Zoom, C-7070 Wide Zoom, C-8080

Panasonic – DMC-FZ50, DMC-FZ30, DMC-FZ28, DMC-LC1, DMC-LX1, DMC-LX2

Pentax – *ist D, *ist DS, *ist DS2, *ist DL, *istDL2, K10D, K100D, K110D

Phase One – H20, H25, P20, P21, P25, P30, P45

Ricoh – GR Digital

Samsung – Pro 815, GX1S, GX1L

Sigma – SD9, SD10, SD14

Sony – A-100, DSC-R1, DSC-F828, DSC-V3

Other considerations when capturing raw

As we have seen there are a variety of settings that need to be considered when enabling your camera for raw capture. Before you turn on your camera be sure to consider memory card requirements to handle storage of large raw files, unless of course you have managed to acquire wireless file transfer capability or are shooting tethered. In that case you need to consider hard disk and offline storage issues.

Memory cards

It is worth investing in memory cards of at least 1 Gb or 2 Gb capacity, preferably with some sort of accelerated read/write speed. In case you're wondering what that 300× , 133× or 60× label means, card performance is based on a benchmark of megabytes per second of read/write rate. Using a starting point of 3 Mb/sec equalling a 20× memory card read/write rate, typical rates will be:

- 9 Mb/sec = 60×

- 10 Mb/sec = 66×

- 20 Mb/sec = 133×

- 45 Mb/sec = 300×

Large capacity memory cards with fast read and write speeds, like these examples from Lexar, are well suited to the task of raw capture.

For example, a 120× 2 Gb SD card has a read rate of 21 Mb/sec and a write rate of 18 Mb/sec. Such read/write speeds will provide not only fast storage of large image files to card, they will also facilitate quick viewing of images and faster transfer rates during downloading than, say, a 60× card. The Lexar Professional UDMA card range with Write Acceleration provide a staggering 300× read/write speed which is currently one of the fastest on the market. Many photographers prefer to use two 2 Gb cards instead of one 4 Gb card. If you are creating huge files from a 22 Mp camera then 4 Gb or even 8 Gb will be attractive.

Some DSLRs have dual memory card slots and allow you to designate what should go where. You can elect to put JPEGs on one card and raw files on the other or you can use only one card and then switch to the other card without having to remove one.

After you scroll through your menu selections in-camera for Image Quality, select the raw setting and decide whether you would also like to simultaneously capture JPEG and raw files. If so, select the file size and image quality of the JPEG files. Check your display to determine how many images may be saved to memory card. If you think you will need to save more to one card, perhaps a 4 Gb or higher memory card will be more appropriate.

Other hardware considerations

Memory cards aren't the only items to think about when capturing raw files. Other devices that you should also consider include:

Portable storage device – Make sure you have plenty of cards for your shoot and consider bringing a portable data bank or tank, actually an external hard drive sometimes. Several types of devices are available, from cheap to expensive; I recently found basic hard drives encased in durable plastic that will directly accept your cards for copying without a computer. More sophisticated devices are available with or without screen displays and other features, such as the Nikon Coolwalker, the SmartDisk™ FlashTrax and Fotochute products, or Delkin eFilm PicturePAD device.

Portable storage options like Nikon's Coolwalker provide a means of downloading the contents of full memory cards when on the move.

Computer – Raw files are much larger than JPEG files, more than twice as large in most cases. And, if you also save a large to medium JPEG with every raw file you will definitely need to be prepared with adequate RAM (Random Access Memory) to download efficiently without slowing down your system and an internal or external hard drive big enough to store the raw files.

Operating system – Install the latest Windows and Mac OS X version and check frequently for updates for raw file browsing and handling.

Backup – Ideally, your computer will have a CD/DVD burner for file backup; a DVD burner is advisable as each disk holds considerably more data than a CD. Another alternative is an external hard drive such as the OneTouch backup systems offered by Maxtor. As we really do not know the life expectancy of CDs or DVDs, many photographers institute a combined backup system for precious photos which involves both DVD and hard drive options.

External hard drives such as Maxtor's OneTouch system are a good way to ensure up-to-date and secure storage of precious picture files.

4

Downloading Raw Files

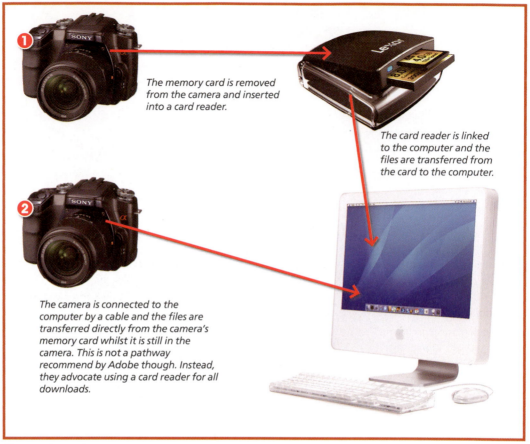

➊ The memory card is removed from the camera and inserted into a card reader.

The card reader is linked to the computer and the files are transferred from the card to the computer.

➋ The camera is connected to the computer by a cable and the files are transferred directly from the camera's memory card whilst it is still in the camera. This is not a pathway recommend by Adobe though. Instead, they advocate using a card reader for all downloads.

There are two main ways to transfer your files from camera to computer – (1) via a card reader or (2) directly.

After enabling the camera and then spending your time creating a bunch of masterpieces, saved in the raw format of course, the next step is to download these photos to your computer. As with most things raw, we have several different download options. Some photographers love to connect their cameras directly to the computer, others who use multiple memory cards make use of a dedicated card reader to transfer their images. And a third group of image makers who shoot tethered are able to capture and download in one action.

In this chapter we will outline the various ways you can port your photos to the computer and take particular notice of some of the automated download options that are now provided by the image editing and raw conversion programs.

Camera to computer

As we saw in the 'Shooting tethered' section in the last chapter, when connecting your camera to the computer it is important to ensure that the drivers for the devices are installed before plugging in the cables.

The drivers are generally installed at the same time that you load the utility software that accompanied the camera. If you haven't yet installed any of these applications then you may need to do this first before the computer will recognize and be able to communicate with the camera. During the installation process follow any on-screen instructions and, if necessary, reboot the computer to initialize the new drivers.

To download images directly from the camera the computer needs to communicate with the connected camera as it would a hard drive or temporary removable drive. For this to occur you may need to change the basic communications setup on the camera before connecting the unit. The need to alter the default setup for the camera is largely based on the operating system (and version) that you are using. Typically you will have a choice between connecting your camera as a mass storage device (the most common option) or via PTP (Picture Transfer Protocol). Check with your camera documentation which works best for your setup and then use the mode options in the camera's setup menu to switch to the transfer system that you need.

The next step is to connect the camera to the computer via the USB/Firewire cable. Make sure that your camera is switched off, and the computer on, when plugging in the cables. For the best connection and the least chance of trouble it is also a good idea to connect the camera directly to a computer USB/Firewire port rather than an intermediary hub.

Now switch the camera on. Some models
have a special PC or connect-to-computer
mode – if yours is one of these then change the
camera settings to the PC connection mode.
Most cameras no longer require this change,
but check with your camera manual just in
case. If the drivers are installed correctly the
computer should report that the camera has
been found and the connection is now active
and a connection symbol (such as PC) will be
displayed on the camera. If the computer can't
find the camera try resinstalling the drivers
and, if all else fails, consult the troubleshooting
section in the manual. To ensure a continuous
connection use newly recharged batteries or an
AC adaptor.

Card reader to computer

Like attaching a camera to your computer, some card readers
need to be installed before being used. This process involves
copying a set of drivers to your machine that will allow the
computer to communicate with the card reader. Some readers do
not require extra drivers to function and simply plugging these
devices into a free USB or Firewire port is all that is needed for
them to be ready to use.

After installing the reader, inserting a memory card into the
device registers the card as a new removable disk or volume.
Depending on the imaging software that you have installed on
your computer, this action may also start a download manager

*Many modern card readers can be used
with multiple card types, making them
a good solution if you have several
cameras in the household or office.*

Note:

*Before turning off the camera,
disconnecting the cable to camera/
card reader, or removing a memory
card from the reader make sure that
any transfer of information or images
is complete. Mac users should then
drag the camera/card volume from
the desktop to the trash icon or select
the volume icon and press the eject
button. Windows users should click
the Safely Remove Hardware icon in
the system tray (found at the bottom
right of the screen) and select Safely
Remove Mass Storage Device from the
pop-up menu that appears.*

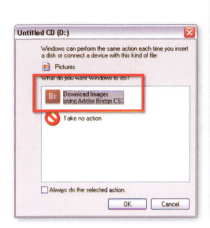

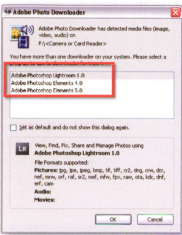

Both the Photoshop and Photoshop Elements versions of the Adobe Photo Downloader software provide auto-start options that allow the user to select the feature from a pop-up window when a memory card (in reader) or camera is attached to the computer or when an archive CD/DVD disk is inserted. Notice the Photoshop Lightroom option in the dialog on the right. It too has its own transfer utility.

or utility designed to aid with the task of moving your raw files from the card to hard drive. In the 'Photoshop Elements', Photoshop CS3 (via Bridge 2.0), Lightroom and 'Camera-specific download' sections later in this chapter you will see examples of these utilities in action.

Failing this, Windows users will be presented with a Removable Disk pop-up or AutoPlay window containing a range of choices for further action. One of the options in Vista is Import Pictures. Choosing this entry will display the new Import Pictures and Videos dialog. Clicking

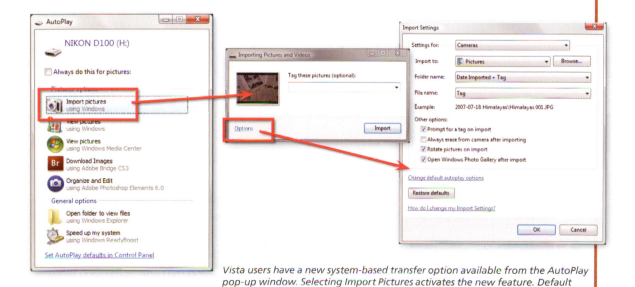

Vista users have a new system-based transfer option available from the AutoPlay pop-up window. Selecting Import Pictures activates the new feature. Default transfer settings can be altered via the Options button.

the Import button will transfer the files to your computer using the default settings for the utility. To change settings used for transferring click on the Options text button in the bottom left of the dialog.

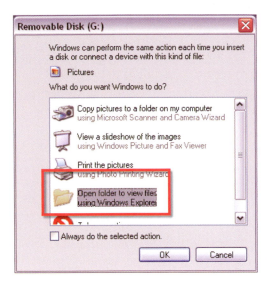

Windows XP users need to use the 'Open folder to view files' option to copy their raw files to the computer as these picture types are not recognized with the current version of the Microsoft Scanner and Camera Wizard.

XP users will see a similar option titled 'Copy pictures to a folder on my computer' in the AutoPlay window. Choosing this entry will open the Microsoft Scanner and Camera Wizard which acts as a default download manager for transferring non-raw-based picture files. If your card contains raw files then the current version of the wizard will report that there are no photos present on the card. This situation will change as the Windows software becomes more raw aware, but for the moment the solution is to select the 'Open folder to view files' option and manually copy the pictures into a new folder on your hard drive.

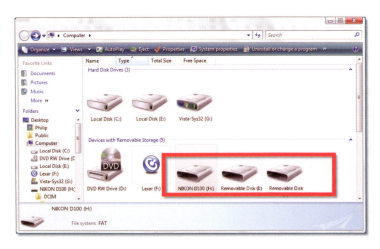

After a multi-card reader has been installed on a Windows computer the various card slots are displayed in the My Computer window as separate removable drives.

Cards inserted into a Macintosh connected reader will appear as a new volume on the computer's desktop. Users can then copy or move the picture files from this volume to a new folder on their hard drive. Alternatively the Image Capture utility can be used to automate this process.

The important last step on both Macintosh and Windows platforms is to ensure that the card is correctly disconnected from the system. Macintosh users will need to drag the volume to the Wastebasket or Eject icon, whereas Windows users can use the Safely Remove Mass Storage Device feature accessed via a button in the Taskbar (bottom right of the screen).

Complete step-by-step instructions for Windows and Macintosh transfer processes can be found in the 'Operating system-based downloads' section in the next part of this chapter.

Memory cards will appear as a new volume on the Macintosh desktop.

Camera and card reader connections

The connection that links the camera/card reader and computer is used to transfer the picture data between the two machines. Because digital photographs are made up of vast amounts of information this connection needs to be very fast. Over the years several different connection types have developed, each with their own merits. It is important to check that your computer has the same connection as the camera/card reader before finalizing any purchase.

CONNECTION TYPE:	MERITS:	SPEED RATING:
USB 1.0	• No need to turn computer off to connect (hot swappable) • Can link many devices • Standard on most computers • Can be added to older machines using an additional card	Fast (1.5 Mbytes per sec)
USB 2.0	• Hot swappable • Can link many devices • Standard on most models • Can be added to older machines using an additional card • Backwards compatible to USB 1.0	Extremely fast (60 Mbytes per sec)
Firewire	• Hot swappable • Can link many devices • Becoming a standard on Windows machines. • In real world tests Firewire can be faster than USB 2.0. • Can be added using an additional card • Standard on Macintosh machines	Extremely fast (50 Mbytes per sec)
Firewire 800	• Hot swappable • Can link many devices • Can be added using an additional card • Not yet standard but some new machines feature the connection	Fastest connection available (100 Mbytes per sec)

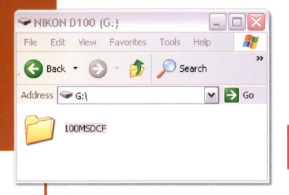

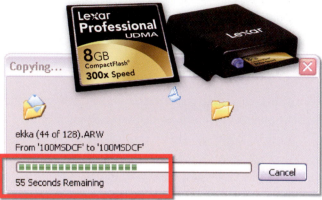

Flash memory companies, such as Lexar, are always producing new products that make the process of downloading files faster than what was possible with the previous generation of cards. Lexar's latest offering boasts 300× speed which dramatically decreases the time taken to download large numbers of files.
In the demonstration, above, the same folder of photos (1Gb in size) was downloaded from both a 133× (lower) and the new 300× card (upper). The UDMA card was noticeably faster, completing the task minutes ahead of the older style flash card and reader.

Fast cards means fast downloads

The latest incarnation of fast memory cards require equally fast card readers in order to take advantage of the increased speed. In the case of the UDMA cards from Lexar that are capable of 300× download speeds, the fast transfer performance is only possible when using the matched card reader and a Firewire 800 connection. Firewire 800 is the fastest of all the plugable connections and is necessary if the upper limit of the card/reader combination download speed is to be reached and, more importantly, sustained.

For Macintosh users working on a recently released model, the Firewire 800 connection is not a problem as these computer models include at least one port of the faster interface as standard. Windows users on the other hand will have a more difficult task tracking down an off the shelf computer that features Firewire 800. Instead most users will need to add the functionality to an existing system via an upgrade card. Be warned though, most Firewire 800 interface cards use the 64bit version of the PCI interface which can only be found on advanced motherboards or those employed by server computers.

Memory cards are used to store your camera's pictures. Various capacity sizes and speeds are available in the four main formats shown here. (1) Compact flash. (2) Multimedia. (3) MemoryStick. (4) Smart media.

MEMORY CARD TYPE:	MERITS:	CAMERA MAKES:
Compact flash	The choice for professional cameras Matchbook size	Most Canon, Nikon, Sony DSLR, Hewlett-Packard, Casio, Minolta and pre-2002 Kodak
Compact Flash (Microdrive)	Same format and connection as standard Compact Flash but contain a small hard drive and so therefore contain moving parts	Same camera categories as above but check the fitting as microdrives are a Type II Compact Flash footprint
Smart media	Credit card thickness Usually colored black Matchbook size	Olympus and Fuji digital cameras, Sharp camcorders with digital still mode, and some MP3 players
Multimedia (MMC) or Secure Digital (SD)	Most popular card Postage stamp size Credit card thickness SD are second generation MMC cards	Most Panasonic camcorders with digital still mode, some MP3 players, and the Kyocera Finecam S3, KB Gear JamCam, Minolta DiMAGE X and most Kodak digital cameras produced after 2001
xD Picture Card	Smallest of all cards About the size and thickness of a thumbnail	Fuji and Olympus cameras
MemoryStick and MemoryStick Pro	Smaller than a stick of chewing gum Longer than other card types	Used almost exclusively in Sony digital cameras, camcorders, handhelds, portable music players and notebook computers

Operating system-based downloads

For non-automated download of raw files you will need to perform a basic copy or move process to transfer your pictures from the card/camera to a folder/directory on your computer. The steps taken to facilitate the transfer vary slightly between Macintosh- and Windows-based machines – two different step-by-step summaries are provided below.

Windows XP

1. Ensure that the card reader is correctly installed and then insert the camera's memory card into the appropriate slot. Windows will display a generic Removable Disk dialog and ask you to select an option to determine how you want to proceed. For standard picture files (non-raw) you would generally select 'Copy pictures to a folder on my computer' but raw shooters need to work

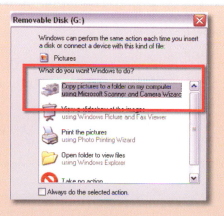

Step by step:

in a slightly different fashion as the operating system doesn't natively recognize raw files as photos.

2. So instead select the 'Open folder to view files using Windows Explorer'. This will simply display the contents of the card as if it were a standard hard drive or CD-ROM. If you want to bypass this dialog in the future tick the 'Always do the selected action' option. Windows will then remember your selection and perform this action every time you insert a camera card.

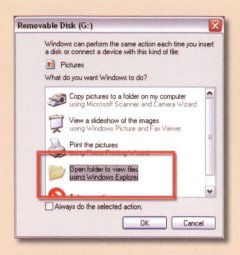

3. A new Windows Explorer dialog will open displaying the default folder created by your camera when saving the pictures to the card. There may be nested folders that you have to work your way through before reaching the actual picture files.

 Pro's tip: The default file and folder structure used for saving your photos to memory card is determined by options in the setup menu of your camera.

4. As the raw files are not recognized as photos in the current version of Windows you will not be able to preview the contents of the files as thumbnails. So switch the View mode to Details (View > Details), which will present the files in list form.

 Note: Recently Microsoft released a free raw thumbnailer and viewer utility for XP that allows the contents of raw files to be viewed in standard Windows file browsing dialogs. See 'The Microsoft Raw Image Thumbnailer and Viewer for Windows XP' section on the next page for more details of this utility.

5. Next open a second window by pressing the My Computer icon. Navigate your way to the My Pictures folder (or the directory you wish to move the raw photos to) and create a new folder to house the transferred files.

6. With both Explorer windows sitting side by side select all the files in the memory card folder and then hold down the Ctrl key and drag the files across to the new folder. This will copy the files to the new position.

 Note: Holding down the Shift key whilst dragging will move the files from the card to the new folder, removing the need to delete the files after the transfer is complete.

7. After the files have been copied or moved and whilst they are still selected in the card window, choose File > Delete to erase the raw pictures from the card. Before removing the card from the reader, right-click the Safely Remove Hardware icon in the System tray. At the next screen select the Stop button to allow you to unplug the memory card (USB Mass Storage Device).

The Microsoft Raw Image Thumbnailer and Viewer for Windows XP

In response to the growing number of Windows users who are also raw shooters, Microsoft released a utility that can be installed on XP-driven machines to provide previews of raw files within the file browsing windows of the operating system. Available as a free download from www.microsoft.com, the utility or Power Toy provides thumbnails, previews, printing and metadata display for raw images from supported Canon and Nikon digital cameras in Windows XP. The sad news for Vista users is that despite initial expectations that raw files would be supported straight out of the box, the new Windows operating system still needs a little tweaking if it is going to work efficiently with your images. Instructions for setting up Vista are listed later in this chapter.

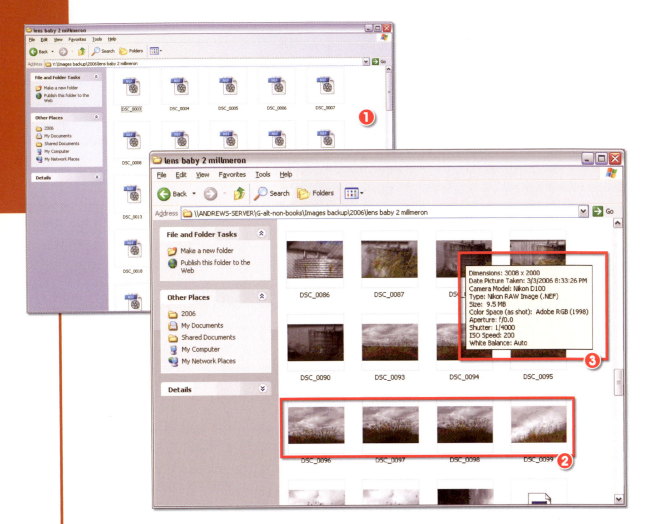

Without the Microsoft Raw Image Thumbnailer and Viewer for Windows XP installed a folder full of raw files cannot be previewed in Thumbnail mode (1). Once the utility is installed the same folder will display thumbnails of the raw photos (2) and metadata for each picture when hovering the mouse over the thumbnail (3).

Photoshop and Raw Image Thumbnailer and Viewer working together

Despite the obvious advantage of installing this utility for file management and organizational purposes it is worth noting that the Viewer and Thumbnailer only displays the pixels from the original captured file. Any processing applied via software such as Adobe Camera Raw will not be reflected in the previews, slideshows or prints. Also, setting the Raw Image Viewer as the default way to view your raw files takes your image editing or raw conversion software out of this position in your raw workflow.

Some photographers who want to thumbnail their raw photos in Windows XP but still retain a specific program such as Photoshop as their default raw conversion/editing program alter the settings in the File Types tab of the Raw Image Viewer Options.

The XP raw utility in action

When Windows users who don't have the utility installed point their file browsers at a folder full of raw photos, the dialog can display the files in tile, icons, list and details views but not the thumbnails option. At the most basic level installing the utility enables this thumbnailing option to function in all file browser windows but there is more to this utility than just the preview options.

The Viewer and Thumbnailer is not intended to replace the raw conversion utilities provided by the camera manufacturer or those found in your imaging software, rather it is designed to make the management tasks regularly performed via operating system (OS) dialogs as simple as they are with other picture formats.

The utility has two main components:

1. A Windows XP 'Shell Extension' which provides the thumbnail rendering, printing and metadata display for raw files (of supported cameras), and

2. A raw image view application that provides previews, printing and slideshow options for raw files. This application looks and works like the Windows Picture and Fax Viewer but with added features designed specifically for raw shooters.

Digital photographers will benefit from installing this utility in several ways. Obviously being able to preview your raw files directly in the OS dialogs will aid in locating and organizing your photos. Add to this the fact that software makes use of the camera manufacturers' own coding libraries to generate the high quality and color correct (yes it is ICC profile aware) previews and you have the ability not only to manage but to accurately preview your raw files natively. Cool!

Top features

Previewing – After installing the utility you can preview raw files by either right-clicking the file and selecting Preview from the menu that pops up or double-clicking the file. Both options will launch the Microsoft Raw Image Viewer for those raw file types (.nef, .crw) selected during the utility installation process.

Metadata viewing – Hovering the mouse over a raw image in Windows Explorer will display the metadata for the file in a pop-up window. Alternatively clicking the yellow properties button at the

bottom of the Raw Image Viewer will display the same information in a floating window.

Custom properties columns – New levels of information can be displayed in the Details view of Windows Explorer. This information is based on the metadata associated with the raw file and it can be shown in a new column by right-clicking the column header bar and then selecting the new data type from those listed.

Slideshows – You can include raw images in an impromptu slideshow by clicking the Slideshow button at the bottom of the Raw Image Viewer. The duration that each slide stays on screen is governed by the Slideshow setting in the General tab of the viewer's Options.

Printing – Raw files can be printed directly from the Raw Image Viewer using the button at the bottom of the dialog and the photos are set up for output via the Photo Printing Wizard.

Limitations

Whilst the Raw Image Thumbnail and Viewer does extend raw functionality to many OS areas it doesn't enable all the digital photography features that XP users may be familiar with. In particular the Windows Filmstrip view doesn't show raw files, the Picture Task options in the Windows Task Pane are not supported, but print and slideshow features are supported in the Raw Viewer application itself, and the Windows Camera and Scanner Wizard and Picture and Fax Viewer do not support raw files.

Raw-enabling Windows Vista

In creating a more 'raw aware' operating system, Microsoft has made use of a structure where the various camera manufacturers supply their own CODECs (Compression Decompression drivers) to be used with their particular type of raw files inside Vista. In this approach, though a little troublesome to start with, the user has to install the CODEC for the camera that he or she uses. This will hopefully future proof the operating system's support for raw files. It is a simple matter in the future to support the latest camera, or raw file type, by installing the latest CODEC from the manufacturer.

Use the following steps as a guide for raw enabling your own Windows Vista machine.

Installing a new raw CODEC

1. Start by searching the internet, or your camera manufacturer's support site, for the specific Vista CODEC that supports your raw files. Once located, download, and in some cases, extract, or decompress, the files to your desktop ready for installation.

2. Next follow the install instructions. Here I am installing the Nikon Raw CODEC for Vista. As part of the process, the user is required to input location and language selections.

3. As the CODEC forms part of the file processing functions of the operating system it may be necessary to reboot (turn off and turn back on again) your computer after installing the software.

4. After rebooting check to see that the CODEC is functioning correctly by either displaying an Icon View of an image folder that you know contains raw files. You should see a series of thumbnails representing your image files.

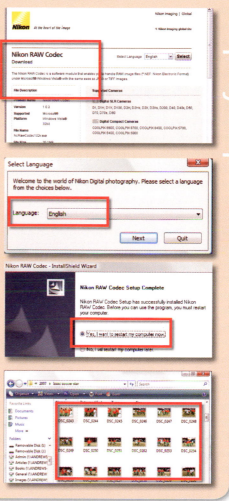

Transferring files with Vista

1. After inserting a card into your card reader or connecting a camera to the computer the AutoPlay dialog will be displayed, providing you with a range of transfer options. To use Vista, select the Import Pictures entry. An Import Photos dialog for Bridge, Photoshop Elements and/or Lightroom may also appear. Cancel out of this window to stop the download process using any of these utilities.

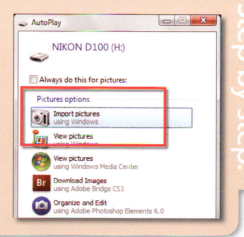

Step by step:

Step by step:

2. Selecting the Import Photos entry will display the Importing Pictures and Videos window. A small preview of the first photo to be transferred will be shown and a text box for 'on the fly' tagging of the files is also included. To start the transfer process using the current defaults, click the Import button. To customize the download click on the Options text (bottom left).

3. The Import settings dialog contains all the download controls. Here you can select where the files will be saved to, how the download folder, and the files themselves, will be named, if tags are applied during import, whether the files are erased from the card or camera after downloading, auto rotate options and if the Windows Photo Gallery is opened when the transfer is finished.

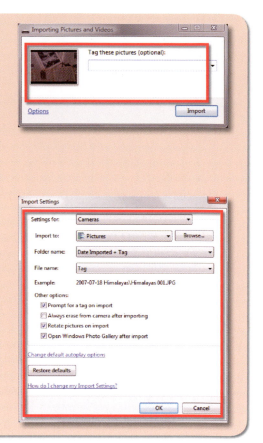

Raw support in Macintosh

From the Tiger version (10.4) of Macintosh's operating system the Apple platform has supported the display and opening of a variety of raw file formats. This includes Nikon and Canon formats along with Adobe's DNG or digital negative file type.

As camera companies continue to release new models and, in doing so, they often release slight variations to their proprietary raw formats to account for new or improved technologies, Apple occasionally releases updates to its Operating System, including in these changes support for newer camera models

and file formats. Check the support web page for Apple Preview (at www.apple.com) for the latest updates.

These updates also provide the basis for raw support for other Macintosh programs such as Preview, iPhoto and Aperture.

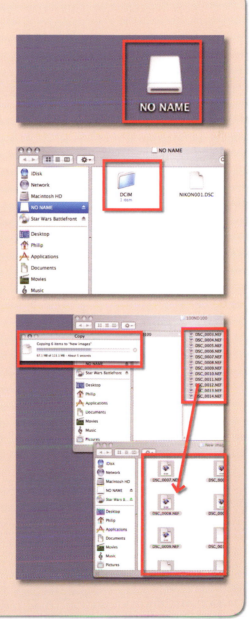

Macintosh step by step

Step by step:

1. Macintosh users can follow a similar route when manually downloading their files from a card reader or camera. After connecting the reader, insert the memory card. The card will be displayed as a new drive icon on the desktop.

2. With the way that most cameras save their captured photos the next step will be for you to navigate your way through a series of folders until you reach the primary folder that contains the raw files. Now open another Finder window and create a new folder on your hard drive in which to save your transferred photos.

3. Select all of the raw files and then drag them to the new folder. This will move the files from the card to the folder. If you wish to copy rather than move the photos, hold down the Opt key as you drag the selected files.

4. Once the pictures are safely in the new folder on your computer you can delete the files from the memory card. Select the photos and drag them to the Trash Can. This step won't be necessary if you moved instead of copied the files in the previous step. Now eject the card from the system by click-dragging the drive from the desktop to the Eject/Trash Can icon in the dock. When the drive icon is no longer on the desktop you can safely remove the card.

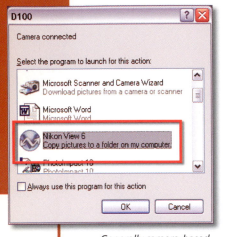

Generally camera-based transfer utilities either start automatically when a camera is connected to the computer, or a card inserted into a reader. Alternatively the utility can also be selected from the AutoPlay menu.

Camera-specific download

Most digital cameras now ship with a host of utilities designed to make the life of the photographer much easier. As part of this software pack the camera manufacturers generally include an automated download utility designed to aid the transfer of files from camera or card reader to computer. These camera-specific download managers are clever enough to know when a camera or card reader is connected to the computer and will generally display a connection dialog when the camera is first attached or a memory card inserted into the reader.

As we will see in the next section of this chapter some software programs such as Photoshop/Bridge and Photoshop Elements load their own download manager when they are first installed. For this reason it is not unusual for a couple of utility windows to appear whenever you insert a memory card into a reader. The particular software you select to handle the file transfer will depend largely on your own preferred workflow. Some photographers download using the camera software and then convert/edit using their imaging program, others prefer to keep to one system from beginning to end using a single program such as Photoshop Elements for both tasks.

Once you have made a decision about which route to use then look for a disable option in the preferences of the manager software that you want to bypass. Failing that, you can always nominate your preferred method of handling downloads via the Windows Removable Disk or Camera dialog. Simply select the download utility from those selected and then tick the 'Always do the selected action' option at the bottom of the dialog. The next time you insert a card into the reader Windows will automatically open the download manager of your choice.

Most hardware companies supply a suite of software products with their cameras. Many include automated download utilities like this one from Nikon.

Nikon's download manager

Nikon owners have the option to use the Nikon Transfer manager, a small pop-up utility that automates the moving of files from card/camera to hard drive. The manager is installed along with camera drivers, photo browser and basic raw conversion software when you load the software on the disk that accompanies your camera. Generally this type of software provides settings for choosing destination directories, renaming files on the fly, adding in copyright information and determining if the files are deleted from the camera or card after transfer.

Software-specific download

Many photographers will choose not to rely on the download options available with their camera-based software or the manual copy route provided by the operating system. Instead they manage the download component of their workflow with the main imaging software package. This may be an editing program, such as Photoshop or Photoshop Elements, or the raw conversion or workflow software, like Lightroom, that they employ. Either way, making this approach generally provides time savings as the raw files are transferred from camera, or card reader, and during the same action they are imported into the editing, workflow or conversion program.

To give you an idea of the options available with this style of download the following few pages contain step-by-step examples for key software titles.

The Adobe Photo Downloader (APD)

Over the history of the development of Photoshop Elements one of the most significant additions to the program has been the Photo Browser or Organizer workspace. This feature provides a visual index of your pictures and can be customized to display the images in browser mode, date mode or sorted by keyword tags or collection. The Adobe Photo Downloader utility has been coupled with the Organizer workspace for the last few versions of Photoshop Elements and it is this utility that provides the primary method for users to import photos from camera, cards and folders to the program.

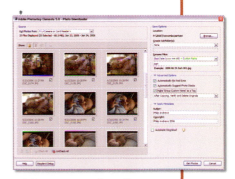

Adobe's own transfer utility now ships with both Photoshop and Photoshop Elements after initially starting its life as an Elements-only product. Like other transfer options the Adobe Photo Downloader can rename, erase images from memory cards, add metadata and, in the Photoshop version, convert to DNG, all during the transfer process.

Photoshop and Bridge get APD....finally!

New for Bridge 2.0 (and Photoshop CS3) and borrowed from Photoshop's little brother, Photoshop Elements, is the Adobe Photo Downloader or APD utility. Just as is the case with Photoshop Elements the downloader manages the transfer of files from camera, card reader or archive CD/ DVD to your computer. In the process, the Bridge version of the utility can also change file names, convert to DNG on the fly, apply pre-saved metadata templates and even save copies of the files to a backup drive. The backup feature alone saves loads of time and effort for the working photographer, over performing this task manually.

Despite the core functionality being the same, there are slight differences between APD as it appears in Photoshop/Bridge and Photoshop Elements. This table summarizes both the similarities and differences between the versions.

Adobe Photo Downloader features:	PS	PSE
Advanced and standard dialogs	●	●
Individually select photos to download	●	●
Auto start on card, camera or CD/DVD insertion	●	●
Choose location folder/directory for transfer	●	●
Create sub-folder for transferred files	●	●
Rename files while transferring	●	●
Apply simple metadata on the fly	●	●
Convert to DNG during download	●	
Save copies to an alternative drive or directory (backup)	●	
Apply custom metadata templates	●	
Automatically fix red eye		●
Suggest photo stacks during transfer		●
Apply group name tags (keywords)		●
After copying perform verification and deletion actions		●

Adobe Photo Downloader is common to both versions of Photoshop (Photoshop CS 3 and Photoshop CS 3 Extended) and is also included in Photoshop Elements. Although the core of the controls are the same, there are a few minor differences between the Elements and Photoshop versions. Because of these differences we will look at each version and its associated workflow in turn.

Transfers with APD and Photoshop Elements

Unlike the standard file browsers, the Organizer workspace in Photoshop Elements creates the thumbnail during the process of adding your photographs to a collection. A similar process is used when moving files from card, camera or folders on your computer (if you have already transferred the pictures using an alternative process).

To commence downloading your raw files and, in the process, create your first collection, simply select the View and Organize option from the Welcome screen and then proceed to the Organizer: File > Get Photos

menu option. Select one of the listed sources of pictures (camera or folders) provided and move through the steps and prompts in the dialogs that follow.

Option 1: Getting your raw files from camera or card reader

1. To demonstrate the process let's start by downloading some photographs from a memory card or camera. This will probably be the most frequently used route for your raw images to enter the Elements program. Connect the camera, being sure that you have first installed the drivers for the unit. Alternatively you may wish to eject the memory card from the camera and insert it into a card reader that is already attached to the computer. Next select the From Camera or Card Reader option from the File > Get Photos menu.

2. After attaching the camera, or inserting a memory card into the reader, you will see the Adobe Photo Downloader dialog. As we have seen already this is a utility and dialog designed specifically for managing the download process. The first step is to locate and then select the source of the pictures (the card reader or memory card in the camera) from the drop-down menu in the top right of the dialog.

3. By default, when using the Standard Dialog, all pictures on the card will be selected ready for downloading and cataloging. Next set the Import Settings. Browse for the folder where you want the photographs to be stored and if you want to use a subfolder, select the way that this folder will be named from the Create Subfolder drop-down menu.

4. To help with finding your pictures later it may be helpful to add a meaningful name, not the labels that are attached by the camera, to the beginning of each of the images. You can do this by selecting an option from the Rename File drop-down menu and adding any custom text if needed. It is at this point that you can choose what action Elements

Step by step:

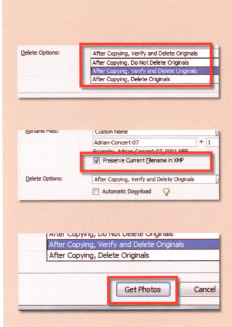

will take after downloading the files via the Delete Options menu.

5. It is a good idea to choose the Verify and Delete option as this makes sure that your valuable pictures have been downloaded successfully before they are removed from the card.

6. If you have elected to rename the files as they are downloaded then choosing to Preserve the Current File Name in XMP will mean that it is always possible to search for the specific file using the original name at a later date.

7. Clicking Get Photos will transfer your pictures to your hard drive – you can then catalog the pictures in the Organizer workspace. For more choices during the download process you will need to switch to the Advanced mode.

Advanced Dialog Options

Selecting the Advanced Dialog button at the bottom left of the Standard mode window will display a larger Photo Downloader dialog with more options and a preview area showing a complete set of preview thumbnails of the photos stored on the camera or memory card. If for some reason you do not want to download all the images, then you will need to deselect the files to remain, by unchecking the tick box at the bottom right of the thumbnail.

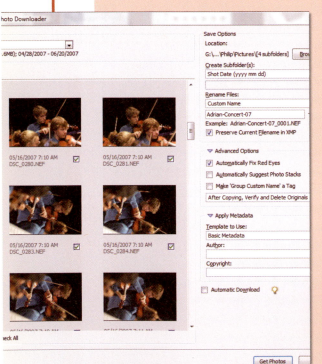

Only files that are selected in Adobe Photo Downloader can be deleted from the camera. This means they have to be downloaded and added to the catalog (even if they're already there from a previous download) before they are deleted.

The Advanced mode of the Photo Downloader contains the same Location for saving transferred files, Rename and Delete after importing options that are in the Standard dialog.

After downloading your pictures from the memory card, or the camera itself, you are given the option to delete the original files. This frees up the memory space on the card, readying it for further use.

The From Files and Folders option allows you to preview thumbnail versions of existing images from the directories or folders on your computer.

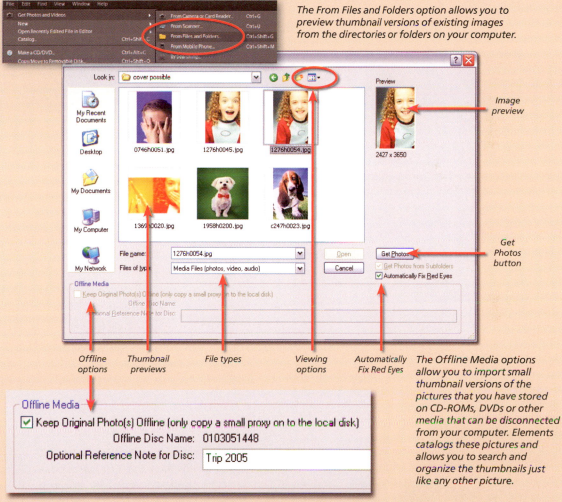

Offline options

Thumbnail previews

File types

Viewing options

Automatically Fix Red Eyes

Image preview

Get Photos button

The Offline Media options allow you to import small thumbnail versions of the pictures that you have stored on CD-ROMs, DVDs or other media that can be disconnected from your computer. Elements catalogs these pictures and allows you to search and organize the thumbnails just like any other picture.

Option 2: Loading raw files from an existing archive, disk or drive

Acting much like the File > Open option common to most programs, the Get Photos > From Files and Folders selection provides you with the familiar operating system browse window that allows you to search for and open pictures that you have already saved to your computer.

Though slightly different on Windows and Macintosh machines, you generally have the option to view your files in a variety of ways. Windows users can choose between Thumbnails, Tiles, Icons, List and Detail views using the drop-down menu from the top of the window.

When importing raw files that have been previously transferred to your computer you will only be able to view the images in thumbnail mode if the correct, or most up to date, CODEC has been installed. When this isn't the case operating system file windows will display a collection of file icons (1) rather than a thumbnail preview of the photo (2).

The thumbnail option provides a simplified file browser view of the pictures on your disk and it is this way of working that will prove to be most useful for digital photographers, but keep in mind that some versions of operating systems will not be able to preview raw files as thumbnails unless the CODEC or special raw viewing software has been installed. After selecting the image, or images, you wish to import into the Photo Browser or Organizer, select the Get Photos button.

How to multi-select the files to import

To select several images or files at once hold down the Ctrl key whilst clicking onto the pictures of your choice.

To select a complete list of files without having to pick each file in turn click on the first picture and then whilst holding down the Shift key click on the last file in the group.

Automatically Fix Red Eyes – *First introduced in Elements 4.0, this feature searches for and corrects any red eye effects in photos taken with flash. Photoshop Elements looks through the metadata of each image for the 'flash-fired' entry before locating and correcting the red eye problem.*

Speed up your Elements workflow with these APD special options

Automatically Suggest Photo Stacks – *Select this option to get the downloader utility to display groups of photos that are similar in either content or time taken.*
The user can then opt to convert these groups into image stacks or keep them as individual thumbnails in the Organizer.

Make 'Group Custom Name' a Tag – *To aid with finding your pictures once they become part of the larger collection of images in your Elements' catalog, you can 'group tag' the photos as you download them. Adding tags is the* Elements equivalent of including searchable keywords with your pictures. This task is normally handled once the photos are in the Organizer workspace but version 5.0 introduces a new automated way to add the same tag to all the photos downloaded in a single session. The tag name used is the same as the title added in the Rename section of the Photo Downloader utility.

Apply Metadata (Author and Copyright) – *With this option you can add both author name and copyright details to the metadata that is stored with the photo. Metadata, or EXIF data as it is sometimes called,* is saved as part of the file and can be displayed at any time with the File Info (Editor) or Properties (Organizer) options in Elements or with a similar feature in other imaging programs.

Delete/Verify options – *Adobe Photo Downloader also provides a range of options for the action that is taken after the pictures have transferred from camera to the computer. It is possible to Copy and Delete, Copy, Verify and Delete or just Copy the files. In most scenarios the best option to choose is Copy, Verify and Delete. This ensures that after the files are transferred they are true replicas of the originals stored on the card, before deleting these documents to free up the memory ready for the next lot of photos.*

Automatic Download – *Both the Standard and Advanced dialogs contain the option to use automatic downloading the next time a camera* or card reader is attached to the computer. The settings used for the auto download, as well as default values for features in the advanced mode of the Photo Downloader, can be adjusted in the Organizer: Edit > Preferences > Camera or Card Reader dialog.

A closer look at Adobe Photo Downloader for Photoshop Elements

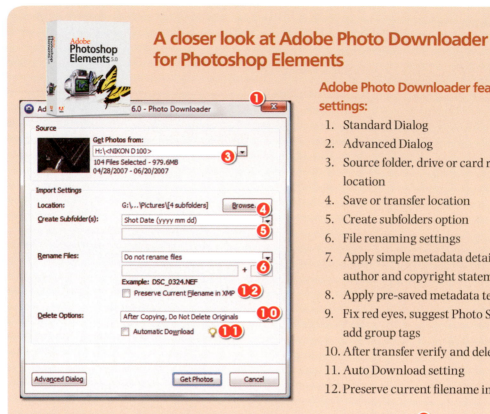

Adobe Photo Downloader features and settings:

1. Standard Dialog
2. Advanced Dialog
3. Source folder, drive or card reader location
4. Save or transfer location
5. Create subfolders option
6. File renaming settings
7. Apply simple metadata details such as author and copyright statements
8. Apply pre-saved metadata templates
9. Fix red eyes, suggest Photo Stacks and add group tags
10. After transfer verify and delete options
11. Auto Download setting
12. Preserve current filename in XMP

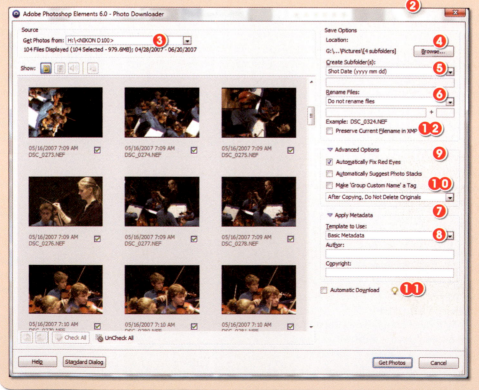

A closer look at Adobe Photo Downloader for Bridge 2.0 (Photoshop CS3)

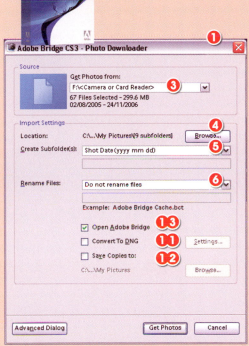

Adobe Photo Downloader features and settings:

1. Standard Dialog
2. Advanced Dialog
3. Source folder, drive or card reader location
4. Save or transfer location
5. Create subfolders option
6. File renaming settings
7. Apply simple metadata details such as author and copyright statements
8. Apply pre-saved metadata templates
9. Apply copyright statement
10. After transfer verify and delete options
11. Convert to DNG
12. Save extra copies to selected drive/folder (back up during transfer)
13. Display transferred files in Bridge

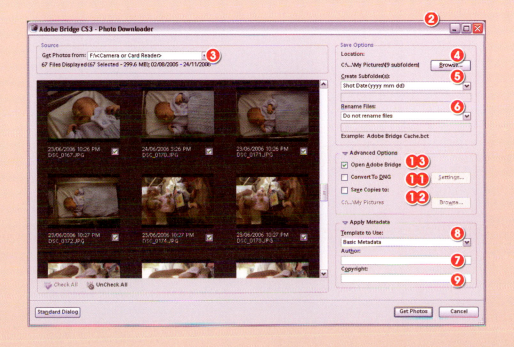

Transfers with APD and Bridge (Photoshop CS3)

The Adobe Photo Downloader is included with Photoshop CS3 and Bridge. Like the version found in Photoshop Elements APD is primarily responsible for transferring newly captured camera files from memory card or camera to computer. There are slight differences between the two versions of APD (see the previous page for a comparison), but both utilities contain a Standard or Basic dialog for simple and quick transfers and a more sophisticated version called the Advanced Dialog.

Step by step:

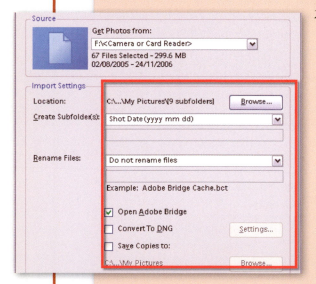

Bridge and the Adobe Photo Downloader

1. Select the Get Photos from Camera option from the File menu inside Bridge 2.0. Next you will see the new Adobe Photo Downloader dialog. The utility contains the option of either Standard or Advanced modes. The Advanced option not only provides thumbnail previews of the images stored on the camera or card, but the dialog also contains several new features for sorting and managing files as they are downloaded. But let's start simply, with the options in the Standard dialog.

2. **Standard mode:** To start you need to select the source of the pictures (the location of the card reader or camera). In the Standard mode all pictures on the card will be selected ready for downloading. Next set the Import Settings. Browse for the folder where you want the photographs to be stored and if you want to use a subfolder, select the way that this folder will be named from the Create Subfolder drop-down menu. To help with finding your pictures later it may be helpful to add a meaningful name, not the labels that are attached by the camera, to the beginning of each of the images. You can do this by selecting an option from the Rename File drop-down menu and adding any custom text needed. There are also options to open Bridge after the transfer is complete and convert to DNG or save copies of the photos on the fly (great for backing up images). Clicking the Get Photos button will transfer your pictures to your

hard drive – you can then organize the pictures in the Bridge workspace. For more choices during the download process you will need to switch to the Advanced mode.

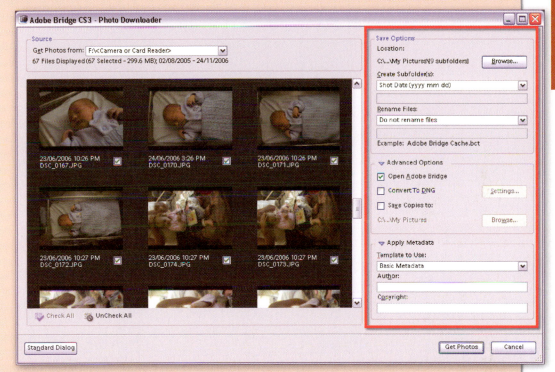

3. **Advanced mode:** Selecting the Advanced Dialog button at the bottom left of the Standard mode window will display a larger Photo Downloader dialog with more options and a preview area showing a complete set of thumbnails of the photos stored on the camera or memory card. If for some reason you do not want to download all the images, then you will need to deselect the files to remain, by unchecking the tick box at the bottom right of the thumbnail. This version of the Photo Downloader has the same location for saving transferred files, rename, convert to DNG and copy files options that are in the Standard dialog. In addition, this mode also contains the ability to add metadata to the photos during the downloading process. You can select a predefined metadata template from the drop-down menu or manually add in Author and Copyright details. Pressing the Get Photos button will start the download process.

Customizing transfers in Bridge 2.0

Open Adobe Bridge –

When using the Adobe Photo Downloader from inside Bridge you have the option of opening Bridge and displaying the transferred files in a new window.

Convert to DNG

– Adobe's Digital Negative format or DNG is an open source raw file format designed to be used as the primary file type for archiving. To help reduce the steps involved in managing the thousands of photos that are transferred each year, the Adobe team has included an automatic conversion option in APD. When selected, the picture files are converted from their native raw format (i.e. .NEF, .CRW) to the DNG automatically. From this point onwards they can still be processed as standard raw files.

Automated backup –

The 'Save Copies to' option provides the ability to automatically store a separate copy of each downloaded file as a primary backup. This saves having to manually back up photos at a later date or transfer the files twice from the camera or memory card – once to the drive used for processing and a second time to the backup device. It is important to note that even when the Convert to DNG setting is selected the file type of the photos copied is the original capture format and not the converted DNG documents.

Apply Basic Metadata – *Like the Photoshop Elements version of APD, the Apply Metadata section contains an option for inserting Author and Copyright information quickly and easily. To display these input fields you will need to select the Basic Metadata option in the Template to Use drop-down menu. Also listed on this menu are any other metadata templates you have created and saved, either in Bridge (via the Metadata panel) or in Photoshop (with the File Info dialog).*

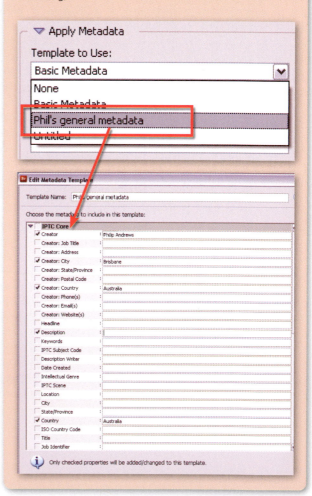

Earlier versions of Photoshop and Bridge

Photoshop CS2 users (and earlier) don't have the option of transferring their images with the Adobe Photo Downloader. Instead they will need to use an alternative method of importing the pictures from card or camera. Bridge 1.0 (which ships with Photoshop CS2) is essentially a browser program and unlike Lightroom it does not contain a built-in download or import feature. Bridge's job is to provide preview and management options for files that have already been transferred to the computer, so Photoshop CS2 users will have to employ either:

- a manual method of transferring files using the computer's operating system or
- a camera-specific download manager such as Nikon Transfer.

Once the files have been downloaded they can be managed and sorted using the features in Bridge 1.0.

Disable the Adobe Photo Downloader In Photoshop Elements

1. Select Organizer: Edit > Preferences > Camera or Card Reader.

2. Elements 6.0/5.0 users should deselect 'Auto Launch Adobe Photo Downloader on Device Connect' option. Elements 4.0 users should deselect 'Use Adobe Photo Downloader to get photos from Camera or Reader'.

Enable the Adobe Photo Downloader In Photoshop Elements

1. Select Organizer: Edit > Preferences > Camera or Card Reader.

2. Select either the 'Auto Launch Adobe Photo Downloader on Device Connect' or 'Use Adobe Photo Downloader to get photos from Camera or Reader' options.

How to:

Both the Photoshop Elements and Photoshop/ Bridge versions of Adobe Photo Downloader contain sophisticated renaming options that can be applied to photos as they are being transferred from card to computer.

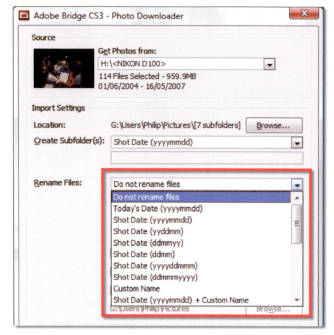

Renaming options in APD

One of the best ways to ensure that you can find your files again after downloading is to take the time to name them with a descriptive title. Thankfully tools such as Adobe Photo Downloader and the Import options in Photoshop Lightroom contain a wide range or renaming options which can be put to great effect when transferring your raw files.

As we have already seen, slightly different versions of the transfer utility are available in Photoshop and Photoshop Elements. Both versions have a Standard and an Advanced dialog (switch between using the button in the bottom left) which contain a drop-down Rename Files menu. The renaming options revolve around three key pieces of data – the current date, the shot date, a custom name and a subfolder name. Each menu entry uses a different combination or sequence of these details. The Photoshop/Bridge version of APD contains 21 different naming formats. Elements users have a smaller number of choices, 14, but these should still provide enough options for most users. Unfortunately APD doesn't include the option to create your own customized naming schema, or Template, as is available in Photoshop Lightroom's own transfer utility.

It is good to see that when dates are part of the renaming process Adobe has thought to include both US- and UK-based date formats. It is also very handy to have the option to include the original filename stored in the XMP data associated with the photo (Photoshop/Bridge only). XMP data is searchable via the Find option in Bridge's Edit menu.

Renaming Option	Action	After Renaming	PS	PSE
Do not rename files	Keeps the name allocated by the camera setup	DSC_0269.NEF	✓	✓
Today's Date (yyyymmdd)	Substitutes the computer's date	20070812_001.NEF	✓	✓
Shot Date (yyyymmdd)	Substitutes the shot date as determined by the camera	20070810_001.NEF	✓	✓
Shot Date (yyddmm)	Substitutes shot date with the year noted in two digits	070810_001.NEF	✓	✓
Shot Date (ddmmyy)	Substitutes shot date in Australian date format	100807_001.NEF	✓	✓
Shot Date (ddmm)	Substitutes shot date with only day and month recorded	1008_001.NEF	✓	✓
Shot Date (yyyyddmmm)	Substitutes shot date with four-digit year, two-digit date and a three-letter month	200710Aug_001.NEF	✓	✓
Shot Date (ddmmmyyyy)	Substitutes shot date with the same details above but using the Australian Date format	10Aug2007_001.NEF	✓	✓
Custom Name	Changes the file name to one that the user has entered	Jills_Birthday_001.NEF	✓	✓
Shot Date (yyyymmdd) + Custom Name	Uses a filename based on the shot date plus the custom name	20070810_Jills_Birthday_001.NEF	✓	✓
Shot Date (yyddmm) + Custom Name	Uses a filename based on shot date (year noted in two digits) plus custom name	070810_Jills_Birthday_001.NEF	✓	✓
Shot Date (ddmmyy) + Custom Name	Uses a filename based on the shot date (in Australian format) plus the custom name	100807_Jills_Birthday_001.NEF	✓	✓
Shot Date (ddmm) + Custom Name	Uses a filename based on the shot date (day and month only) plus the custom name	1008_Jills_Birthday_001.NEF	✓	✓
Shot Date (yyyyddmmm) + Custom Name	Uses a filename based on the shot date (month in letter form) plus the custom name	200710Aug_Jills_Birthday_001.NEF	✓	
Shot Date (ddmmmyyyy) + Custom Name	Uses a filename based on the shot date (Australian format) plus the custom name	10Aug2007_Jills_Birthday_001.NEF	✓	
Custom Name + Shot Date (yyyymmdd)	Substitutes a combination filename of the custom name followed by the shot date	Jills_Birthday_20070810_001.NEF	✓	
Custom Name + Shot Date (yyddmm)	Uses the custom name and the shot date (the year is noted in two digits)	Jills_Birthday_071008_001.NEF	✓	
Custom Name + Shot Date (ddmmyy)	Uses the custom name and the shot date (the date is in the Australian format)	Jills_Birthday_081007_001.NEF	✓	
Custom Name + Shot Date (ddmm)	Uses the custom name and the shot date (day and month only)	Jills_Birthday_0810_001.NEF	✓	
Custom Name + Shot Date (yyyyddmmm)	Uses the custom name and the shot date (full year, day and three-letter month format)	Jills_Birthday_200708Aug_001.NEF	✓	
Custom Name + Shot Date (ddmmmyyyy)	Uses the custom name and the shot date (Australian form with three-letter month)	Jills_Birthday_08Aug2007_001.NEF	✓	
Same as Subfolder Name	Uses the same name used for the subfolder (this can also be customized)	Jills_Birthday_Photos_001.NEF	✓	✓
Preserve current Filename in XMP	The original file name is copied to the XMP data associated with the file during the name change.	–	✓	

Renaming conditions for the example above –

Original filename: DSC_0269.NEF.
User applied custom name: Jills_Birthday.
User applied subfolder name: Jills_Birthday_Photos

Number sequencing (001, 002, 003 etc.): Automatically applied by the download utility
PS: Photoshop CS3/Bridge 2.0
PSE: Photoshop Elements 6.0/5.0

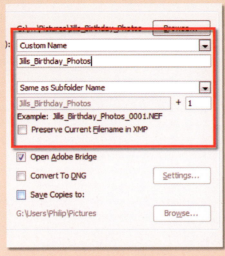

Using a Subfolder name

1. To create some consistency across your naming scheme some photographers will use the same title for both the download folder and the images contained within it. To do this start by selecting the Custom Name option in the Create Subfolder drop-down menu.

2. Next input the title you wish to use in the text box directly below the Custom Name entry. This action sets the name of the folder that will be created on your hard drive and used to store the transferred photos.

3. Now select the Same as Subfolder Name entry from the options in the Rename Files drop-down menu. APD will automatically insert the Subfolder custom name in the Rename Files text box. You still have the option to choose a different starting value for the sequential number by inputting this number in the box to the right of the text.

4. Finally, double check that the naming scheme provides the results that you expect by looking at the Example entry at the bottom of the Rename Files area. This text should display the subfolder custom name, the sequential number and the file extension.

Using a Custom name

1. To substitute a custom name for the one allocated by the camera choose the Custom Name option from the Rename Files drop-down menu.

2. Next input the title you wish to use in the text box directly below the Custom Name entry. At this point you can also add a starting number for the numbering sequence that will be used if more than one image is to be renamed. Here the value is set to 1.

3. Double check that the naming scheme provides the results that you expect by looking at the Example entry at the bottom of the Rename Files area. This text should display the custom name, the sequential number and the file extension.

Embedding the original filename in the XMP data (Photoshop/Bridge)

1. In some circumstances it may be necessary to retain the original filename but not use it as the photo's title. For these times select the Preserve Current File Name in XMP option at the bottom of the Rename Files section of the dialog.

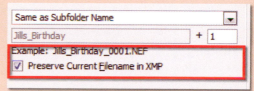

2. With this option selected the original filename is stored in the metadata of the picture file. To view the original name start by choosing Edit > Preferences. In the Metadata section of the Preferences dialog locate and select the File Properties group of data. Next, make sure that the Preserved Filename property is also selected. Click OK to apply the changes.

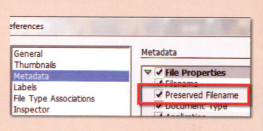

3. Now display the Metadata panel inside Bridge by selecting Window > Metadata panel. Scroll through the metadata headings until you locate File Properties. Directly under the Filename entry should be the Preserved or original filename.

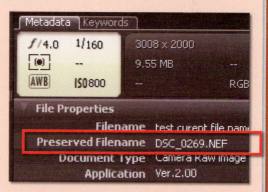

4. To locate images based on their original filename (now embedded in the XMP data for the photo) navigate to the images folder that contains the file. Next choose Edit > Find to display the Find dialog. Browse for the correct folder for searching if it is not already listed in the 'Look in' text box. Choose the All Metadata entry from the leftmost drop-down menu in the Criteria section of the dialog. Leave the Contains entry in the middle box and then type in the filename to search for in the last box.

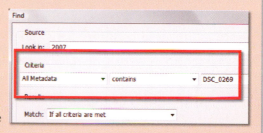

5. Next choose the Match criteria, whether to include all the subfolders and nominate if you want to search through non-indexed files. The last step requires you to click either the Find button, to display the results in a new Bridge Content window, or choose the Save As Collection option which produces the results as a defined search or Collection.

Step by step:

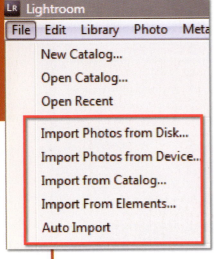

Photoshop Lightroom contains many of the download features we have already looked at with APD but in a slightly different format. Lightroom contains a range of options in the File menu that can be used to start the Import process.

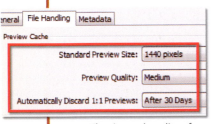

The size and quality of the standard previews in Lightroom can be adjusted using the settings in the File Handling section of the File > Catalog Settings.

Adobe Photoshop Lightroom

Being a complete raw workflow product you would expect that Lightroom would cater for the card/camera to computer part of the process and you would be right. In fact, of all the import or download options we have looked at here Lightroom provides some of the most sophisticated features and functions that are well suited for the job.

One key area that the both Adobe engineers and countless public beta testers have worked on is the Lightroom Library module. Designed to make managing your many raw files a breeze, this module also contains no less than five different import features. Getting this part of the workflow so that it suits the working photographer was a key concern for the development team and many of the ideas first seen here have found their way into other transfer utilities.

Rather than simply providing a means to transfer files from camera/memory card to hard drive, the File > Import entries contain options for renaming and adding customized metadata as well.

Several different options are available when it comes to downloading files into Lightroom. You can opt for the traditional route of transferring the photos from the memory card or camera to a Lightroom library, source images from existing folders on your computer, import pictures from a Lightroom Catalog that you made earlier, convert a Photoshop Elements Catalog to the Lightroom format, or set up Auto Import options which transfer files in a designated way to a specific area when a card is inserted or camera connected.

In some ways the import process in Photoshop Lightroom is similar to that involved with Photoshop Elements. As well as transferring the files from card/camera to computer, the images are also registered as part of a database that each program uses for management purposes. With Elements the database underpins all the activities in the Organizer workspace, whereas in Lightroom the database is the foundation of the functions in the Library module of the program.

During the transfer and database creation process, Lightroom imports all the metadata associated with the image and also creates three different levels of preview thumbnail. The first is low resolution and is usually drawn from the camera preview. Next is an intermediate preview, the size and quality of which is determined by the settings selected in the Preview Cache section of the File Handling part of the File > Catalog Settings. Lastly a full 1:1 preview can be generated on demand when needed.

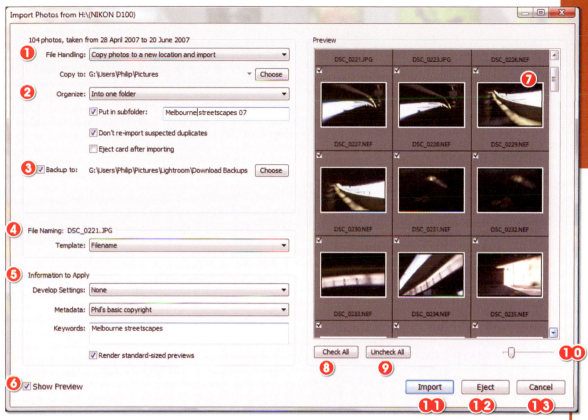

The Lightroom transfer options center around the Import dialog which contains the following features and controls:
1. File handling and location
2. Transfer organization
3. Backup options
4. File naming options
5. Metadata application
6. Display previews
7. Photo previews
8. Check All images
9. Uncheck All images
10. Preview size
11. Import selected thumbnails
12. Eject camera or camera card
13. Cancel

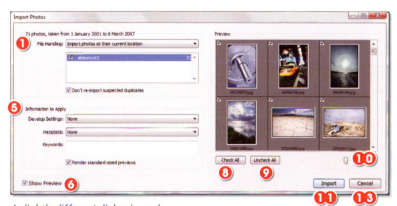

A slightly different dialog is used for importing files that have already been transferred to your computer. The dialog provides a subset of the features found in the more sophisticated window that is associated with photo downloading.

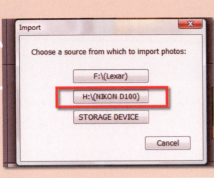

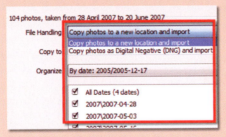

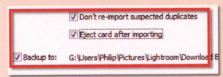

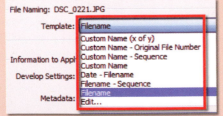

Lightroom – Import Photos from Device

1. After selecting the File > Import Photos from Device option, Lightroom displays an Import dialog listing the various device sources currently available on you computer. This part of the process may be bypassed if you select the Lightroom option from the AutoPlay dialog which is displayed when first inserting a card into a reader or attaching a camera.

2. Once the source has been selected Lightroom displays the Import Photos dialog. To display thumbnails of the images contained on the card make sure that the Show Preview option is selected. Next, using the scroll bar on the right of the previews review the images, deselecting those that you don't want to import.

3. Now working from the top left of the window start to adjust the settings that will be used for the download. Start by choosing between straight copy to a new location or copy and convert to DNG during the Import. Also choose the folder where the images will be copied to and the way that the imported files will be organized (by shot dates or grouped in one folder).

4. In the next group of settings choose what action to take if you are trying to inadvertently import images that already exist in the Catalog, whether to eject the memory card after the transfer is complete and where to back up duplicate copies of the transferred files.

5. As we have already seen in the discussion surrounding naming options in APD, selecting a suitable naming strategy in the transfer process can really help when managing photo files at a later date. The File Naming section of the Import dialog provides many of the naming options available in APD with the added inclusion of a

custom edit feature. Selecting Edit from the drop-down menu options opens the Filename Template Editor window, where you can mix and match naming 'tokens' to create your own naming schema. The results can then be saved as a new name preset and selected from the Filename menu.

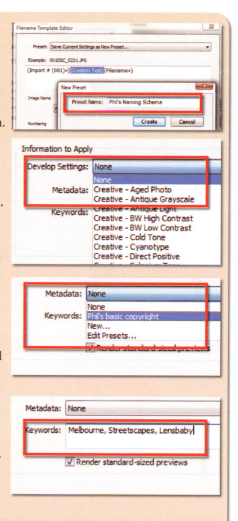

6. The next part of the dialog contains options that can be applied to the images as they are being transferred. The Develop Settings are a list of raw processing presets (some supplied with Lightroom, others saved by the user in the Develop module) that can be applied to the photos on the fly. Use this option if you have a saved preset that suits the group of photos that are being imported.

7. Metadata too can be applied to the downloading pictures. Like the Develop Settings, pre-saved metadata, created with the New and Edit Presets options, can be automatically added to transferred images.

8. Finally the Keywords section provides the opportunity to apply specific keywords associated with a particular shoot or group of photos. Use commas to separate individual keyword headings. Hierachies of keywords can also be added using the '>' as separator such as Places > America. Strategies for keyword selection are detailed in Chapter 13 of the book.

Lightroom – Import Photos from Catalog

1. The File > Import Photos from Catalog option allows for the importation of existing Lightroom catalogs into the program. After selecting the option the standard Import Photos window is displayed. If any of the photos attempted to be downloaded are already in the current catalog then the dialog displays a menu of possible actions to take, including replace settings, metadata and the raw files or do nothing.

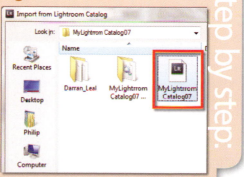

Step by step:

When duplicate photos exist in a Lightroom Catalog that you are importing, the program displays a range of Existing Photos options to help deal with the situation. You can choose to do nothing, replace the existing photos and their Develop and Metadata settings with the downloaded photos or just append the Metadata and Develop settings.

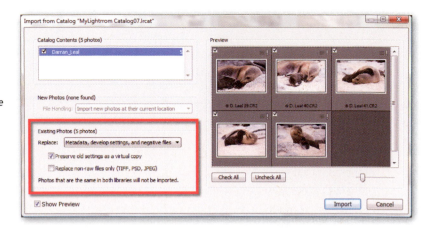

Step by step:

Lightroom – Import Photos from Elements

1. Like Lightroom, Photoshop Elements creates a catalog of its photos when they are imported into the program. When migrating from Elements Lightroom users can import the Elements catalog directly. After selecting the File > Import Photos from Elements option, Lightroom displays a warning that the process can be lengthy.

2. After clicking OK to the warning the Choose a Catalog dialog prompts you for a catalog to import. Either select from those listed or search via the Custom Location option.

3. Before starting the import Lightroom checks the Elements Catalog. The user is notified if errors are located in the catalog file or if offline images (those referenced in the Elements catalog but stored on removable media) are found. Click OK to continue.

4. With the preliminaries out of the way Lightroom then displays the standard Import Photos dialog, allowing the user to determine the settings used for the catalog conversion.

5. After clicking Import, Lightroom starts the conversion process. This certainly can take some time depending on the size of the Elements catalog and the processing speed of the computer.

Lightroom – Import Photos from Disk

1. If your preferred workflow makes use of another download utility then select the File > Import Photos from Disk option to include the images in your Lightroom catalog.

2. Choose the folder of images that you want to import from the file dialog that is displayed. Remember that you will only see previews of your raw files in these OS windows if you have correctly installed the CODEC for the file. After selection click the Choose Selected option to import.

3. Lightroom then displays the Import Photos dialog, where you can adjust the settings to be used to include the pictures in the catalog.

Lightroom – Auto Import

1. The last way to get you photos into Lightroom is the File > Auto Import option. The feature works by automatically importing files that are saved to a specific directory called the 'watched folder'. Using this option is a two-step process. Firstly, the import options must be set up by selecting File > Auto Import > Import Settings and then adjusting the options in the dialog box. Here you can choose the folder to be watched, the destination of the import, file naming strategies, auto applied development settings, and metadata and keywords that are attached to the files as they are transferred.

2. Next the feature is activated by selecting File > Auto Import > Enable Auto Import menu entry. Now any files saved to the watched folder will automatically be imported into Lightroom.

3. To deactivate the feature select File > Auto Import > Enable Auto Import for a second time.

Step by step:

Step by step:

Shooting tethered – capture and download in one step

For those photographers who are shooting with their camera attached to the computer, or tethered as it is usually known, the download process takes a different form. Rather than being a completely separate activity that occurs after capture, most tethered systems bypass the camera's memory card and save the photos directly to the computer's hard drive. This means that there is generally a small time lag between the moment when the photo is captured and when it first appears on screen. Systems such as Nikon Capture use three separate windows/utilities for:

1. adjusting camera settings and tripping the shutter,

2. tracking the download or transfer progress from camera to hard drive, and

3. previewing the resultant photo on screen.

Because the capture and download occurs in one action it is important to nominate the folder used for transferring newly photographed images before the shooting session commences. Depending on the software used for tethered shooting it may also be possible to add in date, time, copyright and even customized shoot information as part of the download process.

Nikon's Capture software provides remote capture capabilities together with built-in download and full image preview functions.

5

Camera-based Converters

All camera companies that manufacture models with raw capture capabilities also supply picture management and raw processing software. In most cases, the applications include a dedicated image browser, a workspace where photos can be enhanced and edited, some raw conversion utilities, management and sorting options, and a means for outputting to print and screen or passing the converted file to an editing program like Photoshop.

The sophistication, features list and abilities of these programs vary from company to company and camera model to model. In addition there are often several different levels of conversion and management functions depending on if you are using the free package that came with the camera or the upgraded pro version that is purchased and shipped separately. In the Nikon system, for instance, basic browsing, management, conversion and output options are all available with the software that accompanies the camera drivers on the freely supplied install disk. However, professionals can opt to purchase an upgrade to this software which provides more functionality for the end user. The upgrade provides more options for raw processing plus the ability to control the camera remotely for tethered shooting scenarios.

In this chapter we will look at how these camera-based converters work and how they compare with other raw workflow solution options.

Camera-based converters software

Camera make	Software
Nikon	Nikon Capture NX Capture Editor Capture Camera Control
Canon	Digital Photo Professional
Sigma	Photo Pro
Leica	SilverFast DC
Samsung	Photofun Studio
Kodak	EasyShare

Camera make	Software
Olympus	Olympus Studio
Pentax	Photo Laboratory
Sony	Image Data Converter
Fuji	Hyper-Utility
Samsung	Digimax Master

Advantages and disadvantages of a camera-based system

As a digital photography author one of the questions we are asked constantly is 'Which is better, converting and editing my raw files with software created by my camera manufacturer, or with utilities produced by the maker of my editing software?' This is not an easy question to answer as there are advantages and disadvantages with each approach.

Camera-based converters are arguably better able to handle the conversion of raw files than their generic counterparts. After all, the guys that are deciding how the image details will be encoded in the raw file are the same guys who are producing the raw conversion software for the camera. If anyone should understand how to get the best from the camera files it should be these folks. 'So I should go with my camera-based software?' 'Well, maybe?'

Keep in mind that the accumulated image processing knowledge that a company like Adobe has developed over the last decade or so provides a substantial foundation for the creation of their own conversion programs. Add to this the fact that a product like Adobe Camera Raw fits so snugly in the Bridge/Photoshop workflow that using any other utility seems like too much hard work to be seriously contemplated and you start to see how compelling the argument is for adopting an all-Adobe workflow.

Which is better – the raw conversion software that came with your camera or the one that is included in your favorite editing program?

Does it sound like I am hedging my bets? Well, yes I am! At the moment there is no definitive answer to this question. The best advice is to try each approach and see which is the best fit for you and the way you work. When testing don't forget to compare the quality of the converted files, the ease of working, and the size and range of the feature and tool set.

Most software producers supply free trials of their products. So don't be backward, download several candidate programs and spend some time comparing the way they work.

Different levels of support – the Nikon system

The Nikon system for handling raw provides a good example of how a camera-based conversion system can function in conjunction with your normal image editing workflow.

Basic features

A basic level of raw support is installed onto your system when you first load the utilities that come with your camera. During this process, not only are camera drivers installed on your computer but Nikon also loads a browsing application called Nikon View. The program is used to view the photos that are downloaded onto your computer. The interface contains thumbnail previews of the pictures, including those captured in the Nikon raw format (.NEF), a display area where shooting data is

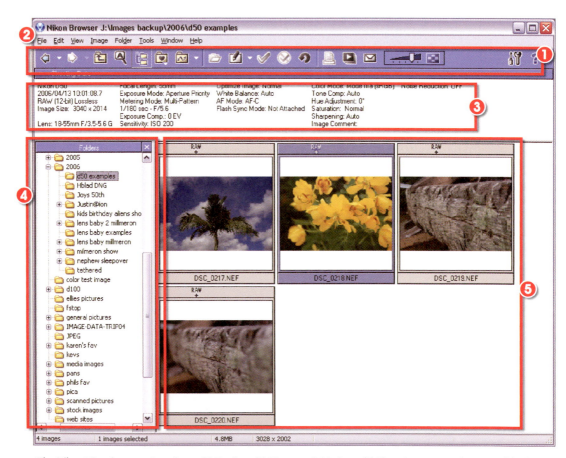

The Nikon View browser interface – (1) Toolbar. (2) Menu and title bars. (3) Shooting or metadata area. (4) File/ folder navigation area. (5) Thumbnail previews.

listed along with a modest range of tools in a simple toolbar. The features grouped here are designed for tagging (rating), searching, printing, emailing and creating slideshows. No editing tools are available in the browser application or even the enlarged preview window which is displayed when a thumbnail is double-clicked. Instead these options are made via linked helper programs. Nikon's own Capture Editor is listed by default as is the standard Editor and the Large Preview Generator for the NEF utility. Other programs can be added to the list and it is here that photographers who want to browse in Nikon View but convert with Adobe Camera Raw add a Photoshop option. Images to be edited in Photoshop are simply highlighted in the browser workspace and then the Photoshop option is selected from the pop-up menu accessed via the Edit button.

Note: Though listed, the Capture Editor is only available as a trial with the basic install and needs to be purchased separately if it is to be used past the trial period. As this program provides the most comprehensive raw conversion options serious raw shooters will need to pay the extra cash or alternatively shift the bulk of their processing requirements to another conversion program.

The NEF Photoshop plug-in

The basic install assumes that photographers will be using a package such as Photoshop for most of their pixel-by-pixel editing changes so as well as loading the browser a small NEF plug-in is also placed in the plug-ins folder of Photoshop. It is designed to provide basic (white balance and exposure only) conversion settings when an NEF file is opened from inside Photoshop. Interestingly, when this plug-in is installed Adobe's own raw utility ACR ceases to function.

Pro's tip: After installing the drivers for a new camera you may find that you no longer have access to ACR and that instead the Nikon plug-in keeps appearing when you are attempting to open raw files. If this occurs and you want to restore ACR as the default raw utility then you will need to remove the NEF plug-in from the plug-ins\Adobe Photoshop Only\File Formats folder in Photoshop.

The Edit button in the Browser and Preview windows of Nikon View provides a quick way to transfer the selected photo to your favorite editing application.

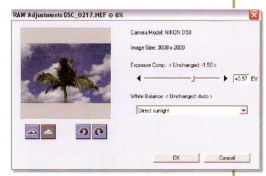

The NEF plug-in is designed as a simple way to convert raw files when opening them into Photoshop. It provides exposure and white balance controls.

The NEF is installed into the Plug-ins folder to help provide Nikon file support but sometimes this action stops ACR from working.

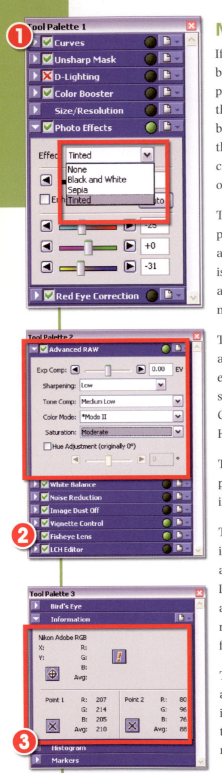

The Nikon Capture Editor palettes.

More sophisticated control

If you want a little more control over your raw conversions than white balance and exposure controls provided by the NEF plug-in then Nikon also produces a dedicated software program called Nikon Capture Editor. Unlike the simple Editor that comes free with Nikon View, Capture Editor is a full-blown raw converter. The package is one part of a two-program upgrade that can be purchased separately from Nikon dealers. The second software component is the Nikon Capture Control which provides remote camera operation for studio use.

The adjustment options in Capture Editor are grouped in three separate tool palettes. Palette one (1) contains a Curves control, the Unsharp Mask filter, a Red Eye Correction tool and a Size/Resolution control. Also in this palette is the D-Lighting feature that opens shadow detail and boosts picture color, and Photo Effects control with options for creating black and white and toned monochromes.

The second palette (2) houses more advanced adjustments, some of which are only available for raw file processing. Here you can alter white balance, exposure, tone compensation (contrast), change color modes and adjust the saturation of the photo. In addition, a Noise Reduction option and Vignette Control are both included alongside a specialist LCH (Lightness, Chroma, Hue) curves control.

The Image Dust Off and Fisheye Lens features are great examples of what is possible when the hardware manufacturer is involved in creating their own image processing software.

The Image Dust Off option lets you eradicate the dust marks that can appear in photos as a result of having a dirty camera sensor. The feature is used via a two-step process. To start, you create a reference photo by switching to the Dust Off Ref Photo selection of the camera's setup menu and then shooting a flat white featureless subject from a distance of 10 cm. This file is then referenced in the Image Dust Off palette where the program uses the reference file to locate and eliminate the dust in the photo.

The Fisheye Lens control automatically dewarps the bulging images that are captured with extreme wide-angle lenses. The feature uses the lens information contained in the metadata of a picture file to correctly identify the lens used at the time of capture. The pixels in the photo are then remapped to a rectilinear format.

You can choose from a range of editing options from inside the Nikon View browser. Simply right-click the photo to be edited, select the 'Edit using other programs' option and then choose the application from the list provided. To add another editing program to the list select the 'Add/Remove editing program' option and locate the program to be added to the list.

This level of lens correction is only possible if the characteristics of the lens are fully known. It's true that other editing programs, such as Photoshop, have sophisticated lens correction features but generally these apply generic adjustments rather than ones designed specifically for the lens in question.

The third palette (3) contains a Navigator-like control Nikon calls Bird's Eye as well as a histogram display, the Nikon equivalent of the History

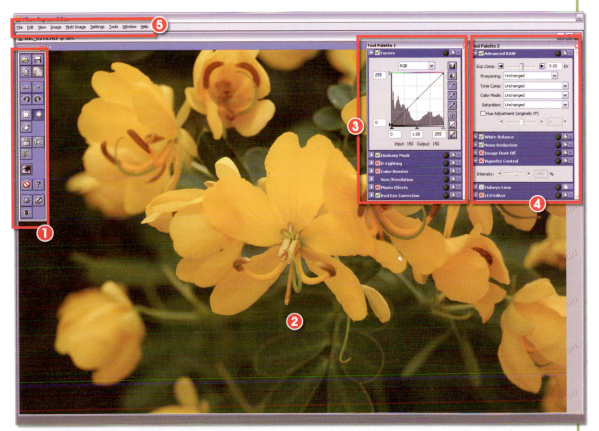

The Nikon Capture Editor interface – (1) Toolbar. (2) Preview area. (3) Tool Palette 1. (4) Tool Palette 2 – Advanced Raw options. (5) Program menu bar.

palette called Markers and an Information palette. The last feature is designed to allow the user to sample the RGB values of various pixels in the image and track these values during tonal and color changes.

A hybrid approach

Because of the camera- and lens-specific corrections such as 'dust off' and 'fisheye lens fix' many photographers prefer to stick with the raw software offerings provided by their camera manufacturer. Though it is not possible to apply and save these corrections to the raw file and then complete the conversion in another program such as Adobe Camera Raw, the corrected file can be passed directly to Photoshop. This hybrid approach to editing means that all raw correction and conversion settings are applied in the camera-based software, after which the file is sent to Photoshop, where the pixel-based editing is completed.

The Fisheye Lens control provides lens-specific dewarping adjustments to images photographed with ultra-wide-angle lenses.

The feature interrogates the metadata of the file to retrieve details about the lens type and settings.

It is in this circumstance that using a piece of software designed by your camera/lens manufacturer really comes into its own.

The software understands how the lens records the very wide scene and via the Fisheye Lens feature it is possible to remap the bulging photo back to a more normal perspective.

1. Non-corrected photo taken with a 10.5 mm Nikon fisheye lens.

2. The same image after remapping with the Fisheye Lens feature in Capture Editor.

3. After remapping with the Include areas where there is no image data option selected.

4. The Fisheye Lens correction palette.

6

Processing with Photoshop Elements

After downloading raw files, or importing raw files into a designated folder, the next step if you are using a 'Convert and then Edit' workflow is to process the files using a raw converter. In this phase of the workflow you examine each raw image in turn, or a group of similarly executed files, making note of any problems with shadows, highlights, exposure, white balance and more. This is the time to make global adjustments (adjustments to the whole of the image) to bring your images within their acceptable dynamic range and to fine-tune them to your personal taste. It is also the time to save files to DNG format and archive them in a safe storage location.

In this section I will walk you through the process of conversion with what is arguably the most widely used raw software in the world – Adobe Camera Raw (ACR). Coming in two slightly different flavors, one shipped with Photoshop Elements and the other with Photoshop and Bridge, ACR provides a logical approach to enhancing your raw files during the conversion process. This chapter concentrates on the steps involved for Photoshop Elements users, with Chapter 7 delving into the intricacies of the utility when used with Photoshop and Bridge.

The Photoshop Elements Organizer, seen here in the PhotoBrowser mode, is an excellent file browser and manager and is generally the pivot point of these image activities for Elements users.

The Organizer workspace (PhotoBrowser) – the starting point

The Photoshop Elements Organizer workspace or PhotoBrowser, as it is sometimes known, is a great file browser and picture manager. Once files are imported into the browser the feature will become a pivot point for all your photo management activities. The PhotoBrowser is an excellent starting point as it provides functions to open, import, tag, search for, catalog and retrieve raw files from a long list of supported cameras. Even though it is possible to open raw files directly into

the Editor workspace of Photoshop Elements, to use the program to its fullest you should always import your photos into the Organizer (PhotoBrowser) workspace first. If you are using the Adobe Photo Downloader for transferring files from your card, or camera, then the utility automatically displays the imported photos in the Organizer space immediately after downloading.

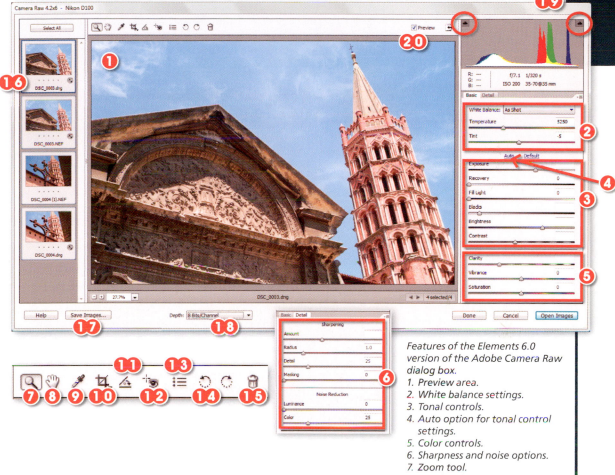

Features of the Elements 6.0 version of the Adobe Camera Raw dialog box.
1. Preview area.
2. White balance settings.
3. Tonal controls.
4. Auto option for tonal control settings.
5. Color controls.
6. Sharpness and noise options.
7. Zoom tool.
8. Hand tool.
9. White balance tool.
10. Crop tool.
11. Straighten tool.
12. Red eye removal tool.
13. ACR preferences.
14. Rotate buttons.
15. Mark for deletion button.
16. Queued raw files.
17. Save button.
18. Bit depth options.
19. Shadow and highlights clipping warnings.
20. Preview checkbox.

Anatomy of the Camera Raw dialog

Before commencing to process our first raw file, let's take a close look at the Adobe Camera Raw feature as it appears in Photoshop Elements 6.0. The ACR dialog, the user interface between you and what goes on inside the Camera Raw plug-in, provides tools to adjust, process, convert and save raw files. After opening a raw photo from inside either the Organizer or Editor workspaces, this dialog will be displayed.

The ACR dialog can be broken into four separate areas:
1. Preview
2. Image adjustment controls
3. Raw file queue
4. Toolbar

The feature's window is broken into four distinct areas:

1. A preview of the file is displayed in the center of the dialog. Any editing or development changes made to the file will be reflected automatically in this preview.

2. A queuing area for raw files awaiting processing. This area of the dialog is only present when multiple raw files are selected for opening.

3. Controls or settings area. This part of the dialog contains all the processing and development controls for altering the look of the color, tone, sharpening and noise in the photo. The settings are grouped under two tabs – Basic and Detail. A histogram graph is also displayed here. The Photoshop version of ACR contains a larger range of controls listed under more tabbed headings.

4. The toolbar sits at the top of the dialog and houses options such as the Zoom, Hand, Crop and Straighten tools.

The Help and Save buttons are located at the bottom left of the window. In the center is the bit depth menu and on the right, are the Done, Cancel and Open Images buttons.

The precise grouping of tools and adjustment controls varies between Photoshop and Photoshop Elements versions of ACR and between different releases of the utility. To ensure that you have the best selection of tools to use on your raw files, make sure that your ACR plug-in is always up to date.

By way of introduction let's look at each of these areas in turn.

DSC_0003.dng ◄ ► 4 selected/4

The preview image in ACR's dialog is capable of being magnified to a range of levels. The current magnification value is shown in the bottom left corner of the window.

The preview space

The preview displays the changes you make to your image via the develop settings. Any adjustment of controls are reflected immediately in the preview image, providing a visual reference to the effect of the alterations. The preview can be enlarged or reduced in size to suit the screen area available. When making some changes, such as Sharpening or Noise Reduction, the preview should be magnified to at least 100%. At this zoom setting, you will be able to preview the results of the adjustments of these controls.

The zoom menu at the bottom left of the dialog provides a variety of zoom levels for quick access.

There are three ways for you to change the magnification level of the preview to 100%:

1. Double-click the Zoom tool,

2. Select the 100% entry from the zoom menu at the bottom left of the dialog, or

3. Use the Ctrl+ to magnify or Ctrl - to reduce the size of the preview to the zoom value in the window at the bottom left of the dialog.

Image adjustment controls

The right-hand side of the ACR dialog is reserved for the core adjustment features.

Histogram

A full color histogram is located under the RGB values. The feature graphs the distribution of the pixels within your photo. The graph updates after changes are made to the color, contrast and brightness of the picture. By paying close attention to the shape of the graph you can pre-empt many image problems. The aim with most enhancement activities is to obtain a good spread of pixels from shadow through midtones to highlights without clipping (converting delicate details to pure black or white) either end of the tonal range.

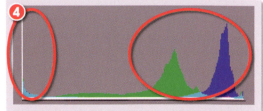

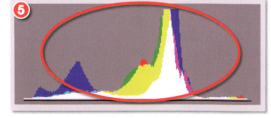

The histogram in ACR shows the distribution of pixels across the image. Areas with the most pixels are the tallest areas of the graph. The shape of the histogram indicates the look of the picture.

1. *An overexposed image has a histogram with the pixels bunched to the right end of the graph.*

2. *Conversely, underexposed photos have pixels pushed to the left.*

3. *Flat or low-contrast pictures typically have all their pixels grouped in the middle.*

4. *High-contrast photos or those that have 'clipped' highlights and shadow areas usually have many pixels at the extreme ends of the graph.*

5. *For the best results, with most images, you should always aim to spread the pixels between the maximum black and white points without clipping any of the image pixels.*

This is not the case for all photos though. Take, for instance, the case of a black cat in a darkened room, the correct histogram for this photo will show a bunching of the pixels towards the left side of central, where as a shot of the sky slopes, also correctly exposed, will display most pixels to the right of the histogram graph.

The Basic tab

Below the histogram is a tab area containing two options – Basic and Detail. The Basic tab contains all the tone and color controls. On the other hand, the Sharpening and Noise Reduction features are grouped under the Detail tab. Here we will concentrate on the controls under the Basic tab.

Image Settings menu

The Settings drop-down menu is displayed by clicking the Settings button on the right side of the Tabs. The menu contains the Image Settings, Camera Raw Defaults, Previous Conversion, Custom, Clear Imported Settings, Save New Camera Raw Defaults, and Reset Camera Raw Defaults entries. Here are some more details on each entry:

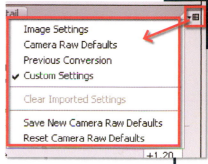

The Settings menu contains options for saving or recalling image settings associated with specific cameras.

Image Settings: The Image Settings option restores the original settings of the current photo. Use this selection when you want to reverse changes that you have made and wish to restore the photo to its virgin state.

Camera Raw Defaults: This option applies a group of slider settings that are default values associated with a specific camera and photograph. When a photo is opened for the first time, the settings and white balance will be altered to Camera Raw Defaults (based on the camera model) and As Shot (based on the camera settings used for the photograph), respectively.

Previous Conversion: Another option in the Settings drop-down menu is Previous Conversion. This setting stores the 'last used' values for all controls and is an efficient way to apply the enhancements used with the previous image to one currently open in the dialog. Using this option will help speed up the conversions of a series of photos taken at the same time under the same lighting conditions. Simply make the adjustments for the first image and then use the Previous Conversion option to apply the same settings to each of the successive photos from the series in turn.

Custom: Moving any of the slider controls such as Temperature or Tint sliders under the White Balance menu automatically changes the settings entry to Custom. Once the settings have been customized for a particular photograph the values can be saved as a new Camera Raw Default entry using the save option in the pop-up menu accessed via the sideways arrow next to the Settings menu.

Pro's tip: As ACR recognizes the raw file created with different cameras the new Camera Raw Default will be applied to only those photos captured with the specific camera that the settings have been saved for.

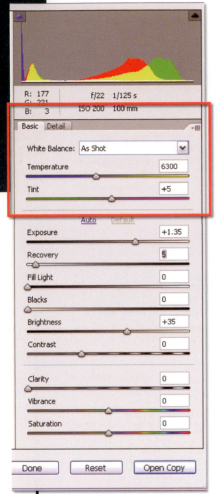

When an original file is opened for the first time in the dialog, the settings and white balance values will be set to Camera Raw Defaults (based on camera model and make) and As Shot (determined by the camera settings at the time of capture), respectively.

White balance correction

White balance is used to correctly balance the color of the scene to the lighting conditions at the time the shot was taken. Leaving white balance set at As Shot means you elect to keep the white balance values that were used when taking the picture.

As you know, one of the advantages shooting raw is that this setting is not a fixed part of the picture file. Altering the specific white balance setting at the time of raw conversion is a 'lossless' action. This is not the case if you have used an incorrect setting and have shot in JPEG or TIFF. Use either of these two formats and the white balance setting will be fixed in the file and can only be changed with destructive adjustments using features like Color Variations or Remove Color Cast. In this regard raw shooters have much more flexibility.

Drop-down menu: For instance, if you selected a Daylight setting in-camera and think that Shade or another white balance preset may be closer to the actual lighting conditions you may select one of the options from the list of presets under the White Balance drop-down menu. Moving either the Temperature or Tint sliders switches the setting to Custom. These controls are used for matching the image color temperature with that of the scene.

Temperature: The Temperature slider is a fine-tuning device that allows you to select a precise color temperature in units of degrees kelvin. When an image is too yellow, meaning it has a lower color temperature than you prefer, move the Temperature slider to the left to make the colors bluer and compensate for the lower color temperature. When an image is too blue, or higher in temperature than you prefer, move the slider to the right to make the image warmer, adding more yellow compensation. So, left is to make image colors cooler and right is to make image colors warmer.

Tint: The Tint slider fine-tunes the white balance to compensate for a green or magenta tint. Moving the Tint slider to the left adds green and to the right adds magenta. This control is often used to neutralize a color cast caused by lighting from fluorescent tube or strip sources.

White Balance tool: The quickest and perhaps easiest way to adjust white balance is to select the White Balance tool and then click in an area that should be neutral gray or even amounts of red, green and blue. For best results, use a dark to midtone as the reference and be careful not to click on an area with pure white or specular highlights. These will

produce unreliable results so keep away from the bright highlight areas of highly reflective or chrome surfaces. One suggestion for working with neutral gray is to:

1. Click on the White Balance tool.

2. Move the White Balance tool cursor over a midtone area which should be neutral gray but contains a color cast in the preview.

3. Click on the image location to neutralize the cast not just in the selected area but in the whole photo.

WB tool workflow

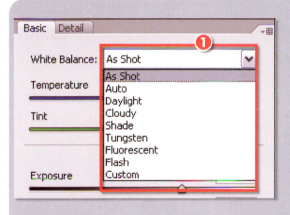

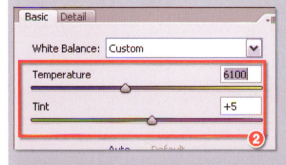

WB summary:

The white balance in your raw photo can be adjusted in one of three ways:

1. Selecting the light source-specific entry that best matches the lighting in the scene from the drop-down list.

2. Manually adjusting the Temperature and Tint slider values until the preview appears neutral and free from color casts.

3. Selecting the White Balance tool and then clicking on a picture part that should be neutral.

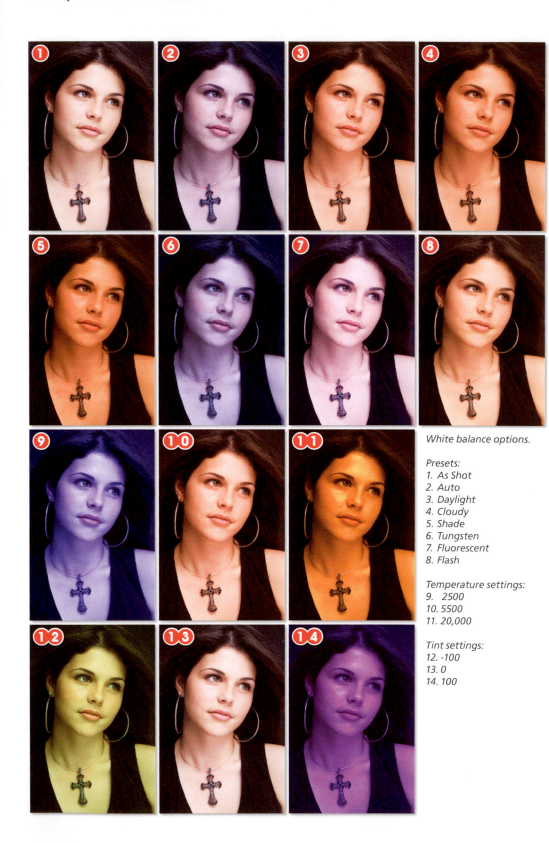

White balance options.

Presets:
1. As Shot
2. Auto
3. Daylight
4. Cloudy
5. Shade
6. Tungsten
7. Fluorescent
8. Flash

Temperature settings:
9. 2500
10. 5500
11. 20,000

Tint settings:
12. -100
13. 0
14. 100

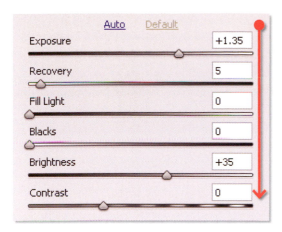

Adobe has positioned the slider controls that adjust the tones within the image in the order (top to bottom) that they should be applied within the ACR dialog. The Exposure and Blacks sliders should be used first to set the white and black points in the photo. Use the Alt/ Option keys in conjunction with these sliders to preview the pixels being clipped and to accurately peg the white/black points. Or alternatively switch on the Shadows/Highlights Clipping Warnings which perform the same function whilst leaving the full color preview visible.

Next lighten or darken the photo using the Brightness slider. Unlike the Exposure control this slider doesn't affect the white and black points of the image but rather adjusts the appearance of the photo by compressing or extending the altered tones.

Recovery and Fill Light sliders are new for this release of Elements' ACR. Use the Recovery control to rebuild highlight areas where one channel has been clipped. The Fill Light slider brightens mid to dark shadow areas.

Making tonal adjustments

Exposure, Recovery, Fill Light, Blacks, Brightness, Contrast, Clarity, Vibrance and Saturation sliders are available for making adjustments to raw files. Adobe has positioned these controls in the dialog so that when working from top to bottom you follow a specific enhancement workflow. For this reason you should follow these steps in order:

1. Set the white clipping points using the Exposure slider.
2. Set the black clipping points using the Shadows slider.
3. Use Recovery/Fill Light controls (if needed).
4. Adjust the overall brightness using the Brightness slider.
5. Adjust contrast using the Contrast slider.
6. Use the Clarity slider to adjust local contrast.
1. Boost specific desaturated colors with the Vibrance slider.
2. Adjust saturation, if needed, using the Saturation slider.

Tonal changes workflow

Exposure

The Exposure slider adjusts the brightness or darkness of an image using value increments equivalent to f-stops or EV (exposure values) on a camera. An image is underexposed when it is not light enough or too dark and it is overexposed when it is too light. Simply move the slider to the left to darken the image and to the right to lighten (brighten) the image.

What do the f-stop or EV equivalents indicate? An adjustment of -1.50 is just like narrowing the aperture by 1.5 (one and a half) f-stops. Moving the slider 1.33 places to the left will dramatically darken an image and to the right the same amount will result in a bright image. If you have to move more than two full stops in either direction this probably indicates your settings at capture were inaccurate. Making adjustments beyond two stops starts to deteriorate image quality as invariably shadow or highlight detail is lost (clipped) in the process.

For those of you who are interested, the Exposure slider sets the white clipping points in the image. Clipping shows as values creeping up the left (shadow) and right (highlight) walls of your histogram (and red and blue areas in the image if shadow and highlight previews are turned on), and occurs when the pixel values shift to the highest highlight value or the lowest shadow value. Clipped areas are completely black or white and contain no detail. As you want to maintain as much detail in the shadows and highlights as possible your aim should always be to spread the picture tones but not to clip delicate highlight or shadow areas.

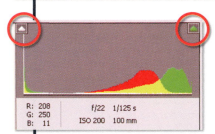

To ensure that you don't accidently convert shadow or highlight detail to pure black or white pixels ACR contains two different types of 'Clipping' warnings.
1. *When the Shadows and Highlights Clipping Warning features are selected at the top of the Histogram graph, areas of highlight clipping are displayed in the preview as red and shadows as blue.*
2. *Holding down the Alt/Option key whilst moving either the Exposure or Shadows sliders will convert the preview to black (for Exposure) or white (for Shadows). Any pixels being clipped will then be shown as a contrasting color against these backgrounds.*

Blacks (Shadows)

Moving the Blacks or Shadows slider adjusts the position of the black point within the image. Just as was the case with the Exposure slider you should only make shadows adjustments when the clipping warning

is active. This will ensure that you don't unintentionally convert shadow detail to black pixels. Remember movements of the slider to the left decrease shadow clipping. Moving it to the right increases or produces clipping.

Brightness and Contrast

The Brightness slider is different to the Exposure slider although both affect the brightness of an image. Brightness compresses the highlights and expands the shadows when you move the slider to the right. When adjusting your photos your aim is to set the black and white points first and then adjust the brightness of the midtones to suit your image.

Contrast adjusts the spread of the midtones in the image. A move of the Contrast slider to the right spreads the pixels across the histogram, actually increasing the midtone contrast. Conversely movements to the left bunch the pixels in the middle of the graph. It is important to adjust the contrast of midtones after working on exposure, shadows and brightness.

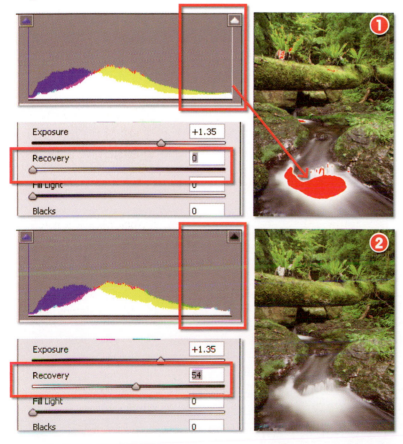

The Recovery slider is used for correcting clipped highlights. With the clipping warning activated it is easy to see problem highlights (1). When moving the slider to the right, ACR will attempt to reconstruct clipped details from the information stored in the non-clipped channels (2).

Recovery

When a photograph is overexposed one of the consequences can be that the lighter tones in the image lose detail and are converted to pure white. This process is called clipping. Digital images are created with details from three color channels (red, green, blue). In situations of slight overexposure, when only one channel is clipped, it is possible to recreate the lost detail with the highlight information from the other two (non-clipped) channels. The Recovery slider attempts to recreate lost highlight details in such cases. Moving the slider to the right progressively increases the degree of highlight recovery.

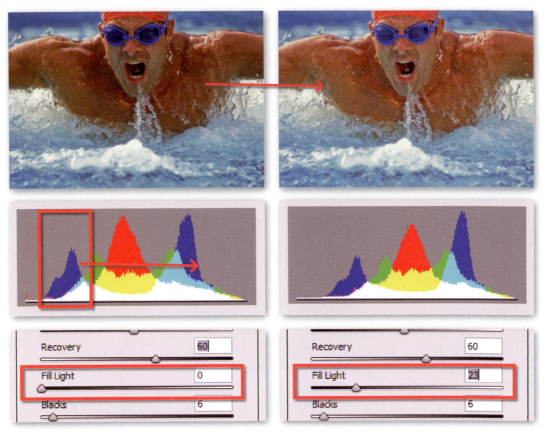

The Fill Light slider manipulates the mid to dark tones in the photo. Moving the slider to the right pushes these tones towards the highlight end of the histogram, lightening them.

Fill Light

The Fill Light slider is used to lighten the darker tones in a picture without affecting the middle to highlight values. Use this control to brighten backlit subjects or boost shadow details. The beauty of this control is that the changes it makes do not generally impact on mid to highlight values.

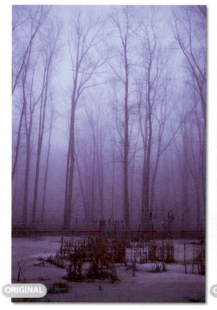

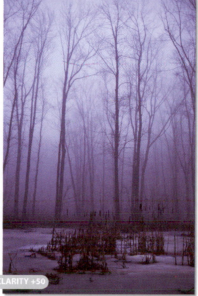

ORIGINAL

CLARITY +50

CLARITY +100

The Clarity slider gradually increases the contrast of details in the photo.

Clarity

Located along with Vibrance and Saturation controls at the bottom of the Basic panel, this new slider produces localized contrast changes to otherwise flat images.

Rather than adding contrast to the whole image by streteching the tones between black and white points, Clarity works on changing contrast on the detail in your photos. There are many sophisticated, multi-step, sharpening techniques that produce similar effects but thankfully Adobe has managed to squeeze much of their contrast-increasing abilities into a single control. Moving the slider to the right increases the effect.

Vibrance

The Vibrance slider is a new addition to the Basic panel of Adobe Camera Raw. Like the Saturation control, Vibrance controls the strength of the color in the photo. Movements to the right boost the color and movements to the left make the vividness of the hue more subtle. But unlike the Saturation slider, Vibrance manages these changes selectively, targeting the least saturated colors and protecting (to some extent) skin tones.

This makes the new control the first tool to reach for when you want to boost the color in your photos. The results are easier to control and less likely to display posterization or color clipping from over-application than the traditional Saturation control.

The Saturation slider controls the strength or vibrancy of the color within your raw photos.
(1) Dragging the slider all the way to left (-100) will remove all color from the photo, creating a monochrome picture.
(2) A value of 0 is the default setting where the saturation is neither boosted nor reduced.
(3) Moving the slider all the way to the right to a setting of +100 produces twice the saturation of the normal or default setting.

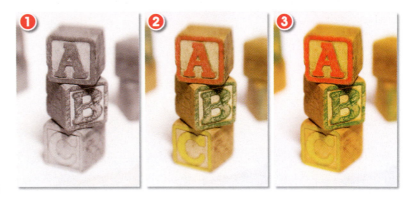

Saturation

If desired, the Saturation slider may be used to adjust the strength of the color within the photo. A setting of -100 is a completely desaturated monochrome image and a value of +100 doubles the saturation. Watch changes in the histogram when you move the Saturation slider in either direction.

Auto tonal control

When first opening a picture ACR will adjust the tonal controls to an average setting for the picture type and camera make/model. When the Auto setting is selected, ACR examines the picture and adjusts the controls according to the images' content. When these settings are in place, moving the associated slider will remove the selection but these values can be reinstated by selecting the checkbox again.

Pro's tip: In some instances you may need to readjust Exposure and Blacks sliders after Brightness, Recovery, Fill Light and Contrast to fine-tune your enhancements.

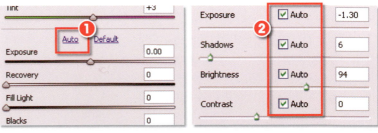

(1) A single Auto button is provided with the version of ACR that ships with Photoshop Elements 6.0.
(2) There are individual Auto options for Exposure, Shadows, Brightness and Contrast controls inside earlier versions of the ACR dialog.

Sharpening, Luminance Smoothing and Color Noise Reduction

Sharpening (Amount, Radius, Detail, Masking), Luminance Smoothing and Color Noise Reduction are all controls that can be accessed under the Detail tab.

Sharpening

Sharpening is an enhancement technique that is easily overdone and this is true even when applying the changes at the time of raw conversion. The best approach is to remember that sharpening should be applied to photos as the very last step in the editing/enhancement process and that the settings used need to match the type of output the photo is destined for. In practice this means images that are not going to be edited after raw conversion should be sharpened within ACR, but those pictures that are going to be enhanced further should be sharpened later using the specialist filters in Photoshop Elements.

When a picture is first opened into the ACR the program sets the sharpening and noise values based on the camera type and model used to capture the image. For many photographers making further adjustments here is an exception rather than a rule as they prefer to address sharpening in the Editor after cropping, straightening, enhancing, resizing and going to print.

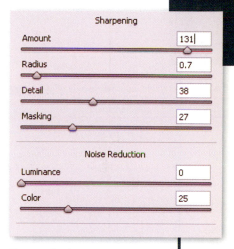

The Detail tab contains both Sharpening and Noise Reduction options.

The inclusion of two new controls in the Detail section of the Camera Raw dialog contributes substantially to the user's ability to fine-tune the sharpening in their images. Added to the existing Amount (strength of the effect) and Radius (number of pixels from an edge that will be changed in the sharpening process) sliders is the Detail and Masking controls. Both sliders are designed to control which parts of the image the sharpening effect is applied to. As with all sharpening techniques ensure that the preview is set to 100% before playing with the new controls. In fact, this magnification level is essential if you are to see the masking previews mentioned below.

Moving the Detail slider to the right increases the local contrast surrounding edge areas and therefore enhances the appearance of details. Moving the slider to the left decreases the effect and also reduces the appearance of halos.

The Masking control interactively applies an edge locating mask to the sharpening process. Sharpening through an edge mask is nothing new

but encapsulating the process in a single slider control is. A setting of 0 applies no mask and therefore all detail in the photo is sharpened. Moving the slider to the right gradually isolates the edges within the photo until, at a setting of 100, sharpening is only being applied to the most contrasty or dominant edges in the picture. Holding down the Alt/Option key (at 100% magnification) as you move the slider previews the masked areas, allowing you to fine-tune exactly where the sharpening is being applied. Remember no sharpening is occurring in the black parts of the mask, in the areas masked by gray tones only partial sharpening is being applied and in white mask sections the full effect is revealed.

After magnifying the preview to 100% there are four different preview options available when holding down the Alt/Opt keys and sliding one of the Sharpening sliders.

As well as including a mask display option, in the latest version of ACR you can also preview the settings for the other sharpening sliders.

Holding down the Alt/Option keys while moving the Amount slider displays a 'luminosity only' version of the image so that you can gauge the sharpening effect without the distraction of color. This preview also reminds us that in the latest version of ACR sharpening is applied to detail only and not the color information in the photo. When the Alt/Opt keys are used with the Radius slider the preview highlights the 'edges' in the image that will be sharpened and the width of the sharpening effect.

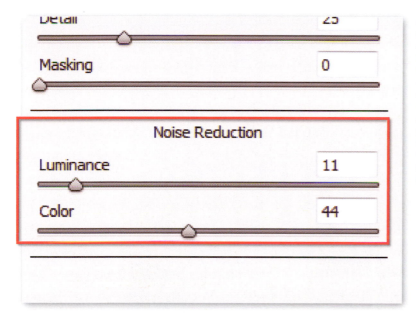

Along with the masking options for Sharpening, the ACR design team also took the opportunity to tweak the noise reduction algorithms in the latest release of the product. Though the effects are not as dramatic as those possible via other methods (see Noise Reduction in Chapter 12), the changes are definitely an improvement.

Noise Reduction

ACR contains two different noise reduction controls. The Luminance Smoothing slider and the Color Noise Reduction control. The Luminance Smoothing slider is designed to reduce the appearance of grayscale noise in a photo. This is particularly useful for improving the look of images that appear grainy. The second type of noise is the random colored pixels that typically appear in photos taken with a high ISO setting or a long shutter speed. This is generally referred to as chroma noise and is reduced using the Color Noise Reduction slider in ACR. The noise reduction effect of both features is increased as the sliders are moved to the right.

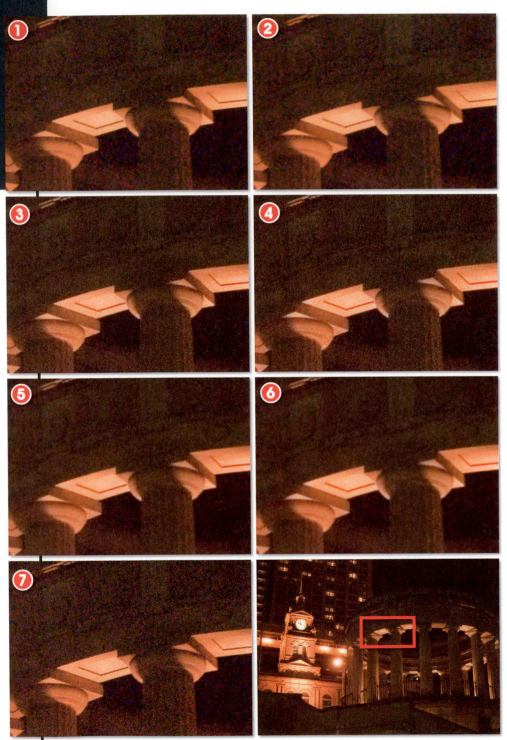

ACR contains two noise reduction controls – Luminance Smoothing for grayscale noise and Color Noise Reduction for minimizing errant color pixels. Like most noise reduction controls effective use is a balance between removing digital grain and creating flat featureless areas of color. This example demonstrates how the different settings alter the look of noisy photographs.

1. 50, 0 (Luminance Smoothing, Color Noise Reduction).
2. 100, 0.
3. 0, 50.
4. 0, 100.
5. 50, 50.
6. 100, 100.
7. 0, 0 (no noise reduction).

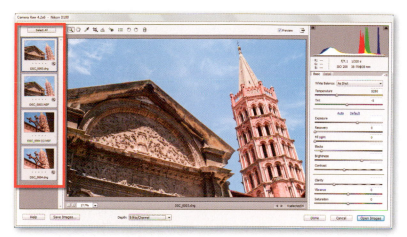

When selecting multiple raw files to open in Photoshop Elements the pictures are listed on the left side of the Adobe Camera Raw dialog.

Raw file queue

The third section of the Photoshop Elements version of the ACR dialog only appears when you select multiple raw files inside the Organizer workspace and then choose the Full Edit option from the right-click menu. The selected files are opened into the ACR dialog and listed on the left-hand side of the main workspace. This function, though available in the Photoshop version of ACR, is new for the edition that ships with Photoshop Elements 6.0.

In general, only one image can be selected from the grouping, and displayed in the preview area, at a time. All changes made to the image settings are applied to the selected photo only. Users can move from image to image making the necessary enhancements before clicking the Done key to apply the changes without transferring the files, or Open to display the converted pictures in the Full Edit workspace. But this is not the only way to work with the files.

The Select All button at the top of the queue area allows the user to apply settings used for a single image across a range of photos grouped here.

Synchronizing enhancements across multiple files

The Select All button at the top of the queued files can be employed for a more efficient workflow. With this feature enhancement changes made to a single photo can be applied across the whole range of images queued in the dialog.

Step by step:

Applying changes across multiple raw files

1. For best results, start by multi-selecting files from the Organizer space that have similar characteristics or were shot under the same lighting conditions.

2. Next, open the pictures in ACR by selecting the Full Edit option from the right-click menu.

3. Now select a single photo from the queue that is indicative in tone and color of the whole group. With this photo displayed in the preview area, choose the Select All option from the top of the dialog.

4. Proceed to make enhancement changes to the previewed files as you would normally. Notice that these changes are also applied to the other photos in the queue.

5. The changes made to all the photos can then be fine-tuned to suit the characteristics of individual images (if needed) by selecting each picture in turn and adjusting the controls.

6. If no changes for individual files are necessary, then the selected photos can be saved, using the Save Images button, transferred to the Edit workspace with the Open Images option or the enhancement settings applied by clicking the Done button.

Step by step:

Applying changes across rated raw files

1. In addition to being able to apply image changes across all the queued files by choosing the Select All button, it is also possible to adjust just a subset of the files listed. Start by reviewing each of the queued files in turn by clicking onto the thumbnail on the left of the dialog.

2. During the review process rate those files that you want to adjust as a group. Do this by clicking the star rating section located under each thumbnail.

3. Once the review process is completed and all files to be enhanced as a group are rated, hold down the Alt key and choose the Select Rated button at the top of the queued list. Notice that this action selects only those files with a star rating attached.

4. Now you can set about applying the changes to those selected as before.

5. If you want to remove an image from the Rated grouping simply click on the no rating option under the thumbnail.

Toolbar

Like the image adjustment tabs on the right of the ACR dialog, the contents of the program's toolbar are different depending on if you are working on files inside Photoshop Elements or Photoshop/Bridge. Elements users have the following tools at their disposal (left to right):

Zoom tool (Z) – The Zoom tool is useful for looking closely at the image for problems with focus and execution – slow shutter speed, lack of stabilization, incorrect aperture setting. At 25% an image may appear to be quite impressive, yet when examining it at 100% often a bit of movement and/or lack of focus appear.

Hand tool (H) – When the preview image is enlarged you can use the Hand tool to easily move around the screen.

White Balance tool (I) – The White Balance tool is very powerful. Clicking this tool on a picture portion that is meant to be neutral (even amounts of red, green and blue) removes any color casts and adjusts the hue of the entire image in one fell swoop.

Crop tool (C) – Use the Crop tool to remove unwanted areas around your photo or to reshape the format of the image to fit a specific paper type. The tool can be click-dragged around the area to keep or a specific

Photoshop Elements users have access to a range of tools via the toolbar at the top of the ACR dialog.
1. *Zoom tool*
2. *Hand tool*
3. *White Balance tool*
4. *Crop tool*
5. *Straighten tool*
6. *Red Eye Removal*
7. *Preferences dialog*
8. *Rotate image 90°CC*
9. *Rotate image 90°C*
10. *Toggle Mark for Delete*
11. *Preview*
12. *Toggle Full Screen*

cropping format can be selected from the drop-down menu accessed via the small downward-facing arrow in the bottom right of the tool button.

Straighten tool (A) – The Straighten tool can automatically rotate a picture taken with the horizon slightly crooked. Simply drag the tool along the line in the image that is meant to be level and ACR will automatically rotate and crop the photo to realign the horizon.

Red Eye Removal (E) – Use the Red Eye Removal tool to recolor the pupil area of photos taken with flash. Either click onto the red pupil or click-drag a marquee around the problem area. The Pupil Size and Darken sliders can be used to adjust the quality of the results.

Open Preference dialog (Ctrl + K) – Displays the Camera Raw Preferences dialog.

Rotate image 90° counter-clockwise (L) – Rotates the selected photo to the left.

Rotate image 90° clockwise (R) – Rotates the selected photo to the right.

Toggle Mark for Delete – Use this tool carefully to delete files that you don't want to keep in the catalog.

Preview (P) – Switches the preview of current image adjustments settings on and off.

Toggle Full Screen (F) – Switches the display mode of the dialog from a floating window to full screen.

Output options

Now to the business end of the conversion task – outputting the file. At this stage in the process ACR provides several options that will govern how the file is handled from this point onwards. In previous versions of the dialog the lower right-hand corner houses all the output options, now they are spread along the bottom of the window. The options include Save Image, Cancel, Open Image, Done and Help, and a further three, Save Image (without the options dialog), Reset and Open Copy, when the Alt/Option button is pushed.

Help: Opens the Photoshop Elements help system with raw processing topics already displayed.

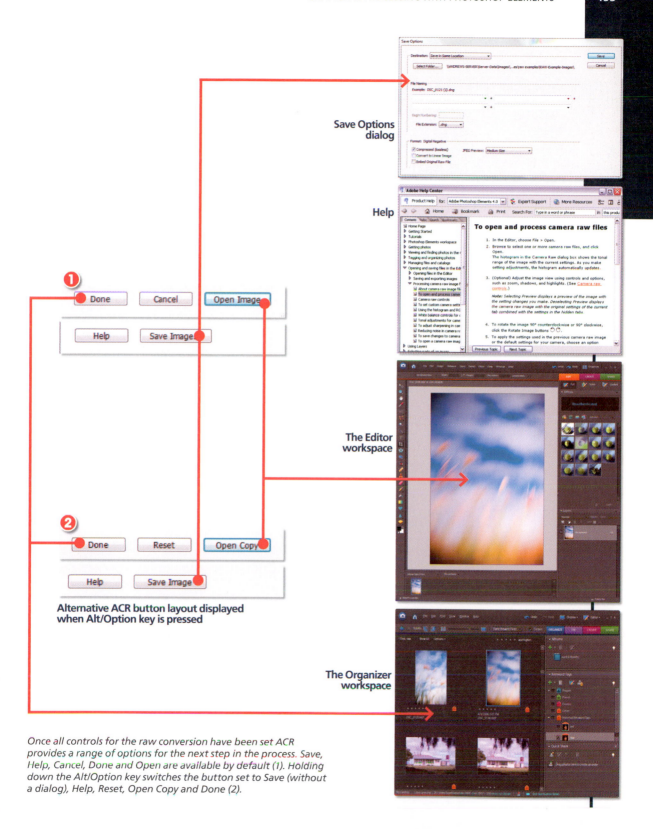

Save Options dialog

Help

The Editor workspace

❶ Done Cancel Open Image

Help Save Image

❷ Done Reset Open Copy

Help Save Image

Alternative ACR button layout displayed when Alt/Option key is pressed

The Organizer workspace

Once all controls for the raw conversion have been set ACR provides a range of options for the next step in the process. Save, Help, Cancel, Done and Open are available by default (1). Holding down the Alt/Option key switches the button set to Save (without a dialog), Help, Reset, Open Copy and Done (2).

The Save Options dialog is displayed when the Save Image ... button is pressed. To skip this dialog and still save the processed file in DNG format hold down the Alt/Option key whilst clicking the Save Image button.

Cancel: This option closes the ACR dialog not saving any of the settings to the file that was open.

Save Image: The normal Save Image button, which includes several dots (...) after the label, displays the Save Options dialog. Here you can save the raw file, with your settings applied, in Adobe's own DNG format. The dialog includes options for inputting the location where the file will be saved, the ability to add in a new name as well as DNG file-specific settings such as compression, conversion to linear image and/or embed the original raw file in the new DNG document. It is a good idea to Select Save in Different Location in the Destination drop-down at the top to separate processed files from archive originals. Clearly the benefits of a compressed DNG file are going to help out in the storage issue arena and compression is a big advantage with DNG. Embedding the original raw file in the saved DNG file begs the questions of how much room you have in the designated storage device and whether you really want to have the original raw file here.

Save Image (without save options): Holding down the Alt/Option key when clicking the Save button skips the Save Options dialog and saves the file in DNG format using the default save settings.

Open Image: If you click on the Open button Elements applies the conversion options that you set in ACR and opens the file inside the Editor workspace. At this point, the file is no longer in a raw format so when it comes to saving the photo from the Editor workspace Elements automatically selects the Photoshop PSD format for saving.

Open Copy: The Open Copy option differs from Open Image in that it applies the development settings to a duplicate of the file which is then opened into the Elements Editor workspace.

Reset: The Reset option resets the ACR dialog's settings back to their defaults. This feature is useful if you want to ensure that all settings and enhancement changes made in the current session have been removed. To access the Reset button click the Cancel button whilst holding down the Alt/Option key.

Done or Update: The Done button applies the current settings to the photo and the dialog is then closed. The thumbnail preview in the PhotoBrowser workspace will also be updated to reflect the changes. In previous versions of the dialog clicking the Open button in conjunction with the Alt/Option key (the Update button) will update the raw conversion settings for the open image in the same way.

Pro's tip: If the thumbnail doesn't update automatically, select the picture and then choose Edit > Update Thumbnail in the PhotoBrowser workspace.

Skip: In previous versions of Adobe Camera Raw holding down the Shift key whilst clicking the Open button will not apply the currently selected changes and just close the dialog. In this way it is similar to the Cancel button.

Differences between Adobe Camera Raw (ACR) in Photoshop/Bridge and Photoshop Elements

The Adobe Camera Raw utility is available in both Photoshop Elements and Photoshop (and Bridge) but the same functionality and controls are not common to the feature as it appears in each program. The Photoshop Elements version contains a reduced feature set but not one that overly restricts the user's ability to make high quality conversions.

Processing with Photoshop Elements and Adobe Camera Raw

Now that we have a good understanding of the various controls in the Adobe Camera Raw dialog let's walk through the complete process.

Opening

This seems like a simple step but just as there are many roads that lead to Rome so too are there a variety of ways to open a raw file in Adobe Camera Raw.

1. Opening the raw file in the Editor workspace

Once you have downloaded your raw files from camera to computer you can start the task of processing. Keep in mind that in its present state the raw file is not in the full color RGB format that we are used to, so the first part of all processing is to open the picture into Adobe Camera Raw. Selecting File > Open from inside Elements will automatically display the photo in this.

2. Starting with the PhotoBrowser

Starting in the PhotoBrowser or Organizer workspace simply right-click on the thumbnail of the raw file and select Full Edit or Go to Standard Edit from the pop-up menu to transfer the file to the Elements version of ACR in the Editor workspace.

Rotate

3. Rotate right (90 CW) or left (90 CCW)

Once the raw photo is open in ACR you can rotate the image using either of the two Rotate buttons at the top of the dialog. If you are the lucky owner of a recent camera model then chances are the picture will automatically rotate to its correct orientation. This is thanks to a small piece of metadata supplied by the camera and stored in the picture file that indicates which way is up.

Adjusting white balance

Unlike other capture formats (TIFF, JPEG) the white balance settings are not fixed in a raw file. ACR contains three different ways to balance the hues in your photo.

4. Preset changes

As we have seen you can opt to stay with the settings used at the time of shooting ('As Shot') or select from a range of light source-specific settings in the White Balance drop-down menu of ACR. For best results, try to match the setting used with the type of lighting that was present in the scene at the time of capture. Or choose the Auto option from the drop-down White Balance menu to get ACR to determine a setting based on the individual image currently displayed.

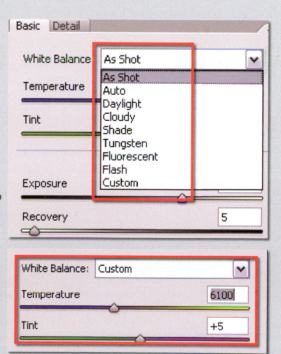

5. Manual adjustments

If none of the preset white balance options perfectly matches the lighting in your photo then you will need to fine-tune your results

with the Temperature and Tint sliders (located just below the Presets drop-down menu). The Temperature slider settings equate to the color of light in degrees kelvin – so daylight will be 5500 and tungsten light 2800. It is a blue to yellow scale, so moving the slider to the left will make the image cooler (more blue) and to the right warmer (more yellow). In contrast the Tint slider is a green to magenta scale. Moving the slider left will add more green to the image and to the right more magenta.

6. The White Balance tool

Another quick way to balance the light in your picture is to choose the White Balance tool and then click on a part of the picture that is meant to be neutral gray or white. ACR will automatically set the Temperature and Tint sliders so that this picture part becomes a neutral gray and in the process the rest of the image will be balanced. For best results when selecting lighter tones with the tool ensure that the area contains detail and is not a blown or specular highlight.

Tonal control

The next group of image enhancements alters the tones within the photo. There are nine different slider controls each dealing with a specific group of image tones. Each of the controls can be controlled automatically based on individual image content by clicking the Auto option just below the white balance options. Use the following steps if you want a little more control.

7. Setting the white areas

To start, adjust the brightness with the Exposure slider. Moving the slider to the right lightens the photo and to the left darkens it. The settings for the slider are in f-stop increments, with a +1.00 setting

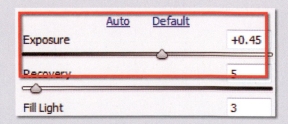

being equivalent to increasing exposure by 1 f-stop. Use this slider to peg or set the white tones. Your aim is to lighten the highlights in the photo without clipping (converting the pixels to pure white) them. To do this, hold down Alt/Option whilst moving the slider. This action previews the photo with the pixels being clipped against a black background. Move the slider back and forth until no clipped pixels appear but the highlights are as white as possible.

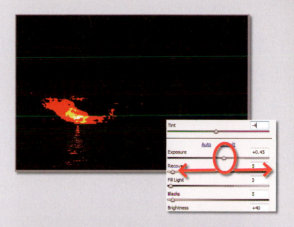

8. Adjusting the shadows (blacks)

The Blacks or Shadows slider performs a similar function with the shadow areas of the image. Again the aim is to darken these tones but not to convert (or clip) delicate details to pure black. Just as with the Exposure slider, the Alt/Option key can be pressed whilst making Shadows adjustments to preview the pixels being clipped. Alternatively the Shadow and Highlights Clipping Warning features (top left and right corners of the histogram) can be used to provide instant clipping feedback on the preview image. Shadow pixels that are being clipped are displayed in blue and clipped highlight tones in red.

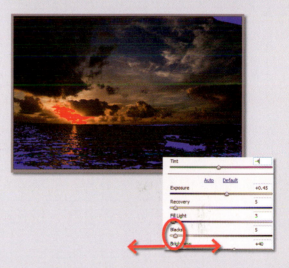

9. Brightness changes

The next control, moving from top to bottom of the ACR dialog, is the Brightness slider. At first the changes you make with this feature may appear to be very similar to those produced with the Exposure slider but there is an important difference. Yes, it is true that moving the slider to the right lightens the whole image, but rather than adjusting all pixels the same amount the feature makes major changes in the midtone areas and smaller jumps in the highlights. In so doing the Brightness slider is less likely to clip the highlights (or shadows) as the feature compresses the highlights as it lightens

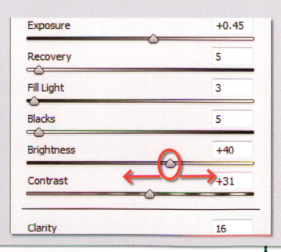

the photo. This is why it is important to set white and black points first with the Exposure and Shadows sliders before fine-tuning the image with the Brightness control.

10. Recovering highlights and shadow detail

If the highlights are still being clipped then use the Recovery slider to recreate detail in the problem area. Likewise if the shadow areas are too dark then drag the Fill Light slider to the right to lighten these tones in the photo. Be careful with over-application of either of these controls as it can make the image look low in contrast.

11. Increasing/decreasing contrast

The last tonal control in the dialog, and the last to be applied to the photo, is the Contrast slider. The feature concentrates on the midtones in the photo with movements of the slider to the right increasing the midtone contrast and to the left producing a lower contrast image. Like the Brightness slider, Contrast changes are best applied after setting the white and black points of the image with the Exposure and Blacks sliders.

12. Local contrast control

The Clarity slider is used to alter the local contrast or the contrast of details within the photo. It works well with photos that have been photographed with diffused light or on a cloudy day. Use Clarity and Contrast sliders together.

Color strength adjustments

As one of the primary roles of the Adobe Camera Raw utility is to interpolate the captured colors from their Bayer mosaic form to the more usable RGB format it is logical to include a couple of color strength controls in the process.

13. Vibrance adjustment

Unlike the Saturation slider, which increases the strength of all colors in the photo irrespective of their strength in the first place, Vibrance targets its changes to just those colors that are desaturated. Use this control to boost the strength of colors in the photo with less risk of posterized results.

14. Saturation control

The strength or vibrancy of the colors in the photo can be adjusted using the Saturation slider. Moving the slider to the right increases saturation, with a value of +100 being a doubling of the color strength found at a setting of 0. Saturation can be reduced by moving the slider to the left, with a value of -100 producing a monochrome image. Some photographers use this option as a quick way to convert their photos to black

and white but most prefer to make this change in Photoshop proper, where more control can be gained over the conversion process with features such as the Channel Mixer.

Sharpness/smoothness and noise reduction

With the tones and colors now sorted let's turn our attention to sharpening and noise reduction. Both these image enhancements can be handled in-camera using one of a variety of auto settings found in the camera setup menu, but for those image makers in pursuit of imaging perfection these changes are best left until processing the file back at the desktop.

15. To sharpen or not to sharpen

The latest version of ACR contains four separate sharpening controls. Use the Amount slider to determine the overall strength of the sharpening effect. The Radius is used to control the number of pixels from an edge that will be changed in the sharpening process. The Detail and Masking sliders are both designed to help target the sharpening at the parts of the

image that most need it (edges) and restrict the sharpening effects from being applied to areas that don't (skin tone and smooth graded areas). Moving the Detail slider to the right increases the local contrast surrounding edge areas and therefore enhances the appearance of details. Moving the slider to the left decreases the effect and also reduces the appearance of halos. The Masking control interactively applies an edge locating mask to the sharpening process. A setting of 0 applies no mask and therefore all detail in the photo is sharpened. Moving the slider to the right gradually isolates the edges within the photo until, at a setting of 100, sharpening is only being applied to the most contrasty or dominant edges in the picture.

16. Reducing noise

ACR contains two different Noise Reduction controls. The Luminance Smoothing slider is designed to reduce the appearance of grayscale noise in a photo. This is particularly useful for improving the look of images that appear grainy. The second type of noise is the random colored pixels that typically appear in photos taken with a high ISO setting or a long shutter speed. This

is generally referred to as chroma noise and is reduced using the Color Noise Reduction slider in ACR. The noise reduction effect of both features is increased as the sliders are moved to the right.

Output options

Now to the business end of the conversion task – outputting the file. The Photoshop Elements version of ACR contains only the Color Depth output option.

17. Controlling color depth/space and image size/resolution

The section below the main preview window in ACR contains the output options settings. Here you can adjust the color depth (8 or 16 bits per channel) of the processed file. Earlier versions of Photoshop Elements

were unable to handle 16 bits per channel images but the last two releases have contained the ability to read, open, save and make a few changes to these high color files.

Save, Open or Done

The last step in the process is to apply the enhancement changes to the photo. This can be done in a variety of ways.

18. Opening the processed file in Photoshop Elements

The most basic option is to process the raw file according to the settings selected in the ACR

dialog and then open the picture into the Editor workspace of Photoshop Elements. To do this simply select the Open Image button. Select this route if you intend to edit or enhance the image beyond the changes made during the conversion.

19. Saving the processed raw file

Users also have the ability to save converted raw files from inside the ACR dialog via the Save Image button. This action opens the Save Options dialog which contains settings for inputting the file name as well as file type-specific characteristics such as compression. Use the Save option over the Open command if you want to process photos quickly without bringing them into the editing space.

Pro's tip: Holding down the Alt/Option key whilst clicking the Save button allows you to store the file (with the raw processing settings applied) without actually going through the Save Options dialog.

20. Applying the raw conversion settings

There is also an option for applying the current settings to the raw photo without opening the picture. By Clicking the Done button (or Alt-clicking the OK button – holding down Alt/Option key changes the button to the Update button in previous versions of the dialog), you can apply the changes to the original file and close the ACR dialog in one step.

The great thing about working this way is that the settings are applied to the file losslessly. No changes are made to the underlying pixels, only to the instructions that are used to process the raw file.

When next the file is opened, the applied settings will show up in the ACR dialog ready for fine-tuning, or even changing completely.

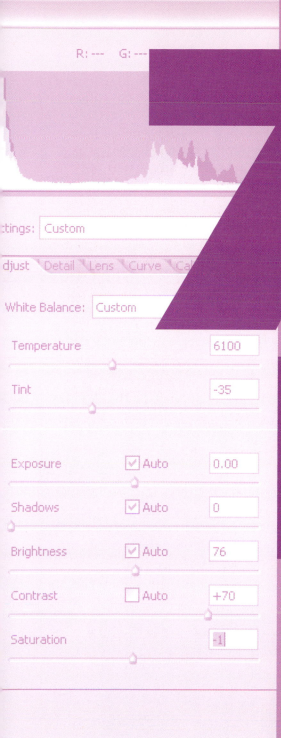

7

ACR, Photoshop and Bridge

How do you process your raw photographs in Adobe Photoshop? You start by opening them. To do this you can always use the ubiquitous Open command but you also have the option to open files via Bridge (CS2 and CS3) or the File Browser (CS).

Over the last few versions of the program both Photoshop and Bridge have become more raw aware. Where Photoshop used to be the beginning of all raw editing it is now possible to process your raw

Photoshop CS3

Photoshop CS2

File > Open *File > Browse* *File > Open* *File > Browse*

Bridge *Bridge*

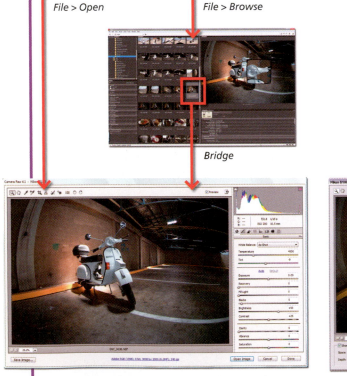

ACR *ACR*

files without even opening the photos into the package. Starting with Bridge raw images can be opened into Adobe Camera Raw, the photos enhanced using the many features found here and then the settings applied to the picture without ever moving the image into Photoshop proper. This Bridge to ACR and back to Bridge workflow is very efficient in time and also computing resources as the resource hungry Photoshop is not touched in the process. Irrespective of the route you take, the key component in the process is Adobe Camera Raw.

Photoshop CS

File > Open

File > Browse

File Browser

ACR

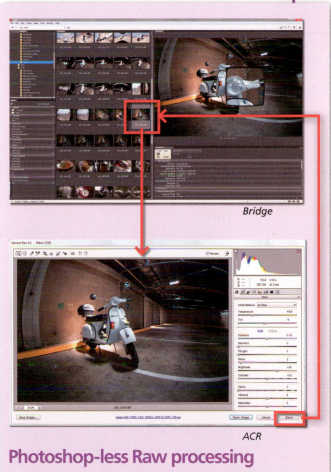

Bridge

ACR

Photoshop-less Raw processing

Photoshop users can open their raw files into Adobe Camera Raw by selecting File > Open or selecting from either Bridge or the Photoshop File Browser in earlier versions of the program.

All roads lead to Adobe Camera Raw (ACR)

Selecting File > Open displays a file dialog where you can select and open your raw photo. File > Browse, on the other hand, opens either Bridge or the File Browser, depending on which version of Photoshop you are running. Both utilities provide a thumbnail view of the raw files you have on your hard drive. To open a photo, just double-click the picture's thumbnail.

Both methods for opening a file will eventually lead to the photo being displayed in Adobe's raw conversion utility – Adobe Camera Raw (ACR). Different versions of the ACR are shipped with Photoshop CS3, CS2 and Photoshop CS. Changes to the list of features present in the utility as well as the cameras supported by each edition of ACR are made from time to time, so to ensure that you have the very latest incarnation of ACR download the most recent version from www.adobe.com and install it by following the steps below:

Keeping ACR up to date manually

For all but the latest version of Photoshop you will need to update ACR using the following steps. Point your browser to **www.adobe.com** and then look for the Adobe Camera Raw update page. Next download the latest version of the utility and install using these steps:

1. If Photoshop is open exit the program.

2. Open the system drive (usually C:).

3. Locate the following directory: **Program Files/Common Files/ Adobe/Plug-Ins/CS2/File Formats.**

4. Find the Adobe Camera Raw.8bi file in this folder.

5. Move the plug-in to another folder and note down its new location just in case you want to restore the original settings.

6. Drag the new version of the Adobe Camera Raw plug-in, the Adobe Camera Raw.8bi file (that you

The knowledge

downloaded), to the same directory as in step 3.

7. Restart Photoshop.

Note: If after installing the new version of ACR your raw files are not displayed as thumbnails, start Bridge and then select Tools > Cache > Purge Central Cache. Keep in mind that this action deletes the stored thumbnail data for all folders as well as any labels, ratings and rotation settings for files that don't have XMP support.

Keeping ACR up to date automatically

Thankfully Photoshop CS3 has an automated update process that includes the Adobe Camera Raw plug-in. Use the following steps to update to the latest version of ACR:

1. Start Photoshop. Navigate to and select the Help > Updates option. This will force the program to go online and search for any new updates.

2. If an update is found, the Adobe Updater is displayed with a list of the updates. Choosing the Install button will download the files and install into the correct directory. During the installation process you may be asked to close Photoshop or Bridge.

3. After restarting Photoshop you will find that the new version of Adobe Camera Raw is available.

The knowledge!

ACR contains a comprehensive toolbar situated at the top of the dialog. Tools that are stored here include:
1. Zoom tool
2. Hand tool
3. White Balance tool
4. Color Sample tool
5. Crop tool
6. Straighten tool
7. Retouch tool
8. Red Eye Removal
9. Open Preferences dialog
10. Rotate image 90° CCW or Rotate image 90° CW
11. Toggle Mark for Delete
12. Preview
13. Toggle Full Screen

Photoshop's own version of Adobe Camera Raw

As we have already seen, Adobe Camera Raw is the raw conversion utility used by both Photoshop and Photoshop Elements. Both versions share the core processing power but it is the one included with Photoshop that contains the fullest range of image editing and enhancement options. Where Elements users have access to the Basic and Detail tabs, Photoshop aficionados have no less than eight different tabs crammed full of tonal, color and sharpness controls to play with. Add to this the inclusion of color sampling tool and retouching tools and options for opening raw files as smart objects inside Photoshop directly from ACR and you will see why running ACR from Bridge or Photoshop is the choice of most professionals.

It is no surprise that the tools and features inside Photoshop Lightroom have an uncanny resemblance to those in ACR. Based on the same conversion technology both the Lightroom and ACR development teams have been working hard to ensure comparability between the two programs. Adobe hopes that these efforts will mean that photographers have a broader choice of workflow, being able to mix and match between Lightroom, Photoshop, Bridge and Camera Raw when finding the best 'fit' for their preferred workflow.

The tabbed panes on the right of the dialog house the image, color and sharpness controls that form the basis of all raw enhancement adjustments.

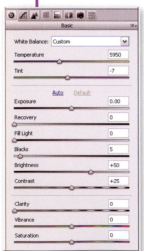

Basic: Contains white balance, tonal and color saturation controls.

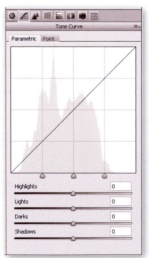

Tone Curve: Both Parametric (slider based) and Point curves for non-linear tonal controls.

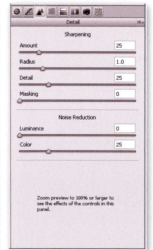

Detail: Houses Sharpening and Noise Reduction sliders.

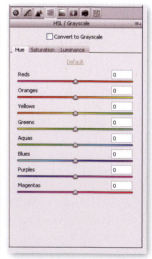

HSL/Grayscale: Contains Convert to Grayscale and Hue, Saturation and Luminance controls.

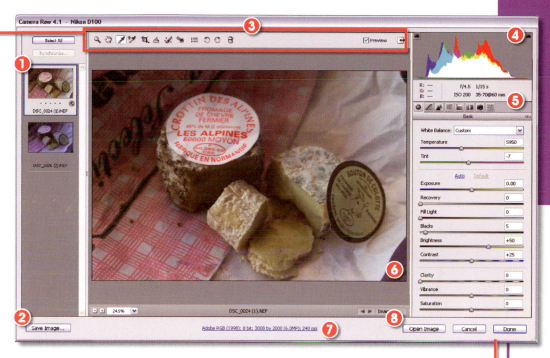

The first thing that you will notice about the Photoshop version of Adobe Camera Raw is that there are more icons across the top left-hand side of the dialog box than Elements users can access. Next look to the tabbed controls on the right. In ACR4.1 there are eight different tabbed panes containing a broad range of tonal, color and sharpness controls.

Multiple raw files can be selected and queued on the left of the dialog while they are being processed either individually or as groups via the Select All and Synchronize options.

Key ACR components:
1. Queue area
2. Save button
3. Toolbar
4. Histogram
5. Tabbed control panes
6. Preview
7. Output options
8. Output buttons

Split Toning: Combines tinting controls for Highlights and Shadows with a Balance control for the split point.

Lens Corrections: Contains controls for Chromatic Aberration, Defringing and Vignetting problems.

Camera Calibration: Includes slider controls for fine-tuning the default Camera Profiles in ACR.

Presets: Lists saved groups of settings for quick application.

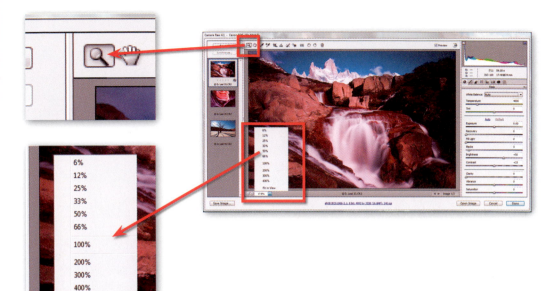

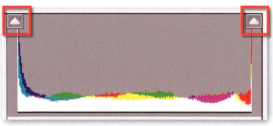

Zoom preview to 100% or larger to see the effects of the controls in this panel.

The preview area

The preview area in the ACR dialog is the main way for photographers to asses the changes made to their images with the feature's controls and tools. As such, the image in the preview space reflects all adjustments made to the file. To ensure the accuracy of some enhancements it will be necessary to get in a little closer to your files so the preview image can be enlarged or reduced in several different ways.

The Zoom tool can be used to draw a marquee around the area to be enlarged or double-clicked to zoom straight to 100% view. Alternatively preset zoom settings can be selected from the zoom menu at the bottom left of the dialog. The same shortcut keys that are employed in Lightroom, Photoshop and Elements can also be used here. Ctrl/Cmd + to enlarge or Ctrl/Cmd - to reduce the image size. The current zoom or magnification factor can be seen at the bottom right of the dialog.

Previewing clipping

One of the critical areas of image adjustment is ensuring that any changes to tone or color don't clip captured details in either the shadow or highlight areas of the photo. The preview image in conjunction with the histogram form a key partnership in providing this clipping feedback to the user when they are making changes to the photo. By activating the highlight and shadow clipping warnings in the histogram (click on the upwards-facing arrows in the top left, for shadows, or top right, for highlights of the histogram), areas being clipped are displayed in the preview image.

Clipped shadow details are displayed in blue and clipped highlights in red. As well as the warning in the preview image, the actual clip warning arrows in the histogram area reflect the color of the channels (red, green, blue) being clipped. If details for more than one channel are being clipped then the arrow turns white. If no details are being clipped then the arrow is black.

Histogram

The histogram provides another way to check the enhancements that you make to your raw photos. The feature graphs the spread of pixels across the tonal range from black (left of the histogram) to white (at the right end) of the photo. The height of the graph represents the number of pixels present in the image at any single tonal area in the photo. The histogram in ACR is presented in full color so that you can also see how individual color channels are distributed throughout the tonal range.

Though not as immediately accessible as the preview image as a mechanism for feedback, the histogram provides a crucial objective view of how your changes are affecting the image. Spend some time getting to know how the histogram represents different image types. Once you understand this, you will better be able to diagnose the problems in your pictures and, more importantly, the steps needed for correction.

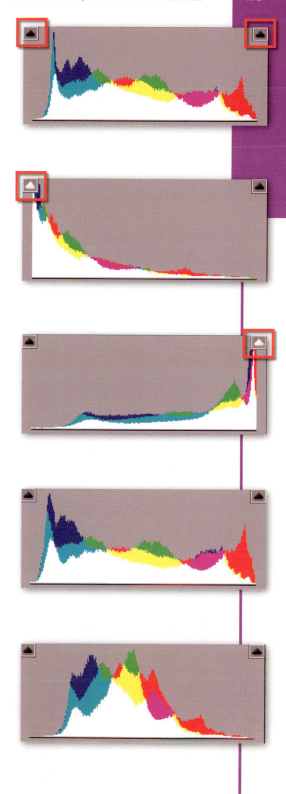

Toolbar

The toolbar at the top of the ACR dialog houses the features used by photographers to interact directly with the photo. The list of tools available here has been steadily growing over the last few releases of the program, with the current version containing 14 entries on the toolbar.

Zoom tool

The Zoom tool, like its namesake in many other imaging programs, is designed to enlarge the preview image, enabling the user to carefully examine the appearance of key areas of the photo.

Double-clicking the Zoom tool automatically displays the photo at 100%. This is handy because this is the minimum zoom setting recommended for previewing the effects of the controls in the Detail tab. In fact, in the latest version of the ACR sharpening, noise reduction and defringing effects are only previewed at 100% or greater. You will be able to manipulate the slider controls at less magnified settings but it just won't be possible to see the changes in the preview window. However, most photographers use the Zoom tool by click-dragging a marquee around the area to be enlarged. Once the mouse key is released the preview snaps to the selected area.

The preview area and zoom level can be selected by drawing a marquee with the Zoom tool on the preview image.

The current zoom level is indicated in the small window next to the zoom presets drop-down menu at the bottom left of the dialog.

Hand tool

The Hand tool is employed when the preview is magnified in such a way that the image extends beyond the boundaries of the preview window. Click and drag the preview to move the picture within the window. This is a handy technique to use when retouching dust spots or viewing sharpening effects across the photo.

For those readers who use shortcuts to speed up their workflow it is worth noting that holding down the space bar with the Zoom tool selected will switch the Hand tool, allowing faster navigating.

White Balance tool

The White Balance tool, along with the White Balance options in the control panel (presets, temperature and tint sliders), provide the user with a variety of ways to adjust the overall color of the photo. These features are used to correct color casts caused by capturing images under differently colored light sources. The White Balance tool is used to click on an image part that is meant to be a neutral tone (light gray) in the photo. ACR calculates the color cast of the picture part or how different the red, green, blue values are from a neutral target and then adjusts the color of the whole image to account for the difference.

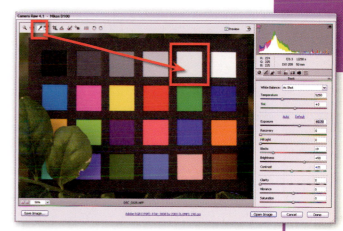

Depending on the subject matter you are photographing it may be difficult to locate a neutral picture part to use as a reference for this tool. For this reason many photographers now carry a small gray card, or set of color swatches, which they insert into a scene containing mixed lighting. Next a reference picture, with the swatches included, is captured before continuing to photograph normally. Back at the desktop the reference image is balanced by clicking on the light gray swatch with the White Balance tool. The White Balance settings for this image are then saved and used for the rest of the images in the series.

Color Sample tool

The Color Sample tool is used for measuring the red, green, blue values (RGB) of different picture parts. After selecting the tool from the ACR toolbar the user clicks onto the image area to be measured. A small target icon is added to the picture indicating the area being measured. Next, a special Sampler Bar is displayed beneath the toolbar and the values for the sampled area are listed here. Multiple samplers can be added to an image. Each sample is numbered on the image and its RGB values listed in the Sampler Bar. The samples remain active until the Clear Samples button is selected. This allows the user to make tone and color settings changes and review the resultant changes to RGB values. Using this process it is possible to customize the way that images captured under difficult lighting circumstances are processed through the ACR dialog. For more details on this technique go to Chapter 9.

Crop tool

The Crop tool is a comparatively recent inclusion in the ACR dialog. With this feature it is possible to non-destructively crop your raw files. The tool works in two different modes – via a drawn marquee or with presets selected from the drop-down menu.

After selecting the tool click and drag the marquee around the area of the image to be retained. The shape and size of the marquee can be adjusted by dragging either corner of edge handles. It is also possible to rotate the marquee by moving the cursor outside of the marquee edge and click-drag to pivot. Upon clicking the Done button ACR applies the crop to your image and updates the thumbnail in the Bridge content space. If the rotated crop has been applied then the image is pivoted as well. Don't be concerned though, as cropped picture parts are only removed from view and not deleted permanently. A crop icon is added to the Bridge thumbnail to indicate that the picture is not being viewed full frame.

Alternatively, you can apply a preset crop from the list available when you click the downwards arrow at the bottom right of the Crop button. You can select from a list of preset options or create your own with the Custom entry. Selecting a preset will automatically apply a crop to the image in the format selected. You can adjust the size and shape of the crop as you would normally, but if you want to resize and still retain the aspect ratio (shape) of the crop use the Shift key while dragging the corner handle.

Custom crops are applied in the same fashion except, when selecting the Custom Crop entry from the menu, you will need to enter the ratio and units that will be used for the crop, before it is applied to the photo.

To remove an existing crop, open the file in to ACR and click on the Crop tool. Next you can either hit the Esc key or select the Clear Crop option from the drop-down menu available from the Crop tool button.

Straighten tool

The Straighten tool provides an efficient way to realign cooked horizons back to horizontal. Simply click on the tool and click-drag a line along the edge that is mean to be horizontal. Let go of the mouse button and ACR will automatically rotate and crop the image to straighten the horizon.

The feature works just as well on picture parts that are meant to be vertical. Simply click-drag the Straighten tool along the image edge that needs to be vertical, let go and ACR will automatically rotate and crop.

Retouch tool

Adobe included the Retouch tool in Camera Raw 4.0. Alongside the Red Eye Removal tool, the inclusion of these two new features completes the feature set for ACR, and turns the program from a processing step on the way to Photoshop into an enhancement end in itself. Now wedding, portrait, journalist, documentary, architecture and candid photographers alike can complete the majority of their enhancement tasks without ever having to leave the program.

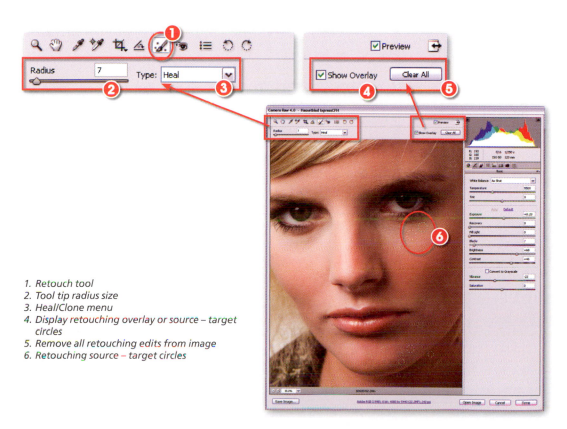

1. Retouch tool
2. Tool tip radius size
3. Heal/Clone menu
4. Display retouching overlay or source – target circles
5. Remove all retouching edits from image
6. Retouching source – target circles

The process for using the Retouch tool borrows from both the Clone Stamp and Spot Healing brush tools that feature in Photoshop and Photoshop Elements.

The feature contains two sections: a circle that indicates the target of the retouching, which is generally placed over the mark to remove, and a circle to select the source area that will be used as a reference for the color, tone and texture that will be painted over the mark. Sound familiar? It should – this is how the Clone Stamp tool works. The difference is that with ACR's Retouch tool, the target area is selected first by click-dragging the cursor to the size of the mark. ACR then automatically searches for a suitable source point in the nearby pixels.

For ease of recognition the target circle is colored red and the source circle is a green hue. Both circles are linked with a straight line to indicate which source belongs to which target.

For the majority of the time ACR does a pretty good job of selecting a source point, but there will be occasions when you may want to choose your own. This is a simple matter of click-dragging the source circle to a new location. The same technique can be used for moving the target circle. To change the target size use the Radius slider in the tool's options bar at the top of the dialog. Holding down the Alt/Option key while clicking on the target circle deletes or cuts the retouching entry.

Heal or Clone: The tool works in two modes – Heal and Clone. The Heal mode uses the technology found in the Spot Healing Brush to help match texture and tone of the source area to the target surrounds. The Clone option gives more weighting to the specific qualities of the source area when over-painting the mark.

1. Start the process by ensuring that the preview window is enlarged to at least 100%. Select the magnification level from the pop-up menu on the bottom left of the dialog. Viewing the image zoomed in helps guarantee accuracy when specifying both target and source areas and presents a more precise preview of the results. Switch to the Hand tool using the H keyboard shortcut, to click-drag the preview area around the photo. You can switch back to the Retouch tool by pressing the letter B key.

Step by step

2. Now drag the preview until you locate an area to be retouched. Select the Retouch tool from the ACR toolbar at the top of the dialog. By default the tool draws from the center, so move the pointer over the middle of the mark and click-drag the circle until it encompasses the blemish. This action sets the red target circle or the area to be retouched.

3. Unlike the situation with the Clone Stamp or Healing Brush tools there is no need to select the sample area separately. Adobe Camera Raw automatically searches the surrounds of the target area for a likely source and draws a corresponding circle attached with a single straight line. The source circle is colored green to distinguish it from the red target circle. If the source circle has been positioned incorrectly or is providing less than acceptable results in the target area then simply click-drag the circle to a new location.

4. Once the target and source have been positioned, the retouching entry can be modified in a couple of different ways. The size of the target circle can be adjusted by clicking onto the circle and then changing the radius setting in the tool's options bar. The mode used for retouching can be switched between Heal (the technology used by the Spot Healing Brush) and Clone (which simulates the way that the Clone Stamp tool functions) using the drop-down menu in the bar.

5. Individual retouching entries can be removed or deleted altogether by cutting the entry. With the Retouch tool selected, hold down the Alt/Opt key while positioning the cursor over either the source or target circles of the retouching entry. The cursor will switch shapes to a pair of scissors (see aside). Clicking the mouse button will then delete the entry.

6. Once you have positioned and adjusted all retouching entries for a given image you can preview the results, without the target and source circles, by de-selecting the Show Overlay setting in the tool's options bar. To re-display the circles, reselect the option.

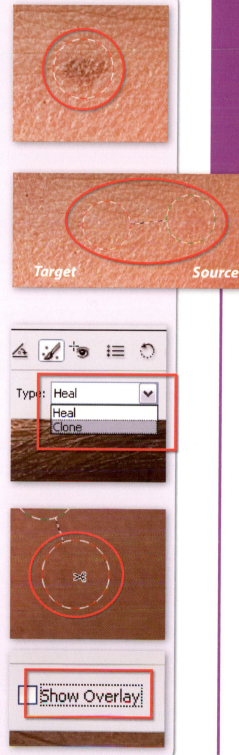

7. As all retouching entries created in Adobe Camera Raw are non-destructive they can be removed at any time, even if the file has been saved and reopened (as a DNG file). To remove all retouching entries for the current image, select the Clear All button in the Retouch tool options bar.

8. Synchronization of settings across a group of raw files being processed in ACR was a feature introduced in Photoshop CS2. After multi-selecting several images in Bridge and opening them in Adobe ACR, the pictures are listed vertically as thumbnails along the left-hand side of the dialog. Selecting more than one of these files (by holding down Shift or Ctrl/Cmd and clicking a second thumbnail) makes the Synchronize button at the top of the dialog active. Pressing the button will display the Synchronize window (left), allowing you to select which enhancement settings to copy from the current image to the others selected in the thumbnail list.

From ACR 4.0 the Synchronize list also includes a Spot Removal option, allowing users to copy Retouch tool entries from one picture to another. Though not all that useful in the example demonstrated here, this synchronize option is a godsend for photographers struggling with removing sensor dust from the same position in every image. ACR is so clever that it even accounts for changes in camera orientation when it is applying synchronized spot retouching.

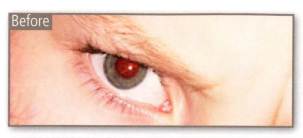

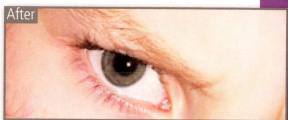

Red Eye Removal

From version 4.0 of Adobe Camera Raw the utility included a Red Eye Removal tool. The feature works in a similar way to the Red Eye tool in Photoshop proper. After selecting the tool, click-drag a marquee around the red eye to replace the color with a more realistic dark gray. The Pupil Size and Darken sliders can be used to fine-tune the results if the initial correction is not successful.

It is important to note that the changes made with the Red Eye Removal and the Retouch tools in ACR are non-destructive and can be removed at any time by selecting the Clear All button in the options bar.

Open Preferences Dialog

The Open Preferences Dialog button located on the ACR toolbar displays the same settings dialog as when you select Edit > Camera Raw Preferences inside Bridge. The options listed here control the way that ACR behaves. Entries include:

Save image settings in – Here you can choose between saving the conversion or Develop settings you use with your raw files to XMP-based sidecar files or a centralized database. If your images are only ever enhanced on a single machine with the same software then the central system is a good choice. If your image library is accessed by multiple machines using different workflows and associated software then XMP files will be a better choice.

Apply sharpening to – Select whether to apply sharpening to all images or just the previews.

Apply auto tone adjustments – Set the Develop settings to apply the auto option by default when first bringing the photo into ACR. The auto option in the latest version of ACR determines settings based on the characteristics of individual photos.

Apply auto grayscale mix when converting to grayscale – This option instructs ACR to examine the content of the photo being converted to grayscale and automatically determine the manner in which colors are mapped to gray. Again this is on an image-by-image basis.

Make defaults specific to camera serial number – Saves any fine-tuning of the way that ACR handles files for specific cameras rather than more generically for models. This setting is handy for specialized circumstances where images from multiple cameras of the same model type are processed via ACR.

Maximum size of Camera Raw cache – Determines the maximum size of the preview cache used by ACR.

Purge cache – Deletes the current system-wide camera raw cache.

Cache location – Sets the location of the camera raw cache.

Ignore sidecar files for DNG – When opening existing DNG files this setting instructs ACR to ignore any settings contained in associated sidecar or XMP files.

Update embedded JPEG previews for raw files – Automatically updates the JPEG previews attached with DNG files when opening. You can also select the size of these previews from the drop-down menu listed here.

Always open JPEG files with settings using Camera Raw – Displays JPEG files with any associated ACR settings previously saved.

Always open TIFF files with settings using Camera Raw – Displays TIFF files with any associated ACR settings previously saved.

Note: For the first time in ACR 4.0 both JPEG and TIFF files can be opened and enhanced in the program. When hitting the Done button the ACR Develop settings are applied to the files just as they are for raw. If the two last settings are not selected then the ACR settings are ignored when the files are opened directly into Photoshop.

Rotate image 90° CCW or rotate image 90° CW

The rotate buttons provide a quick way to reorientate images that have been shot vertically but appear as horizontals. This is less of a problem nowadays as most raw-enabled cameras also have the ability to recognize and record the orientation used for picture taking. This information is stored in the metadata of the photo and used at the time of import to correctly orientate the image.

Both buttons rotate the image in full 90° steps, one working clockwise, the other counter-clockwise. For rotating photos in steps other than 90°, draw a marquee first with the Crop tool and then rotate the marquee by dragging the cursor outside the boundaries of the marquee.

Toggle Mark for Delete

There are a range of simple editing options available to the user when several images are listed in the queue area of the ACR dialog. These include the Select All, Select Rated, Synchronize and Mark for Delete features.

The Toggle Mark for Delete button adds, or removes, a deletion red cross from the top right-hand corner of the image thumbnail. When marked for deletion images are automatically moved to the Trash when the ACR dialog is closed. Because this is akin to hitting the Delete key it is important to be very careful when using this feature.

To add a deletion red cross to any image, select the picture from the queue group and click the Toggle Mark for Delete button. To remove the cross, click the Toggle button a second time with the same image selected.

The Toggle Mark for Delete button only appears on the ACR toolbar when multiple images are queued on the left of the dialog.

Preview

The Preview checkbox located on the right-hand end of the ACR toolbar controls if the settings currently selected are applied and displayed in the preview image. Unchecking the Preview option means that any changes made to the slider controls will not be seen in the preview image. This setting should always be checked by default.

Toggle Full Screen

New from the 4.0 version of Adobe Camera Raw is the ability for the dialog to be enlarged to full screen mode. Until this edition the utility was only available for display in a floating window version.

Clicking the Toggle Full Screen button will enlarge the ACR dialog to full screen. The larger dialog means that the preview area is much bigger, leading to less need for zooming to check details in the photo. Click the button again to reduce it back to its original size.

Tabbed control panes

The right-hand side of the ACR dialog contains the histogram at the top of the screen and then a series of tabbed panes underneath. It is the controls grouped in these panes that allow users to enhance their raw files. From version 4.0 the number of panes has been increased from five to eight. Let's look at each in turn.

Basic (formally Adjust)

The controls in this pane can be broken down into three main sections – white balance, tonal and color controls. The controls are sequenced so that users work their way from the top of the pane to the bottom to enhance their photos.

White Balance controls – The White Balance menu provides a range of preset options that duplicate those found in your camera. As the raw file doesn't have a fixed white balance you can select a different option here than the one set on your camera. If you need a little more control then the Temperature and Tint sliders allow for white balance fine-tuning. The Temperature slider values are measured in kelvin, a measure of the color of light. So if you know the color temperature of the light source then match this slider to the light source value. In the absence of this information move the Temperature slider to the left to account for yellow casts, or a warm light source, or to the right for blue casts, or a cool light source. The Tint slider works with magenta and green casts and is typically used for neutralizing casts associated with fluorescent light sources.

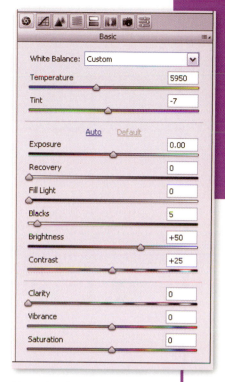

The Basic tab contains the main controls that you use for enhancing the tones and colors in your raw photos.

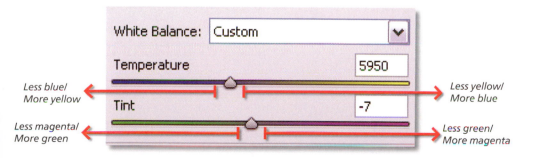

The Temperature slider is used to adjust the balance between yellow and blue in the photo and is linked to an incremental scale called degrees kelvin which is a photographic measure of color temperature. The Tint slider balances the magenta/green light in the image and is typically used to eliminate color casts caused by fluorescent strip lighting.

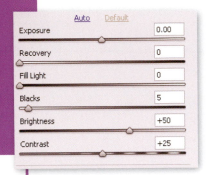

Tonal controls and auto function.

Tone controls – Below the white balance controls are six sliders that are used for adjusting the tones of the photo.

Exposure is used to alter the brightness of all the tones. Make sure that highlight clipping warning is activated before using this control. Moving the slider to the right pushes tonal detail towards the right end of the histogram. For best results move the slider to the right until you see the first pixels being clipped and back the control off a little so no tones are clipped. This sets your highlights.

The Recovery and Fill Light controls are new for the latest version of ACR. The Recovery slider attempts to rebuild any highlight detail that has been clipped in-camera. It does this by using detail in any non-clipped channels. As long as detail remains in two of the three channels then the slider can reconstruct the highlights. The Fill Light slider concentrates the changes it makes to the darkest tones in the picture. The control can lighten detail normally hidden in the shadow area. Both of these controls should be used carefully as over-application can make a picture look dull and lacking in contrast. Too much Fill Light application can also produce the appearance of halos.

Pro's tip: For quick indications of clipping hold down the Alt/ Opt key while moving the Exposure or Blacks sliders.

The Blacks slider adjusts the point at which image detail is converted to pure black. Make sure that the clipping warning is activated before using this slider. Like the Exposure slider the best way to use this control is to move it to the right until you start to see clipping and then pull the slider to the left slightly until no clipping is present. This action sets the black point of the photo.

The Brightness control makes the midtone values of the image brighter

The 0–100 Clarity scale will provide enough range for most local contrast changes. For those occasions when substantial alterations are necessary, you can always apply the effect, save the image as a TIFF file (this applies the development settings), re-open the photo in Adobe Camera Raw and then apply the effect again. Be careful though, as this method removes the possibility of retracing your steps and undoing the effect if the changes prove too strong.

(slider movements to the right) or darker (movements to the left) without unduly affecting the black or white points of the photo.

The Contrast slider controls the contrast or spread of tones in the image. Increasing the contrast, moving the slider to the right, will spread the image tones towards the extremes of the histogram. Decreasing contrast bunches the pixels around the middle of the graph, making the image appear flat.

It is a good idea to keep the clipping warning features active when making all the tonal changes listed here. Even though the Exposure and Blacks sliders are primarily responsible for 'pegging' or establishing the white and black points of the photo, it is possible that some readjustment to these points may be necessary after alterations made with the other tonal sliders.

Color controls – The last section of the Basic pane contains three controls – Clarity, Vibrance and Saturation. Clarity and Vibrance are new additions to the group. The Clarity control adds local contrast to images shot under flat lighting conditions or when the subject comprises of very similar tones.

The Vibrance slider, like the Saturation control, increases the vividness of the colors in photos but applies the changes selectively to only those hues that are destaurated in the first place. This means that the slider targets the more pastel tones and doesn't boost those colors that are already rich vibrant. In addition, the Vibrance slider tends to safeguard skin tone when it is applied.

In contrast the Saturation slider increases the saturation, or vividness, of all the colors in a photo irrespective of their original value. These factors make the Vibrance slider perfect when working with portraits or photos where selective adjustment is needed. The Saturation slider, on the other hand, is very useful for bumping the color of the whole photo up a few notches.

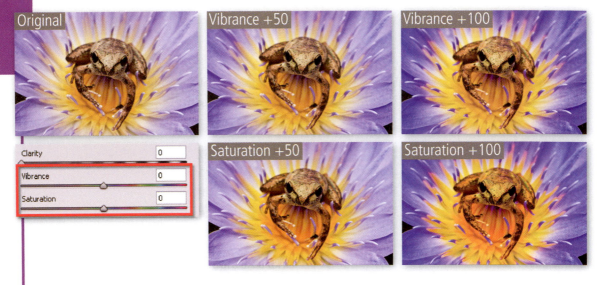

Tone Curve (formally Curve)

The Tone Curve feature provides the user with the ability to manipulate tones in a non-linear fashion. Experienced film aficionados often find working with a curves-based control easier to understand than a series of sliders that operate on specific tonal ranges. Well, in the latest version of the ACR curves control users are spoilt for choice. The feature now contains two distinct modes – Parametric and Point.

The Parametic option breaks the curve into four tonal areas – highlights, shadows, lights and darks – and then provides slider controls to alter each range of tones independently. Unlike the standard curve mode (or Point mode as it is called here) the user doesn't change the spread of tones in the picture by directly pushing or pulling the curve; instead the sliders are used to change the curve shape.

You can also refine the adjustments by altering the position and range of the tonal quadrants via the three sliders directly under the curve graph. This allows the user to spread or reduce the range of tones for each of the four tonal groupings.

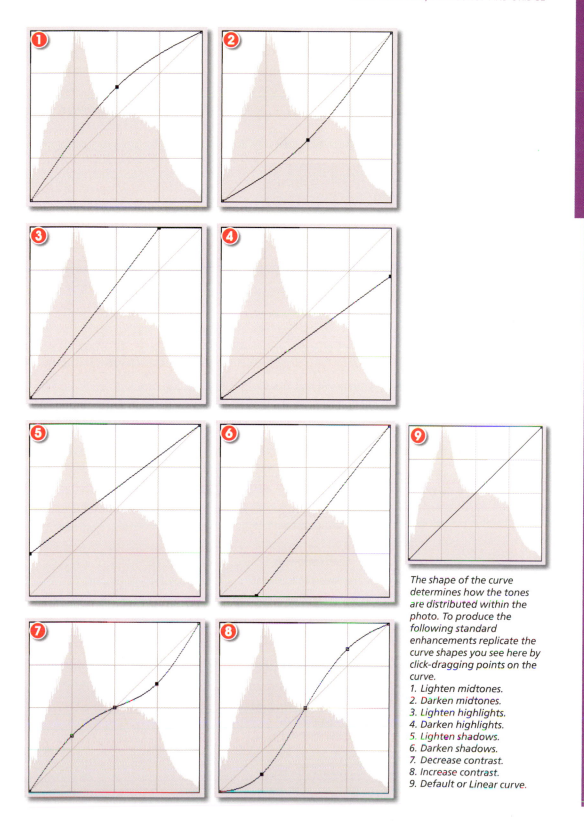

The shape of the curve determines how the tones are distributed within the photo. To produce the following standard enhancements replicate the curve shapes you see here by click-dragging points on the curve.

1. Lighten midtones.
2. Darken midtones.
3. Lighten highlights.
4. Darken highlights.
5. Lighten shadows.
6. Darken shadows.
7. Decrease contrast.
8. Increase contrast.
9. Default or Linear curve.

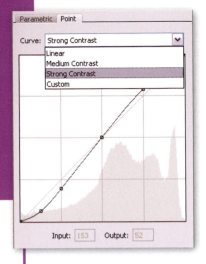

The Point mode in the Tone Curve works in a much more traditional manner, allowing you to push and pull the shape of the curve around via a series of control points. The points are added to the curve by clicking onto the curve line. The number and position of the points will affect how the curve bends and deforms when it is repositioned. Most photographers use the control points to establish key tonal areas around which the changes will pivot. As well as providing free form manipulation of the curve, the Point dialog also contains a drop-down menu containing popular curve manipulation options.

To help with making informed decisions about tonal changes via the curves control, Adobe has shadowed a luminosity (detail) histogram in the background of the dialog.

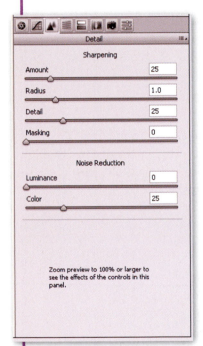

Detail

In the latest version of ACR the sharpening controls have been increased to four from a single slider a couple of versions ago. Where originally users were only able to control the Amount of sharpening, now it is possible to manipulate where the effect is applied. Sharpening effects are controlled via the following sliders – Amount, Radius, Detail and Masking.

The Amount slider controls the strength of the sharpening effect. Move the slider to the right for stronger sharpening, to the left for more subtle effects. The Radius slider determines the number of pixels from an edge that will be changed in the sharpening process. The Detail slider is used to increase the local contrast around edge parts of the picture. Doing so makes the picture's details appear sharper. The Masking control channels the sharpening effect through an edge locating mask.

Both the Detail and Masking sliders are used to target the sharpening more precisely in the image. Increasing the Detail value will raise the local contrast around smaller picture parts. Reducing the value will decrease the appearance of halos around these areas. Moving the Masking slider to the right gradually isolates the edges until the sharpening is only being applied through the most contrasty sections of the photograph.

With the preview at 100% magnification, holding down the Alt/Opt key will display different previews for each of the Sharpening sliders. The preview for the Amount slider shows the sharpening applied to

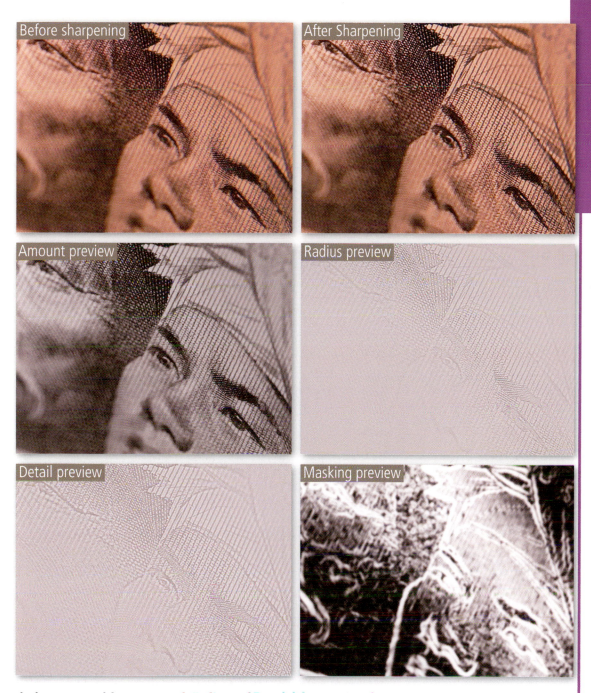

Before sharpening

After Sharpening

Amount preview

Radius preview

Detail preview

Masking preview

the luminosity of the image. Both Radius and Detail sliders preview the value of the slider and the Masking option displays the mask being used for restricting where the sharpening is being applied. Remember the black areas of the mask restrict the sharpening and the light areas allow the sharpening to be applied.

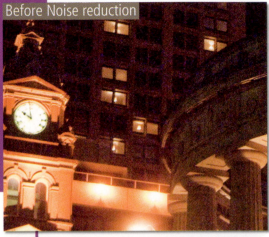

Before Noise reduction

After Noise Reduction

The next section in the Detail pane contains two controls for dealing with the noise in a raw image. Titled Luminance and Color, each slider deals with a different type of noise issue.

The Luminance slider concentrates on the grayscale, or 'grain-like', noise in the image. The control attempts to remove this spotiness from the photo while still maintaining edge detail in the photo. In contrast, the Color slider works on removing the random red, green and blue pixels that appear in photos taken with a long exposure or high ISO setting. Don't expect these controls to turn an unusable 3200 ISO photo into an image that looks like it has been captured with the 200 ISO setting, but they are capable of noticeable noise reduction in problematic images.

In the latest revision of ACR, the design team took the opportunity to tweak the noise reduction algorithms. Though the effects are not as dramatic as those possible via other methods (see the noise reduction section in Chapter 12), the changes are definitely an improvement.

HSL/Grayscale

Drawing inspiration from the type of features that we have seen in Photoshop Lightroom, the sliders here provide control of the Hue, Saturation and Luminance of each color group (red, orange, yellow, green, aqua, blue, purple and magenta) independently.

This is a great improvement over what was available previously, when color changes were limited to red, green and blue channel-based divisions and saturation control.

Hue – The Hue tab in the HSL control provides the ability to tweak the flavor of a specific color range. Unlike the drastic changes brought about by the Hue control in Photoshop's Hue/Saturation feature, the sliders here manipulate the color of a selected color within a given range. The Reds slider, for instance, moves from a magenta red through to a pure

red to an orange red. Moving this slider would enable the fine-tuning of just the reds in a photo between these limits.

Saturation – The Saturation control provides the ability to customize the saturation of not the whole image as is provided with the Saturation slider in the Basic pane, but a specific range of colors.

Luminance – The third tab in the HSL control deals strictly with the luminance of specific colors. With the sliders grouped here it is possible to change the brightness of a color grouping, which can translate into altering the color contrast in a photo by selectively increasing and decreasing the brightness of opposite hues.

Grayscale – By clicking the Convert to Grayscale option the feature changes to provide a method for creating custom mapping of the same color groupings to gray. Using this control it is possible to restore contrast to a grayscale conversion when the colors in the photo have translated to similar tones of gray, producing a low-contrast monochrome.

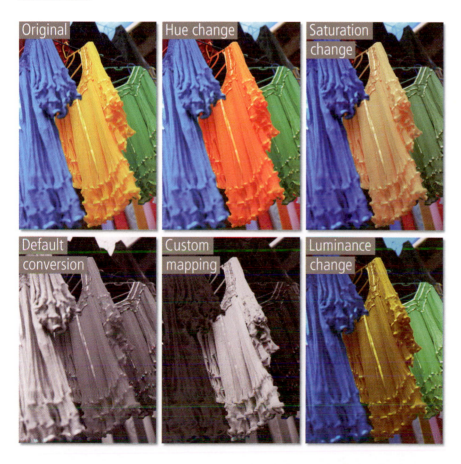

Split Toning

Monochrome printers can now rejoice as the addition of this feature means that you can tone highlights and shadows independently with the included Hue and Saturation sliders. Hue controls the color of the tint and Saturation its strength. Holding down the Alt/Opt key while moving either of the Hue sliders, will preview the tint at 100% saturation, allowing for easier selection of the correct color. To understand how the Hue slider works imagine the control moving progressively through the colors of the rainbow from red, through yellow, green and blue to purple and magenta.

Also included is the Balance slider, which provides the ability to change the point at which the color changes. Movements to the right push the split point towards the highlights, whereas dragging the slider to the left means that more mid to shadow areas will be colored the selected highlight hue.

To use split toning with a monochrome image you must make the conversion to grayscale first. Do this by selecting the Convert to Grayscale option in the HSL/Grayscale pane first. Then move back to the Split Toning pane and adjust Highlight and Shadow Hue and Saturation and then the Balance point to suit.

Pro's tip: Don't restrict your split toning activities solely to the realms of monochromes. The feature can also be applied to color images as well, providing some rather unusual but striking results.

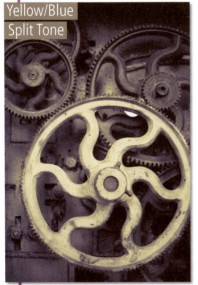

Yellow/Blue Split Tone

Original

Default conversion

Yellow highlights

Blue shadows

Lens Corrections (formally Lens)

The Lens Correction pane contains options for correcting three different types of imaging problems associated with lens design – Chromatic Aberration, Fringing and Vignetting.

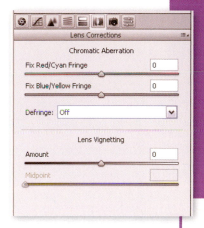

Two sliders are available to help with Chromatic Aberration, or the situation where edges recorded towards the outer parts of the frame contain slight misalignment of colors. Caused by a lens not focusing all the visible wavelengths together on a sensor, the sliders are designed to realign the problem areas and, in so doing, remove the colored edges.

Included for the first time from ACR 4.1 is the ability to control, to some extent, the sensor 'flooding' caused by overexposure in picture areas such as specular highlights. Located in the Lens Corrections panel, the new Defringe drop-down menu contains three options – Off, Highlight Edges, and All Edges. Selecting the Highlight Edges option decreases the purple-colored areas that often surround brightly lit metallic surfaces or sparkly water reflections. These errant colors are not caused by lens aberrations but rather result from a small selection of sensor sites being overexposed. Switching to the All Edges setting applies the effect to all the fringe areas in the image.

Vignetting is the slight darkening or lightening of the corners of a photo due to the inability of the lens to provide even illumination across the whole surface of the sensor. Most prevalent in ultra-wide-angle lenses when coupled with cameras with full frame sensors, two sliders are included in the Lens Correction pane to deal with this problem. When the Amount slider is moved to the right it lightens the corners. Dragging the control to the left has the opposite effect. The Midpoint control alters the amount of the frame affected by the vignetting correction. Higher settings concentrate the corrections to the corners of the frame.

The new Defringe option helps remove the purple color that can surround very bright highlights.

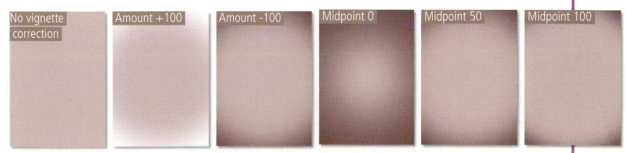

The features located under the Lens tab are designed to aid in the correction of typical lens faults. The first two sliders are used to correct chromatic aberration (1) or the strange color edges that can fringe the sides of contrasting picture elements. Also included in this dialog is the ability to correct vignetting (2) or the darkening of the corners of a photo. The Amount slider controls the strength of the correction effect and the Midpoint alters how much of the image is included in the enhancement.

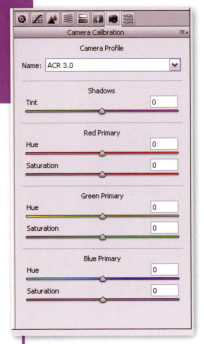

Intentional vignetting can can also be added as a creative effect to help focus the viewer's eye on the central portion of the image. To preview the results of all these controls make sure that the image is being displayed at 100% or greater.

Camera Calibration (formally Calibrate)

The Camera Calibration pane provides four sets of sliders that can be used to fine-tune the camera profiles that ship with ACR. These profiles are specific to individual manufacturers and camera models and will suit most users' needs straight out of the box. That said, there may be occasions when difficult lighting, or the wayward characteristics of a specific camera, could benefit from some fine-tuning of how the raw data is interpreted by ACR.

Keep in mind that this is not a task that you would undertake for all images; instead, it is a calibration activity that you perform when encountering a difficult shooting scenario or acquire a new camera body. To get the best from the controls listed here you should make adjustments based on a reference photograph containing a color target such as the Mini ColorChecker available from X-Rite(Gretagmacbeth). Also you will need to make sure that the key adjustments in the Basic tab are set first before starting the Camera Calibration process.

For more details on how to perform the calibration process go to Chapter 9. In the meanwhile, here are some details on the functions of each of the sliders:

Shadow Tint – This control adjusts the red–green balance tint of the shadow areas. Whereas the White Balance controls in the Basic pane target the color of the highlight areas, this slider works with the shadows.

Red, Green, Blue Primary Hue – The Hue sliders tweak the key colors in the photo within a broad range and are similar in function to the Hue sliders in the HSL/Grayscale pane.

Red, Green, Blue Primary Saturation – These controls concentrate on manipulating the strength of the specific colors in relation to each other.

Presets

The Presets pane provides a single common area to store the settings, and groups of settings, that you save. Once saved and listed in the

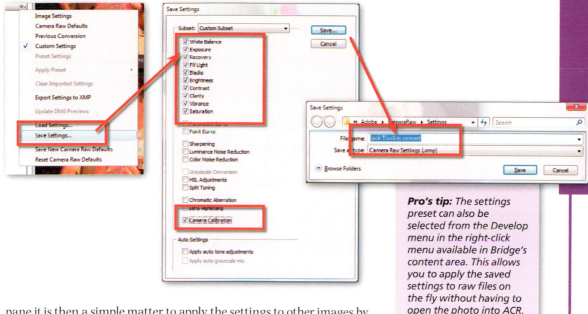

Pro's tip: *The settings preset can also be selected from the Develop menu in the right-click menu available in Bridge's content area. This allows you to apply the saved settings to raw files on the fly without having to open the photo into ACR.*

pane it is then a simple matter to apply the settings to other images by opening the photo and selecting the option from the list.

Saving settings is also an easy task. Start by adjusting the slider controls in the various panes until you achieve the result that you want. Next click on the Presets menu button in the top right of the pane. Select the Save Settings option from the pop-up menu. In the settings dialog that appears, choose the settings that you want to save in the preset and click Save. Add in a name for the presets in the window that appears and click Save again. The newly created preset now appears in the Presets pane ready for application.

ACR output options

Apart from the Open Image button ACR provides several other options that will govern how the file is handled from this point onwards. To this end, the lower part of the dialog contains four buttons: Save Image, Open Image, Cancel and Done, and a further four, Save Image (without the options dialog), Reset and Open Copy when the Alt/Option button is pushed, and Open Object when the Shift key is pushed.

Cancel: This option closes the ACR dialog, not saving any of the settings to the file that was open.

Save Image: The normal Save Image button, which includes several dots (...) after the label, displays the Save Options dialog. Here you can

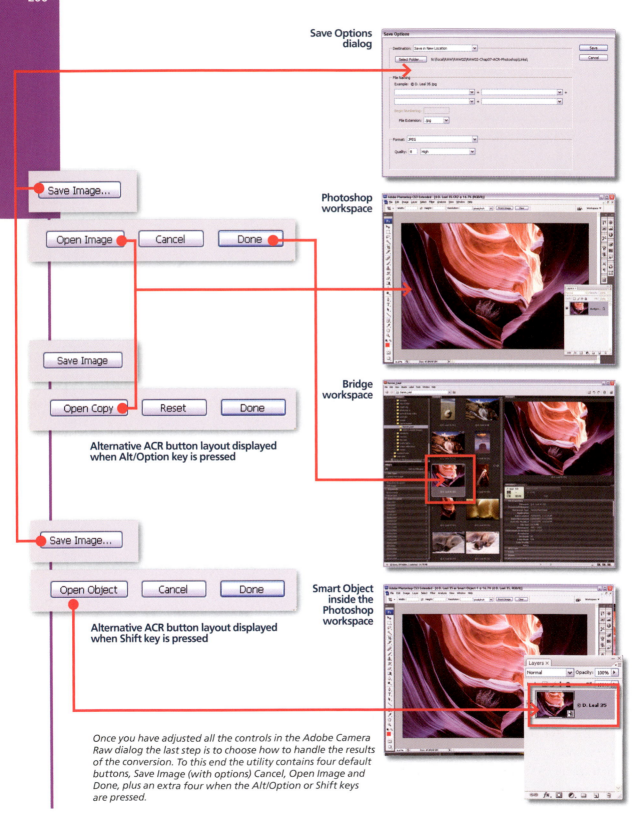

Save Options dialog

Save Image...

Open Image | **Cancel** | **Done**

Photoshop workspace

Save Image

Open Copy | **Reset** | **Done**

Bridge workspace

Alternative ACR button layout displayed when Alt/Option key is pressed

Save Image...

Open Object | **Cancel** | **Done**

Smart Object inside the Photoshop workspace

Alternative ACR button layout displayed when Shift key is pressed

Once you have adjusted all the controls in the Adobe Camera Raw dialog the last step is to choose how to handle the results of the conversion. To this end the utility contains four default buttons, Save Image (with options) Cancel, Open Image and Done, plus an extra four when the Alt/Option or Shift keys are pressed.

save the raw file, with your settings applied, in Adobe's own DNG format as well as TIFF, JPEG and PSD formats. The dialog includes options for inputting the location where the file will be saved, the ability to add in a new name as well as format-specific settings such as compression, conversion to linear image and/or embed the original raw file for the DNG option.

It is a good idea to Select Save in Different Location in the Destination drop-down at the top to separate processed files from archived originals. Clearly the benefits of a compressed DNG file are going to help out in the storage issue arena and compression is a big advantage with DNG. Embedding the original raw file in the saved DNG file begs the questions of how much room you have in the designated storage device and whether you really want to have the original raw file here.

Save (without save options): Holding down the Alt/Option key when clicking the Save button skips the Save Options dialog and saves the file in DNG format using the default save settings, which are the same as those last set.

Open Image : If you click on the Open Image button ACR applies the conversion options and opens the file inside the Photoshop workspace. At this point, the file is no longer in a raw format so when it comes to saving the photo from the Editor workspace Photoshop automatically selects the Photoshop PSD format for saving.

Reset: The Reset option resets the ACR dialog's settings back to their defaults. This feature is useful if you want to ensure that all settings and enhancement changes made in the current session have been removed. To access the Reset button click the Cancel button whilst holding down the Alt/Option key.

Done: Clicking the Done button will update the raw conversion settings for the open image. Essentially this means that the current settings are applied to the photo and the dialog is then closed. The thumbnail preview in the Bridge workspace will also be updated to reflect the changes.

Open Copy: Holding down the Alt key whilst clicking the Open button will apply the currently selected changes and then open a copy of the file inside the Photoshop workspace.

Open Object: The most exciting new addition to the list of ACR output options is the Open Objects entry, which is displayed when the Shift key is held down. Choosing Open Object will create a new document in Photoshop and embed the raw file in the document as a Smart Object. This route for transferring your files to Photoshop is the only one that continues to work with the picture in a lossless manner and is the core of all non-destructive editing techniques discussed in Chapters 10, 11 and 12.

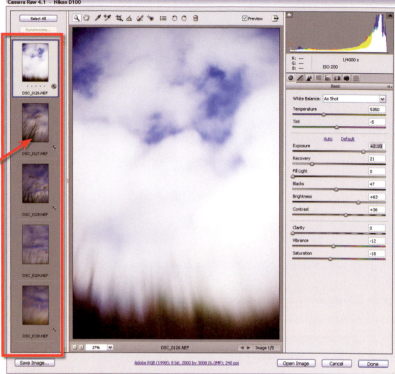

Queueing files for processing

As well as being able to process files one at a time, Adobe Camera Raw is capable of queueing multiple raw files and work on this either in sequence or in sets of pictures. When several raw photos are selected inside Bridge and then opened into ACR (File > Open in Camera Raw) the pictures are listed on the left side of the dialog. The same scenario occurs when selecting multiple pictures in the File > Open dialog from inside Photoshop.

Once loaded into ACR the files can be worked on individually by selecting each thumbnail in turn, making the necessary changes and then moving to the next picture in the list. But there is a more efficient way to process multiple files. Firstly, select a group of images either taken under the same conditions with similar subject matter, or that you are wanting to process

in a similar way (e.g. convert to grayscale and then sepia tone). Next open these into ACR using the keyboard shortcut Ctrl/Cmd + R. Now pick one of the photos that best represents the characteristics of the group and proceed to make the corrections to color, tone and sharpness that you would normally. When complete, pick the Select All button at the top of the Queue section of the dialog to pick all queued photos, or multi-select a subset of photos and then push the Synchronize button. The Synchronize dialog will be displayed listing all the ACR controls that can be copied from the initial photo to the rest of the group. Select, or deselect, the controls as desired, and then click OK. Automatically the settings are synchronized across all the selected photos.

This provides a good starting point for the enhancement process; all that now remains is to flick through each individual image and double check that the settings are working for that specific photo. If need be, then the settings can be fine-tuned to better suit any image.

Once the settings have been applied, the images can be saved, opened, copied or opened as objects just like any other files. When more than one picture is selected from the queue grouping, the output button titles change to plural to account for the fact that multiple photos will be saved, opened, copied, etc.

Another way to select a subset of images from those listed is to rate the pictures you want to apply common settings to and then select these photos with the Select Rated button (hold down the Alt/Opt key). With the Alt/Opt key still depressed, clicking the Synchronize button will synchronize using the last settings without displaying the Synchronize dialog.

Processing with Photoshop, Bridge and Adobe Camera Raw

With the basics now out of the way let's concentrate on the steps that you would take when processing a raw file in Photoshop, Bridge and Adobe Camera Raw.

Opening

With the inclusion of Bridge from Photoshop CS2 there are now more ways to open your raw files.

1. Opening the raw file in Photoshop

After downloading from the camera you can start processing the raw files. To do this you must start by opening the picture into the conversion utility. The simplest option is to select File > Open from inside Photoshop. This will import the photo into the Adobe Camera Raw (ACR) utility.

2. Using Bridge to open ACR in Photoshop

Bridge users can achieve the same result by right-clicking the file's thumbnail and then choosing Open With > Photoshop.

3. Opening into ACR in Bridge

Alternatively the photo can be imported directly into ACR without having to open Photoshop first by right-clicking and then selecting Open in Camera Raw. Working in Bridge allows for faster raw processing as the conversions take place without the need to share computer resources with Photoshop at the same time.

Pro's tip: The preferences for Bridge can be adjusted so that double-clicking a thumbnail of a raw picture will automatically open the file in Camera Raw in the Bridge workspace. If this option is not selected then double-clicking will open the file in ACR in the Photoshop workspace.

Rotate and Straighten/Crop

4. Rotate right (90 CW) or left (90 CCW)

Once the raw photo is open in ACR you can rotate the image using either of the two Rotate buttons next to the preview window. If you are the lucky owner of a recent camera model then chances are the picture will automatically rotate to its correct orientation. This is thanks to a small piece of metadata supplied by the camera and stored in the picture file that indicates which way is up.

5. Straightening horizons or verticals

Photoshop and Bridge users can fine-tune the rotation of their pictures with the new Straighten tool. After selecting the tool click and drag a straight line along an edge in the photo that is meant to be horizontal or vertical. Upon releasing the mouse button ACR automatically creates a crop marquee around the photo. You will notice that the marquee is rotated so that the edges are parallel to the line that was drawn with the Straighten tool. When you exit ACR by saving or opening (into Photoshop) the picture, the rotated crop is applied.

6. Cropping to suit

Also new to the latest release of ACR which can be found in Photoshop or Bridge is the Crop tool. The feature works just like the regular Crop tool in Photoshop proper, just select and then click and drag to draw a marquee around the picture parts that you want to retain. The side and corner handles on the marquee can be used to adjust the size and shape of the selected area. The crop is applied upon exiting the ACR dialog. Predefined crop formats are available from the menu accessed by clicking and holding the Crop tool button. Also included is a Custom option where you can design your own crops to suit specific print or other outcome requirements.

Step by step

Adjusting white balance

Unlike other capture formats (TIFF, JPEG) the white balance settings are not fixed in a raw file. ACR contains three different ways to balance the hues in your photo.

7. Preset changes

You can opt to stay with the settings used at the time of shooting ('As Shot') or select from a range of light source-specific settings in the White Balance drop-down menu of ACR. For best results, try to match the setting used with the type of lighting that was present in the scene at the time of capture. Or choose the Auto option to get ACR to determine a setting based on the individual image currently displayed.

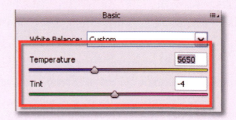

8. Manual adjustments

If none of the preset White Balance options perfectly matches the lighting in your photo then you will need to fine-tune your results with the Temperature and Tint sliders (located just below the Presets drop-down menu). The Temperature slider settings equate to the color of light in degrees kelvin – so daylight will be 5500 and tungsten light 2800. It is a blue to yellow scale, so moving the slider to the left will make the image cooler (more blue) and to the right warmer (more yellow). In contrast the Tint slider is a green to magenta scale. Moving the slider left will add more green to the image and to the right more magenta.

9. The White Balance tool

Another quick way to balance the light in your picture is to choose the White Balance tool and then click onto a part of the picture that is meant to be neutral gray or white. ACR will automatically set the Temperature and Tint sliders so that this picture part becomes a neutral gray and in the process the rest of the image will be balanced. For best results when selecting lighter tones with the tool ensure that the area contains detail and is not a blown or specular highlight.

Tonal control

Then next group of image enhancements alters the tones within the photo. There are five different slider controls each dealing with a specific group of image tones. Each of the controls has an Auto option that when checked will let ACR decide on the best tonal setting to use. Use the following steps if you want a little more control.

10. Setting the white areas

To start, adjust the brightness with the Exposure slider. Moving the slider to the right lightens the photo and to the left darkens it. The settings for the slider are in f-stop increments, with a +1.00 setting being equivalent to increasing exposure by 1 f-stop. Use this slider to peg or set the white tones. Your aim is to lighten the highlights in the photo without clipping (converting the pixels to pure white) them. To do this, hold down Alt/Option whilst moving the slider. This action previews the photo with the pixels being clipped against a black background. Move the slider back and forth until no clipped pixels appear but the highlights are as white as possible.

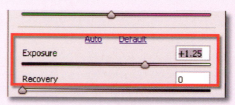

11. Adjusting the blacks (shadows)

The Blacks slider (previously Shadows) performs a similar function with the shadow areas of the image. Again the aim is to darken these tones but not to convert (or clip) delicate details to pure black. Just as with the Exposure slider, the Alt/Option key can be pressed whilst making Blacks adjustments to preview the pixels being clipped. Alternatively the Shadow and Highlights Clipping Warning features can be used to provide instant clipping feedback on the preview image. Shadow pixels that are being clipped are displayed in blue and clipped highlight tones in red.

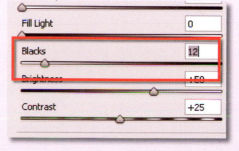

12. Brightness changes

The next control, moving from top to bottom of the ACR dialog, is the Brightness slider. At first the changes you make with this feature may appear to be very similar to those produced with the Exposure slider but there is an important difference. Yes it is true that moving the slider to the right lightens the whole image, but rather than adjusting all pixels the same amount the feature makes major changes in

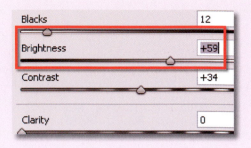

the midtone areas and smaller jumps in the highlights. In so doing the Brightness slider is less likely to clip the highlights (or shadows) as the feature compresses the highlights as it lightens the photo. This is why it is important to set white and black points first with the Exposure and Shadows sliders before fine-tuning the image with the Brightness control.

13. Increasing/decreasing contrast

The last tonal control in the dialog, and the last to be applied to the photo, is the Contrast slider. The feature concentrates on the midtones in the photo, with movements of the slider to the right increasing the midtone contrast and to the left producing a lower contrast image. Like the Brightness slider, Contrast changes are best applied after setting the white and black points of the image with the Exposure and Contrast sliders.

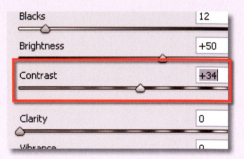

14. Tweaking problem areas

The Fill Light and Recovery sliders are new for the latest version of ACR. Use Fill Light to boost the brightness of just the middle to dark tones in the photo. Employ the Recovery control to rebuild the lost image data that occurs when overexposure has caused one of the color channels to be clipped.

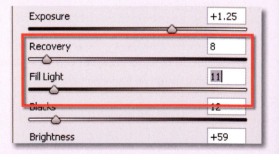

Color strength adjustments

As one of the primary roles of the Adobe Camera Raw utility is to interpolate the captured colors from their Bayer mosaic form to the more usable RGB format it is logical to include a color strength adjustment as one of the controls in the process.

15. Increasing clarity

The Clarity slider can be used to increase the local contrast of images taken in hazy or overcast weather or with diffused lighting. When applying watch that fine details are not overly darkened by the control.

16. Vibrance and Saturation controls

The strength of the colors in the photo can be adjusted using the Vibrance and Saturation sliders. Vibrance boosts image colors that are desaturated whilst protecting skin tone values, whereas the Saturation control increase the vividness of all hues. Moving the Saturation slider to the right increases saturation, with a value of +100 being a doubling of the color strength found at a setting of 0. Saturation can be reduced by moving the slider to the left, with a value of -100 producing a monochrome image.

Lens corrections

The Lens tab contains tools for correcting three of the most common lens faults – color fringing and vignetting.

17. Reducing the appearance of color fringing

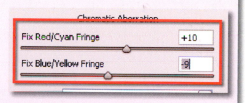

Chromatic aberration is essentially a lens flaw where color edges appear around the perimeter of picture parts. This occurs because the lens fails to focus all colors at the same point in the picture. The two sliders in this part of the dialog are designed to correct this problem. To obtain the best results zoom into the raw preview and locate an area that contains fringing. The sliders are split into two groups, Red/Cyan and Blue/Yellow. Move one at a time back and forth until you find a point where the fringing is least apparent.

Pro's tip: Holding the Alt/Option key down whilst adjusting either slider hides the other fringing colors.

18. Reducing blooming-based fringing

In cases of extreme overexposure generally caused by pin or specular highlights, these clipped areas of the image can be tinted with a tinge of magenta. Use the options here to remove the problem.

19. Counteracting vignetting

Vignetting or the darkening of the corners of a photo is another lens aberration that can be corrected with the help of the controls grouped under the Lens tab. To start adjust the zoom of the preview so that you can see the whole image. Move the Amount slider to the right to lighten the corners and to the left to darken them. The Midpoint slider controls the amount of the picture changed by the feature. Moving the slider to the left includes more of the picture, movements to the right restrict the changes to just the immediate area around the corners.

Curve controls

Need even more control over the tones in your photo? Then it is time to tweak those pesky shadow and highlight pixels with the Curves feature. For straight changes to highlight and shadow points and the brightness of the midtones look to the controls found under the Adjust tab, but for sophisticated compression and expansion of specific ranges of tones then Curves is the feature to use. Many photographers apply a little Curves adjustment as the final enhancement step in the raw conversion process. The alteration may be to better suit the picture tones to the way that a temperamental printer prints or as a way of providing a signature 'look' to their photographic work; either way, Curves offers great flexibility for tonal enhancement.

20. More tonal adjustments

In this example I have tweaked the curve to add a little more contrast to the whole image. I start by pegging the midpoint (adding a control point to the middle of the curve). This will act as a pivot for the other Curves alterations and will ensure that the middle tones in the image stay put. Next I click on the highlight area (upper right) and push this part of the curve upwards slightly. This lightens these tones. Now to the shadows. Here I click on the shadows and push down slightly and then add a second point lower on the curve and do the same thing. Two points in this region give me better control over how the shadow detail is represented. The overall effect is that of a simple contrast-increasing curve.

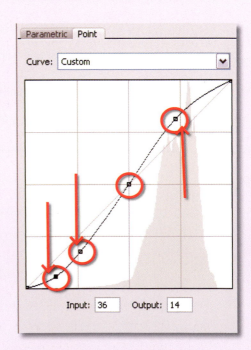

Fine-tune color with calibration

In most photographs the occasional cast appearing in the shadow area of a picture that is different to the highlight is not a major problem. For these majority of images the Temperature/ Tint controls under the Adjust tab will suffice but for those occasions where absolute control is needed then most professionals click onto the Calibrate tab.

21. Controlling shadow color

The Camera Profile is the version number of ACR when the camera was profiled. So the Canon 20D will only show ACR 2.4. Some have been reprofiled so they may show two versions of the profile. In this case start by choosing the Camera Profile you want to modify. If you are not using an embedded profile and haven't enhanced the image before in a previous version of ACR, then choose ACR 3.0.

Next move the Shadow Tint slider to try to obtain a neutral shadow tone. In most cases moving the slider to the left adds green to the shadows and to the right adds magenta but this is largely dependent on the way that your camera sensor functions.

Refine the color of the shadow areas further by adjusting the Hue and Saturation of the individual color channels (red, green and blue).

Sharpness/smoothness and noise reduction

With the tones and colors now sorted let's turn our attention to sharpening and noise reduction. Both these image enhancements can be handled in-camera when not shooting raw, using one of a variety of auto settings found in the setup menu, but for raw shooters control over sharpness and noise reduction occurs back at the desktop.

22. To sharpen or not to sharpen

Sharpening is an enhancement technique that is easily overdone and this is true even when applying the changes at the time of raw conversion. The best approach is to remember that sharpening is applied at two points in the process - capture and output. The settings here are used for capture sharpening and the output side of things is handled as the last step of the editing process. In practice this means

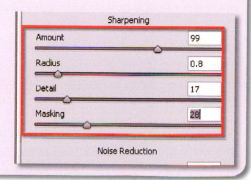

that all images should be sharpening to some extent in ACR first and then specific sharpening determined by output size and media applied later in the process. The sharpening abilities of ACR have been boosted in the latest revision so now there are four sliders to fine-tune the sharpening application.

The Amount slider determines the strength of the effect. The Radius slider is used to adjust the range of pixels used in the sharpness calculation. Detail and Masking both control where the sharpening effect is applied. Increasing the Detail value raises the local contrast around small picture parts. Moving the Masking slider to the right gradually restricts the sharpening to just the most contrasty edges of the picture.

Always make sure that the preview is zoomed to a value of 100% before manipulating these controls so that you can preview the effects. Holding down the Alt/Opt key provides a preview of the settings for each slider as the effect is applied.

23. Reducing noise

ACR contains two different Noise Reduction controls. The Luminance slider is designed to reduce the appearance of grayscale noise in a photo. This is particularly useful for improving the look of images that appear grainy. The second type of noise is the random colored pixels that typically appear in photos taken with a high ISO setting or a long shutter speed. This is generally referred to as chroma noise and is reduced using the Color slider in ACR. The noise reduction effect of both features is increased as the sliders are moved to the right.

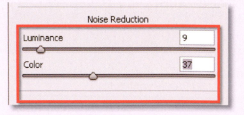

Pro's tip: When using these tools keep in mind that overuse can lead to flat, textureless photos so ensure that you zoom into the image (at least 100%) and check the results of your settings in important areas of detail. The golden rule is apply the least amount of Luminance and Color noise reduction to get the job done.

Output options

Now to the business end of the conversion task – outputting the file. At this point in the process ACR provides options that will govern the type of file generated in the conversion.

24. Controlling color depth/space and image size/resolution

The section below the main preview window in ACR contains the output options settings. Here you can adjust the color depth (8 or 16 bits per channel), the color space (ICC profile), the image size (maintain capture dimensions for the picture or size up or down) and the image resolution (pixels per inch or pixels per centimeter).

Save, Open or Done

The last step in the process is to apply the changes. This can be done in a variety of ways in both Photoshop and Photoshop Elements.

25. Opening into Photoshop

The most basic option is to process the raw file according to the settings selected and then open the picture into the editing workspace of Photoshop. To do this click the Open Image button at the bottom right of the dialog. Select this route if you intend to edit or enhance the image beyond the changes made during the conversion.

26. Saving the processed raw file

Photoshop users have the ability to save converted raw files from inside the ACR dialog via the Save button. This action opens the Save Options dialog which contains settings for inputting file names, choosing file types and extensions as well as file type-specific characteristics such as compression. Opt for this approach for fast processing of multiple

files without the need to open them in Photoshop. Unfortunately the same functionality is not available for Photoshop Elements users. Instead they will need to open (click the OK button) the converted file in the Editor workspace and then select File > Save As to perform the same function.

27. Applying the raw conversion settings

Both versions of ACR allow the user to apply the current settings to the raw photo without opening the picture. Just click the Done button. The great thing about working this way is that the settings are applied to the file losslessly. No changes are made to the underlying pixels only to the instructions that are used to process the raw file. When next the file is opened, the applied settings will show up in the ACR dialog ready for fine-tuning, or even changing completely.

28. Creating a Smart Object

If you are wanting to continue working with your unconverted raw file inside Photoshop then you will need to embed the file in a Smart Object layer within a Photoshop document. Unlike the previous version of ACR where this process had to be accomplished manually it is now possible to embed the file using a single button inside ACR. Holding down the Shift key, press the Open Object button. This action automatically creates a new Photoshop document and embeds the raw file in a smart object layer.

8

Photoshop Lightroom

tarting life in a most un-Adobe way, as a public beta, Photoshop Lightroom has quickly become the raw workflow program of choice for many photographers. It was an interesting approach for Adobe to open up the development process to let the public in to comment and contribute, but the gamble worked. The resultant program is a deceptively simple application that upholds the importance of the digital negative (the raw file) as central to the editing process while providing a full workflow for the photographer.

What is Photoshop Lightroom?

I don't think you would find any argument stating that 'Photoshop is a complex beast'. It is not that the individual parts of the program are overly complex in themselves (OK, some bits are!), it is just that when you start to layer and merge the many, many brilliant features it contains, you eventually get to a point where first-time users are daunted by the prospect of trying to do even the most basic tasks. And with successive releases of the program it gets harder to simplify without diluting the power and reducing the extent of the feature set.

Lightroom, on the other hand, is a deceptively simple product. Even at this beta stage it feels like a well-designed and streamlined photographer's work tool. The Adobe engineers have been able to elegantly distil the core power and features of both the workflow and raw conversion elements of Photoshop/ACR and package them into a completely new interface. There are features in the program like the Tone Curve which will be familiar in nature to the Photoshop users, but even such controls have been given a new breath of life, providing customization options that are way beyond what we currently have available. Add to this brand new controls like direct adjustment by dragging options in many Develop panels and the Histogram, Split Toning and HSL Color Tuning and you have a very exciting addition to the Adobe lineup. And did I mention that all these enhancement tools, though being applied to your raw files, never actually change the original pixels captured at the time of shooting?

The workflow employed in Lightroom roughly follows a route that progresses from one module to another. Import and management functions are carried out in the Library module. Raw conversion settings are applied in the Develop module and output to screen or print processes are handled in the Slideshow, Web and Print modules.

The whole workflow is lossless – read 'non-destructive'. Image enhancement and raw conversion settings are stored separately to the original image data and are then used to generate screen previews of the pictures, print output and the screen-based slideshows of the files.

Photoshop Lightroom is based on two key technologies – a Database that keeps track of metadata, development settings and preview images and a Raw conversion engine which is compatible with Adobe Camera Raw and is responsible for all image enhancement changes.

Enough talk, let's get to it!

The program is based on two core technologies: a relational database that stores all the details, settings and metadata relating to your images and the engine that drives Adobe Camera Raw. The database provides fast, reliable searching and cataloging options and the ACR engine supplies the tools needed for enhancing your pictures. The user accesses these technologies via a new interface and five workflow modules. Let's look at each of these sections in turn.

The suggested workflow for Photoshop Lightroom users is based around the five modules or workspaces that underpin the structure for the whole program. Switching workspaces is a simple matter of selecting a different heading from the list on the upper right side of the window. The module you are currently working in will be highlighted.

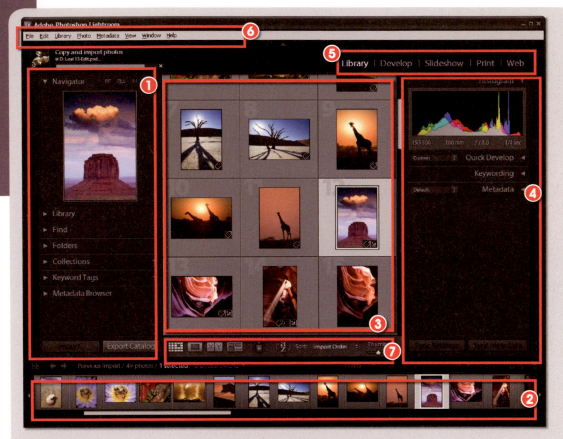

The workspace

As a full workflow product Lightroom contains not just the tools and controls needed for the conversion of raw files, but also for their management and presentation. These functions are all contained in a slick interface with a workspace that can be broken down into the following sections:
1. left panel,
2. filmstrip,
3. preview area,
4. right panel,
5. module menu,
6. program menu, and
7. tools and options.

The workspace can be divided into several sections (see image above).

1. The **left panel's** role changes depending on which module or mode you are in. The example screen shot shows Lightroom in the Library mode, which is primarily designed for managing your photos and organizing your shots. So here you will see that this section of the screen houses Navigator, Find, Collection, Keyword Tags, Metadata Browsers and Library options. If you switch to the Develop, Slideshow, Print or Web modules the contents change to display preset and saved options settings.

2. The **filmstrip** area is located at the bottom of the screen and displays all the images from the currently selected Collection, Folder or Find results. Individual pictures, or groups of images, can be selected from the filmstrip in any module.

3. In the default setting for the Library module, the main workspace displays a grid view of thumbnails. Double-clicking any thumbnail

will display an enlarged **preview** in what is called Loupe view. A single mouse click on the preview image zooms the picture to and from a default 1:1 magnification setting. Images can be viewed in Grid (like a sorting area on a slide box), Loupe (enlarged to 1:1 or a range of other settings), Compare (side-by-side comparisons of multiple photos) or Survey (interactive review of multiple photos) modes. In Slideshow, Web and Print modes the workspace displays a preview of the images as they will appear on screen or on the printed page.

The contents of the right panel change according to the module selected. Shown here are the contents for:
1. Library,
2. Develop,
3. Slideshow,
4. Print, and
5. Web modules.

4. The **right-hand panel** holds the settings controls available for the current module. In Library mode it displays some quick development options. In the Develop module the panel contains the complete set of enhancement controls, and in the Slideshow, Web and Print modules it houses layout and output settings.

5. The **module** menu appears at the top of the screen and not only lists the options available but also highlights the one currently selected. At the moment there are five modules included in Lightroom (Library, Develop, Slideshow, Print, Web).

6. The **menu** bar provides access to standard menu commands, but like most screen elements in the Lightroom interface, this too can be hidden from view and restored when needed.

7. The small section beneath the preview area houses tools and/or options for the selected module. For instance, when Library is selected view mode buttons, rating settings, and zoom settings are just some of the options available here.

The contents of the left panel when the Library module is selected control all the settings for managing shoots, collections, searches and keywords.

The workflow modules

Adobe consulted far and wide when they were putting together Lightroom. Who did they talk to? The answer is photographers! They asked them to describe their workflows and to list the sort of enhancement controls they regularly used. From these discussions the Lightroom team created a simple modular-based workflow.

Library

All image management starts with the Library module. Here you import your photos, arrange them in collections, add keywords, search your library or browse individual shots. All this activity is handled with the options in the left-hand panel, while in the workspace you can view your images in magnified Loupe mode, side-by-side Compare mode, the sorting Survey mode, or Grid mode.

One thing that you will notice immediately is the speed with which you can edit, rate and label your pictures. Unlike other browser products, Lightroom is not as tied down to the operating system file structure as is normally the case. When you import photos from a shoot, the program generates its own organizational structure (relational database) that not only maintains the management choices you make (rating, adding metadata, etc.) but also holds the raw processing settings you choose. Although exposure, brightness and contrast can be quickly adjusted here using the settings in the Quick Develop section, the majority of enhancement changes are made in the Develop module.

Library left panel contents

As we have seen, the contents of both right and left channels change according to which module is selected. The left panel of the Library contains the following options:

Navigator – The Navigator acts as another way to preview images in a slightly larger format than what is generally displayed with the filmstrip thumbnails. Moving over filmstrip images automatically changes the picture displayed in the Navigator area. This is not the same when moving over images in the Grid View though. Only when a picture is selected will it be previewed in the Navigator. The options at the top of the Navigator provide various zoom modes for the Loupe view. Selecting any of these entries will automatically switch the preview space to the

Loupe view and enlarge to the zoom setting. Selecting a different zoom level from the drop-down menu will change the default magnification of the Loupe tool to this level.

With settings greater than the Fit option, a rectangle is shown that indicates the extent of the area currently displayed. Click-dragging the rectangle around the Navigator will move the picture parts previewed.

Library – The Library section lists details of the status of the Lightroom database. Here you will find numbers relating to all the photographs in your Library, the images currently marked for inclusion in the Quick Collection and the amount of photos in the last import.

Find – The Find feature works much like search options in other software in that its job is to locate specific files using a bunch of search criteria. The feature contains two separate sections – one that allows text input and the other date based. Inputting search parameters in either of these areas automatically filters the images being displayed in the grid view of the preview area as well as the filmstrip. If a folder, collection, metadata or keyword selection is active when using the Find feature then the search will be conducted on this subset of images and not the whole Library. Unchecking the Date and Text options redisplays the collection images pre-search.

Folders – The Folders section mirrors the folder hierarchy of your hard drive. It is possible to move files from one folder to another by selecting the pictures in the grid view and dragging them to the new folder. Unlike many other management changes in Lightroom, moving files in this way forces a corresponding change at system level. The same is true for the changes made in the operating system file browser outside Lightroom. Folder structure and contents made in the OS file browser are reflected in the Folder display. Folders can be added or removed using the + or - buttons at the top of the section.

Collections – Collections are one way that Lightroom helps you organize your photos. Unlike folders, collections are virtual groupings of images. The same image can be a member of several different collections. This doesn't mean that the photo is duplicated and stored several times, rather that the different collections reference the same image in its original folder.

Clicking a collection heading displays the member images of the collection in the preview space and filmstrip. To create a new collection,

The Find feature helps to filter which pictures are displayed in the contents area.

The Collections feature is used to group together similar photos. Once a new Collection is created clicking on the entry heading will quickly display the member photos.

Clicking the small grey dot in the top right of thumbnail images will add the photo to a generic Quick Collection.

Adding Keyword tags to photos provides yet another way of displaying a sunset of photos from your whole collection.

The Metadata panel lists a variety of entries based on the metadata details saved with the file. Selecting an entry will filter the display to display only those photos containing the selected characteristic.

click the + button at the top of the section and input a new name. To add photos to the collection, multi-select the photos in the Grid View and drag them to the collection heading. Selecting the - button at the top of the section will delete the current selection without deleting the member images.

Clicking the grey dot that appears in the top right of grid view thumbnails will automatically add the file to the Quick Collection, a temporary collection space. To convert a Quick Collection to a full Collection simply select File > Save Quick Collection, enter a name in the dialog and click OK. Select File > Clear Quick Collection after saving to remove the images from the Quick Collection.

Keyword Tags – Another approach to image management is to use keywords for searches and creating groups of similar photos. These descriptive words are added to the metadata either at the time of importing, or during the sorting process in the Library module. Keywords are stored either in the file itself or its associated XMP sidecar file. Keywords can be added to images by dragging the photos to an entry in the Keyword section of the left panel, typing them into the Keywording section of the right panel, or with the Painter tool.

New keyword tags can be created by clicking the + button at the top of the section and filling out the Create Keyword Tag dialog. Images with keywords are displayed in Grid View with a small tag icon.

To display all images containing a single keyword click the entry in the Keyword Tags section. To view the keywords associated with a specific image select its thumbnail and locate the entries with a tick next to them.

Metadata Browser – The Metadata Browser section is used to display groups of images based on the metadata entries associated with the photos. Selecting an entry from the list will sort through the photos and only display those images that contain the metadata entry.

Much of the metadata or EXIF information associated with digital photos is recorded at time of capture and is inaccessible to the user, but there are groups of metadata details that can added, or changed, by the users. In particular, information entries used by the International Press Telecommunications Council (ITPC) can be added for each photo, or groups of photos, via the Metadata section in the right-hand panel of the Library module.

Import and Export buttons – The Import button at the bottom of the left-hand panel provides a shortcut to importing files or other Lightroom catalogs. More extensive import options are located in the File menu. The Export button displays the Export dialog which contains a range of options that can be used to output either single or groups of photos in specific formats.

The Import button provides quick access to Lightroom's download dialog.

Library right panel contents

Histogram – The Histogram appears in both the Library and Develop modules. In the Library module the graph provides a visual representation of the spread of tones in the image from black (left) to white (right). The high of the graph represents the numbers of pixels contained in the photo at a specific tonal value. The graph also displays each of the color ranges separately. The Develop module version of the Histogram is described in the next module section.

Quick Develop – The Quick Develop section provides the most used tone and color controls right inside the Library for easy and fast adjustments during the picture management phase. The controls are button driven rather than slider based. The single sideways arrow makes changes in small steps, whereas the double sideways arrow uses larger settings jumps.

Starting at the top of the feature, the Saved Presets menu lists any Develop settings that have been previously saved. Select one of the entries to apply these settings to selected images. Choosing an entry from the Crop Ratio menu automatically applies a crop to the current image. Select Original from the menu to restore the photo. For quick grayscale conversion change the Treatment setting from Color to Grayscale.

The next section contains the same White Balance options that are available in the main Develop section. To balance your photos, either choose from the Presets in the drop-down menu or use the Temperature and Tint controls to remove any casts present.

The Tone Control section contains the same set of adjustment options that is grouped in the Basic section of the Develop module. Sharpening and Saturation sliders are revealed when the Alt/Opt key is pressed.

Normally I would not recommend the use of auto enhancement tools, or controls that offer little or no objective feedback about the changes they are making, but as Lightroom uses a non-destructive workflow

Just as is the case in other image editing programs, the Histogram provides a graphical view of the distribution of tones and colors through the image.

The Quick Develop panel groups major image adjustment options in a single place.

any adjustments made with Quick Develop can be tweaked or even removed later with no damage to the photo.

Keyword and Keyword Set entries are handled via the controls in the Keywording panel on the right of the Library workspace.

Keywording – Unlike the Keyword Tags control on the left, which is used to filter the preview display based on keywords attached to images, the Keywording section on the right side of the dialog is used for adding keywords to photos.

You can attach a keyword to a selected photo by either typing it directly into the Keyword Tags space (using commas to separate multiple keywords) or by clicking onto one of the keyword entries in the Keyword Set section of the panel. Click on the entry a second time to remove a keyword attached incorrectly. Keywords manually entered into the Keyword Tags area automatically become entries in the Recent Keyword set. The Recent Keyword set can be saved as a permanent Keyword Set by selecting the Save Current Settings as a New Preset from the drop-down menu.

Metatdata – Similarly, the Metadata panel on the right enables the user to input and change metadata information stored with the file, whereas the Metadata Browser provides view and sort options only. The specific grouping of metadata displayed is controlled by the drop-down menu at the top left of the panel. Presaved sets of metadata information, called metadata templates, can be selected from the Presets menu. New Preset entries can be created via the Edit Presets entry in the same menu.

To add custom details under a specific metadata heading, click in the text box area next to the entry and type in the information.

Specific Metadata entries can be added or edited via the Metadata panel.

Sync Settings and Sync Metadata buttons – The Sync Settings and Sync Metadata buttons are active when two of more images are selected in the grid view. When multi-selecting images in the Grid View the first thumbnail selected is the reference image. The reference image is displayed with a lighter tone than the other selected thumbnails.

The Sync Settings button copies the Develop settings from the reference image to the rest of the preselected photos. In contrast the Sync Metadata button copies the metadata to the selected photos. In the process of copying both metadata and settings, the user is able to select the specific entries that are synchronized.

Library tools

Several view options and tools are grouped under the preview area. The specific entries listed here change according to the module currently selected. The following are options for the Library module, but the display can change depending on those entries selected in the Toolbar Content menu.

Views – The preview section of the Library module can be configured in four different view modes. The Grid View displays thumbnails of the images. The size of the thumbnails is adjusted using the Thumbnail slider in the Toolbar. The Loupe View fills the preview area with a single photo (specifically the one currently selected in Grid View or in the filmstrip). Clicking on the image in the Loupe view will magnify the photo even further. The settings used for the two zoom levels are selected in the Navigator window. The Compare View displays two images, Select and Candidate, side by side in the preview space. The controls in the toolbar allow you to zoom in and out, switch thumbnails, display different images, rate, and flag as Pick or Rejected. The Survey Mode offers the ability to compare and rate more than two images at a time. Unlike the Compare mode the photos need to be multi-selected before choosing the View mode.

Images in the main content area of the Library workspace can be viewed in a range of different modes:
1. Grid.
2. Loupe.
3. Compare.
4. Survey.

The specific tools displayed in the toolbar is determined by the options selected in the Select Toolbar Content pop-up menu located on the right side of the bar.

Painter tool – The Painter tool (select Painter from the toolbar menu to display on the toolbar) is used to paste keywords, labels, flags, rating, metadata, settings or image rotation to one or more photos. After selecting the tool from the toolbar, choose what will be pasted by selecting an entry from the drop-down Paint menu and then either type in the content (Keywords), pick an option from those grouped on the toolbar (Label, Flag, Rotation), or choose a preset from the associated menu (Metadata, Settings). With the options selected, paste the content to other images in the preview area by clicking onto the thumbnails.

To remove the content pasted by the Painter tool, click on the image a second time for Keywords, Labels, Flags, Ratings, or select Edit > Undo (Ctrl/Cmd + Z) for the other content types.

Sort order and direction – The order that thumbnails are displayed in the grid view can be adjusted with the drop-down menu option displayed in the toolbar. Change the order direction by clicking the Sort Direction button. Changes made to the sort direction and order are also reflected in the filmstrip section at the bottom of the window. If the Sorting options aren't displayed on the toolbar choose the option from the Toolbar Content drop-down menu on the far right of the Toolbar.

Adding Ratings, Flags, Pick settings and Color Labels – When the Rating, Pick and Color Label entries are selected from the Toolbar Content menu, each of these organizational features are displayed on the toolbar. Clicking any of the buttons will then place the Rating, Pick flag or Color Label on the selected image or images in the preview space.

Rotating photos – The Rotate buttons pivot the selected photo or photos in 90° increments either left of right.

Navigate and Slideshow options – There are two Navigation buttons available for display on the toolbar. The Select Next Photo or Select Previous Photo buttons move the selection from one photo to another. The Play button displays the images in a full screen slideshow using the current settings of the controls in the Slideshow module.

Zoom settings – The Thumbnail slider controls the size of the thumbnails in the Grid View of the preview area.

Information bar – When the filmstrip is displayed, an information bar is also shown just above the filmstrip area and below the preview space. A series of filters, forward and back buttons, grid view button, plus a drop-down menu for Library panel options are stored here.

Develop

The Develop module is the next step in the Lightroom workflow and is central to all enhancement changes that are applied to your photos. Just like when you are working in the Adobe Camera Raw dialog, the enhancement settings and controls are grouped in a panel on the right of the window and a preview of the interpolated raw file is also included.

Develop contains familiar ACR controls such as White Balance, Exposure, Shadows now called Blacks, Brightness, Contrast, Detail (sharpness and noise), Lens Correction (fringing and vignetting) and Camera Calibration. These controls work in a similar fashion to their counterparts in ACR, as they should given that adjustments made in one of the programs is now fully recognized and respected by the other.

Develop left panel contents

Navigator – The Navigator as displayed in the Develop module functions in the same way that it does in the Library module. For more details refer to the Library section of this chapter.

Presets –The Preset section stores groups of Develop settings. Some of these are supplied with the program as general defaults (Zeroed, Flat, Sepia, etc.) and are stored under the Lightroom Presets heading. Others are presets saved by the user. These are grouped under the User Presets title. To apply a Preset simply select its title in the Presets menu. To remove a setting after applying hit Ctrl/Cmd + Z.

To add extra presets to the panel, make the changes to the current image and then click the + button at the top of the Presets panel. Now choose the settings to include in the preset from those listed, add a new name and choose a title before pressing Create. The newly created preset will be added to the panel ready for selection.

Snapshots – Snapshots are saved history states. They can be used to revert a photo's development back to a specific stage in its enhancement. Photographers save a snapshot of their photo when they are about to experiment with the enhancement of their photo or at key points in a series of complex enhancement steps. Once added to the panel, the photo can be returned to the way that it looked at the time that the Snapshot was created, by selecting the entry from the list.

To add a Snapshot, click the + button at the top of the panel and type a name for the entry. Press the Enter/Return key to add the entry. To

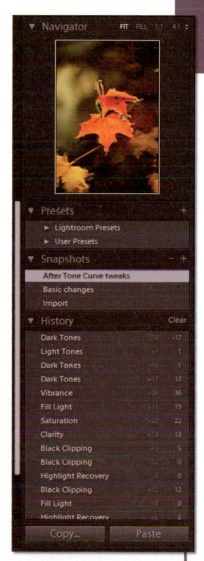

The left panel options in the Develop module revolve around enhancement Presets, Snapshots of history states and a listing of the History steps themselves.

Enhancement steps are recorded and listed in the History panel.

Development settings can be move from one image to another using the Copy and Paste buttons at the bottom of the left side panel.

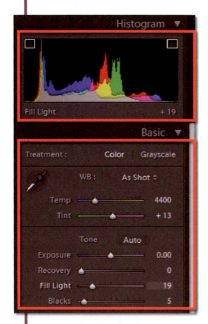

Development settings can be moved from one image to another using the Copy and Paste buttons at the bottom of the left side panel.

remove a saved Snapshot, select the entry in the panel list and then click the - button at the top of the panel.

History – An entry is placed in the History panel for each editing or enhancement setting change. The values for specific controls are listed to the right of each entry. The entries are listed chronologically. This process of creating entries happens automatically, and the entries remain associated with the file until the Clear button, located at the top of the panel, is selected. Like the Snapshot entries, selecting an entry from the History list will adjust the image to the settings listed.

Copy and Paste buttons – The Copy and Paste buttons at the bottom of the left side panels are used for copying the Develop settings from one photo and applying them (Paste) to another photo. To copy and paste settings click the Copy button, choose the settings to copy from the Copy Settings dialog, click Copy and then navigate to the new photo in the filmstrip and click the Paste button.

Develop right panel contents

Histogram – The Histogram we see here contains the same full color graph of the spread of pixels in the image as was the case in the Library module but with a couple of differences – the graph can be directly manipulated (push and pulled around) and the top left and right corners contain the shadow and highlight clipping warning buttons and displays. Unique to Lightroom is the ability to manipulate how tonal ranges are displayed by dragging them in the Histogram display. Moving the mouse over the graph changes the pointer to a left–right arrow. The histogram is broken into four tonal areas from left to right or shadows to highlights. The groups are titled Blacks, Fill Light, Exposure and Recovery, and are linked directly to the similarly named controls in the Basic panel. Depending on where the mouse pointer is positioned along the graph the tonal group name will appear on the bottom left of the Histogram panel. By click-dragging the graph you can change the settings for each of these tonal ranges and their associated controls. The current setting for control is listed on the bottom right of the Histogram panel.

Basic – The contents of the Basic panel reflect those provided by ACR in both Photoshop and Photoshop Elements versions of the utility. Mirroring development controls and settings is a key part of Adobe's workflow strategy which allows users to process raw files via a multitude of pathways. To this end I will concentrate the discussion here

on the differences between the implementation of similar controls in Lightroom as opposed to ACR and leave the general comments about how the feature works to the previous two chapters.

The Treatment option at the top of the Basic panel provides the most basic of all enhancement decisions up front. 'Is the image going to be processed as a grayscale or color photo?' Fine-tuning of the avenue selected here will occur with the controls that follow, both here and in the next panels.

Next are the White Balance options. As with ACR there are three ways to neutralize shifts in color caused by incorrect White Balance settings. The WB menu contains the presets for different lighting sources, the Temp and Tint sliders allow for fine-tuning and the White Balance Selector tool (shaped like an eyedropper) is used for one-click corrections.

Rather than include an auto option for each slider control a single Auto button is located just below the White Balance controls. Clicking this button will cause Lightroom to analyze the image and set the controls accordingly. The Exposure, Recovery, Fill Light, Blacks, Brightness and Contrast controls concentrate adjustments on the tone in the image and work in the same way as the ACR features of the same name. Clarity, Vibrance and Saturation are grouped under the Presence heading and are also mirrored in the ACR dialog.

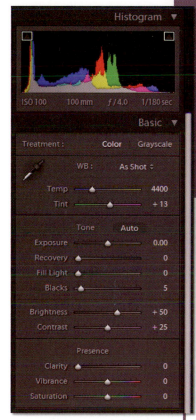

The right panel are in the Develop module contains all the main enhancement controls.

Tone Curve – The Tone Curve option in Lightroom is slightly different from the two mode curve offerings in the Photoshop version of ACR. The user has the option of adjusting the shape of the curve, and therefore the tones in the photo, in four different ways. Firstly, you can push/pull the curve directly by clicking onto the line of the curved and click-dragging with the mouse. No control points are used for the adjustment and the movements are restricted to within an upper and lower amount and apply to a set range of tones. This is termed Parametric Curve Editing.

Like the adjustments made in the Histogram, curve changes are broken into four tonal range segments, but here they are called Highlights, Lights, Darks and Shadows. Moving the cursor over the curve will highlight one of the four tonal ranges as well as a shaded area on the background representing the extent to which the curve can be moved by dragging. The controls, beneath the curves dialog, provide the same adjustments but via sliders instead of curve-dragging.

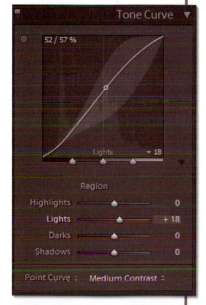

The Tone Curve panel provides curves based adjustment of images.

The sliders beneath the Tone Curve display provide the ability fine tune what pixels are included in specific tonal ranges.

Also shadowed in the background of the curves dialog is a luminosity histogram of the current image, providing valuable details about how the tones are spread. The four tonal ranges are called regions. The tones encompassed by each region can be altered by dragging one of the arrowheads beneath the curves dialog.

Yet another way to manipulate the curve in Lightroom is to select an entry from the Point Curve drop-down menu at the bottom of the dialog.

The final curve control is again a unique feature in Lightroom as well as being one that is used for other controls. The Targeted Adjustment Tool (TAT) located at the top left-hand corner of the dialog is used to make changes by click-dragging on the image itself. After selecting the tool, move the cursor over the picture until it sits on an image part that you want to darken or lighten. Next click-drag the cursor upwards to lighten the area, or downwards to darken it. This is a very interactive way of adjusting you pictures and all changes made with this tool are reflected in changes to the shape of the curve and the settings of the sliders below it.

The Targeted Adjustment Tool (TAT) allows users to apply enlacement changes by clicking and dragging the mouse cursor over specific picture parts.

HSL/Color/Grayscale – The HSL/Color/Grayscale panel contains the same type of controls located in the HSL/Grayscale panel in Adobe Camera Raw. In the color modes (HSL and Color) the feature allows the independent adjustment of Hue, Saturation and/or Luminance of red, orange, yellow, green, aqua, blue, purple and magenta colors. The degree of control of color enhancement provided here is easier to use and more flexible than has ever been possible before.

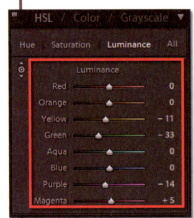

Selecting the Grayscale option switches the concerns of the control to how the eight color groupings are mapped to gray tones. In so doing,

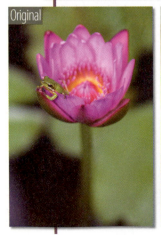

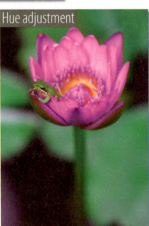

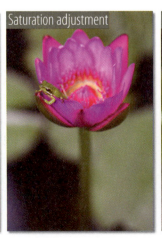

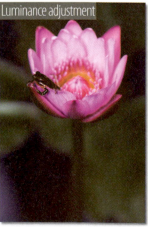

the slider controls make it possible to fine-tune the contrast and visual drama in the final monochrome conversion in a way that is similar to Photoshop's channel mixer, but far easier to apply. The Auto Adjust button at the bottom of the Grayscale option analyzes the color distribution in the photo and automatically applies a set of mapping settings to maintain contrast.

As with the Tone Curve feature the Targeted Adjustment tool is available for use with the controls in this panel. Selecting the tool allows the user to interactively control the Hue, Saturation, Luminance or grayscale mapping of specific picture parts by click-dragging up or down in the preview area.

Split Toning – The Split Toning control works the same way as the feature in ACR. There are separate controls for Hue and Saturation for the highlight and shadows areas of the photo plus a Balance slider that controls the position of the split along the tonal scale.

Detail – Both Luminance and color controls are available in the Noise Reduction section of the Detail panel. As is the case with the latest release of ACR, Lightroom 1.1 gets additional sharpening controls which bring the sliders in this section to four – Amount, Radius, Detail and Masking. For more information on how these controls function see the Sharpening section in the previous chapter.

Lens Corrections – The Lens Corrections section has also been revamped so that it mirrors the features available in ACR. Along with the original Chromatic Aberration and Vignetting controls there is also a drop-down menu with Defringe options for cases when blown highlights have a magenta tinge.

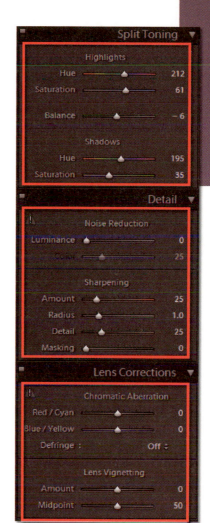

The controls grouped in the HSL/Color/Grayscale panel provide better fine tuning control over the hue, saturation and/or luminance of specific color ranges in a photo than has ever been possible before.
Opposite page – The original image sits beside iterations of the photo with adjustments made to the Hue, Saturation and Luminance of the picture.
Right – When the Grayscale option is select in the panel, the sliders control how various colors are mapped to gray.

Straight conversion

Grayscale mapping

Automatic grayscale mapping

New for both the Detail and Lens Correction panels is the Zoom Level warning button in the top left corner. The warning/button appears when the preview image is being displayed at less than 1:1 or 100%. Clicking the warning button automatically enlarges the preview to the 1:1 magnification so that the settings made in the panel can be previewed on screen.

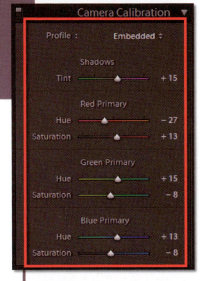

Camera Calibration – The controls in the Camera Calibration panel allow for fine-tuning of the default color conversion options of specific camera models. Like the same panel in ACR, controls for shadow tint, and the hue and saturation settings for each of the primary colors are located here.

Previous and Reset buttons – The Previous and Reset buttons are located at the bottom of the right side of the Develop module. Selecting the Previous button applies the Develop settings of the last selected photo to the newly selected image. Clicking the Reset button changes the Develop settings for the current image back to the Lightroom defaults. As well as clicking this button, you can also select the Zeroed preset from the Develop menu to reset the settings of the image.

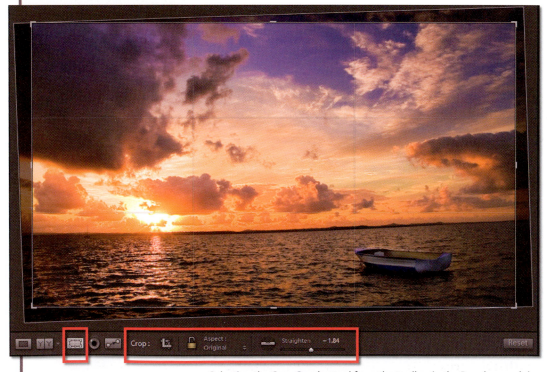

Selecting the Crop Overlay tool from the toolbar in the Develop module provides options for straightening crooked horizons as well as removing unwanted edge areas of the photo.

Develop tools

The toolbar in the Develop module of Lightroom contains three key features used for editing your photos.

Crop Overlay – The Crop Overlay tool is used for removing unwanted edges and straightening photos. After selecting the Crop Overlay button, you can crop a photo in three ways:

1. Click and drag the Crop Frame tool on the preview image to draw a cropping frame.
2. Move the corner or side handles on the cropping marquee to resize and reshape the crop.
3. Select a crop shape from the drop-down Aspect menu and then use the corner handles to resize the crop frame.

The crop frame can be moved around the photo by positioning the mouse pointer inside the frame and click-dragging it to a new position. The crop is applied by pressing Enter or clicking the Crop Overlay button again. To undo or remove a crop click the Reset button on the right side of the toolbar.

Images can be rotated by moving the mouse pointer outside the frame and click-dragging to pivot the photo in the frame. Alternatively, the Straighten tool can be selected from the toolbar and used to draw a line along an image part that is meant to be horizontal or vertical. Lightroom will automatically realign the photo to straighten the picture part. Finally the slider control in the straighten section of the dialog can be used to adjust the rotation of the image numerically. Specific degree values can be input directly into the text box just above the slider.

To help with positioning key focal points, or aligning straight edges, in your photos when cropping, Lightroom provides several different grid overlays. To switch the current grid option click the O key.

Remove Red Eye – Like Adobe Camera Raw Lightroom too has a non-destructive Red Eye Removal tool. After selecting the tool from the toolbar the mouse pointer changes to display a central crosshair and four boundary marks outlining the extent of the correction. To use, either click on the red eye to use the current size, or click-drag from the center of the eye to redefine the size to suit. Next, adjust the size of the Pupil Size and Darken amount to match the problem area in the eye. Once the red has been removed for one eye, repeat the process for the other eye in the photo.

When the Crop Overlay tool is selected Lightroom helps the user position key focus points of the picture by displaying a fine grid over the image. Clicking the O key cycles the grid through the six different options available.

To remove red eye from a photo start by selecting the Red Eye Removal tool from the toolbar and then clicking onto the red portion of the eye (1). Next use the slider controls in the tool bar to fine tune both the Pupil Size and Darken amount (2). To interactively adjust the pupil size click-drag the mouse pointer when first selecting the area to repair.

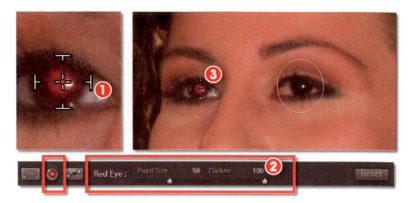

Remove Spots – Alongside the Red Eye Removal feature is the Remove Spots tool. Designed to eliminate dust spots and unwanted subject marks, the tool works by sampling another part of the photo and using this detail, color and texture to paste over the problem spot.

After selecting the tool, click on the mark on the picture. Lightroom automatically places a circle around the area being repaired and then places another circle adjacent to the first one that is used as a source of the repair. If the repair circle does not fully cover the mark, click onto the circle and adjust the Spot Size slider in the toolbar. To relocate the sample circle to an area that better matches the color, texture or density of the mark surrounds, click on the circle and drag it to a new position on the photo.

The feature has two repair modes, Clone, which simulates the way that the Clone Stamp tool functions in Photoshop, and Heal, which makes use of the 'magical' blending characteristics of the Spot Healing Brush to match seamlessly the tones, textures and colors of the sample and repair areas. This setting is best left as the default for the tool. Once a repair mode is selected the feature keeps this setting as the default for the next time the tool is used.

To use the Remove Spots tool, start by selecting the mode for the tool from the two options in the tool bar (1). Most photographers use the Heal mode by default. Next click onto the mark in photo first, Lightroom will place a circle around the mark and a second circle over an adjacent area that will be used as the source for the repair (2). If necessary, move the sample area to another position by click dragging the circle (3).

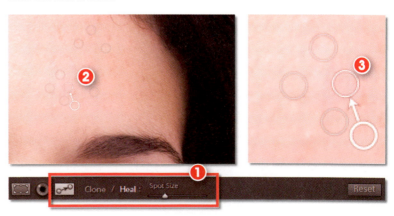

Other Develop features

As well as the contents of the left and right sections of the dialog and the toolbar, it is important to point out two other features that you will encounter when enhancing your photos in Lightroom.

Virtual Copies – Lightroom provides the ability to develop the same photo in several different ways. Called Virtual Copies, the main (original) picture is not duplicated for each development option; instead different development settings are applied and previewed as a new thumbnail in the Library. Virtual copies can be enhanced, presented and printed like any other photos in the Lightroom library.

To create a virtual copy of a photo, simply right-click on the image in Grid View and select Create Virtual Copy from the pop-up menu. The new copy is positioned next to the original in the Library and is automatically included in a new image stack. Virtual Copies display a curled page corner in the bottom left of the thumbnail so that you can distinguish them from the original photo.

When a virtual copy is exported or edited in an external program the Develop settings are applied to a copy of the original photo, creating a new image.

Virtual Copies are a unique way for users to enhance the same image in a variety of way. Choosing the Photo > Create Virtual Copy option creates an additional copy of selected image and places it beside the original. The copy displays a curled page corner in the bottom left of the thumbnail (1). The original and the copies are automatically placed into an Image stack. When creating Virtual Copies the original file is not duplicated, rather each copy just represents different ways to enhance the image.

Edit in Photoshop – If photos that are managed and enhanced in Lightroom require editing changes only possible in Photoshop, the pictures can be transferred to Photoshop via the Photo > Edit in Photoshop option. For full details of how to edit Lightroom images in Photoshop go to Chapter 11.

The Slideshow module provides creative presentation options that can be output in Adobe's Acrobat or PDF format. The interface includes:
1. *a template preview,*
2. *a template browser,*
3. *slides selected for inclusion from the filmstrip,*
4. *slideshow settings,*
5. *play and export options, and*
6. *slide layout preview.*

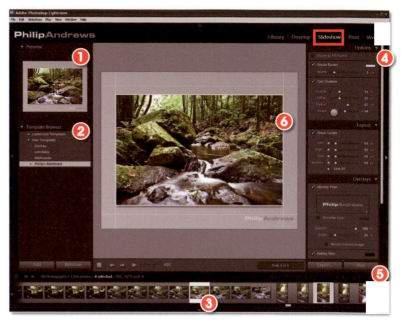

The left panel options in the Slideshow module house the Preview and Template Browser features.

Slideshow module

In Lightroom the Adobe guys have provided several to output your photos – as prints, in a slideshow presentation, as individual files, or as part of a web gallery. The Slideshow module is where you can lay out a group of images and present them to clients or family and friends as a slideshow or produce them as a self-running PDF presentation.

Slideshow left panel contents

On the left-hand side of the workspace are the Template Browser and Preview panels.

Preview – The Preview panel displays a thumbnail view of the current selected template. Moving over the template entries will switch the preview between different slideshow templates whilst viewing a preview of how your images will look with each layout.

Template Browser – Lists Lightroom default and user-created slideshow templates. To apply a template to your show, click on the entry in the Template Browser. To switch to another template, select a different entry.

Add and Remove buttons – The Add and Remove buttons at the bottom of this section provide the options to create new template designs based on your own custom settings or delete no longer needed templates from the list.

Slideshow right panel contents

When selecting the Slideshow module, the contents of the right panel change to options that alter the settings for your presentation.

Options – The options panel contains Stroke Border and Cast Shadow settings as well as the option to force photos to 'Zoom to Fill Frame'.

Layout – The four slider controls in the Layout panel control the margin spaces around the slideshow picture. Changing these values will alter the size and positioning of the photo in the slide frame.

Overlays – Choose what other content will be included on the slide along with the photo in this panel. You can include the Identity Plate, Rating settings and/or metadata or custom text.

Backdrop – Select the background color, or whether to include a color wash or a background image.

Playback – The Playback panel includes options for including an accompanying soundtrack, and settings for slide duration and transition timing.

Export and Playback buttons – The production can be previewed by pressing one of the VCR-type Play buttons in the toolbar or the Play button at the bottom of the right panel entries. The Export button produces the slideshow as a self-running PDF presentation.

The right panel options include image Options, Layout, Overlays, Backdrop, and Playback settings.

Slideshow tools

Beneath the preview area is the Slideshow toolbar.

Navigation buttons – The First Slide button displays the initial image in the show. The Play and Stop buttons are used for previewing the show using the current settings.

Add Text button – Selecting the Add Text button allows the user to input custom text, or choose from a list of metadata entries, to be displayed in the slide. Adding text automatically selects the Text Overlays option in the Overlays panel.

Sequencing slideshow photos – To organize the order of images in the slideshow either drag photos to new positions in the Filmstrip or Grid View. Alternatively, add the photos from multiple sources to a collection, or Quick Collection, and use this group of images as the basis of the slideshow.

Extra text can be added to a slide via the Add Text button (the ABC icon) in the toolbar.

The Print module is the center of all hard copy output action, including the production of contact sheets and individual prints. Like the Slideshow module, the print interface contains:
1. *a print template preview area,*
2. *a template browser list,*
3. *a main print preview,*
4. *a print settings panel, and*
5. *Page Setup and Print buttons.*

The left panel in the Print module includes a Preview area and Template Browser.

Print module

If you ever wondered if anybody at Adobe listens to the suggestions of its users, then the Lightroom Print module is confirmation that they do. Here in the one dialog are all the controls you need to output contact sheets, print packages as well as individual prints. The right panel contains print and layout settings. The middle of the screen has a preview of the photos as they will appear on the printed page and on the left you have a range of template presets and the ability to save your own print layouts. Gone are the layer upon layer of settings dialogs, replaced with a single pane of settings with all the critical controls and settings up front.

Print left panel contents

Preview – The Preview pane displays the layout of the print template that is currently selected. The images are not shown in the layout, just the spaces where these photos will be positioned.

Template Browser – The Template Browser contains a list of supplied print layouts along with any template designs saved by the users. To apply a template setting to a group of selected images, click on the entry in the Template Browser. The preview area will then update to display the images positioned in the layout. If there are more images than the spaces available, new pages are created and the extra images are positioned on the additional pages. You can navigate between pages

using the Go to Next Page or Go to Previous Page buttons on the Print toolbar.

Add and Remove buttons – The Add button is used for creating new print templates from the current settings. The Remove button deletes unwanted templates.

Print right panel contents

Image Settings – The Image Settings panel houses placement controls such as Zoom to Fill Frame, Auto-Rotate to Fit, and Repeat One Photo per Page options along with border size and color settings.

Layout – The Margins, Grid and Cell options in the Layout panel control the image positioning and overall design of the print template. The Show Guides entries, such as rulers, margins and gutters, can be displayed, or hidden from view by checking the entry here.

Overlays – Just as was the case for the Slideshow module, the settings in the Overlays panel determine what other details are printed alongside the images themselves. Here you can add the Identity Plate, page and/or image information.

Print Job –The Print Job settings group together the main output options of Resolution, Sharpening, and Color Management. Users can input their preferred pixels per inch (ppi) setting in the Print Resolution section.

There are three Print Sharpening options – Low, Medium and High. For best results make a test print of the final image cropped to a thin strip at all settings before choosing the correct option.

When setting the Color Management profile select the one that matches your printer/ink/paper combination the best. If it is not listed then click the Other option and select it from those profiles loaded on your system. The Rendering Intent determines how colors of the photo will be adjusted to suit the colors of the printer. Both options will squeeze out of gamut colors within the printer's capabilities but Relative will not alter those colors that are already in gamut. Perceptual, on the other hand, will try to maintain the visual relationships within the photo and will massage all colors (both in and out of gamut) in the process of doing so.

Print Settings – The Print Settings button displays the Print Setup dialogs for the operating system as well as the printer itself. Here you adjust the core media, print quality and printer setup options.

Print output options have been simplified and are centered around the settings in the Print Job panel.

Print – Pressing the Print button will also display the OS and printer dialogs to ensure proper setup before finally outputting the photo. Holding down the Alt/Opt key will bypass these dialogs and print the photo using the last settings.

Print toolbar

Page Setup – Printer level control is also possible with the options accessed via the Page Setup button on the toolbar.

The Web module is used for creating and uploading a web gallery of images. The user can select from a range of supplied designs and can generally customize the design's colors and insert specific site details to suit. The Web module dialog includes:
1. a Preview area to review the gallery template design,
2. a Template Browser listing the available gallery designs,
3. a main web page preview area displaying the user's images inserted into the design,
4. a Web settings panel, and
5. Export and Upload buttons.

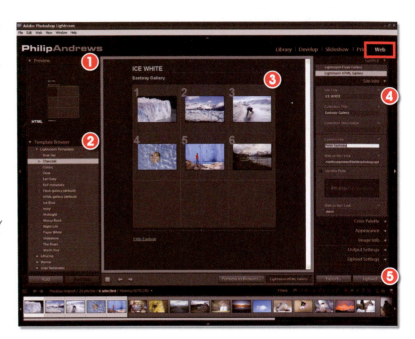

Web module

Early in the development of Photoshop Lightroom the slideshow and web gallery options were part of the same module, the Presentation module. But very quickly it became obvious that the two activities, though similar, required their own dedicated modules in order to provide the level of settings and control required by most photographers. The Web module has the ability to create both traditional thumbnail and feature image HTML-based galleries, or the more interactive Flash-based sites complete with animation and simple navigation controls.

Web left panel contents

Preview – The Preview panel displays a small version of the Web Gallery template currently selected in the Template Browser. Though

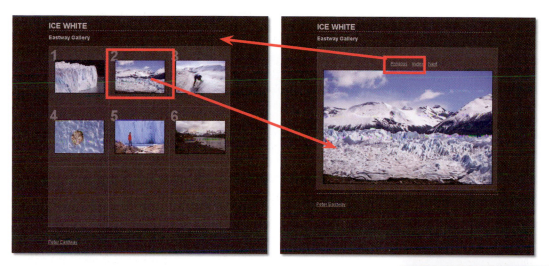

Many of the gallery designs in the Web module are based around a thumbnail index home page and feature image page design. Clicking on a thumbnail will display a larger version of the photo displayed on its own page.

the preview does not show your images in the design it does give the user a basic idea style of the gallery.

Template Browser – The Template Browser lists supplied and user-created templates. Applying a template to the current group of selected images is as easy as clicking on the entry in the template list. Some third-party companies produce additional template designs that can be incorporated into Lightroom. See Chapter 12 for more details.

Add and Remove buttons – New web gallery designs can be added to the list in the Template Browser by making the appropriate settings with the controls in the right-hand panel of the Web dialog and then clicking the Add button. Existing templates can be removed from the list by selecting them first and then pressing the Remove buttons.

Web right panel contents

Gallery – The Gallery section contains two gallery options: Flash Gallery, for websites created with Flash technology, and HTML Gallery, for more traditional style web pages and sites. Selecting one of these options will impact on the range of options available for the customization of the gallery templates as well as the general design and functionality of the pages.

Site Info – The contents of the Site Info panel may vary slightly depending on the gallery template selected and if the website is Flash or HTML based. In most cases, the site title, collection title, collection

The entries in the right panel in the Web module group together the options for web page design and output.

description, contact info and web or mail link can be added here. To aid with more efficient processing, previously added details can be selected from the drop-down menu on the right of the text box for each heading.

Color Palette – The colors used in the template design can be adjusted or replaced with the controls in the Color Palette panel. The number of website components listed here will depend on the design of the template.

Note: The preview in the center of the dialog automatically updates to reflect the changes made in these panels.

Appearance – Along with the Color Palette, the Appearance panel contains the main controls for changing the look and style of a web template. In this section the user can adjust characteristics such as drop shadows, selection borders, the number of images displayed in index or grid pages, displaying or hiding of cell numbers and the use of photo borders. But again this is just an example of the custom options available for the template used here. Switching to another template or from an HTML-driven design to a Flash-based site will alter the contents of this panel.

Image Info – The Image Info panel contains settings for the inclusion of extra text with each of the photos displayed. There are two areas where more details can be added – the Title and Caption areas. In the example design the Title area is just above the photo and the caption text is shown below the image. The content of both these areas can be customized by making a selection from the drop-down menu. Some preset metadata options are already listed but you can choose your own metadata entry to use by selecting Edit from the menu and creating a new entry in the Text Template Editor. Alternatively, the Custom Text option can be used for adding simple titles without leaving the dialog.

Output Settings – The Output Settings for most templates include a Quality slider that governs the image quality of the larger gallery images, plus the option to display a watermark-based copyright on the larger images. Selecting a higher Quality value will make your photos look better on screen but it will also mean that your website will take longer to load. It may take a couple of trial runs with your first website before you strike a balance between image quality and load time that you are happy with.

Upload Settings – Lightroom has the ability to upload the completed website directly to the web server where your pages are stored and displayed to the world. For this to occur the program uses an FTP, or file transfer protocol, utility that links the user's computer with the web server and then transfers the files. To make the connection, Lightroom uses details contained in the Custom Settings section of the Upload Settings panel. Clicking this option will open the Configure FTP File Transfer dialog. The user inputs the server, user name, password, path and port details and then clicks OK. If you are unsure of what to include here these details are generally available from your internet service provider (or ISP). With all the details entered clicking the Upload button will automatically transfer the completed website to the web server.

The Custom settings dialog for the FTP utility in Lightroom is where web address, login name and password information is noted.

Export and Upload buttons – The Export button at the bottom of the right panel provides the option to save the Lightroom website to disk in a format that can be viewed with a web browser. The Upload button uses the in-built FTP utility to transfer the files to your web server.

Web tools

Go to Home Page – The Go to Home Page button looks like a square box on the left side of the toolbar. Click this button to change the main preview window in the center of the screen to main or front page of the website. As this preview window acts as a live preview of the website and all its pages, clicking onto a picture thumbnail will display the gallery page with a larger view of the photo. When this occurs you can navigate back to the front page with this button.

Previous and Next photo – The right and left arrow buttons in the toolbar are the Previous Photo and Next Photo buttons. These controls move the focus between the selected photos in the filmstrip that are featured in the website.

Preview in Browser – The Preview in Browser button produces the website and then displays it in a new browser window. This process can take some time as Lightroom performs all of the web optimizing of the image files and the building of the pages and navigational structure. The progress of the action is detailed in the top left corner of the Lightroom workspace.

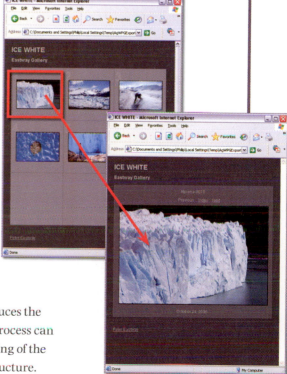

The Preview in Browser feature displays the current web design in the computer's default browser.

Raw processing with Photoshop Lightroom

With the basics now out of the way let's concentrate on the steps that you would take when processing a raw file in Photoshop Lightroom.

Opening

As I will concentrate this Lightroom workflow on the steps involved in enhancing the raw file, I am assuming that you already have imported the photos into the Library module of the program. For more details on this part of the Lightroom process go to Chapter 4.

1. Opening the raw file in Lightroom

Select the Library module from the five listed at the top right of the Lightroom workspace. Using the features in the Find, Keyword Tags or Metadata panel, locate the photo that you want to enhance.

2. Checking the file before processing

Double-click the thumbnail to change from Grid View to Loupe View. Hide the side panels by pressing the Tab key to provide more screen space to view the picture. Click onto the photo another time to zoom into 1:1 magnification. Click-drag the enlarged picture around the screen and check sharpness and fine details. When finished click the mouse button a second time to revert to the 'Fit' to screen magnification in the Loupe view.

Setup enhancement

3. Selecting enhancement treatment

Start the enhancement process by selecting the Develop module at the top of the workspace. Make sure that the Histogram and Basic panels are displayed. Choose

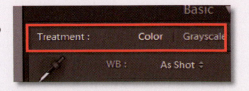

the general direction of the enhancement from the Treatment menu. Here we will be working in Color.

4. Activating clipping warnings

To ensure that the enhancements are being made without clipping important highlight and shadow detail, it is a good idea to activate both the Highlight and Shadow clipping warnings. Do this by clicking the small upward triangles in the top left and right of the histogram. A white box around the arrows indicates the warnings are active.

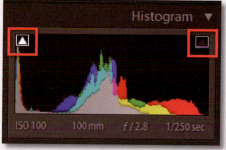

White balance adjustment

5. Adjusting general white balance

To adjust the general white balance settings and remove any obvious casts, try to match the lighting conditions in the photograph with one of the options in the WB drop-down menu. If you are unsure of which option will work best, either stick with the mode used by the camera or select each in turn and examine the results.

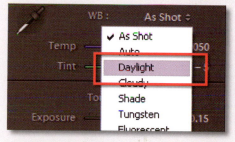

6. Fine-tuning white balance

If further fine-tuning of the white balance is needed you have two options. The first is to click onto the White Balance tool (eyedropper) and click onto a part of the image that should be neutral gray or white. Alternatively you can use the Temperature and Tint sliders to manually tweak the colors.

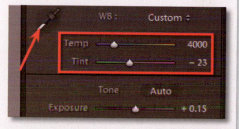

Tonal control

7. Setting the white point

To correctly adjust the tones in the photo it is always a good idea to set the white and black points of the photo first. This establishes the end points of the image's tonal

Step by step

range. The tones, details and colors that sit in between these extremes are adjusted next. But first set the white point. With the clipping warnings still active, start to move the Exposure slider to the right. This action is gradually lightening the tones and moving the highlight image detail towards pure white. When you start to see red areas appear on the preview image or the highlight clipping warning in the top right of the histogram change from gray to a color, highlight detail is being lost. Move the slider gradually back to the left until the warnings disappear.

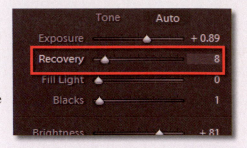

Pro's tip: Some photographers use an alternative approach where they slightly clip the highlights and use then Recovery control to bring back the detail.

8. Reclaiming lost highlights

If the preview image is displaying areas of red when the Exposure slider is set to 0 then this can indicate that some of the highlight detail has been clipped during capture. If the clipping is only in a single channel then the lost highlight information can be recovered with the Recovery slider. Moving the slider to the right increases its effect.

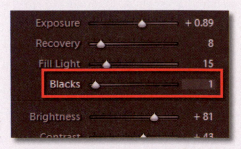

9. Setting the black point

With the white points fixed let's turn our attention to the other end of the scale. Make sure that the shadow clipping warning is still active and then gradually move the Blacks slider to the right. Once you start to see blue areas appear in the preview or clipping warning in the histogram change color from gray, then shadow detail is being converted to pure black. Gradually move the slider back to the left until the blue disappears.

10. Revealing hidden shadow detail

If blue patches appear even when the Blacks slider is at its lowest or near lowest setting it is possible that the shadow areas are too dark. The Fill Light slider can be used to gently boost these shadow details so that they are not pure black. Moving the slider to the right brightens the shadow detail. Be careful though as applying too much Fill Light adjustment can cause halo effects.

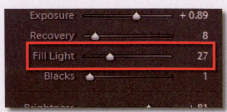

11. Adjusting brightness

The Brightness slider is then used to adjust the density of the middle values. To lighten the midtones push the control to the right, to darken the values move the slider to the right. Generally these changes have little or no effect on the white and black points, but watch for any inadvertent clipping and adjust Exposure and Blacks sliders accordingly.

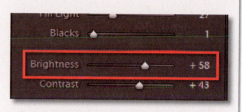

12. Altering contrast

Setting the black and white points determines the tonal range of the photo; adjusting the Contrast slider alters the spread of tones within these two extremes. Moving the slider to the right increases contrast and to the left reduces contrast. Again watch for clipping and readjust if needed.

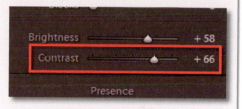

Color control

13. Adjusting color saturation and vibrance

With the tones set we now turn to the colors in the photo. Starting with the strength of the color we have two options that control this image characteristic – Vibrance and Saturation. Use the Saturation slider to boost or quieten all the colors in the image and employ the Vibrance slider when you only want to increase the vividness of the desaturated colors in the photo.

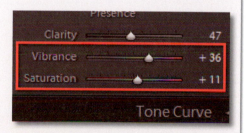

14. Adding clarity

Use the Clarity slider to add local contrast to the details in the photo. This will increase the appearance of detail and make diffused images appear sharper.

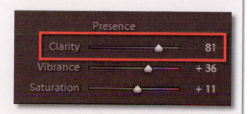

Sharpness control

15. Noise reduction

To preview the effects of both Noise Reduction and Sharpening features the image must be magnified to at least 1:1. Click the exclamation mark in the top left of the dialog to jump straight to this magnification.

Next, use the Luminance slider to remove grayscale noise and the Color slider to reduce the appearance of random red, green and blue pixels that sometimes appear when using high ISO settings or long exposures.

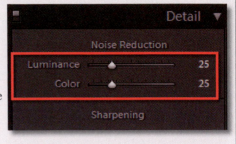

16. Tweaking sharpness

Use the four sliders in the Sharpening section of the Detail panel to add some sharpness to the image. Use the Amount slider to control the strength of the effect and the Radius the distance from edges that the effect is applied. Refine the way that the sharpening is applied to details with the Detail slider and restrict the sharpening to edges only with the Masking control.

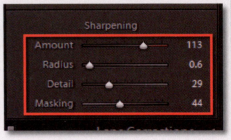

9

Settings: Custom

| Adjust | Detail | Lens | Curve

Tone Curve: Custom

Input: 132 Output: 180

Beyond ACR Basics

249

In the previous chapter we saw how we could take a camera file in raw format and, using the features of Adobe Camera Raw (ACR), process the image, enhancing color, tone and sharpness. Let's now look at some more specialized Adobe Camera Raw techniques that the professionals are using daily to speed up their workflow whilst maintaining the ultimate image quality.

Curves provide advanced tonal control

Available in: ACR for Photoshop/Bridge and Lightroom

Experienced digital photographers who want a little finer control over the tones in their pictures often turn to the Curves feature in Photoshop. The feature contains a graph-based workspace with a light gray histogram preview of the picture's tones and a straight line that represents the relationship between input values and output tones. By manipulating the line in the Curves dialog, the user can finely tune the appearance of different tones in the photo without unduly affecting other areas of the image.

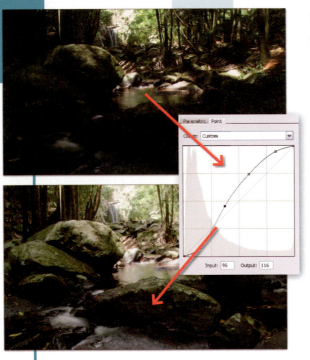

The Curves feature in ACR works in a similar way to the similarly named tool in Photoshop and provides custom control over the tones in your raw photos.

Sophisticated raw converters, such as Adobe Camera Raw (Photoshop and Bridge) and Lightroom, contain curves features as well. This means that such fine-tuning steps can be applied directly to raw files without having to transfer the images to Photoshop first. The feature is located in the Tone Curve panel in both programs, but the ACR implementation contains two different modes – Parametric and Point.

In the ACR's Point version and Lightroom (via the Point Curve menu) the user can select from several different curve presets. Alternatively all modes provide the ability for the user to create their own 'custom' curve settings. Tonal range sliders are used in Lightroom and Parametric mode of ACR to adjust specific tones. In the Point mode of ACR users place control points on the curve and then click-drag the points to new positions to alter the tones in this part of the image.

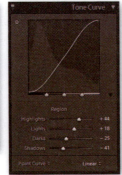

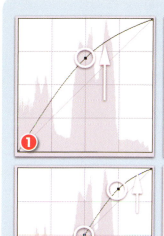
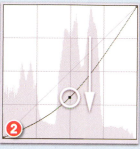

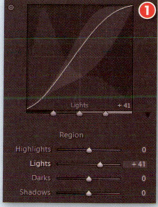

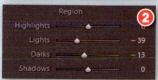
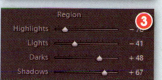

Quick start Curves summary

1. **To lighten midtones but no change to highlight and shadow areas** – Click and drag a middle control point upwards **or** move the Lights slider to the right.

2. **To darken midtones but no change to highlight and shadow areas** – Click and drag a middle control point downwards **or** move the Lights slider to the left.

3. **To decrease contrast** – Click to add a control point to the middle and then click and drag a shadow control point upwards and a highlight point downwards **or** drag Highlights/Lights sliders to the left and Darks/Shadows sliders to the right.

4. **To increase contrast** – Click to add a control point to the middle and then click and drag a shadow control point downwards and a highlight point upwards **or** move the Highlights/Lights sliders to the right and the Darks/Shadows to the left.

5. **To lighten shadows only** – Click to add a control point in the middle and then click and drag a shadow point upwards. Now adjust the middle point until the highlight area of the line is almost straight again **or** move the Darks/Shadows sliders to the right.

6. **To darken highlights only** – Click to add a control point in the middle and then click and drag a highlight point downwards. Now adjust the middle point until the shadow area of the line is almost straight again **or** drag the Highlights/Lights sliders to the left.

Top left: *Point curve adjustments in Adobe Camera Raw.*

Above: *Slider-based adjustments in Lightroom or the Parametric mode of Adobe Camera Raw.*

Color fine-tuning with the Calibrate feature

Available in: ACR for Photoshop/Bridge (can be used in Lightroom)

As well as the white balance presets and Temperature and Tint sliders, Adobe Camera Raw also contains a set of color-specific controls grouped under the Calibrate tab in the Settings section of the dialog. Though daunting to start with, the options found here do provide an amazing amount of control and are used by many professional photographers to 'profile' the way that the color from their cameras is interpreted by the raw converter. This is particularly useful for building a profile for neutralizing the casts that are present in images photographed under mixed artificial lighting conditions. Though this technique is only possible in ACR, the results can be used in Lightroom as well.

The process involves photographing a GretagMacbeth Color Checker reference board under the lighting conditions that are typical for the scene. The raw file is then opened into Adobe Camera Raw and the color and tones of the captured file are adjusted to match the 'true' values of the patches. The RGB values that each patch should be (in a variety of color spaces) can be obtained from Bruce Lindbloom's great website (www.brucelindbloom.com). These synthetic values will act as a reference when making your adjustments.

Start by setting a basic white balance by clicking onto the light gray patch of the Color Checker with ACR's White Balance tool. Next use the Exposure and Shadow sliders to adjust the contrast of the image. Use the Color Sampler tool to check the patch values in the raw preview against those synthetic values found on Lindbloom's site.

The Calibrate control provides the ability for photographers to fine-tune their white balance in their pictures to match difficult non-standard lighting conditions. After making these settings you can then save the values to be used with other pictures photographed under the same lighting conditions.

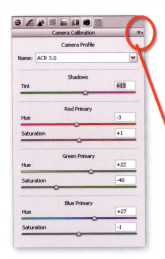

Next switch to the Calibrate tab and use the sliders to start to adjust the color of the test patches. Again your aim is to match as closely as possible the captured (sampled from the preview) values with the synthetic values of the Color Checker. This can be a pretty exacting task as moving one slider will not only affect its color but also the value of the other two. Matching the two values is a process of adjust, check and then adjust again, but once completed the final color settings can be saved as a new settings subset and applied to all photographs taken under the same lighting conditions.

Performing this process manually is tedious and takes a lot of time, a better approach is to employ the help of a specially written custom script that automates the process. The cross platform script is available from the Chromoholics website (http://www.fors.net/chromoholics/) and once installed automates the fine tuning procedure detailed here.

You can obtain a script that automates the fine-tuning process from the Chromoholics website (http://www.fors.net/chromoholics/).

Synthetic RGB values for the Macbeth Color Checker patches (Adobe RGB)					
Red 106	182	103	95	129	133
Green 81	149	122	108	128	189
Blue 67	130	154	69	174	170
194	79	170	84	167	213
121	91	85	62	186	162
48	162	97	105	73	57
54	101	152	228	164	63
62	148	48	199	83	134
149	76	58	55	144	163
242	200	159	122	84	53
241	200	160	121	84	53
236	199	159	120	84	53

The table is laid out in the same 6 × 4 array as the Color Checker chart, and within each cell, the color components are shown in red, green, blue order from top to bottom. When adjusting the sliders in the ACR Calibrate tab aim to replicate these RGB values.

The version of ACR that ships with Photoshop and the latest version of Photoshop Elements can process multiple raw files at the same time. Multi-selected files are displayed as thumbnails to the left of the main preview area.

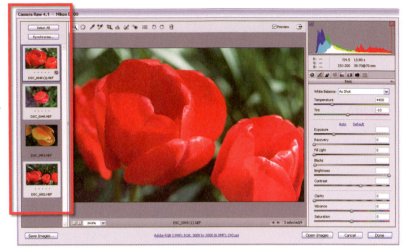

Applying raw conversion settings without opening files

Available in: ACR for Photoshop/Bridge and Photoshop Elements

The version of Adobe Camera Raw that ships with Photoshop and Photoshop Elements includes many features that make processing several files at a time an easier task than it has been. Earlier versions of the utility were only able to work on one file at a time.

To process several files at once, multi-select their thumbnails in the Bridge or Organizer workspaces and then select File > Open with Camera Raw (Alt/Option + R) or select the Full Edit option from the right-click menu for Elements users. The first selected file is previewed in the ACR workspace and highlighted in the slide table section (left) of the dialog. The rest of the pictures are also displayed here in thumbnail form.

To process the files simply click on each thumbnail in turn, making your enhancements using the slider controls and then clicking Save or Done to apply the changes. For images shot at the same time under the same lighting conditions, the enhancement process is even quicker. Photoshop users start by adjusting the settings for the first photo in the series. Next choose the Select All button at the top left of the dialog (you can also multi-select specific thumbnails) and then click Synchronize. ACR then displays the Synchronize dialog, where you can select the specific enhancements that you want to apply to all selected images. Click OK to exit the dialog and apply the changes to the thumbnails. Press the Save or Done buttons to apply the changes to the photos.

Elements users click the Select All button first and then start to adjust the Develop controls. The changes made to the first image are flown through to the rest of the selected photos. And remember that the enhancements have not been applied permanently – you can always reopen the raw file and change the settings or even remove the enhancements altogether.

One step further...

Photoshop users can take this multi-image processing idea a step further with the ability to apply saved Camera Raw settings directly to thumbnails from within Bridge. Development settings are listed in the pop-up menu that is displayed when you right-click a raw thumbnail in the Bridge workspace. The default options include Camera Raw Defaults and Previous Conversion. To apply these to an unopened raw file, simply right-click onto the thumbnail and select the entry from the pop-up menu. To set a new Camera Raw Default, open a file, make any adjustments and then click the sideways arrow button beside the Settings drop-down menu in the top right of the dialog and select the Save New Camera Raw Defaults option from the menu that is displayed. This records the current settings as the new defaults. To reset all the settings choose Reset Camera Raw Defaults from the same menu.

To store custom raw conversion values as new entries on the right-click pop-up menu, open an example file, make the changes necessary to achieve the look you want and then select the Save Settings entry from the pop-up menu. In the Save window that follows, you will get a chance to name the settings with a title that will become a new entry on the right-click menu. Now to apply these new custom raw conversion settings to a series of images, choose several thumbnails from within Bridge, right-click on one of the photos and select your custom settings entry from those listed. ACR will then apply the group of settings to all the selected photos and automatically update the thumbnails to reflect the changes.

Lightroom users don't miss out on this efficient way to process multiple raw files. Simply make changes to a sample photo using the settings in the Develop module. Next, click the + button at the top right of the Presets dialog and save the settings as a new develop preset. To apply the saved settings to other images, multi-select the photos in the Grid View and then choose the preset from the Develop Settings menu on the right-click pop-up menu.

The Select All and Synchronize (Photoshop) options allow the user to apply the settings created for one file to a selection of other raw photos.

Lightroom users can apply Develop Setting Presets to multiple photos by selecting the pictures in the Grid View and then choosing the preset from the Develop Settings option on the right-click menu.

The Save Settings option in ACR is used to store a specific group of raw conversion values.

Raw settings (1) and cropping (2) icons are displayed on thumbnails in Bridge and the Lightroom Library when the picture has had conversion settings applied to the photo.

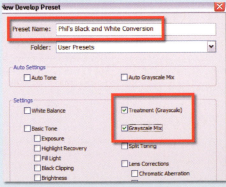

Save Lightroom develop settings to a new preset by clicking the + button in the top of the Presets panel and selecting the settings options to include.

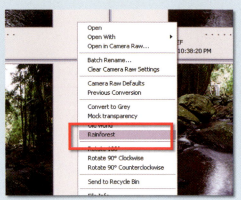

In Bridge saved conversion settings can be applied to raw files by right-clicking the thumbnail and then selecting the setting entry from the menu list.

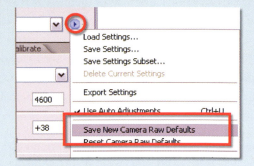

The Save New Camera Raw Defaults in ACR replaces the stored default settings with those applied to the currently selected photo.

Apply Develop presets to selected images by either choosing the option from the Presets panel in the Develop module or by right-clicking a picture in the Grid View and then choosing the option from the Develop Settings menu.

Correcting color fringes and vignetting

Available in: ACR for Photoshop/Bridge and Photoshop Lightroom

The ultra-wide-angle lenses that are now available for many DSLR cameras can capture incredible angles of view, but in doing so some images from these lenses exhibit color fringing and vignetting problems.

The fringing is the result of different wavelengths of light not being focused at the same position on the sensor. Known as chromatic aberration, the visual results of this lens defect is most noticeable on areas of contrast around the borders of the photo. Most users will see the problem as colored lines hugging the sides of edge detail. In the example image, there is distinct red/cyan fringing (1) visible along the main structural element in the photo. The Lens Correction section in both Adobe Camera Raw and Lightroom contains two sliders that are designed to reduce the appearance of chromatic aberration in your photos.

The feature contains two sliders, one that concentrates on Red/Cyan fringing and a second that works on Blue/Yellow fringes. To reduce

Use the Chromatic Aberration sliders in the Lens Corrections section of ACR or Lightroom to correct the color fringes that sometimes occur on photos taken with wide-angle lenses.
1. Before chromatic correction.
2. After chromatic correction.

the effects of this lens problem, zoom into the photo in the preview and navigate to a part of the picture where the colored lines are clear and easy to see. Now carefully move one of the sliders and watch the preview. Move the slider enough to reduce the effects of the fringing but be careful not to overcompensate and introduce fringing of the opposite color to your photo.

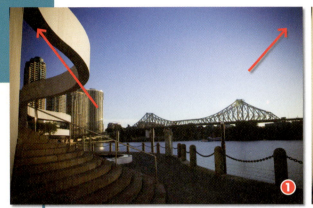 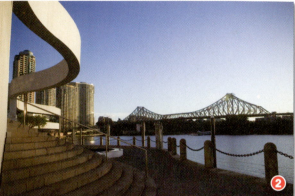

The darkening of photo edges or vignetting can be corrected with the aid of the Amount and Midpoint sliders in the Vignetting section of the Lens tab part of ACR. (1) Before vignette correction. (2) After vignette correction.

Vignetting is another visual effect that results from a lens problem. This time it is the lens's inability to maintain even exposure across the whole sensor. This results in the darkening (sometimes lightening) of the corners of the frame. Now sometimes this effect can be artistic, and many photographers actually introduce a little vignetting into their photos as part of the enhancement process, but dark corners, when they are not wanted, are a problem.

Included alongside the Chromatic Aberration controls under the Lens Corrections section are two sliders that help counteract the vignetting effect. The Amount slider lightens the corners of a photo when moved to the right and darkens them when moved left. The Midpoint control adjusts the amount of the picture that the lightening or darkening is applied to. To reduce the vignetting in your photos drag the Amount slider until the brightness of the corners is similar to the rest of the picture then use the Midpoint slider to fine-tune the lightening effect so that the transition to the rest of the photo is even.

10

Lossless Image Enhancement Comes of Age

As we have already seen in Chapter 2 the current state of play for photographers who want to take their image processing a little further than what is available with most dedicated raw programs involves a 'Convert and then Edit' approach. The conversion step is handled by a dedicated raw utility such as Adobe Camera Raw, or Lightroom, and the editing operations fall to Photoshop. But this way of working doesn't take full advantage of the possibilities that abound in the area of non-destructive or lossless editing.

For years photographers have advocated using a non-destructive editing workflow whenever possible. On a simple level, this meant applying changes to images in Photoshop via adjustment layers, rather than altering the original pixels themselves. Until recently, no matter how much a photographer wanted to adopt a non-destructive editing workflow the first step was to convert the raw file from its original state (image data taken from the sensor with little processing applied) to a picture format that enabled further processing. Sure, from this point forward, it was possible to make use of non-destructive editing techniques, but these changes were made to the converted file, not the original raw picture.

Well, thankfully, 'times are a changin''. Companies such as Adobe have taken up the challenge and have started to create non-destructive editing options for raw shooters that maintain the integrity of the original raw file throughout the editing process. With dedicated programs such as Adobe's Lightroom, and new 'Smart raw-aware' workflows in Photoshop, the future for raw shooting photographers is looking decidedly rosy.

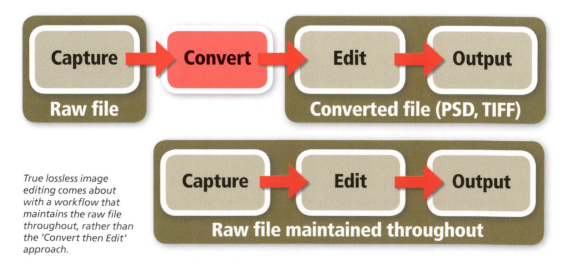

True lossless image editing comes about with a workflow that maintains the raw file throughout, rather than the 'Convert then Edit' approach.

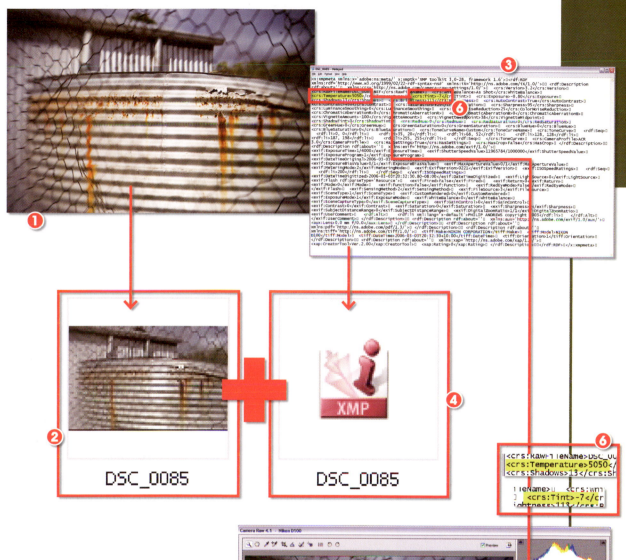

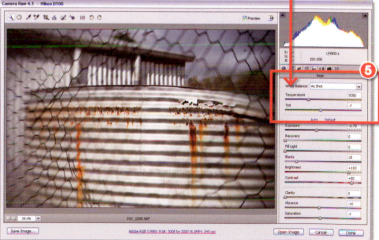

With Adobe's approach to non-destructive editing of raw files the primary picture data or raw photo (1) is maintained in the original file (2) whilst the conversion settings (3) are stored in a separate XMP file (4) or in the Camera Raw Database (ACR) or Lightroom database.

The specific values (5) used for raw conversion are saved as text entries and in the case of Adobe Camera Raw these are stored in the XML sidecar file (6).

But how does it work?

Providing a workflow that is non-destructive is pretty tricky, but how do the software developers actually make the process work? Well, the underlying principle of the approach is to maintain the original raw files as a separate entity from the conversion and editing settings that are applied to the picture. With Adobe's system these conversion, or 'Develop', settings are stored separately from the picture data, often in an XML (Extensible Markup Language) file that is named the same as the picture itself. More recently, it has also become possible to write the settings to the metadata section of the image file itself. This is necessary if the development settings are to be recognized in a different program to the one in which the photo was originally enhanced.

Check this out yourself. Have a look at the folders containing pictures that have been processed through Adobe Camera Raw (ACR); you will see a series of XML files associated with the raw files. The XML file is essentially the full set of conversion settings that were selected in ACR at the time of processing. When the raw file is reopened, ACR uses these values to automatically set up the dialog's controls as well as adjust the preview of the raw photo so that it matches how the picture will look when processed. Making a change to conversion settings, such as white balance, exposure or saturation, merely adjusts the appropriate entry in the settings file, which in turn updates the preview in the ACR dialog and the thumbnail displayed in Bridge.

Working this way means that the original raw file data are never destructively changed. The settings can always be altered at a later date, or even removed, without any loss of quality – it is, if you like, the ultimate form of 'Undo'.

When making adjustments to the look of your files inside Adobe Camera Raw, or Photoshop Lightroom, the settings you select are not applied to your files directly. Instead, they are stored with the image file, either in a small associated sidecar file or in the metadata section of the image file, and are used to display a preview of the developed file on screen. It is necessary to select the 'Automatically write changes in XMP' in Lightroom's Catalog Settings to ensure that Develop changes are recognized by other programs.

Note: This method of providing a live preview of how the image looks with the conversion settings applied is one of the reasons why some full workflow programs require substantial system resources (processor and video power as well as high levels of available RAM) to function quickly.

Smart workflows

Starting with Photoshop CS2 and continuing with CS3 Adobe has been developing an editing system that is sufficiently 'raw aware' that it is now possible to continue non-destructive editing of the raw file beyond the conversion software. Instead of converting the image in order to undertake localized editing tasks, the use of powerful Smart Object technology enables the raw file to be embedded in a Photoshop document, where it can be edited and enhanced pretty much like any other photo.

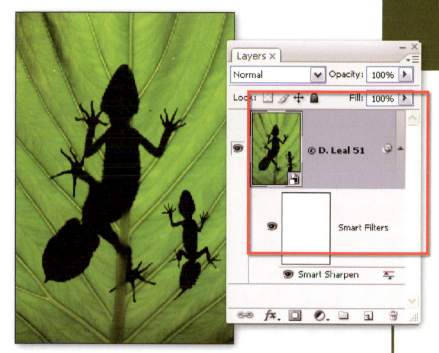

The Smart Object technology in Photoshop CS3, including the new Smart Filter system, provides the ability to embed raw files into Photoshop documents.
Once in this form, the user can make further editing changes to the image that are not possible when working with the file in Adobe Camera Raw or Lightroom.

The embedding process ensures that you can re-open the raw file at a later date and can change the Develop settings that you initially applied. Sure, there are some tasks that still require conversion of the file to a standard photo format such as PSD, TIFF or JPEG, but in many other cases, simple Smart Object-based workflows will get the job done.

What happens when I want to print or create a slideshow?

Okay, that is editing, what about the output side of things? Unfortunately raw files cannot remain so forever. By their very nature the act of printing, or presenting photos on screen, requires a change in the picture's state. This means at some stage the raw file will be converted to a standard format that is suitable for output.

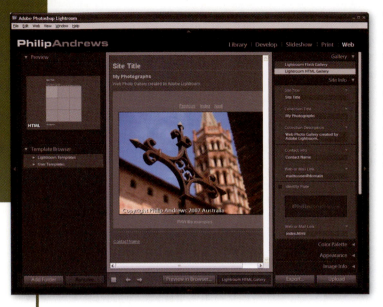

When creating a web gallery using Photoshop Lightroom's Web module, the program seamlessly creates web-ready versions of the raw files with all Develop settings applied.

With full raw workflow packages like Photoshop Lightroom, that contain print, slideshow and web gallery production options, the raw file is duplicated with development settings applied and then sent to the printer or screen or used to produce the thumbnail and gallery photos for online work. Because of the sophistication of the Lightroom workflow the user is blissfully unaware of the mechanics involved in the output sections of the program.

When working with Bridge and Photoshop it is also possible to retain the original embedded raw file during the enhancement process and then use the tools in Photoshop to make the necessary conversions when printing or creating a web gallery or presentation.

State of play

Over the next couple of chapters we will look at the current state of play for photographers who want to maintain their raw files but still be able to manage, manipulate and output these pictures as easily as if they were stored in more traditional formats (PSD, TIFF or JPEG). In particular we will look at the workflows and techniques associated with Bridge, Photoshop and Lightroom.

11

Editing Raw Files in Photoshop

Edit Layou

ntil recently, raw files were viewed as a capture-only format with the first step in any workflow being the conversion of the picture to another file type so that editing, enhancing and output tasks could be performed. I say recently because with the release of products such as Lightroom from Adobe, it is no longer necessary to change file formats to move your pictures further through the production workflow.

Even Photoshop and Bridge are now sufficiently raw aware to allow the user to edit, enhance, print and even produce contact sheets, PDF presentations, picture packages and web galleries all from raw originals. Yes, sometimes the files are converted as part of the production process for these outcomes, but I can live with this intermediary step if it means that my precious pictures stay in the raw format for more of the production workflow. With a little trickery associated with Photoshop's Smart Object technology it is now even possible to edit individual pictures inside a standard Photoshop document without having to convert the file first.

So with this in mind let's look at some editing, enhancing and output options that are available for the raw shooter who wants to use Photoshop, but also wants to maintain his, or her, picture's raw status for longer.

All roads lead to Photoshop

It has long been possible to import and edit converted raw files into Photoshop. In fact, this is the basis of the traditional raw workflow where the captured photo is first converted to a standard picture format, such as PSD, TIFF or JPEG, before being opened in Photoshop. This is still the route you will have to take for most pathways that lead to Photoshop (see pathway diagram opposite), but the inclusion of Smart Object technology in Photoshop CS2 and CS3 provides an editing alternative that retains the original raw file (see green pathway in the illustration opposite).

This option provides a non-destructive raw workflow with editing possibilities that go way beyond the global options (changes applied to the whole picture) available with Adobe Camera Raw and Photoshop Lightroom. Non-destructive enhancement might not always be your goal or, with some complex techniques, might not even be possible, so to start with in the next few pages we will look at all the different ways to open your raw images in Photoshop.

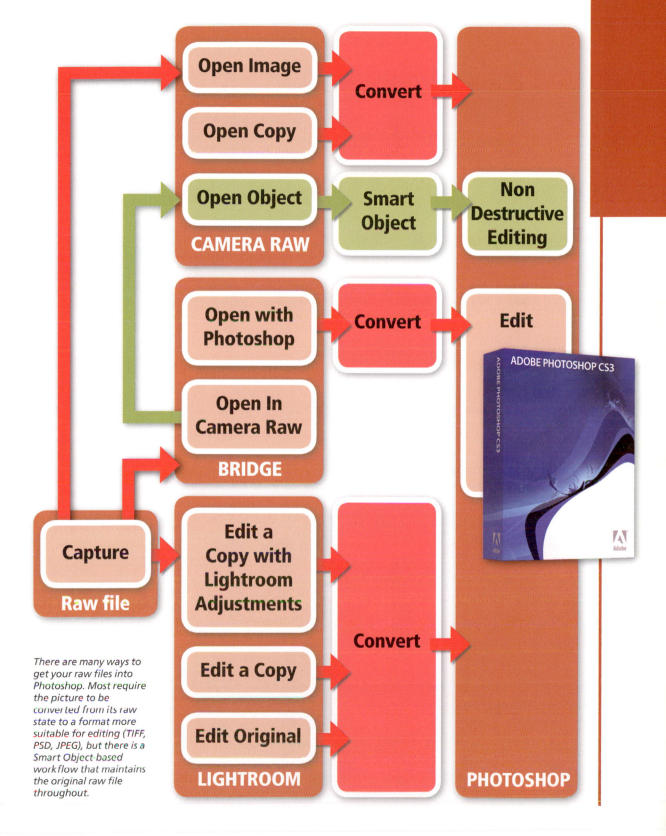

There are many ways to get your raw files into Photoshop. Most require the picture to be converted from its raw state to a format more suitable for editing (TIFF, PSD, JPEG), but there is a Smart Object-based workflow that maintains the original raw file throughout.

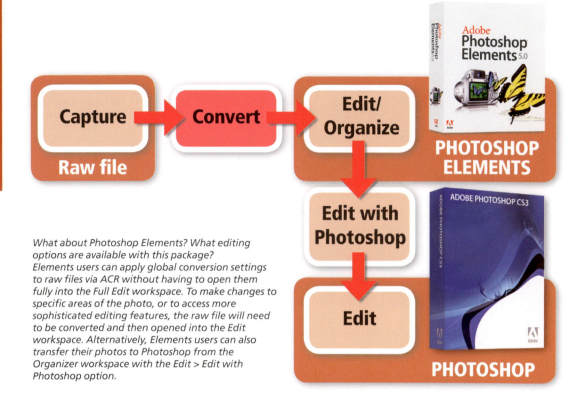

What about Photoshop Elements? What editing options are available with this package? Elements users can apply global conversion settings to raw files via ACR without having to open them fully into the Full Edit workspace. To make changes to specific areas of the photo, or to access more sophisticated editing features, the raw file will need to be converted and then opened into the Edit workspace. Alternatively, Elements users can also transfer their photos to Photoshop from the Organizer workspace with the Edit > Edit with Photoshop option.

From the menu

To pass a photo from your Lightroom Library to Photoshop select the image in the Library or Develop module and then choose Photo > Edit in Adobe Photoshop. The shortcut key for this action is Ctrl/Cmd + E.

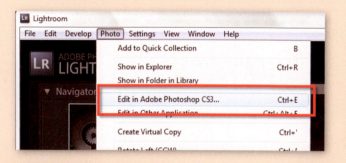

Right-click access

Alternatively you can right-click on a photo in the Library module (in Grid, Loupe, Compare, or Survey View) and select the Edit in Adobe Photoshop option from the pop-up menu. This option is also available in the Develop module.

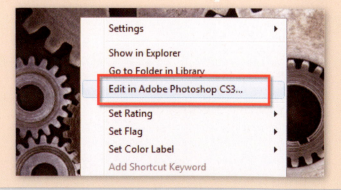

Edit Photo dialog

Once the Edit in Adobe Photoshop option is selected, Lightroom displays the Edit Photo with Adobe Photoshop dialog. Here you can select from the following three options:

Edit a Copy with Lightroom Adjustments – Lightroom duplicates the raw file, applies the current set of development or conversion settings and then opens the new file into Photoshop. The file format, color space and bit depth of the copy are determined by the settings in the Copy File Options section of the dialog. This is the only option available for raw or DNG files. The duplicated file is titled with the original filename plus '-Edit'.

Edit a Copy – Lightroom opens a copy of the file in Photoshop. No Develop settings are applied to the copy. This option is only available with non-raw files (i.e. PSD, TIFF or JPEG). The format, color space and bit depth of the copy are controlled by the settings in the Copy File Options section of the dialog. The filename of the copy is automatically set to the original name plus '-Edit'.

Edit Original – Again this option is only available with non-raw files. Lightroom opens the original file into Photoshop. All saved changes are applied to the original file.

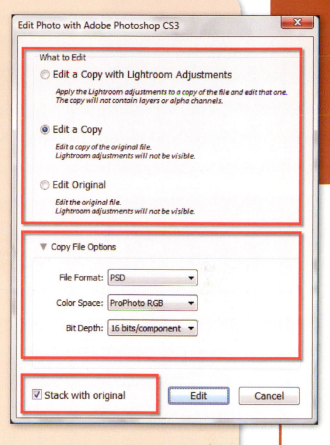

Stacking edited versions

Selecting the 'Stack with original' option when making a copy saves the duplicate alongside the original in the Lightroom library and automatically creates a stack from the two files.

Right-click access

To pass a photo from Bridge to Photoshop right-click on the image in the Content panel and then select Open With > Adobe Photoshop. If Photoshop is the default application for the file type you are opening then you can select the Open option from the pop-up menu for the same result. These options will not open the file directly into Photoshop, but rather they will open the file in Adobe Camera Raw first, and from here you can open the image in Photoshop.

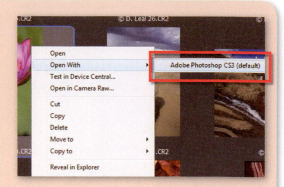

Double-click

Double-clicking on an image in the Content panel in Bridge will open the photo in the default program associated with the image's file type. If Photoshop is the default program for raw files then holding the Shift key down while double-clicking will bypass the ACR dialog, convert the raw image and open the picture into Photoshop. The conversion is based on the Camera Raw Defaults.

Pro's tip: To change the program that opens a specific file type, Windows users should right-click the file and choose the Properties menu entry. Alter the 'Opens with' program by clicking on the Change button.

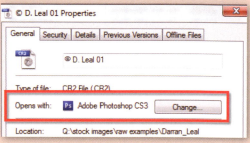

Photoshop via ACR

By far the most popular way to move your raw photos into Photoshop is via the Open in Camera Raw option (located on the pop-up menu when you right-click a raw file in the Content panel). This opens the image into the Adobe Camera Raw dialog. From here you have three methods for opening the photo into Photoshop. See opposite page for details.

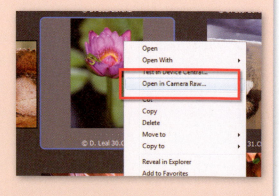

ACR to Photoshop

With the raw file open in Adobe Camera Raw there are three ways to transfer the image to Photoshop. They are:

Open Image – This option applies the current Develop settings to the raw file and also converts the photo to the PSD format. The resultant file is then opened into Photoshop. After changes are made in Photoshop the files will be saved with the same filename as the original raw file but the fie type will have changed to PSD.

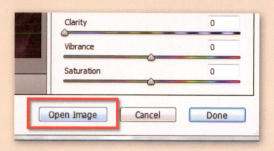

Open Copy – Holding down the Alt/Opt key changes the Open Image option to Open Copy. With the Open Copy selection ACR applies the current Develop settings to a duplicate, converted, version of the file. This image is opened into Photoshop as a PSD file. The original raw file is left untouched. If multiple images are select in ACR then this option will open copies for each file.

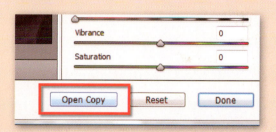

Open Object – Holding the Shift key down will change the Open Image button to Open Object. This selection applies the current Develop settings, creates a new PSD document the size and format of the original file, and embeds the raw photo as a Smart Object. It is important to note that this approach DOES NOT convert the raw data to create a usable Photoshop document. This forms the basis of all the non-destructive techniques detailed here and in the next chapter.

Pro's tip: The Done button simply applies the current Develop settings and then closes the ACR dialog without opening the file into Photoshop.

From ACR

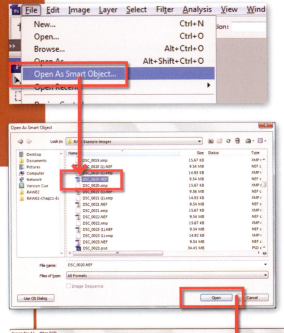

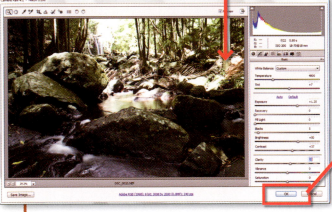

Creating raw Smart Objects from inside Photoshop CS3

As an alternative to using the Open Object route from Adobe Camera Raw, it is possible to open a raw file from inside Photoshop itself. The Open as Smart Object option is located under the File menu. After selecting the entry Photoshop presents you with a file browser so that you can locate the raw file. After selecting the photo click the OK button at the bottom of the dialog.

The raw file is then loaded into Adobe Camera Raw. Here you can make any changes or enhancements necessary before clicking the OK button to close the dialog and open the embedded file in a new Photoshop document.

Embedding raw files in Photoshop CS2

Smart Object technology was first released in Photoshop CS2 but the version of Adobe Camera Raw that came with that product didn't contain the Open Object option. If you haven't yet upgraded then don't despair, the following technique provides a neat workaround for the problem. Smart Objects are a way of embedding the original file within a special layer in a Photoshop document.

Step by step:

1. Creating a new document preset

Start by finding out the exact pixel dimensions of the raw file. Switch to Photoshop CS2 and create a new document using these dimensions in the New Document dialog. Save this document as a new preset. Label it something like 'Nikon/Canon Raw Embed'. It will now be installed as a new entry on the preset document list.

2. Placing the raw file

Next, jump back to Bridge and click onto the thumbnail of the raw file. Now select File > Place > In Photoshop. Bridge opens Photoshop CS2 and then displays the raw file inside the Adobe Camera Raw dialog. Make any adjustments, but don't fuss as you will be able to readjust the raw settings later on. Click the Open button and then Enter/Return to place the raw file into the Photoshop document.

Note: Make sure that the new document you create is the same orientation (portrait or landscape) as the raw file you are trying to embed.

3. Creating a Smart Object layer

Notice in the Layers palette that the raw picture has been placed as a special Smart Object layer rather than standard image layer. The raw file is now embedded into the Photoshop document. To make any changes to the raw settings, simply double-click onto the layer's thumbnail. This action displays ACR, allowing you to tweak the raw settings until you are satisfied with the results. From this point onwards the file can be treated as a standard Photoshop document.

Making changes to an embedded raw file

OK, so you have successfully managed to embed your raw file and you now have a new Photoshop document complete with a Smart Object layer. The original conversion settings that were applied to the photo at time of embedding look fine but you want to fine-tune the color and contrast of the file. Or maybe there are a couple of marks on the photo that need removing. How can we make these changes in Photoshop without having to first convert the raw file to a standard format such as PSD or TIFF?

Well, the following collection of techniques will provide you with an inkling of the type of workflow that is now possible without having to convert your raw file first.

But you can't edit a Smart Object. Not true!

Using this approach, simple retouching tasks are also not out of the question and they don't require that the Smart Object be rasterized first. Jobs like removing a pimple from the face of an otherwise glamorous model are possible by creating a new layer above the Smart Object layer and then selecting the Spot Healing Brush (set to Use All Layers). Proceed to make the retouching corrections on the new layer. This is a great way to maintain the original raw file and provide the retouching options that are sometimes needed. This is especially helpful if you are not using Lightroom or the latest version of Adobe Camera Raw, which both contain options for spot removal.

The technique also demonstrates how skillful use of Photoshop technologies such as Sample All Layers, Adjustment Layers and Layer Blend Modes can provide innovative workflows that maintain the raw file throughout.

To remove marks and blemishes from an embedded raw file, start by creating a new layer above the Smart Object layer.

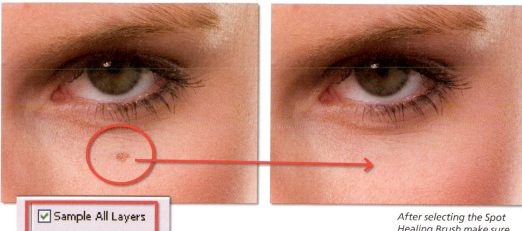

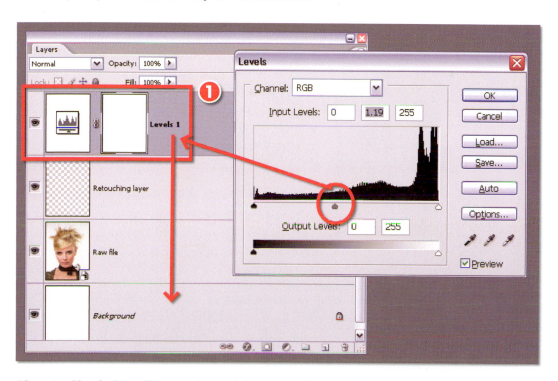

After selecting the Spot Healing Brush make sure that the new layer is selected and that the Sample All Layers option is ticked before clicking on the blemish.

Pro's tip: Keep in mind that any changes made directly to the color, contrast and brightness of the raw file Smart Object will not be reflected in the retouching image layer. If you want to make such changes to both layers, create a new adjustment layer above both the retouching and Smart Object layers and use this for your enhancements.

After retouching the Smart Object any changes (color, contrast, brightness) that you make to the embedded raw file will not match the details in the retouching layer. So rather than making these changes directly to the raw file, add an adjustment layer (1) above both the Smart Object and retouching layers and alter the image via this control.

Tonal and color changes via the raw file

For color and tonal enhancements that don't involve an existing retouching layer use the editing abilities of the Smart Object to make these changes directly to the raw file. Double-clicking the Smart Object layer opens the file inside the program of origin. For placed Illustrator files this means that the file is opened inside Illustrator ready for editing, for our embedded raw file the picture is opened inside Adobe Camera Raw. Cool!

All the settings for the values used for the current conversion are set in the dialog and it is a simple matter to adjust contrast, brightness, white balance, sharpness or any of the other variables available in the dialog. Clicking the Done button then saves the changes back to the Smart Object layer and in the process updates the view of the document in the Photoshop workspace. This way of working might seem a little convoluted but it provides a radical lossless method of manipulating your raw files as Photoshop documents.

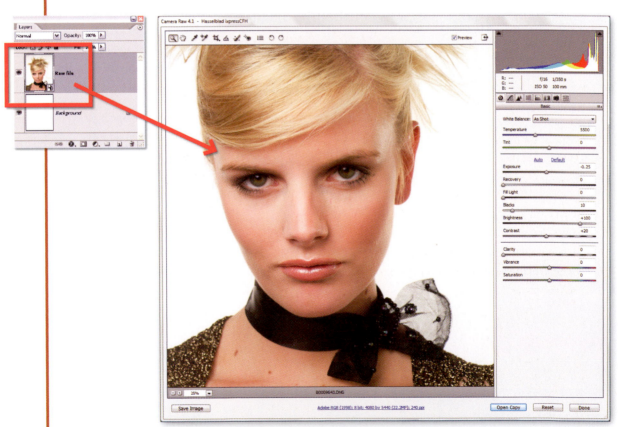

Double-click the Smart Object layer or choose Layer > Smart Objects > Edit Contents to open ACR and edit the conversion settings of the raw file.

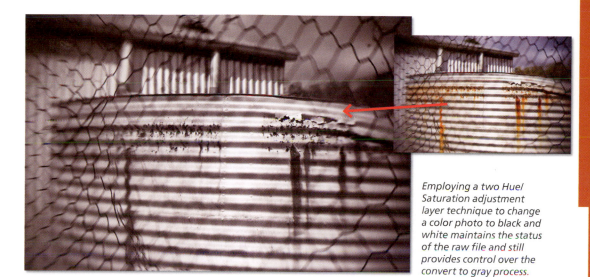

Employing a two Hue/Saturation adjustment layer technique to change a color photo to black and white maintains the status of the raw file and still provides control over the convert to gray process.

Convert to gray

Let's take this lossless enhancement approach a little further and look at a new twist on an old convert to gray technique. First proposed by the Adobe evangelist Russel Brown, this method uses two Hue/Saturation adjustment layers to create an editable convert to gray technique that leaves the original pixels untouched. In our situation this means producing a grayscale picture from the raw file in its virgin state. This technique is suitable for CS2 and CS3 users alike.

1. Embed a raw file in a new Photoshop document in the manner described above. Next make a new Hue/Saturation adjustment layer above the Smart Object layer. Don't make any changes to the default settings for this layer, just create the layer and then close the dialog. Set the mode of the adjustment layer to Color. Label this layer 'Filter'.

2. Now create a second Hue/Saturation adjustment layer above the Filter layer and alter the settings so Saturation is -100. Call this layer 'Black and White Film'. The monochrome image now on screen is the standard result we would expect if we just desaturated the colored original.

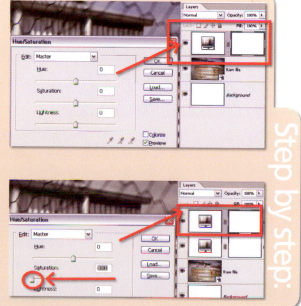

Step by step:

3. Next double-click on the layer thumbnail in the Filter layer and move the Hue slider. This changes the way that the color values are translated to black and white. Similarly if you move the Saturation slider you can emphasize particular parts of the image. In effect you now control how the colors are mapped to gray.

4. For more precise control of the separation of tones you can restrict your changes to a single color group (red, blue, green, cyan, magenta) by selecting it from the drop-down menu before manipulating the Hue and Saturation controls.

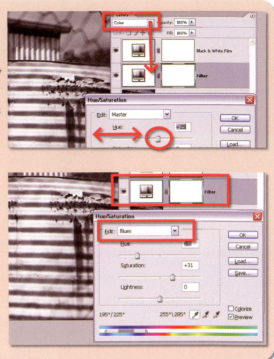

New grayscale conversion options in CS3

Photographers have had such a long and glorious history of producing fantastic black and white images that in making the transition to digital we expected this tradition to continue unabated. But despite the ease with which digital allows us to convert a color photo to black and white, the ability to create richly toned monochromes is still a black art filled with mysterious magic for many image makers.

It is for this reason that Adobe has produced a range of pathways, tools and techniques to convert color images to black and white over the past few years, starting with simple change to grayscale mode and desaturate techniques, and then moving on to the more sophisticated, and most say more difficult to use, Channel Mixer feature. Well, Photoshop CS3 includes a new feature that promises to bring quality grayscale conversions to the masses.

Called the Black and White feature (Image > Adjustments > Black and White), the new tool provides all the power of the Channel Mixer without the drawbacks. Overall density of the conversion is handled automatically and so there is no need to watch the channel settings

Thankfully the Black and White feature is also available as an adjustment layer for non-destructive conversions for embedded raw files. Simply insert the adjustment layer above the raw Smart Object layer.

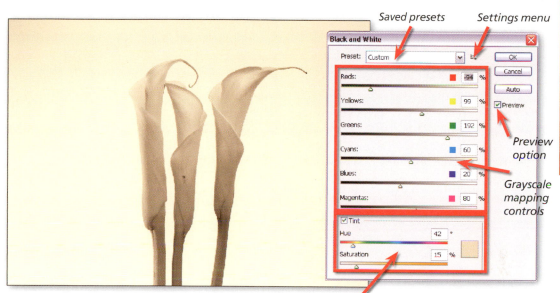

Saved presets | *Settings menu*

Preview option

Grayscale mapping controls

Tint sliders

The Black and White feature in Photoshop CS3 provides a powerful new way to convert color pictures to grayscale photos. The way that different colors are mapped to gray can be adjusted with the channel sliders in the feature and a color added to the result using the Tint options.

numbers to ensure that they add up to 100, as was the case with Channel Mixer. Add to this the ability to tint the final result and you will quickly find yourself falling in love with monochromes again.

The feature's dialog contains six slider controls for each of the color channels. Moving a slider to the right increases the dominance of the color in the conversion result. By changing several sliders at once you can very quickly alter the look and feel of the resultant monochrome. Towards the bottom of the screen there is a separate section that controls the tinting of the picture. To add a color to the grayscale click on the Tint checkbox and then use the Hue slider to adjust the color and the Saturation slider to adjust the strength or vibrancy of this color.

Favorite conversion values can be saved using the options in the settings menu next to the Presets area of the dialog. Here you can Save current settings, Load previously stored settings or Delete any settings displayed in the Presets list.

But best of all, this new feature can be just as easily applied to raw files as it can to standard images. Simply add the Black and White adjustment layer above the raw Smart Object layer to create a totally customized, non-destructive, convert to gray option.

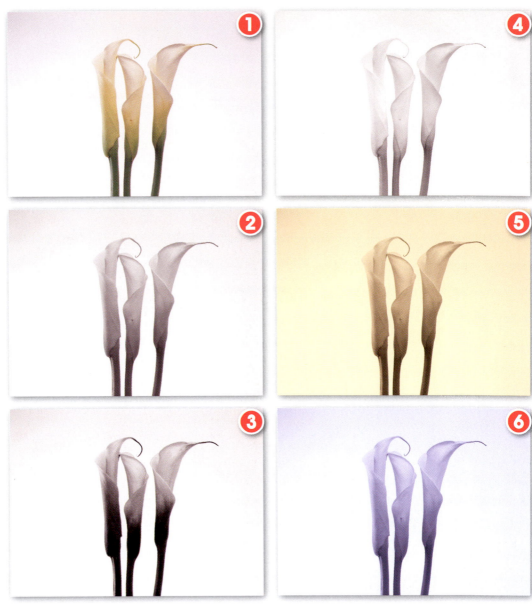

The Black and White feature provides sophisticated conversions for embedded raw files quickly and easily. Here are some examples (see right) of the different results that are possible:
1. Original color photo.
2. Conversion using the Auto button.
3. Conversion using 300, 189, 168, 63, 35, 63 settings.
4. Conversion using 23, 187, 268, 40, 300, 289 settings.
5. Conversion using the Auto button and 42, 20 Tint settings.
6. Conversion using the Auto button and 231, 19 Tint settings.

1. Start by creating a new Photoshop document with a raw file embedded in a Smart Object layer. Do this by either selecting the Open Object option from Adobe Camera Raw or by selecting the File > Open as a Smart Object and choosing the raw file to include.

2. To start the conversion process open a color photo into the Photoshop workspace. Next, apply the grayscale conversion non-destructively by using the Black and White adjustment layer. Select the option from the pop-up menu displayed via the New Fill/Adjustment Layer button at the bottom of the Layers palette.

3. Ensure that the Preview option is selected in the Black and White dialog so that the changes you make are reflected in the photo. Click the Auto button for a general conversion or adjust how each color is mapped to gray using the sliders in the top portion of the dialog.

4. To color the monochrome select the Tint checkbox and then adjust the Hue and Saturation sliders until the desired color is achieved.

5. Alternatively, you can click on the color swatch to the right of the sliders to display a color palette where you can select the base color used in the tinting process.

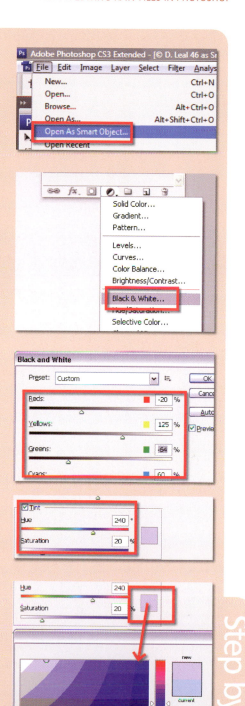

Step by step.

Grayscale conversions whilst converting

Of course, the Photoshop Lightroom as well as the latest versions of Adobe Camera Raw grayscale conversion options are capable of customizing how individual colors map to gray. Have a look at Chapters 6, 7 and 8 for more details. The techniques detailed above are not necessarily meant to replace these features, but rather they are designed to show you what is possible when you start to think and work in a non-destructive fashion.

Add texture to your raw images non-destructively by using the new Smart Filters available in Photoshop CS3 or by applying the characteristics of a textured layer with layer Blend Modes.

Adding texture

But why stop there? Many monochrome workers also love the atmospheric texture that old grainy film stocks added to their images. Simulating grain is not a particularly difficult task with Photoshop. Most users will have played with the Filter > Noise > Add Noise filter and in doing so would have instantly added digital grain to their otherwise smooth photos. The Smart Filters technology in CS3 means that we can now filter the contents of Smart Object layers just as easily as we would other image layers.

Smart Filters 101

Photoshop CS3 includes a new filtering option called Smart Filters. This technology allows you to apply a filter to an image non-destructively and more importantly for us it works with embedded raw files as well.

Based around the Smart Object technology first introduced into Photoshop in CS2, applying a Smart Filter is a two-step process. First the image layer needs to be converted to a Smart Object. This can be done via the new entry in the Filter menu, Convert for Smart Filters, or by selecting the image layer and then choosing Layer > Smart Objects > Convert to Smart Objects. In our case the embedded raw file is already a Smart Object layer so we are good to go. Next, pick the filter you want to apply and adjust the settings as you would normally before clicking OK.

Smart Filters are added as an extra entry beneath the Smart Object in the Layers palette. The entry contains both a mask as well as a separate section for the filter entry and its associated settings. Like Adjustment Layers, you can change the setting of a Smart Filter at any time by double-clicking the filter's name in the Layers palette. The Blending mode of the filter is adjusted by double-clicking the settings icon at the right end of the filter entry.

The Smart Filter mask can be edited to alter where the filter effects are applied to the photo. In CS3, multiple Smart Filters can be added to a photo, but they all must use the one, common mask.

For raw shooters trying to maintain the integrity of their original raw file, Smart Filters provide a way to apply such things as sharpness, or in this case texture, non-destructively.

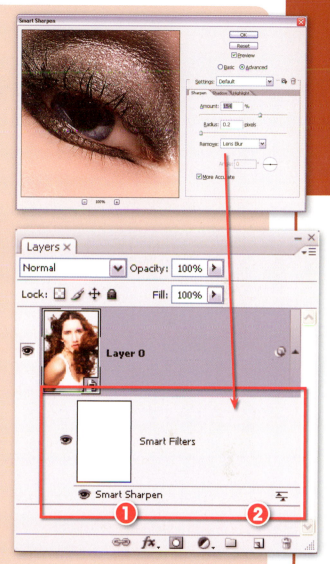

Applying a Smart Filter is a two-step process. To start the image layer needs to be converted to a Smart Object. Once this has occurred applying a filter to the layer will automatically create a Smart Filter entry in the Layers palette. The settings for any Smart Filter can be adjusted by double-clicking the filter's name (1) in the Layers palette. The Blending Mode can be changed by double-clicking the settings icon (2) at the right end of the entry.

1. As with the other techniques detailed here, we start by creating a new Photoshop document with a raw file embedded in a Smart Object layer. Do this by either selecting the Open Object option from Adobe Camera Raw or by selecting the File > Open as a Smart Object and choosing the raw file to include.

2. Next, make sure that the Smart Object layer is selected and then choose the Filter > Noise > Add Noise filter. With the image set to 100% and the Preview option selected adjust the settings to suit the image. In this case Uniform distribution was selected and the Monochrome option was used as the effect is being applied to a grayscale image.

3. The strength of the filtering effect can be altered by changing the opacity of the filter. Do this by double-clicking on the settings icon on the right of the filter entry in the Layers palette. The Blend Mode used for the filter can also be changed here.

4. You can easily localize the effects of a Smart filter by painting directly onto the mask associated with the entry. With the mask thumbnail completely white the effect is seen at full strength. To reduce the dominance of the texture in an area the mask thumbnail is selected and the area painted with a black soft-edged brush of low opacity.

 Pro's tip: Alternatively, the mask thumbnail could be changed to black or inverted using the Image > Adjust > Inverse option. Keep in mind that black sections of a mask do not apply the filter to the picture so inverting the thumbnail basically removes all filtering effects from the image. Next, a white soft-edged brush could be used to paint in the texture to the areas required.

Trying to filter a Smart Object layer directly in Photoshop CS2 will result in this warning dialog being displayed. Selecting OK will convert the raw file to a standard picture format and in the process lose the file's ability to edit raw conversion settings at a later date.

If you want to maintain a non-destructive workflow then you will need to find a way around this rasterization process. In the case of adding texture it is a simple matter of applying the texture to another layer and then altering the layer Blend Mode to mix the contents of both the texture layer and Smart Object layer.

Texture without Smart Filters

Unfortunately CS2 doesn't contain Smart Filters. Applying texture non-destructively to an embedded raw file with this version of Photoshop is another matter. To achieve the same outcome we need to think a little more laterally. Rather than trying to filter the Smart Object layer itself, which would require the layer to be rasterized, losing the embedded file in the process, we will introduce the texture with the aid of layer blend modes.

1. Start by adding a new blank layer to the top of the Layer stack. You can do this by clicking the Create a New Layer button at the bottom of the Layers palette or by selecting Layer > New Layer. Rename this layer 'Texture'.

2. Next make sure that the layer is selected and then fill the layer (Edit > Fill) with the 50% Gray option available from the drop-down Use menu in the Contents section of the dialog. You will end up with a gray layer that sits above all other layers in the stack.

3. Now filter the layer with the Add Noise filter, making sure that the Monochrome option is selected so that no colored pixels are introduced into the grayscale image.

 Note: For the sake of this example the texture settings used here are stronger than you will need to use.

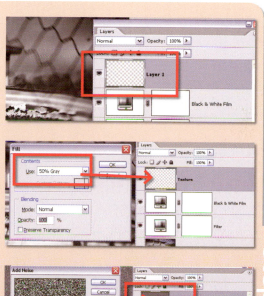

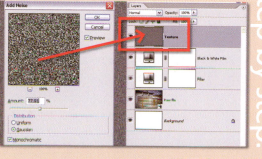

Step by step:

4. Lastly select the texture layer and choose the Overlay entry from the list of Blend Modes available at the top of the Layers palette. Now the original grayscale image returns to view in the workspace but the texture of the upper layer is combined with the pixels from beneath.

Pro's tip: To adjust the strength of the grain effect select the texture layer and alter the Opacity of the layer.

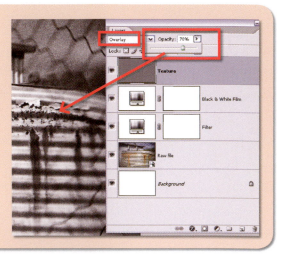

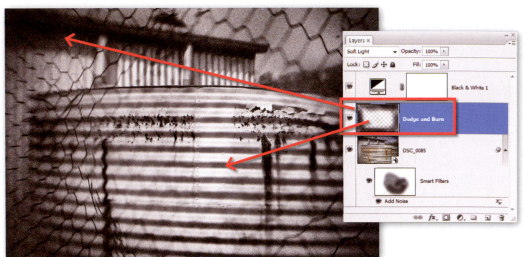

Darkening or lightening specific sections of the photo, generally called dodging and burning, can also be achieved without converting the embedded raw file by painting black or white onto a separate layer set to the Soft Light Blend Mode .

Non-destructive dodging and burning

Dodging and burning, or lightening and darkening specific parts of a photo for dramatic effect, has long been a part of photographic practice. Photoshop contains both Dodge and Burn tools but these features are often avoided by photographers as the changes they make are applied destructively to the original pixels. This, coupled with the fact that the tools don't work with Smart Object layers, means that we need to find a workaround for localized darkening and lightening activities. The following technique uses a Dodge and Burn layer, set to the Soft Light Blend Mode, that sits above the image layer. Picture parts are darkened by painting on this layer with a black brush and lightened when painting with a white brush. The result is a technique that provides dodge and burn-like functionality but doesn't change the original image.

1. Start by adding a new blank layer above the Smart Object layer. You can do this by clicking the Create a New Layer button at the bottom of the Layers palette or by selecting Layer > New Layer. Rename this layer 'Dodge and Burn'.

2. Next, change the Blend Mode of the layer to Soft Light. This will change the way that the layer interacts with the Smart Object layer beneath. Painting onto the layer with colors darker than mid gray will darken the image. Painting with lighter colors will lighten the photo.

3. To burn in specific areas of the image start by selecting black as the foreground color. Next, choose the Brush tool and adjust the edge to soft and reduce the Opacity to between 10% and 20%. Now, with the Dodge and Burn layer still selected, start to paint over the picture areas to darken. Because of the low opacity setting you will need to build up strokes in areas that need a stronger effect.

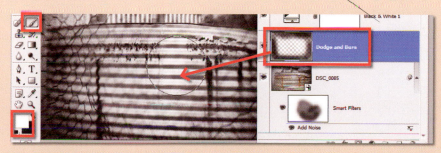

4. To lighten areas, or dodge, change the foreground color to white and paint over these parts of the photo.

Step by step:

Reintroducing some color

Taking the monochrome scenario one step further it is a simple task to add back some color in the form of a simple tint by adjusting the settings of the upper Hue/Saturation adjustment layer. Double-click on the Layer thumbnail (the left icon in the adjustment layer) to open the Hue/Saturation dialog. Now select the Colorize option and carefully adjust the Hue slider to choose the color to tone the photo. The Saturation slider in the same dialog can be used to control the strength of the toning effect.

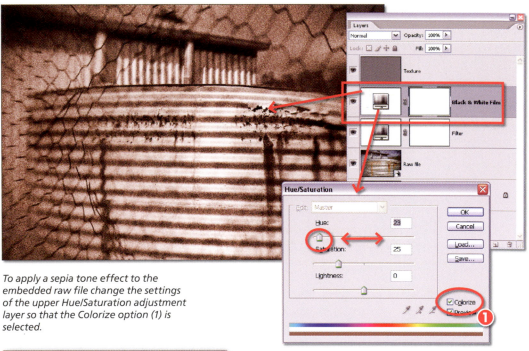

To apply a sepia tone effect to the embedded raw file change the settings of the upper Hue/Saturation adjustment layer so that the Colorize option (1) is selected.

Split toning

For layer-based split toning effects, simply add two Color Balance adjustment layers above the Black and White adjustment layer. With one Color Balance layer target the Highlight range of tones, changing the tint of the image using the sliders. Use the second Color Balance adjustment layer to tint the shadow tones a different color.

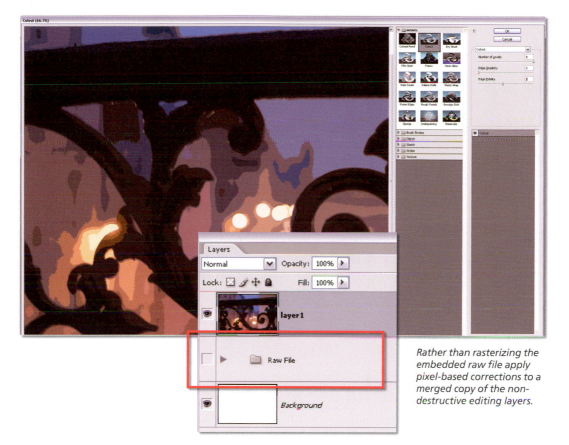

Rather than rasterizing the embedded raw file apply pixel-based corrections to a merged copy of the non-destructive editing layers.

When you have no choice but to rasterize

Despite our best efforts there will be times when the particular Photoshop function that we need to use cannot be applied non-destructively to the embedded raw file. For example, features like filters just will not work on a Smart Object in CS2 unless the file is rasterized first. In these circumstances, there seems little option but to convert the Smart Object to a standard image layer (rasterize) before continuing the editing process. But even at this point it is worth looking for a technique that will still maintain the spirit of the non-destructive approach.

The way I work is to perform as much editing on the Smart Object as possible and when the need arises to rasterize I place all the non-destructed editing components (Smart Object layer, adjustment layers, retouching layers) into a Group (Layer Set) and create a single image layer that is the composite of all these editing effects. I can then apply the pixel-based editing techniques directly to the composite secure in the knowledge that if I need to go back to the original file later I can access the primary data via the Group. Here's how it works:

1. Start by creating a Smart Object layer from your raw file. Add in any adjustment and retouching layers and complete all the editing work that is possible using a Smart Object.

2. Multi-select all the layers (except the background layer) that are used for editing the Smart Object layer. Next place these layers into a new Group (Layer Set) by shift-clicking the Create a New Group button at the bottom of the Layers palette. Rename the Group 'Raw File'.

3. Now make sure that the Group layer ('Raw File') is highlighted and then choose Select > All. You will notice a marquee is now around all the image. Next choose Edit > Copy Merged. This creates a copy of all the merged layers including the active layer and all other layers beneath. The copy is stored on the clipboard and can be pasted as a new image layer by selecting Edit > Paste.

4. With the composite layer created you can hide the contents of the Group by clicking on the eye icon on the left of the layer. Pixel-based enhancements can now be applied directly to the merged layer.

5. Where possible, from this point forward, continue using layers, adjustment layers and smart objects to keep the file as flexible as possible.

Step by step:

Photoshop functions for multiple images

Until now we have concentrated on tips and techniques for editing individual raw files inside Photoshop, but what about the more automated features in the program. You know, the ones that use a group of images for the presentation or printing. Is it possible to include raw files when using these features? Well the short answer is yes!

Options for screen output

Instant slideshows

Slideshow is one of the view modes available in the Bridge workspace. Selecting this option creates an automatic self-running slideshow containing the images in the current workspace or those multi-selected before choosing the feature. Raw files displayed in the Content panel can be selected for inclusion alongside standard image file formats. Pressing the H key displays a list of commands that can be used to navigate, edit and adjust the slideshow.

This feature provides a great way to quickly edit and label a bunch of images that you have just photographed. Multi-select the photos within the Bridge workspace and then click Ctrl/Command + L to switch to Slideshow view. As each of the photos is being displayed you can rate the pictures by clicking the number keys 1–5 or label them by pressing 6–9. Some photographers use this approach with their clients interactively rating the pictures based on the client's feedback to the slideshow.

Bridge contains an automated slideshow feature that can be accessed directly from the View menu or by pressing Ctrl/Command + L.

By clicking H you can display the list of
shortcut keys used to control the
slideshow or add labels to pictures
during the presentation.

Portable slideshows

If you need to send a series of photos to a friend or client,
rather than showing them directly from your desktop, you can
create a special portable slideshow which Adobe calls a PDF
Presentation. The end result is a self-running slideshow saved
in the PDF or Adobe Acrobat format that can be emailed or
saved to a CD and then forwarded.

As before, start the process by multi-selecting the photos to be
included in the presentation from the thumbnails inside the
Bridge workspace. Next, select the PDF Presentation option
from those listed in the Tools > Photoshop menu. Photoshop
opens and the PDF Presentation dialog is then displayed. Here
you have the option of adding to the files selected or removing
any that are already on the list. Next, select the Presentation
option at the bottom of the dialog and adjust the Advance and
Transition settings before clicking the Save button.

The PDF Presentation dialog contains
settings that control the timing and
transitions in the slideshow.

Select a name and folder for the presentation before clicking
Save for a second time. Choose the Screen Res setting from
the PDF Presets dialog that is displayed, before pressing the
Save PDF button. Photoshop now does its magic opening,
converting, sizing and saving the pictures in the presentation
format. The final result can be viewed in Adobe's free Acrobat
Reader.

The completed slideshow is produced in the form of a self-running PDF presentation which can be viewed with Adobe's free Acrobat Reader.

Exporting to other file formats

Automated conversions using the Image Processor

Back when CS was first released Adobe evangelist Russell Brown developed the Image Processor to demonstrate the power of the scripting engine within Photoshop and at the same time provide a very handy image conversion utility. Now the Image Processor is a permanent part of both Bridge and Photoshop's feature lineup.

The utility is designed to quickly convert a range of raw files into JPEG, PSD and TIFF versions. There is an option to manually adjust

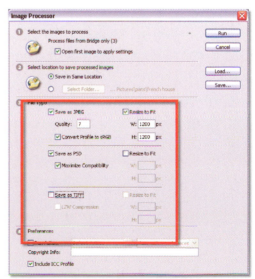

The Image Processor script generates up to three different file format versions of the original raw file automatically.

the raw conversion settings for the first file and then apply these settings to the rest of the images. The utility can also rename, run a pre-saved action, add copyright details and size at the same time as converting between formats, providing a fast and efficient workflow for processing images that have been captured in a single session.

After processing, the files are stored in three separate folders on your hard drive. To use the utility, select your raw files from inside Bridge and then choose Tools > Photoshop > Image Processor. Set the location where processed files are to be saved, the file type and any associated settings (size, compression, color profile), add in copyright details and then choose any actions to apply to the files.

The copies created by the Image Processor are conveniently stored in separate folders labelled with their file type.

Printing from raw files

Producing a contact sheet

The familiar Contact Sheet option that has been present in Photoshop for the last few versions can be used from Bridge to print 'proof' sheets of raw files. Thumbnails are multi-selected from the Bridge workspace before accessing the utility via the Tools > Photoshop menu.

The options contained within the Contact Sheet dialog allow the user to select the number of columns of image thumbnails per page and the content of the text labels that are added. The page size and orientation can also be chosen via the Page Setup. Pressing the OK button instructs Photoshop to open each image in turn, resize the picture and then position it in a new document ready for printing.

The Contact Sheet option in Bridge can generate proof sheet versions of multiple files from raw files.

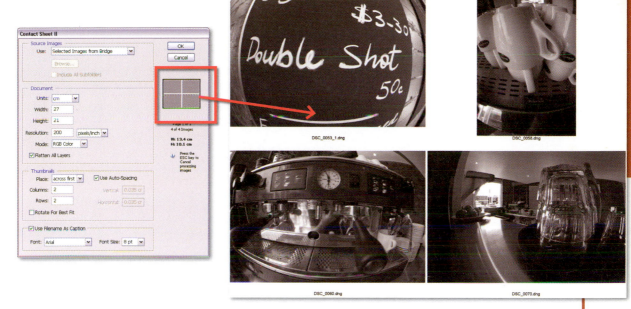

The feature automatically lists the photos selected in Bridge in the Contact Sheet dialog. It is here that you can alter the sheet's layout and design before producing the group of thumbnails as a new Photoshop document.

Picture Package

The multi-image printing idea is extended via the Picture Package utility which is also located under the Tools > Photoshop menu in Bridge. With this print utility you have the option of laying out several images of different sizes on a single page. Alternatively you can produce several copies of the same photo in a range of template designs. Use this utility to efficiently put together multi-print pages that are destined for cutting up and presenting separately.

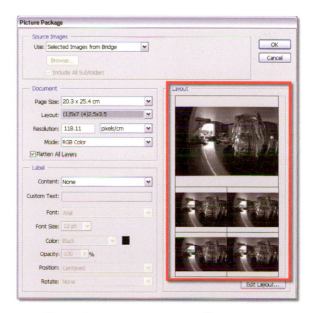

As well as producing contact sheets, raw files can be collated into other multi-print designs using the Picture Package feature also located in the Tools > Photoshop menu in Bridge.

Once you have completed the editing and enhancing of your embedded raw file it is possible to print the file just like any other Photoshop document.

Printing individual photos without conversion

Unfortunately Bridge doesn't contain a straight print option that allows individual raw files to be printed directly from the Content panel. But don't despair! Using the embedded raw file technique described earlier in this chapter, the raw photo becomes a Photoshop document, which in turn can be printed using the standard print options in the program.

12

Creative Raw

A fter all is said and done, raw processing is a tool that we use to help us in the pursuit of creating great imagery. So rather than spend the whole text on the underlying technology and its related techniques, let's take some time to look at some of the workflow concepts and ideas that we have examined in practice. The following projects make the most of the latest image editing tools we have available to use. They will, I'm sure, provide you with a greater sense of how to apply raw workflow to your daily workflow.

Lith printing

There is no doubt that a well-crafted lith print is, to borrow an oft-used phrase from my father-in-law (and before that, John Keats), 'a thing of beauty that is (therefore) a joy forever'. The trick, for experienced and occasional darkroom users alike, is the production of such a print. Even with frequent reference to publications penned by lith guru Tim Rudman, I have always had difficulty getting consistency with the production of my prints. Despite this frustration, my love affair with the process still continues. There is something quite magical about the quality of images created using this technique and it is this magic that I hanker after. They are distinctly textured and richly colored and their origins are unmistakable.

The process, full of quirky variables like age and strength of developer and the amount of overexposure received by the paper, is unpredictable and almost always unrepeatable. In this regard at least, most printers, myself included, find the whole lith printing process both fascinating and infuriating. This said, it's well over a decade since lith printing started to become more commonplace and there is no sign of people's interest declining. 'Long live lith!' I hear you say, 'but I shoot digital'. Well, good news: the digital worker with basic skills, a copy of Photoshop and a reasonable color printer can reproduce the characteristics of lith printing without the smelly hands, or the dank darkroom. What's more, arm that digital worker with quality raw files, and a copy of Photoshop CS3, and the technique can be completed totally non-destructively with the capture images still intact. Cool!

Step by step:

Lith – Step by step

1. If you ask most photographers what makes a lith print special the majority will tell you it's the amazing grain and the rich colors. Most prints have strong, distinctive and quite atmospheric grain that is

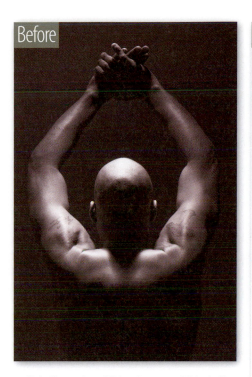

Before

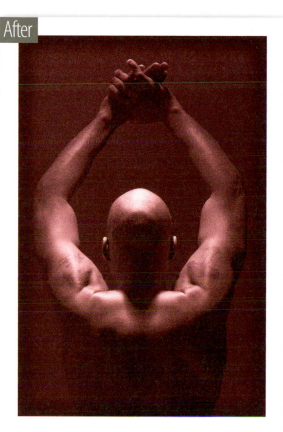

After

A digitally produced lith print can exhibit similar color and grain characteristics to those typically found in chemically produced originals. In Photoshop CS3 it is possible to produce a digital lith image non-destructively from a raw file using Smart Objects and Smart Filters.

a direct result of the way in which the image is processed. This is coupled with colors that are seldom seen in a black and white print. They range from deep chocolate, through warm browns, to oranges and sometimes even pink tones. If our digital version is to be convincing, then the final print will need to contain all of these elements. Make sure that the subject matter is conducive to making a lith-type print. The composition should be strong and the image should contain a full range of tones, especially in the highlights and shadows. Delicate details may be lost during the manipulation process, so select an image that still works when the fine details are obscured by coarse grain. Good contrast will also help make a more striking print.

The next step after selecting a suitable image is to open the raw capture file in Photoshop as a Smart Object (File > Open as Smart Object). Basing your adjustments around a Smart Object will ensure that they can be tweaked at any time later and the original pixels

are always maintained. Immediately save the picture as a .PSD file (this helps with the Smart Object editing steps later on).

2. Now, let's add some color. Photoshop provides a couple of options for adding the distinctive lith colors. The simplest approach uses the Tint options in the new Black and White control. Previously we would have used Hue/Saturation but this new feature has the added bonus of providing the chance to manipulate the monochrome conversion (convert to gray) before adding the tint hues. As we are using an embedded raw-based workflow, the Black and White feature is applied via an Adjustment Layer (Layer > New Adjustment Layer > Black and White). If your original is in color, start by adjusting the color sliders in the upper section of the dialog. These allow you to control the way that specific colors are converted to gray. Next move to the bottom of the feature and check the Tint option. Use the Hue slider to select the color for the tint and the Saturation slider to adjust the vividness of the effect.

3. To simulate the texture of the lith print we will add a Noise filter to the photo but rather than applying it directly, more control is possible if the texture is applied to a separate layer first, and then blended with the image. Start by creating a new layer (Layer > New > Layer) and filling it with 50% gray (Edit > Fill then choose 50% Gray from the contents menu). Name this layer Texture.

To ensure that we can adjust the settings used for the filtering effect later on, convert the Texture layer to a Smart Object (Layer > Smart Objects > Convert to Smart Object) and change the mode of the new Smart Object layer to Overlay or Soft Light. Next, Smart Filter the layer using either the Grain (Filter > Texture > Grain) or Noise (Filter > Noise > Add Noise) filter.

Most of these types of filters have slider controls that adjust the size of the grain, its strength and how it is applied to various parts of the image. The settings you use will depend on the resolution of your picture, as well as the amount of detail it contains. The stronger the filter effects, the more details will be obscured by the resultant texture. Be sure to preview the filter settings with the image magnification set at 100%, so that you can more accurately predict the results. Here I have the used the 'Noise' filter with both the Gaussian and Monochrome options set.

4. At this point in the project the lith-print effect is finished but to show the power of working with Smart Objects, let's take the process a little

further by adding some extra canvas space and a blurred border to the otherwise completed photo. Start by selecting the base image's Smart Object layer. Next choose Layer > Smart Objects > Edit Contents. This will open the original photo as a separate Photoshop document with no color or texture effects applied. Change the background layer to a standard image layer by double-clicking on its entry in the Layers palette. Now add a new layer and convert this layer to a background layer by selecting Layer > New > Background from Layer. Make sure that the default Foreground/Background colors are selected before this step. To extend the white background, choose Image > Canvas Size, and add 120% for both Width and Height settings.

5. To add a blurred border the size of the image, create a new layer above the photo. Label this layer Border. Hold down the Ctrl/Cmd key and click on the picture in the thumbnail of the image layer. This creates a selection based on the size and shape of the picture content of this layer. Now choose the Border layer and then select Edit > Stroke. Adjust the settings so the stroke is 100 pixels wide (this may change for your image), black, and is located on the inside of the selection. Click OK to draw the stroke.

6. We will use the Gaussian Blur filter to blur this border but before applying the filter, change the Border layer to a Smart Object. This way it will be possible to alter the settings used for the border later, if needed. Select the border layer and choose Layer > Smart Objects > Convert to Smart Object. Next, with the selection that you used to create the border in the first place still active, apply the Gaussian Blur filter to blur the inner edge of the stroked border. If you have lost the selection, recreate it by holding down the Ctrl/Cmd key and clicking on the image layer's thumbnail.

7. With the border now created, it is time to apply the settings back to the original lith print. Save the file (File > Save) and then close the document. Photoshop will automatically update the picture Smart Object layer that sits inside the lith document with the changes. Select Image > Reveal All to show the extended canvas area. Using Smart Objects in this technique provides endless opportunity to adjust the settings for the color and texture of the final result. Even the blur of the border can be manipulated at a later date, as applying the filter via a selection automatically creates a mask that will restrain the blur effect to the inside of the image.

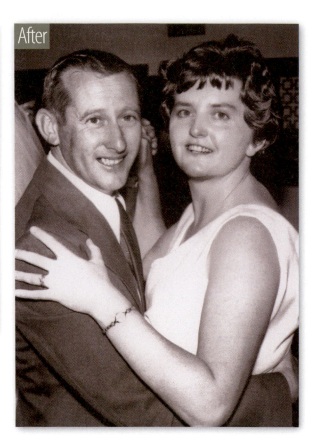

The enhancement features in Adobe Camera Raw can be used good effect with both TIFF and JPEG files in the latest Photoshop version of the product. Here the highlight recovery and Smart Object workflow usually reserved for raw pictures is employed to help rescue this family portrait.

Image restoration

As a digital imaging author, I am often asked about techniques for repairing old photos. I'm sure that this is not unusual as most photographers will attempt to restore an old picture at least once during their lifetime. After all, many of the memories of important family events and history are associated with images of the time and, even with the right care and attention, lots of these photos end up a little worse for wear.

Until now the tools and techniques used by raw shooters couldn't be used with most restoration projects as the digital files requiring correction work are generally sourced from scanners rather than cameras. Although some scanners use a proprietary form of raw capture when creating a digital file, most models output their digital images in TIFF or JPEG.

I say until now, because both TIFF and JPEG files can be opened and enhanced in the latest version of Adobe Camera Raw. So here I thought I would present a couple of techniques that use raw-based workflow techniques to restore, or repair, those images most precious to you.

Removing stains – Step by step

In this example, the repair work centered around the removal of a yellowish stain running through the middle of the photo. There was also the need to try and restore some details in the highlights sections of the photo.

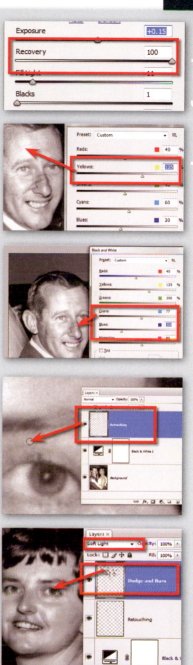

1. Some of the highlight areas in the example file are clipped. The Recovery slider in Adobe Camera Raw 4.0 is able to reconstruct details in some blown highlights by referencing the details in the other channels. So the first step is to rebuild as much lost detail as possible using this control. NB: ACR 4.0 also works with TIFF and JPEG files as well as most raw formats.

2. Next the file is opened as a Smart Object in Photoshop from ACR. To remove the yellow stain a Black and White adjustment layer is added above the image layer. This feature allows you to control how specific colors are mapped to gray. By adjusting the Yellow slider it is possible to hide the stain in the grayscale conversion process.

3. To minimize the blue pen scribble on the subject's nose, adjust the Blue and Cyan sliders. Variation in density of the stain, or scribble, may cause some, or only part of the stain to disappear. This is the case here so we will have to resort to another process for the final touchup of these problems.

4. To retouch residual stains and other marks, create a new layer above both the background image layer and the Black and White adjustment layer. Select the new layer and then choose the Spot Healing Brush. Change the brush settings to Sample All Layers in the options bar and proceed to retouch problem areas.

5. After removing dust marks and scratches, add another blank layer at the top of the layers stack. Change the Blend Mode of the layer to Soft Light and choose a black soft-edged brush. This setup works like the Burn tool but the changes are made non-destructively. Carefully add some depth to the areas of the image that appear flat because of the harsh, direct, flash lighting.

6. The last part of the restoration process is to add a very small amount of texture to the photo to provide detail in the blown out areas. Add a new blank layer and change the mode to Overlay. Next fill the layer with 50% gray and filter the layer with the Add Noise filter. Make sure that you view the photo at 100% in order to properly gauge the appearance of the texture.

Step by step:

The variety of gallery types produced by the Lightroom Web module can be expanded by adding in extra templates created by third-party Lightroom enthusiasts. The examples detailed here are available from www.lightroomgalleries.com.

Web template heaven

One of the really valuable features of Lightroom is the ability to output your raw files directly to slideshow, print or web galleries from inside the program. That said, the web templates supplied with Lightroom can seem a little formulaic and, for some photographers, downright limiting. Thankfully there are clever individuals out there, like the guys from www.lightroomgalleries.com, who are able to create third-party gallery components that fit neatly into Lightroom.

It is important to realize up front that many of these web templates are not officially sanctioned by Adobe although they are referenced in many Adobe blogs around the world. They are generally created by Lightroom aficionados who, despite liking the overall package, want a little more pizazz or more custom options in the web gallery.

Here I look at how to install one of the great galleries that can be found on the www.lightroomgalleries.com website.

Using third-party web galleries – Step by step

1. Start by navigating to the Template Downloads section of the Lightroom Galleries website. Download the gallery of your choice and then proceed to save the new template folder to the Web Galleries directory on your computer. Use the following locations:

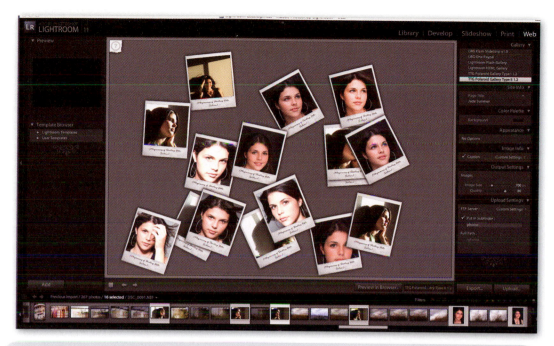

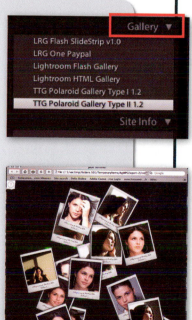

Mac: Users/YourUserDirectory/Library/Application Support/
Adobe/Lightroom/Web Galleries
Windows Vista: C:\Users\YourUserName\AppDataRoaming\
Adobe\Lightroom\Web Galleries
Windows XP: C:\documents and Settings\YourUserName\
Application Data\Adobe\Lightroom\Web Galleries
Make sure that the folder name you use has no spaces.

2. Next restart Lightroom. The new gallery templates will be loaded
 into the Web module and will appear in the drop-down Gallery
 menu at the top right of the dialog (and not in the Template presets
 on the left).

3. To use the new gallery template, multi-select the pictures to include
 in the gallery and then navigate to the Web module. Select the
 new layout option from the gallery list and then proceed to adjust
 the settings in the rest of the sections in the right-hand side of the
 Lightroom dialog.

4. With all the settings complete you can select the Export, Upload
 or Preview in Browser options just as you would for any other web
 gallery.

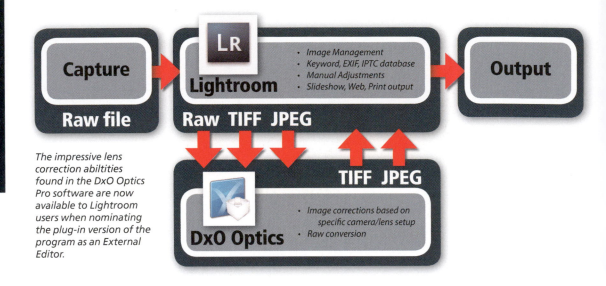

The impressive lens correction abiltities found in the DxO Optics Pro software are now available to Lightroom users when nominating the plug-in version of the program as an External Editor.

Extending Lightroom's power

Over the last few years DxO Optics Pro has gained an enviable reputation as one of the best ways to adjust the optical problems that exist with all digital cameras and lenses. Unlike other solutions, including the Lens Corrections features available in both Lightroom and Adobe Camera Raw, DxO Optics provides the ability to automatically correct and enhance images based on extensive measurement and calibration of supported cameras and lenses.

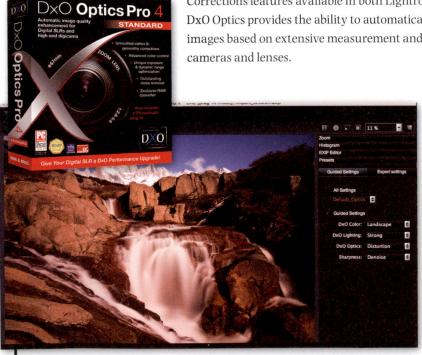

DxO Optics Pro is particularly good at automatically correcting a set of images, taken with different lenses at different focal lengths, that exhibit different distortion problems. In addition, the program can also correct lens softness, chromatic aberration, vignetting, volume anamorphosis and keystoning, either automatically or with comparatively little user intervention.

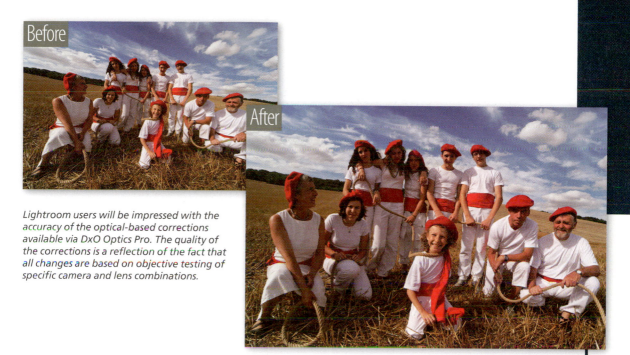

Before

After

Lightroom users will be impressed with the accuracy of the optical-based corrections available via DxO Optics Pro. The quality of the corrections is a reflection of the fact that all changes are based on objective testing of specific camera and lens combinations.

In the most recent release of DxO Optics Pro, the company has provided a plug-in version of the correcting software that works with Lightroom. Essentially the user nominates the plug-in as one of the External Editors for Lightroom, which, in turn, provides the ability to transfer the photo to DxO Optics Pro, make the necessary changes and then 'round trip' the corrected image back to Lightroom.

The Lightroom and DxO Optics workflow

This approach provides Lightroom users with the ability to take advantage of the incredible optical correction options for supported camera/lens combinations that the program provides. Sound too good to be true? Well, there are some issues to be aware of when employing a combined workflow featuring Lightroom and DxO.

First of all, DxO has its own raw conversion engine. This means that when you pass raw files to the plug-in they return to Lightroom corrected, but in a TIFF or JPEG format. Generally this is not a problem as the lens-correcting abilities of the DxO Optics plug-in outweigh the downsides of early raw conversions. However, if you are purposely employing a full raw, or non-destructive, workflow then this does have an impact on the nature of the resultant image. In this situation, it may be better to use the full DxO Optics program to batch process all your raw files first and save the corrected images in the DNG format before then importing them into Lightroom.

Secondly, DxO recommends making corrections in the DxO Optics plug-in first, before applying any enhancement changes in Lightroom itself. This is because the Lightroom alterations are not recognized (for raw files), or only recognized in part (for JPEG images), by the DxO program. This is the case irrespective of if you select the Edit a Copy with Lightroom Adjustments option when sending the file to the plug-in. DxO Optics actually performs its corrections on the full raw file before returning a copy to the Lightroom library. When the Lightroom SDK is finally released to developers, greater integration with 3rd party products should occur

So to make sure that you get to use the best features of both programs, open your files into Lightroom, make corrections in DxO next and then apply any global enhancements in Lightroom. A trial version of DxO Optics Pro plug-in is available for download and use with a limited number of photos during a specific period from www.dxo.com.

Using DxO and Lightroom – Step by step

1. After installing the DxO Optics program you will need to set up the connection between Lightroom and the plug-in version of the program. Do this by going to the Preferences part of Lightroom (Edit > Preferences for Windows users) and selecting the External Editing tab in the dialog. Leaving Photoshop as the Main External Editor, add the DxO Optics Pro plug-in as the Additional External Editor.

2. Ensure that the Additional External Editor fields in the dialog are set to the following: File Format – Tiff, Color Space – AdobeRGB, Bit Depth – 16 Bits/component and Compression – None. In addition, ensure that you don't modify the default renaming scheme at the bottom of the dialog, as this helps link the corrected file back to the Lightroom Library. It should read IMG_0002-Edit.PSD.

3. To open images into the plug-in select the file in the Grid View of the Library and select the Edit with DxOOpticsProPlugin option from the right-click menu (Ctrl-click for Macintosh users). Next the Lightroom Edit Photo dialog will be displayed. Select the Edit a Copy with Lightroom Adjustments option but remember that DxO ignores any enhancement changes made in Lightroom so these won't, in fact, be applied to the copy before opening the photo into the plug-in. Choose the 'Stack with original' entry at the bottom of the Edit Photo dialog to group the edited copies and the original together in the Lightroom Library as an Image Stack. Click the Edit button to continue.

4. The photo will then be transferred to the DxO Optics plug-in. Here you can make changes to the photo using the full range of features available in the plug-in. So as not to confuse myself by making tone and color corrections in both Lightroom and DxO, I tend to stick to using the plug-in to make the camera/lens-based optical corrections in the photo, before returning to Lightroom for the more general enhancements.

Adjustments can be made using two different sets of controls – Guided Settings or Expert controls. The Guided Settings group the main changes around several drop-down menus, providing quick correction of key areas based on presets, whereas the Expert settings list manual controls for all DxO correction features. The key lens-based corrections are grouped under the DxO Optics heading and include controls for geometric distortion, chromatic aberration, purple fringing and vignetting. Adjustments here are based on the characteristics of the lenses used for image capture and so the features are only available when the correct lens module is installed for the image currently being enhanced.

The Volume Anamorphosis Correction and Keystoning/Horizon features in the Geometry section of the Expert settings will also prove useful, but are manually controlled, on an image-by-image basis.

5. Once the adjustments have been set, in either of the two settings modes, the process tab at the top right of the dialog is selected to switch from the Enhance view to the processing view. To process the file, or apply the settings, click the Process button. The Output location and Format options are automatically set to ensure capability with Lightroom, so there is no need for user intervention with these settings. Remember that raw files sent to the DxO Optics plug-in are returned to Lightroom in the TIFF format.

6. The corrected images are displayed in the Lightroom Library as separate files to the raw original.

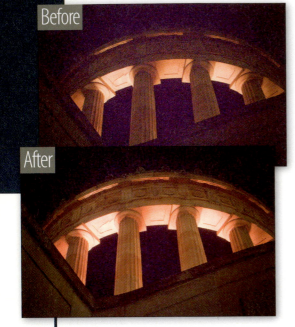

The noisy image (top) was captured using an ISO 6400 setting. The same file was then processed using the Image Stack noise reduction technique detailed here (bottom).

Advanced noise reduction

As part of the new analysis features inside Photoshop CS3 Extended, you can now compare the contents of several layers and use the differences and/or similarities in this content as the basis for creating a new image.

The technology makes use of Smart Objects, Auto-Align and Stack Mode features. Although not specifically designed to remove noise, these features, along with shooting multiple versions of the original scene, provide one of the most successful techniques available for the task.

Unlike other noise removal techniques, this approach requires some forethought at time of capture. If you are using a high ISO value or long shutter speed (and a stationary object), snap at least three source photos of the same scene, ready for noise removal at the desktop.

Unfortunately the Image Stack technology in CS3 doesn't support using embedded raw files as the stack layers, so yes, you will need to convert your photos to PSD via ACR before using this technique.

Step by step

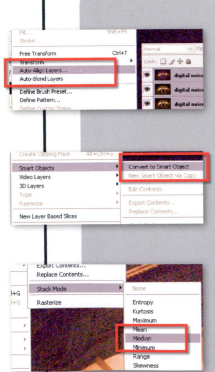

1. To start the process it is necessary to layer the source images in a single document. With the Move tool selected, click and drag the various separate files onto a single document. Holding down the Shift key during this action will center each file. Next multi-select all layers in the new document and choose the Edit > Auto-Align option to ensure registration of common picture details.

2. Next the layers are multi-selected in the layer stack and converted to a Smart Object (Layer > Smart Object > Convert to Smart Object).

3. With the new Smart Object selected, the Median option is chosen from the list of Rendering entries in the Layer > Smart Object >Stack Mode menu.

Pro's tip: To simplify the first three steps in this technique Photoshop CS3 Extended ships with a special script which loads files into a stack (File > Scripts > Load Files into Stack). The script displays a Load Layers dialog which contains options to Auto-Align and Convert to Smart Object as part of the stacking process.

13

Organizing Raw Assets

With no film or processing costs to think about each time we take a picture, it seems that many of us are pressing the shutter more frequently than we did when film was king. The results of such collective shooting frenzies are hard drives all over the country full of photos. Which is great for photography but what happens when you want to track down that once in a lifetime shot that just happens to be one of thousands stored on your machine? Well, believe it or not, being able to locate your raw files quickly and easily is more a task in organization, naming and camera setup than browsing through loads of thumbnails.

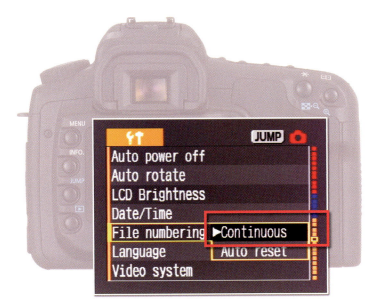

This Canon camera, as do most raw-enabled cameras, provides options for selecting the way in which files are numbered. The continuous option ensures that a new number is used for each picture even if memory cards are changed in the middle of a shoot.

It starts in-camera

Getting those pesky picture files in order starts with your camera setup. Most models and makes have options for adjusting the numbering sequence used for the pictures you take. Generally you will have a choice between an ongoing sequence, where no two photos will have the same number, and one that resets each time you change memory cards or download all the pictures. In addition, many models provide an option for adding the current date to the file name, with some including customized comments (such as shoot location or photographer's name) in the naming sequence or as part of the metadata stored with the file.

Search through the setup section of your camera's menu system for headings such as File Numbering and Custom Comments to locate and change the options for your own camera.

Pro's tip: Ensure that number sequencing and date inclusion options are switched on and where available append the metadata with the photographer's name and copyright statement.

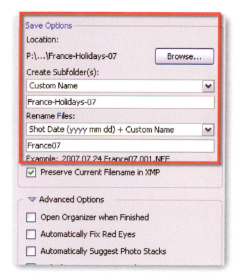

As we have already seen in Chapter 4 both the Adobe Photo Downloader, that comes bundled with Photoshop and Photoshop Elements, and the Import options in Photoshop Lightroom allow the user to automatically apply naming changes and to determine the location where transferred files will be saved.

And continues when downloading

As we have seen in earlier chapters most camera manufacturers, as well as producers of photo editing software, supply downloading utilities that are designed to detect when a camera or card reader is attached to the computer and then automatically transfer your pictures to your hard drive. As part of the download process, the user gets to select the location of the files, the way that the files are to be named and numbered, as well as what metadata will be included with the file.

It is at this part of the process that you need to be careful about the type of folder or directory structure you use. Most photographers group their images by date, subject, location or client. The approach that you employ is up to you but once you have selected a folder structure try to stick with it. Consistency is the byword of organization.

If your camera doesn't provide enough automatic naming and metadata options to satisfy your needs, then use the downloading software to

enhance your ability to distinguish the current images with those that already exist on your hard drive by including extra comments with the picture files.

Pro's tip: Nominate and create a new directory for the downloaded photos. Add extra metadata captions, keywords, photographer and copyright details.

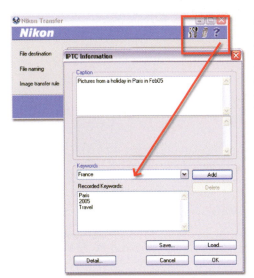

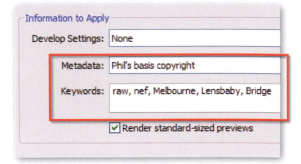

In addition to naming and location changes, metadata keywords can be added to groups of picture files as they are being downloaded using the latest version of Nikon's transfer software (left). Keywords and pre-saved metadata templates can also be added in the Information to Apply section of the Lightroom Import dialog (below). These keywords and metadata entries can be used later to help locate pictures.

Organizing and searching software

Most image editing software contains file browsing features which not only provide thumbnail previews of your photos but increasingly contain options for attaching keywords, editing the image's metadata as well as providing a variety of search mechanisms. Photoshop's own file browser, Bridge, and Lightroom's Library module both contain all of these functions and, when used in conjunction with the program's label and rating options, provide a sophisticated method of organizing and locating files.

Even the latest version of Adobe's entry-level image editing program, Photoshop Elements, employs such organizational concepts in its Organizer workspace. Here images are not just previewed as thumbnails, but can also be split in different Albums (previously called Collections), located as members of different groups or searched based on the keywords associated with each photo. Unlike a traditional

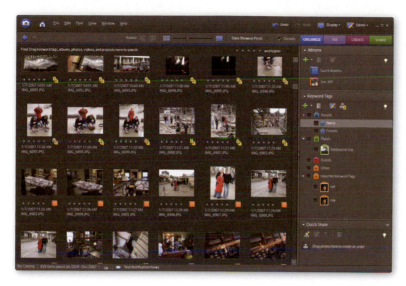

The Organizer workspace, or Photo Browser as it is sometimes called, in Photoshop Elements (Windows) provides an easy to use organizational tool complete with keyword tagging, album creation (previously called Collections) and cataloging, together with the proven editing abilities of the package.

browser system, which is folder based (i.e. it displays thumbnails of the images that are physically stored in the folder), Elements' Organizer creates a catalog version of the pictures and uses these as the basis for searches and organization. With this approach it is possible for one picture to be a member of many different groups and to contain a variety of different keywords.

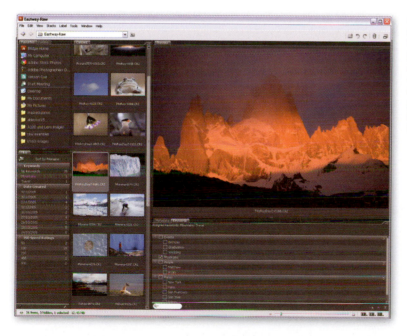

Photoshop's own super browser, Bridge, supplied with Photoshop from CS2, provides preview, search and customized view options, as well as the ability to add and edit the photo's metadata and keywords, all from within the browsing window.

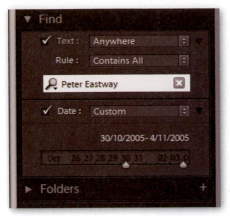

The Library module in Photoshop Lightroom contains a variety of ways to search for individual images or groups of photos. The Find panel provides a filtered search option based on metadata, EXIF or keyword text and date range.

Lightroom too provides substantial support for features that aid in the organizing of your photos. Centered around the Library module, users can add keywords and metadata entries in the Keywording and Metadata panels. As in Photoshop Elements, groups of photos can be divided virtually into Collections or sunsets of the main library. The same photo can be referenced in a variety of collections or image groups.

Individual files can be located in Lightroom via the collection, keyword tag, folder, metadata entry or with the sophisticated Find feature. Here the images displayed in the Grid View are progressively filtered according to the criteria (text and/or date range) entered in the dialog.

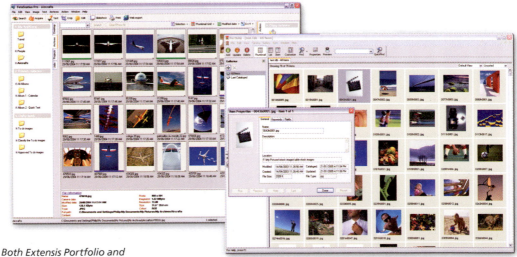

Both Extensis Portfolio and Fotoware Fotostation contain sophisticated cataloging, sorting, searching and displaying features and are firm favorites with professionals.

Moving beyond these included browsers are the dedicated organizational programs that take the cataloging, searching and attaching keywords idea to the next level. These stand-alone pieces of software range from those designed with the professional or dedicated

amateur in mind and include products such as Extensis Portfolio and Fotoware Fotostation, to lower priced but still sophisticated offerings such as Apple's iPhoto, Jasc Photo Album, Ulead Photo Explorer and the ever popular ACDSee. When considering any of these browsing products ensure that they are raw enabled and that the software supports the raw files that your camera creates.

Pro's tip: Try using the organizational or browsing utilities that came bundled with your camera or those that are included in your photo editing software. When they prove not to be up to the challenge then move on to a dedicated organizational program.

Grouping and keyword strategies

The best way to group or catalog your pictures will depend a great deal on the way you work, the pictures you take and the type of content they include, but here are a few different proven methods you can use as a starting point.

- **Subject:** Photos are broken down into subject groups using headings such as family, friends, holidays, work, summer, night shots, trip to Paris, etc. This is the most popular and most applicable approach for most readers and should be the method to try first.

 Readers who regularly submit their images to stock libraries or online stock services should contact the administration of these organizations and ask for a keyword subject list. Most libraries have a set list of descriptive words they use to organize their images. Using the same keywords will mean that your images will fit better into the management system of the library, be easier to find and will secure more revenue. Photojournalists are often required to categorize their photos according to the subject groupings published by the International Press Telecommunications Council or IPTC. Using the subject and topic headings recommended by the IPTC, called News Codes, allows for consistent keywording and makes your photos more easily found, and therefore more easily sold. Go to www.iptc.org/newscodes/ for the latest list of subject headings.

The International Press Telecommunications Council or IPTC manages a core set of subject keywords used by news organizations across the world to categorize their media content. You can download the latest list of these keywords, called News Codes, from the organization's website, www.iptc.org.

- **Time line:** Images are sorted and stored based on their capture date (when the picture was photographed), the day they were downloaded or the date they were imported into the organizational package. This way of working links well with the auto file naming functions available with most digital cameras, but can be problematic if you can't remember the approximate dates on which important events occurred. Try using the date approach as a subcategory for subject headings, e.g. Bill's Birthday > 2007.

- **File type:** Image groups are divided into different file type groups. Although this approach may not seem that applicable at first glance it is a good way to work if you are in the habit of shooting raw files which are then processed into PSD files before use.

- **Project:** This organizational method works well for the photographer who likes to shoot to a theme over an extended period of time. All the project images, despite their age and file type, are collated in the one spot, making for ease of access.

- **Client or job:** Many working pros prefer to base their filing system around the way their business works, keeping separate groups for each client and each job undertaken for each client.

Most of the more sophisticated organizational software on the market allows you to allocate the same image to several different groups. Unlike in the old days, this doesn't mean that the same file is duplicated and stored multiple times in different folders; instead the picture is only stored or saved once and a series of keywords (tags) or group associations are used to indicate its membership in different groups. When you want to display a group of images based on a specific subject, taken at a particular time or shot as part of a certain job, the program searches through its database of keywords or tags and only shows those images that meet your search criteria.

Pro's tip: Find out how your organizational software categorizes pictures and then use these features to catalog, group or add keywords to your pictures. Where possible add multiple tags or keywords to the same picture to make it a member of several different groups.

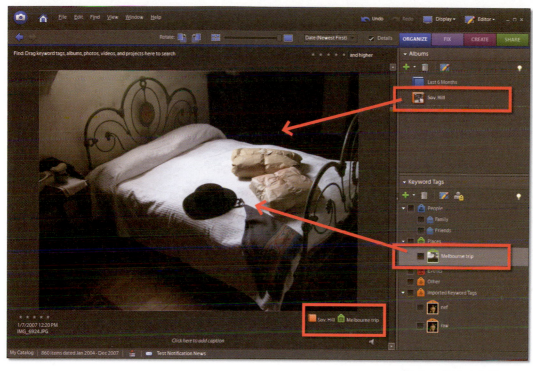

The tags feature in the Organizer workspace of Photoshop Elements provides drag and drop subject organization for individual pictures. In this program one picture can have multiple tags and belong to several different albums or collections.

The Painter tool in Photoshop Lightroom can paste a range of settings onto images displayed in the Grid View. One option for the tool is the pasting of keywords.
Here the Keyword entry is selected from the drop-down Paint content menu before the photographer's name is typed into the text box (on the right). Next, the Keyword is painted onto one or more images in the Grid View.

Now we can search

With the pictures named in-camera, downloaded to a structured set of folders, grouped, tagged, keywords attached and cataloged, we are all set for quick, easy and, more importantly, accurate searches of our picture archives. Depending on the software you may locate pictures based on adding a variable in a search dialog, selecting a keyword from a list, gradually filtering photos using a growing list of selection criteria, or clicking a group icon in a collections window. Whatever the approach, a little organization up front will work wonders when tracking down those elusive shots.

The Find dialog in Bridge has options for locating files based on the contents of the metadata. Here the pictures were located because the word 'tivoli' was used in their file names.

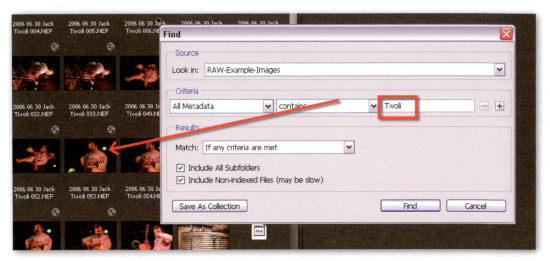

Managing raw files within Bridge

By replacing the file browser found in previous versions of Photoshop with the full featured Bridge application, Adobe made a big change to the way that picture files were handled. Bridge is not just a tool for viewing your photos, it is a key technology in the managing, sorting and enhancing of those files. And this pivotal role is never more evident than when one is managing raw files. So with the general theory outlined in the previous section let's look at the 'nitty-gritty' of the ways you can bring order to your raw files using Bridge.

Using keywords

As we have seen keywords are single-word descriptions of the content of image files. Most photo libraries use keywords as part of

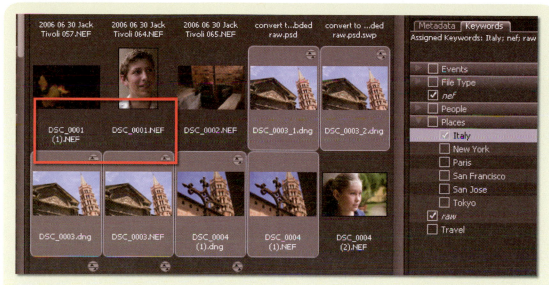

the way they locate images with specific content. The words are stored in the metadata associated with the picture. Users can allocate, edit and create new keywords (and keyword categories) using the Keywords panel in the Bridge browser and File Info palette in Photoshop.

New keywords and keyword categories (set) can be added to the Keyword panel by clicking the New Keyword Set and New Keyword buttons at the bottom of the panel. Unwanted sets or keywords can be removed by selecting first and then clicking the Delete button. Unknown keywords imported with newly downloaded or edited pictures are stored in the panel under the Other Keywords set.

Attaching keywords to your pictures means faster searching especially when your picture library grows into the thousands.

A quick method for adding a star rating is to click the space just below the thumbnail in Bridge.

Star ratings and colored labels can be applied to photos in Bridge using the options in the Label menu or the associated keystroke combination.

Rating and labelling files

One of the many ways you can organize the raw files displayed in the Bridge workspace is by attributing a label to the picture. In CS3/CS2 the labels option is supplied in two forms – a color tag, called a Label, or star rating, called a Rating. Either or both label types can be applied to any picture. The Label tag can then be used to sort or locate individual pictures from groups of photos.

Labels and/or ratings are attached by selecting the thumbnail(s) in the workspace and then choosing the desired label from the list under the Label menu. Keyboard shortcuts are also provided for each label option, making it possible to quickly apply a label to a thumbnail, or group of thumbnails, or you can quickly add star ratings by clicking beneath the thumbnail in the workspace. Labels can also be attached to pictures in Adobe Camera Raw and Slideshow features.

Raw thumbnails can be sorted and displayed in different ways in the Bridge workspace by selecting different entries from the View > Sort menu.

Sorting images

The thumbnails that are displayed in the Bridge workspace can be sorted and displayed in a variety of different ways.

By default the pictures are displayed in ascending order based on their file names but Bridge provides a variety of other options in the View > Sort menu. Most of the settings listed here are self-explanatory. Once a Sort entry is selected the workspace is automatically updated and the files reordered.

In addition, the following related features extend the control that you have over how your files are sorted for display:

- The Show options in the View menu,

- The Ratings and Labels features, together with the filtering options contained in the drop-down menu, at the top right of the Bridge workspace.

Finding files

One of the great benefits of organizing your raw pictures in the Bridge workspace is the huge range of search options that then become available to you. Selecting Find from the Edit menu displays the Find dialog. Here you will be able to nominate what you want to search for, the criteria for the search, which folder you want to search in, what type of metadata to search and finally what to do with the pictures that match the search criteria.

To locate pictures with specific keywords, input the text into the Find feature in Bridge, setting Keywords as the location for the search.

A huge variety of search criteria can be used for the search. For many tasks, those listed in the Criteria drop-down menus are all that is needed, but for complex find operations it is possible to add multiple search criteria in the same dialog.

The Find command also displays a subset of the total images in a library. Images are selected for display if they meet the search criteria input via the Find dialog.

To form a search based on a rating level, select the Edit > Find feature and choose Rating, equal to, greater than, less than and the star value as the criteria.

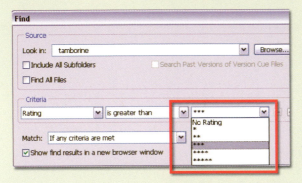

The Find dialog provides the ability to search based on Rating as an alternative to the options located in the Filter drop-down menu.

Metadata panel

The Metadata panel in Bridge displays a variety of information about your picture. Some of this detail is created at time of capture and other parts are added as the file is edited. The metadata includes File Properties, IPTC (copyright and caption details), EXIF (camera data), GPS (navigational data from a global positioning system), Camera Raw settings and Edit History. To display the contents of each metadata category click on the side-arrow to the left of the category heading.

The data displayed in this palette, such as the copyright, description, author and caption information, can be edited here or via the File > File Info dialog in Photoshop and the range of content types displayed in the palette is controlled by the selections in the Metadata Preferences in Bridge (Edit > Preferences > Metadata).

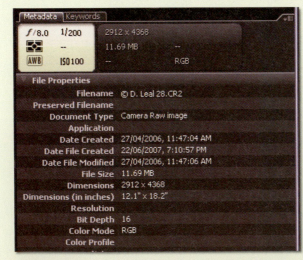

The Metadata panel displays the metadata info stored with the picture file. It is a rich source of image and EXIF details.

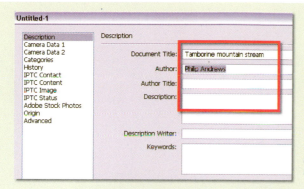

Users can enter custom metadata details via the File Info dialog (File > File Info) in Photoshop or the Metadata panel in Bridge.

As well as entering metadata details image by image, a set of details can be saved and added to groups of files via the options available in the sideways arrow menu (top right) of the File Info dialog.

Metadata Templates

The metadata options in CS3/CS2 also allow users to create and apply groups of metadata settings to individual or groups of files. The settings are created, saved and applied as a metadata template. This functionality really speeds up the management of the many files taken during shooting sessions, all of which need to have shoot, location, client and copyright details attached.

In Photoshop: To create a template, open an example image in Photoshop and then display the File Info dialog. Add your own details and information into the editable areas of the various data sections in the dialog. Next, select the Save Metadata Template option from the pop-up menu that appears after pressing the sideways arrow at the top right of the dialog.

Using Bridge: You can also create a Metadata Template in Bridge. Start by selecting the Create Metadata Template option from the pop-up settings menu (accessed by clicking the settings icon in the top right of the Metadata panel). Add specific entries in the Create Metadata

Template dialog. Add a name for the template and then click the Save button.

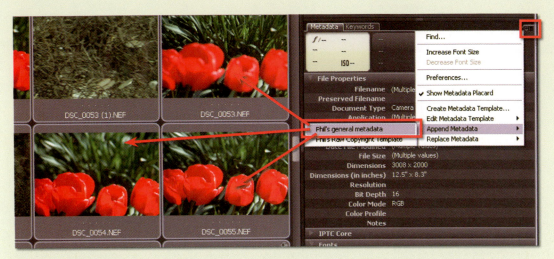

Saved metadata templates can be accessed either via the File Info dialog in Photoshop or with the settings menu in the Metadata panel in Bridge.

The new template will be added to the template list, allowing you to easily append existing details in Photoshop by opening the picture's File Info dialog and selecting the template from the pop-up menu. The same template can be applied to several pictures by multi-selecting the thumbnails first and then choosing the desired template from the list available in the pop-up menu in the Metadata panel in Bridge.

The template files that you create are stored in XML format and are saved to a Metadata Templates folder in Documents and Settings\User\ Application Data\Adobe\XMP for Windows machines.

Like a lot of settings used for image processing in Photoshop, Bridge and Lightroom, the metadata templates that you save are stored as individual files in the XML format.

Some basic filtering options can be found in previous versions of Bridge with the entries in the drop-down Filter menu. The choices here provide a mechanism for adjusting the subset of pictures being displayed based on their Labels or Ratings.

Live filtering

In yet another technique for locating individual images, or groups of files, the entries in the Filter panel of Bridge can be used to sort images displayed in the content area of the program.

The panel displays a range of information about the images currently being displayed. The panel entries change according to the characteristics of the folder currently selected. If all the photos in the folder are of the same file type, for instance, there will be no File Type heading displayed. If both JPEG and DNG files are present then the File Type heading will appear with two filter entries – JPEG and DNG.

Selecting a heading in the panel automatically filters the images being displayed so that only those with the selected characteristic are left. Picking another entry refines the display further to only those images containing both selected characteristics. This is a very fast method for sorting through your images.

At the top left of the Filter panel is the View Subfolders/View Current Folder only toggle button. Select this option to display images in the current folder and any subfolders. On the right side is a Sort by drop-down menu providing a range of options for the way that the results are displayed.

At the bottom left of the panel is the Keep Filtering while Browsing button, that maintains the current filter selections even when changing the folders being viewed. On the right is the Clear Filter button, which the user chooses to remove all current filter selections.

The Filter panel in Bridge 2.0 provides the ability to progressively filter the current displayed folder of images using file type as one of its criteria.

Managing raw files in Lightroom

Unlike Photoshop, which uses a sister program, Bridge, for the bulk of its organization and management tasks, Lightroom keeps these activities in-house and centers them around the Library module. In fact, this 'all included' approach is one of the main reasons that many photographers are switching to a Lightroom-based workflow. Let's look at how to perform some of the basic management tasks in the program.

Applying keywords

To add a keyword to a photo selected in the Grid View, or in the Filmstrip area of the dialog, either type the keyword directly into the Keyword Tags area of the Keywording panel (multiple keywords can be added with a comma separating each entry), or click the + button at the top of the Keyword Tags panel and input the keyword here.

Once a new keyword is added to the Keyword Tags panel you can apply the word by selecting the image (or images) in the Grid View and then choosing the Assign this Keyword to Selected Photo option. This option is available from the menu that is displayed when right-clicking the keyword entry in the Keyword Tags panel.

Also available on the same menu is the option to Use this as Keyword Shortcut. Selecting this option holds this specific keyword in memory, allowing the user to apply it by choosing images in the Grid View and pressing the K key.

Sets of keywords can be imported into Lightroom by selecting Metadata > Import Keywords and then browsing for the text file containing the words. Keywords used in a different Lightroom Catalog can also be imported in this way. After importing the keywords become Keyword Tags and appear in the Keyword Tags panel.

The Create Keyword Tag dialog is displayed after clicking the + button at the top right of the Keyword Tags panel.

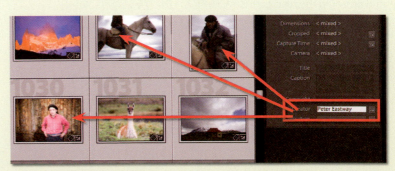

Add specific metadata details to several photos at once by selecting them first in the Grid View and then typing in the information in the Metadata panel.

Adding metadata

The Metadata functions in Lightroom pivot around the Metadata panel. Both fixed (EXIF data from the camera) and custom metadata entries are listed in the panel. Entry types that allow users to input their own text are displayed with text boxes next to the entry. Adding details on a picture-by-picture basis is possible by selecting the photo and then typing in the metadata content directly into the panel. To add the same entry to several files, simply multi-select the images in Grid View and then input the metadata details.

The latest version of Lightroom includes extra options in the Metadata panel for large captions, location, email and URLs. Also, extra functions have been added in the form of action buttons on the right of the metadata fields.

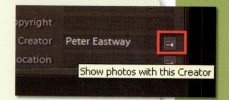

The new buttons on the right of the metadata fields in the Metadata panel automate a range of associated actions. Here clicking the button next to the Creator field will automatically display all photos, with this person listed as the creator.

Sorting files

The order that photos are displayed in the Grid View of Lightroom is controlled by the Sort setting. To change the order simply select a different option from those listed in the Sort menu located in the Library toolbar. The direction, ascending/descending, the images are displayed in using the sort criteria from the menu can be switched via the Sort Direction button, which is also located in the toolbar.

Searching

The Find panel in Lightroom provides two distinct ways to search for photos. The first is by using text input by the user. Using the drop-down Text menu at the top of the panel you can nominate where to search (filename, title, keywords, ITPC, EXIF, anywhere, etc.) and what type of search rule (contains, contains all, doesn't contain, etc.) is applied during the process. The actual text used for the search is input at the bottom of this part of the panel. Lightroom filters the displayed photos and presents the results of the search in Grid View. By selecting the Date search options as well, in the section below the text area, you can further refine the search process.

Images displayed in the Grid View are arranged based on criteria selected in the Sort menu on the Library module's toolbar. The order or direction, ascending or descending, is changed by clicking the Sort Direction button to the left of the menu.

Filtering the display

Like the Filter panel in Bridge, Lightroom filters the images displayed in the Grid View of the Library module as you select different criteria. Filtering is like performing a search live. The subset of images that are presented at the end of the filtering process may be the result of setting several different criteria across a range of panels.

For instance, you may start the filtering process by making sure that your whole collection of photos available. To do this you would select the All Photographs option from the Library panel. Next you may want to narrow the display to only those images captured with a particular camera. Filter out the others by selecting a specific camera model under the camera heading of the Metadata Browser. Lastly, you want to narrow the search to only the images captured over a specific time period. For this filter, use the Date section in the Find panel. In this example, with just three filter criteria, and in a matter of seconds, it has been possible to reduce the number of images displayed from over a thousand to just three. This is the power of the Lightroom filtering approach in practice.

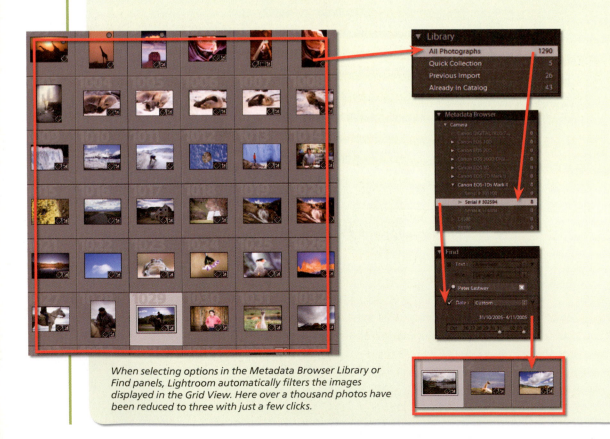

When selecting options in the Metadata Browser Library or Find panels, Lightroom automatically filters the images displayed in the Grid View. Here over a thousand photos have been reduced to three with just a few clicks.

14

Protecting
Raw Files

Even in this era of alleged 'increased masculine sensitivity' it is a difficult thing to watch a grown man cry. But recently I had to witness such a spectacle when a professional photographer friend of mine related his story of the crashing of his hard drive and the loss of 5 years' worth of images. When I enquired whether he kept backups, the response said it all, a blank expression followed by a growing awareness of an opportunity missed. Ensuring that you keep up-to-date duplicates of all your important pictures, both the original raw files as well as any working documents derived from them, is one of the smartest work habits that the digital photographer can adopt.

Decide what to back up

Ask yourself 'What images can't I afford to lose – either emotionally or financially?' The photos you include in your answer are those that are in the most need of backing up. If you are like most image makers then every picture you have ever taken (good and bad) has special meaning and therefore is worthy of inclusion. So let's assume that you want to secure all the photos you have accumulated.

Organizing your files is the first step to guaranteeing that you have backed up all important pictures. To make the task simpler store all your photos in a single space. This may be a single drive dedicated to the purpose, or a 'parent' directory set aside for image data only. If currently your pictures are scattered across your machine then set about rearranging the files so that they are stored in a single location. Now from this time forward make sure that newly added files or older images that you are enhancing or editing are always saved back to this location.

Organizing your image files into one central location will make it much easier to back up or archive all your pictures in one go.

Pro's tip: Ensure that all your picture assets are organized and stored in a single location.

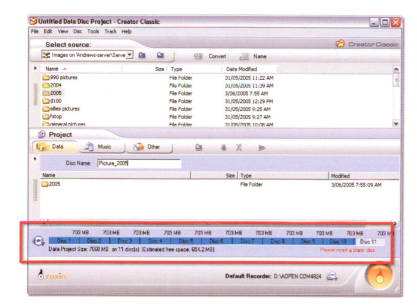

Most CD or DVD writing software has multi-disk spanning features built in. This technology allows you to archive large numbers of files across several disks without the risk of losing data.

Making your first backup

Gone are the days when creating a back up of your work involved costly tape hardware and complex server software. Now there are a variety of simpler ways to ensure that your files are secure.

1. Create duplicate CD-ROM or DVD disks

The most basic approach employed by many photographers is to write extra copies of all imaging files to CD-ROM or DVD disk. It is easy to create multi-disk archives that can store gigabytes of information using software like Roxio Creator Classic or Toast. The program divides up the files into disk size sections and then calculates the number of blanks needed to store the archive. As each disk is written, the software prompts the user for more disks and sequentially labels each DVD in turn. In this way whole picture libraries can be stored on a set of disks.

2. Back up from your editing program

Photoshop Elements, Photoshop (in conjunction with Version Cue) and Photoshop Lightroom all have backup options built in.

The Backup Options built into the Organizer workspace of Photoshop Elements for Windows creates an archive of all the files you have in your catalog via an easy to use step-by-step wizard.

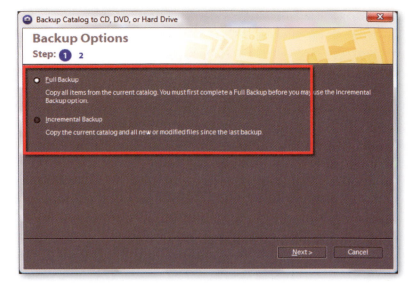

The Backup feature (Organizer: File > Backup) in Organizer in the Windows version of Elements is designed for copying your pictures (and catalog files) onto DVD, CD or an external hard drive for archiving purposes.

To secure your work simply follow the steps in the wizard. The feature includes the option to back up all the photos you currently have cataloged in the Organizer along with the ability to move selected files from your hard disk to CD or DVD to help free up valuable hard disk space.

The Version Cue program, which ships as part of Adobe Creative Suite, can automate the backup of Photoshop projects via the settings in the Administration component of the program.

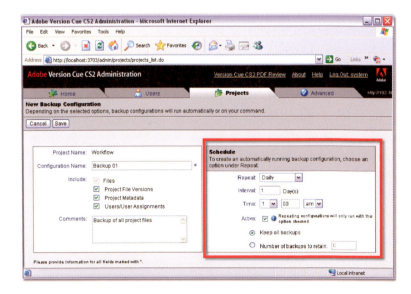

Adobe has also included sophisticated backup options in its Creative Suite release. By placing your Photoshop files in a Version Cue project you can take advantage of all the archive features that this workspace provides.

Backups are created via the Version Cue Administration screen. Here individual archive strategies can be created for each of your projects with the user selecting what to back up, where the duplicate files will be saved and when the automated system will copy these files.

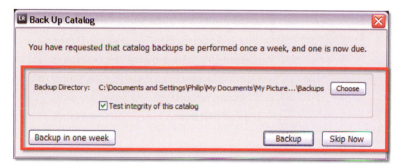

Lightroom contains a sophisticated backup system that copies its catalog files to a specific Backup directory when Lightroom starts up. Users can nominate how often the automatic backups will be performed in the Catalog Settings dialog.

Lightroom also takes the task of keeping your catalog and image files safe very seriously. Ensuring that your files are safe is a two-step process. Let's look at the catalog files first. The program contains an automated Catalog backup system that you can schedule to run either at regular intervals, or each time Lightroom starts.

When the backup option is selected the Back Up Catalog dialog is displayed when Lightroom first opens. The user has the option to perform the backup, skip the backup, or reschedule the backup for one week's time. The dialog also contains an option to select the backup directory and a setting to instruct Lightroom to perform an integrity check on the catalog at the same time as backing up.

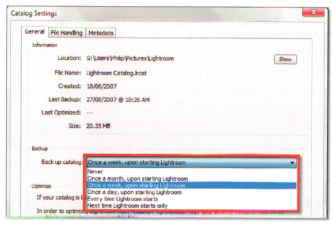

The scheduling options for the Backup system in Lightroom are located in the Catalog Settings dialog (File > Catalog Settings). Choose when the system functions from the list available here.

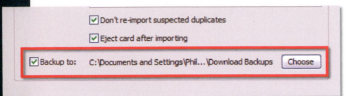

Use the Backup option in the Import dialog to make duplicates of the raw files that you download to Lightroom.

The second part of the Lightroom backup process is making sure that your raw photos are archived as well. Backing up the catalog doesn't copy the image files to the backup directory, it just archives the database of Develop settings and saved metadata associated with these files.

Lightroom provides the opportunity to back up the originals raw photos when first importing the pictures into the program. By selecting the backup option in the Import dialog you can choose where Lightroom will make and store a duplicate version of the files as it imports the pictures into the program. You can even nominate a portable hard drive as the default backup medium for importing photos just as long as the drive is connected at the time of downloading.

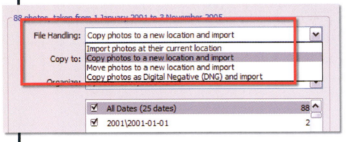

When working with files stored on DVD disks, select the 'Copy photos to a new location and import' option from the File Handling section of the Import dialog.

If you are working with photos that have already been downloaded to you computer or network, the same Backup option is available in the Import Photos from Disk dialog. If your workflow includes writing the original photos to a DVD before importing then it is possible to select the 'Copy photos to a new location and import' option in the File Handling section of the dialog. This setting makes a copy of the DVD files and stores them on your system before import.

With both the catalog and the original image files backed up, your Lightroom library should be secure as you can always re-import the image and catalog files.

3. Use a dedicated backup utility

For the ultimate in customized backup options you may want to employ the abilities of a dedicated backup utility. Until recently many of these programs were designed for use with high-end networked environments and largely ignored the smaller home or SOHO users, but recent releases such as Roxio's BackUp MyPC, Retrospect or SupewrDuper on the Mac, are both affordable and well suited to the digital photographer. The program provides both wizard and manual approaches to backing up your photos, includes the option to compress the archive file and gives you the choice of Full (all files duplicated) or Incremental (only backs up changed files since last backup) backup types.

Pro's tip: Use a backup solution that fits your budget as well as the way you work.

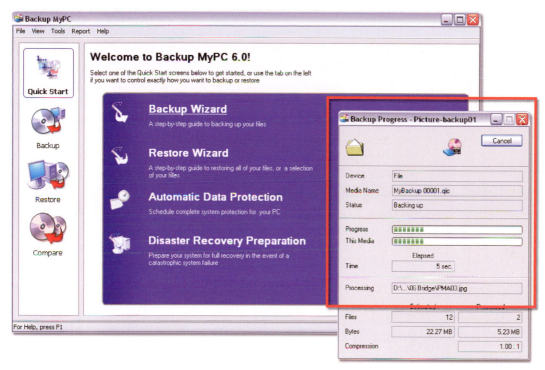

Dedicated backup software such as BackUp MyPC generally provides more features than the archive options built into other programs.

Back up regularly

There is no point having duplicate versions of your data if they are out of date. Base the interval between backups on the amount of work you do. In heavy periods when you are downloading, editing and enhancing many images at a time, back up more often; in the quieter moments you won't need to duplicate files as frequently. Most professionals back up on a daily basis or at the conclusion of a work session.

Pro's tip: The quality of your protection is only as good as the currency of your archives.

Store the duplicates securely

In ensuring the security of your images you will need to protect your photos not only from the possibility of a hard drive crash, but also from such dramatic events as burglary and fire. Do this by storing one copy of your files securely at home and an extra copy of your archive disks

or external backup drives somewhere other than your home or office. I know that this may sound a little extreme but swapping archive disks with a friend who is just as passionate about protecting their images will prove to be less painful than losing all your hard work.

Pro's tip: Make sure you keep a second archive set off site as insurance against fire and theft.

The DNG or Digital Negative file format is an open source raw file format that Adobe designed to try to bring some stability and capability to the area.

Which format should I use for backups?

After reading the bulk of this book it should be plain to see that the raw format has many advantages for photographers, offering greater control over the tone and color in their files, but unfortunately there is no one standard available for the specification of how these raw files are saved. Each camera manufacturer has their own flavor of raw file format. This can make the long-term management of such files a little tricky. Backing up the original files is great, but what happens if, over time, the specific format used by your camera, and archived by you faithfully, falls out of favor and is no longer supported by the major editing packages? Will you be able to access your picture content in the future?

Adobe developed the DNG or Digital Negative file type to help promote a common raw format that can be used for archival as well as editing and enhancement purposes. The company hopes that the specification will be adopted by the major manufacturers and provide a degree of compatibility and stability to the raw format area. At the moment

Hasselblad, Leica, Ricoh and Samsung have all produced cameras that capture in the DNG format, with more predicted to follow.

Adobe has included DNG output options in both Photoshop CS2 and Photoshop Elements 4.0, and other software producers, such as Apple (via Aperture), also provide DNG output options. In addition, Adobe also provides a DNG Converter that can change many proprietary Camera Raw formats directly to DNG. The converter is free and can be downloaded from www.adobe.com.

In addition to providing a common raw file format, the DNG specification also includes a lossless compression option which, when considering the size of some raw files, will help reduce the space taken up with the thousands of images that photographers accumulate.

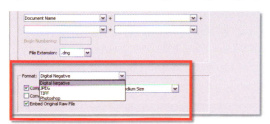

Saving DNG – To save your raw files in the DNG format, select this option as the file type when saving from the Adobe Camera Raw utility or other software with DNG save options.

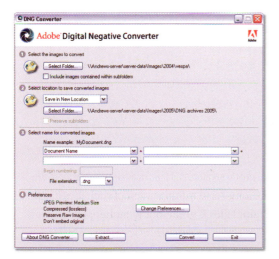

The DNG Converter – Alternatively, multiple files can be converted to the DNG format using the free DNG Converter which is available as a download from www.adobe.com. After launching the utility select the source and destination directories and determine the name and extension to be used with the converted files. The last setting in the dialog is the Change Preferences button. Click here to alter the default settings used for the conversion.

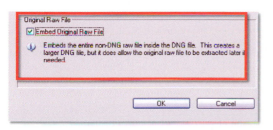

Embedding raw – The current version of the DNG Converter offers the option to embed the original raw file within the DNG conversion. This action will cause the resultant file to be larger, as it will contain two forms of the picture, but it does provide an added sense of security knowing that you can extract the original file at a later date.

Backup jargon buster

Multi-disk archive – A process, often called spanning, by which chunks of data that are larger than one disk can be split up and saved to multiple CD-ROMs or DVDs using spanning software. The files can be recompiled later using utility software supplied by the same company that wrote the disks.

Version Cue – Version Cue and the backup features it includes is included free when you purchase the Adobe Creative Suite 2 and is not supplied when you buy Photoshop CS2 as an individual product.

Full backup – Duplicates all files even if they haven't changed since the last time an archive was produced.

Incremental – Backs up only those files that have changed since the last archive was produced. This makes for faster backups but means that it takes longer to restore files as the program must look for the latest version of files before restoring them.

Restore – Reinstates files from a backup archive to their original state on your hard drive.

Backup hardware options

CD-ROM or DVD writer – This option is very economical when coupled with writing software that is capable of writing large numbers of files over multiple disks. The sets of archive disks can easily be stored off site, insuring you against theft and fire problems, but the backup and restore process of this approach can be long and tedious. New optical formats such as Blu-Ray, and HD-DVD, although relatively new will gradually become the default standard fro mass archiving.

Internal hard drive – Adding an extra hard drive inside your computer that can be used for backing up provides a fast and efficient way to archive your files, but won't secure them against theft, fire or even some electrical breakdowns such as power surges.

External hard drive – Connected via USB or Firewire, these external self-contained units are both fast and efficient and can also be stored off site, providing good all-round protection. Some, like the Maxtor One Touch models, are shipped with their own backup software. Keep in mind that these devices are still mechanical drives and that care should be taken when transporting them.

Online or web-based backup – Not a viable option for most image makers as the number of files and their accumulative size make transfer slow and the cost of web space exorbitant.

Versioning your edits – 'on-the-fly' backups

Backing up on a whole system level is pretty obvious but what about applying the same ideas on a file-by-file basis? In this section we look at a sure-fire method for protecting your files from accidentally being overwritten in the editing process.

Save me from myself

OK, here goes. I'm going to make an embarrassing confession but please keep it just between ourselves. Occasionally, yes that means not that often, I get so involved in a series of complex edits that I inadvertently save the edited version of my picture over the top of the original. For most tasks this is not a drama as the edits I make are generally non-destructive (applied with adjustment layers and the like) and so I can extract the original file from inside the enhanced document, but sometimes because of the changes I have made there is no way of going back. The end result of saving over the original untouched digital photo is equivalent to destroying the negative back in the days when film was king. Yep, photographic sacrilege!

So you can imagine my relief to find that in the latest editions of Adobe's flagship editing software programs, Photoshop and Photoshop Elements, the company has technology that protects the original file

and tracks the changes made to the picture in a series of successive saved photos. This technology is called versioning as the software allows you to store different versions of the picture as your editing progresses. What's more the feature (in both Elements and Photoshop) provides options for viewing and using any of the versions that you have previously saved.

Let's see how this file protection technology works in practice.

Versions and Photoshop Elements

Versioning in Photoshop Elements is an extension of the idea of image stacks and works by storing the edited version of pictures together with the original photo in a special group or Version Set.

All photos enhanced in the Organizer workspace using tools like Auto Smart Fix are automatically included in a Version Set. Those images saved in the Quick and Full Edit spaces with the Save As command can also be added to a Version Set by making sure that the Save with Original option is ticked before pressing the Save button in the dialog.

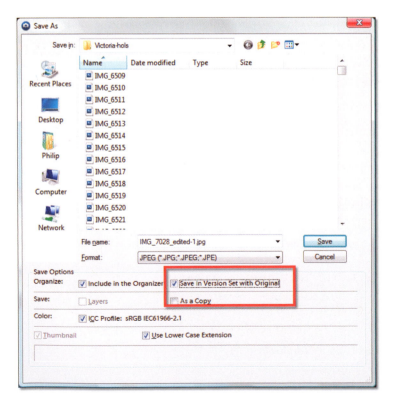

When editing pictures that have been opened from the Organizer into the Editor workspace Photoshop Elements provides the user with the opportunity of saving the edited file as part of a Version Set. To use the feature, click the option in the Save As dialog when storing pictures.

The small stacked pictures icon in the top right of the thumbnails in the Photoshop Elements Organizer workspace indicates that the picture displayed is part of a Version Set.

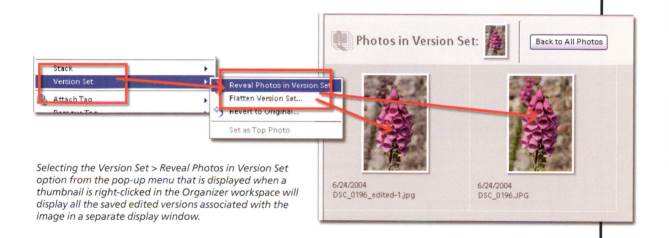

Selecting the Version Set > Reveal Photos in Version Set option from the pop-up menu that is displayed when a thumbnail is right-clicked in the Organizer workspace will display all the saved edited versions associated with the image in a separate display window.

Saving in this way means that edited files are not saved over the top of the original; instead a new version of the image is saved in a Version Set with the original. It is appended with a file name that has the suffix '_edited' attached to the original name. This way you will always be able to identify the original and edited files. The two files are 'stacked' together in the Photo Browser with the most recent file displayed on top.

When a photo is part of a Version Set, there is a small icon displayed in the top right of the Photo Browser thumbnail. The icon shows a pile of photos.

To see the other images in the version stack simply right-click the thumbnail image and select Version Set > Reveal Photos in Version Set. Using the other options available in this pop-up menu the sets can be expanded or collapsed, the current version reverted back to its original form or all versions flattened into one picture. Version Set options are also available via the Photo Browser Edit menu.

What are image stacks?

An image stack is slightly different from a Version Set as it is a set of pictures that have been grouped together into a single place in the Organizer workspace. Most often stacks are used to group pictures that have a common subject or theme and the feature is one way that Elements users can sort and manage their pictures. To create an image stack, multi-select a series of thumbnails in the workspace then right-click on one of the selected images to show the menu and from here select the Stack > Stack Select Photos option. You can identify stacked image groups by the small icon in the top right of the thumbnail.

The Stack feature in Photoshop Elements groups together several different images into a set. To create a Stack, multi-select the images in Organizer first and then choose the Stack > Stack Select Photos option from the right-click pop-up menu.

Elements indicates that a picture is the upper image in a stack of photos in Organizer by displaying a small 'photo stack' icon in the top right-hand corner of the thumbnail.

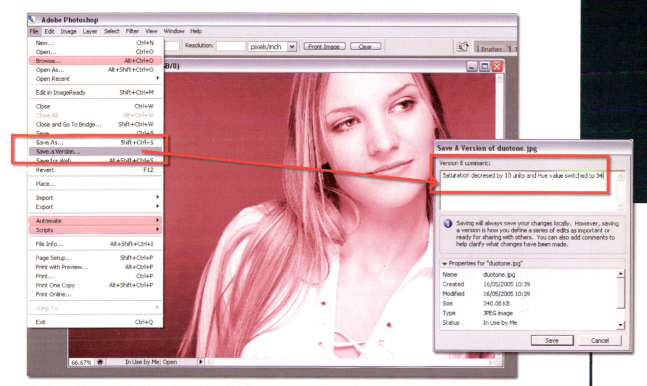

The Save a Version option is available when the files you are working on in Photoshop are part of a Version Cue project. The Save a Version dialog is displayed as part of the save process and allows the user to insert version-based comments before storing the new version of the file.

Photoshop CS3/CS2 and versioning

The Versions feature in Photoshop CS3/CS2 is a very useful tool for photographers who create multiple editions of the same image or design. When activated, the feature allows you to save a version from inside the Photoshop workspace. After using either the File > Save a Version (CS2) or File > Check In (CS3) option, a Version details dialog is displayed. The window contains all the details for the picture as well as a space for you to enter comments about the version you are saving.

After clicking the Save button the latest version of the file is then saved and displayed in the standard thumbnail view in Bridge. To see the previous version saved with the file, switch the workspace to the Versions and Alternates View (Bridge: View > As Versions and Alternates). This will display all the previous iterations of the photo.

Alternatively, right-clicking on the Bridge thumbnail and selecting the Versions option from the pop-up menu displays just the versions available for the selected image.

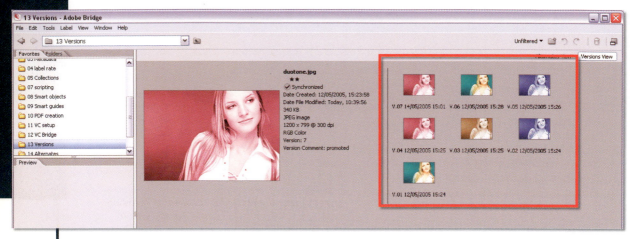

All the versions associated with a specific file can be viewed in Bridge, Photoshop's new file browser, by selecting the View > As Versions or Alternates.

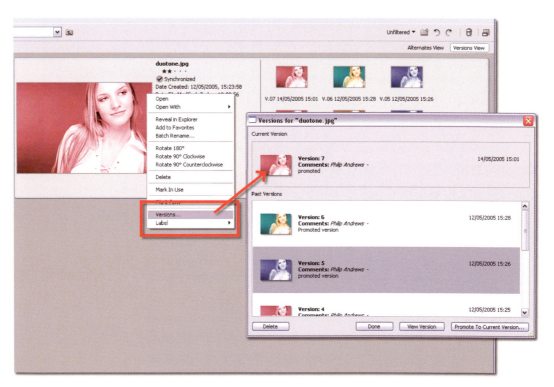

The versions associated with a Photoshop file can also be displayed in a separate Versions window by selecting the Versions option from the pop-up menu that is displayed when right-clicking the picture thumbnail in Bridge.

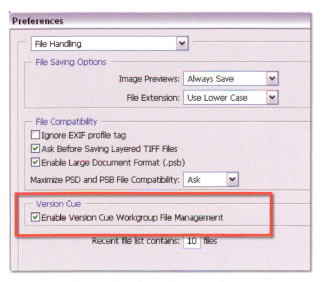

To use the versioning features in Photoshop and other Adobe Creative Suite programs you need to ensure that Version Cue is installed and active, and that the Version Cue options are enabled in the preferences of the program you are using.

Setting up for saving Photoshop versions

In order to make it possible to use the Save a Version feature in Photoshop (or any other CS2 program) the folders or files that you are working with must be organized in a Version Cue project or workspace. In addition, the Enable Version Cue options in the preferences of each of the CS2 programs also need to be selected. In Photoshop this setting is located in the File Handling Preferences dialog.

Now when a Version Cue protected file is opened and enhanced or edited in any way, the Save a Version option appears as a usable option on the File menu.

What is Version Cue?

To use versioning in Photoshop CS3/CS2 the Version Cue program must be installed and the Version Cue features must be enabled in the File Handling Preferences in Photoshop. Version Cue is included free when you purchase the Adobe Creative Suite 3/2 and is not supplied when you buy Photoshop as an individual product.

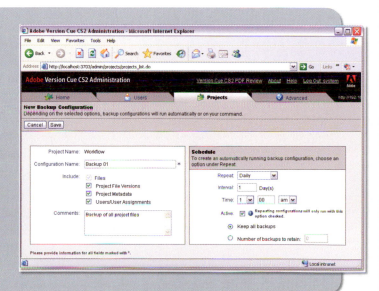

Though not quite the same as versioning, Lightroom does provide the ability to create virtual copies of images and apply different development settings to each, leaving the original untouched.

Alternatively, a virtual copy can be made of the original file at pivotal points in its processing history. This provides a versioning-like result where the different copies of the image act as separate versions.

Or you can use the Snapshots feature to keep a copy of the settings at key points in the development process.

Lightroom and virtual copies

Even though lightroom doesn't contain a versioning feature there are still a couple of Lightroom technologies that may help when you have overwritten the original file.

Firstly keep in mind that Lightroom employs a completely non-destructive workflow. All enhancement changes you see on screen are the 'on-the-fly' application of a bunch of settings that are stored separately to the image component of the file. At any time during the life of a Lightroom image it is possible to right-click on the photo in Grid View and select Reset from the Develop Settings menu. This will remove all enhancement changes and return the picture to its captured state. This is the ultimate form of undo and safeguards your files as well.

What about the situation where you want to revert to an enhancement state midway through a series of changes? Well, the Snapshots feature works well in this scenario. When reaching pivotal points in the enhancement of a photo it is worth creating a snapshot of the development settings at that time. This way it is always possible to return to the version of the image later. To retain several versions of the image at different stages of processing, employ a strategy of creating a virtual copy of the file at each pivotal point in the processing. These virtual copies will act as different versions of the image in a similar way to how the technology works in Photoshop and Photoshop Elements. Virtual Copies are not file duplicates, just extra sets of metadata instructions, that are applied to the same base raw file providing different previews.

Last appeal

Now be honest, 'Have you backed up your photos lately?' 'Do you have a file-by-file protection method in place?' If you haven't, then I hope that I have convinced you to do so and that you will start today; otherwise, like my photographer friend, you may just need to keep a stack of tissues handy for that day, heaven forbid, when your photos go missing.

D

DCT: Discrete Cosine Transform. A bit rate reduction algorithm that is used during JPEG image compression to convert pixels into sets of frequencies.

DEFAULT: A decision that your software or hardware makes for you, which is automatically carried out unless you intervene and change those settings. Most program allow the default setting to be changed by entering you own preferences.

DEVICE RESOLUTION: Refers to the number of dots per inch (dpi) that any device, such as a monitor or printer, can produce. Device resolution for computer monitors varies from 60 to 120dpi, but don't confuse this with screen resolution, which is the line screen (measured in lines per inch) that is used by commerc printers to reproduce a photograph with a press. Im resolution refers to the amount of information stor a photograph and is usually expressed in pixels per (ppi). The image resolution of a photograph deter how big the file will be: the higher the resolution, more disk space it grabs and the longer it takes to

DESPECKLE: The Despeckle filter in Adobe Photo (Filter > Noise > Despeckle) detects the edges of – where significant color changes occur – and bl selection except the edges. This has the effect of noise while preserving detail, although CS2's R Noise command (Filter > Noise > Reduce Noise a better job removing digital camera noise.

DIALOG BOX: A window that software uses to communicate with a user to achieve a specific

DIGITAL: Information represented by numbe Computers use information measured in bits digits. Binary is a mathematical system base numbers one and zero, and inside a comput signals are represented by positive and nega = off) current.

DIGITIZE: To convert into digital form; e.g. can be used to digitize a photograph and t pixels.

DLL: Dynamic Link Library. Microsoft Wi Dynamic Link Libraries for linking and s

DISK CRASH: The failure of a disk usua read/write head (of any drive) coming i with the disk surface.

DISPLAY: Another word for the box co cathode ray tube (or LCD panel), powe other components that enable you to displayed by your computer.

DITHERING: A graphics display or p that uses a combination of dots or te impression of a continuous-tone gr

DOT GAIN: An increase in the size

Index

349

More great titles by Philip Andrews...

Do you need more information on Photoshop, Photoshop Elements, Raw file processing or general photography? Do you crave extra tips and techniques? Do you want all these things but presented in a no nonsense, understandable format?

Philip Andrews is one of the world's most published photography and imaging authors and with the following titles he can extend your skills and understanding even further.

Photoshop® CS3: Essential Skills

'...excellent coverage of Photoshop as a digital darkroom tool as well as covering a truly amazing amount of background information.'
Mark Lewis, Director of Technology Training, Mount Saint Mary College, USA

- Put theoretical knowledge into a creative context with this comprehensive text packed with original student assignments and a supporting DVD-ROM
- Discover the fundamental skills vital for quality image manipulation and benefit from the highly structured learning approach
- CD-ROM and dedicated website – *www.photoshopessentialskills.com*

ISBN: 0240520645 / 9780240520643 – $36.95 / £21.99 – Paperback – 448pp

Photoshop CS3 A–Z
Tools and features illustrated ready reference

- Find solutions quick with this accessible encyclopedic guide
- Conveniently organized in a clear A-Z format, this illustrated ready reference covers every action you are likely to make as a photographer
- You'll never want it far from your side while you work with Photoshop
- Dedicated website – *www.photoshop-a-z.com*

ISBN: 9780240520650 – $29.95 / £17.99 – Paperback – 316p